Contents

Contents

Contents

How to cheat, and why

Why yet another book on Photoshop?

Most of the Photoshop books in print go to great lengths to explain how each tool, dialog and menu works, examining the smallest tweak of each slider and variable and discussing its effects on the image.

What they don't tend to show is how to use Photoshop to achieve a task you've been commissioned to do – specifically, how to use it to create artwork that looks as if it's been photographed.

Photorealism simply means making montages look real. Too often we'll see montages where the heads are different colors to the bodies, where there's no eye contact or interaction between a group of people stuck together in a single image. In my view this is unforgivable: few photographers would be able to earn their living producing bland, emotionless pictures, yet those creating photomontages seem to forget the most basic of rules. A picture must tell a story – which means rhythm, composition, and interaction between its constituent elements.

The truth about cheating

I've used the word 'cheating' in the title of this book in two ways. The most obvious is that I'm describing how to make images look as much as possible like photographs, when they're not. In this sense, it simply means creating photographic work without the need for a studio.

The other sense of 'cheating' is finding shortcuts to help you work more quickly and more economically. Too often you'll see Photoshop techniques explained using long-winded, complex operations that take an age to complete.

Wherever possible, I've used quicker solutions to achieve the same results. For the artist on a deadline, the difference between a perfect work of art and one that's turned in on time means the difference between a happy client and one faced with a blank page in the next day's newspaper.

Workthroughs and examples

Each workthrough in this book is designed as a double page spread. That way, you can prop the book up behind your keyboard while going through the associated file on the CD ROM. While the workthroughs are all designed to illustrate a specific technique, I've also outlined each step as a general guide to the process of creating illustrations in Photoshop. So you may find that several steps in a workthrough appear to have nothing to do with the subject of the chapter: I've just taken the opportunity to discuss other points of interest.

Some of the workthroughs take the form of case studies, where I dissect an illustration I've done as a commissioned job; many of the sections open with one of my illustrations as a real-world example of the technique I'm talking about. One reason I've used my own artwork is that I know how it was created. In many cases I've kept the original layered Photoshop files, so it's been possible for me to take the images apart and show how they were made.

There's another, more pertinent reason. Messing about in Photoshop can be the most fun you can have without breaking the law, and the novice user will experiment with filters and color changes endlessly. But it's not until you produce an illustration to a specific brief that you realize the issues and problems involved – and then find a way around them. Almost all the techniques I describe in this book have been learned out of necessity; there's nothing like a tight deadline to concentrate the mind. Adrenaline is sometimes the best drug there is.

At the end of each chapter you'll find an Interlude, in which I discuss an issue of relevance to the Photoshop artist. Think of them as light relief.

Screen shots and windows

Most Photoshop books use standard screen grabs as examples, which means two things: the examples are constrained to the monitor's 4:3 proportions, and an awful lot of space is taken up with frames, title bars and borders. I take the view that anyone working in Photoshop knows what a window looks like, and doesn't need to be reminded half a dozen times on every page. So except in the instances where I'll show a dialog box I've dispensed with the window frames altogether, so we can just concentrate on the images. This has also given me greater flexibility in the number and shape of the examples I include for each workthrough. Hopefully, it's also made the book more varied and interesting to look at.

What's on the CD?

I've included most of the workthroughs in this book on the CD, so that after reading about them you can open up the original Photoshop files and experiment with them for yourself. I've reduced the image sizes to make them more manageable, so you'll find yourself working with screen resolution rather than high resolution images. I've also included some movies showing specific techniques in action.

In a few cases, I haven't been able to provide the examples on the CD. These tend to be workthroughs that are case studies, in which I've used images of politicians and other celebrities for whom it was impossible to get clearance to include them for electronic distribution. All the other images have been either photographed by me or generously provided by the various image libraries concerned, to whom I owe a debt of gratitude. A credit on each page in the book indicates the source of the images that have been included on the CD. You'll also find demonstration versions of some of the third party plug-ins I've described on the CD, so go ahead and try them out. For full details of what's included, see the back pages.

Spelling and metaphors

I've tried to use American spelling wherever possible. First, because we're more used to reading US spelling in England than Americans are to reading English spelling; and second, because Photoshop is an American product. Initially I tried not to use any words that were spelled differently in the two languages, but I found it impossible to get through the book without once mentioning the words 'color' and 'gray'. My apologies if I've employed any phrases or vernacular that don't work on both sides of the Atlantic. It's a wide ocean, and some expressions don't survive the journey.

Going further

You'll find links to sites of interest, as well as contact details and any extra information that may come to light after this book is published, on the website at www.howtocheatinphotoshop.com where there's also a user forum where you can post questions or problems – follow the link from the main website.

Steve Caplin
London, 2004

Acknowledgments

This book is dedicated to Carol, of course.

I'm immeasurably grateful to the following:
Marie Hooper of Focal Press, for her patience and persistence
Martin Evening, for help and advice
Keith Martin, for helping me create the keyboard shortcuts font
Those readers who bought the first edition of the book and who took trouble to write to me with suggestions
Adobe Systems Inc., for making Photoshop in the first place.

I'm indebted to the art editors of the newspapers and magazines who commissioned the artwork I've used as examples in this book:
Jonathan Anstee, Kevin Bayliss, Julian Bovis, Roger Browning, Zelda Davey, Miles Dickson, Robin Hedges, Paul Howe, Lisa Irving, Alice Ithier, Ben Jackson, Jasmina Jambresic, Vicky McManus, Fraser McDermott, Garry Mears, John Morris, Doug Morrison, Lawrence Morton, Martin Parfitt, Mark Porter, Stephen Reid, Tom Reynolds, Caz Roberts, Caroline Sibley and Matt Straker.

A couple of the workthroughs in this edition have previously been published, in a slightly different form, in the magazine Total Digital Photography. My thanks to editor Simon Joinson for allowing me to repurpose my work here.

Many of the images in this book are taken from royalty-free photo libraries. Their websites are as follows:

AbleStock	www.ablestock.com
Bodyshots	www.digiwis.com
Corel	www.corel.com
Hemera	www.hemera.com (digital image content © 1997–2002 Hemera Technologies Inc. All rights reserved.)
Photodisc	www.photodisc.com (digital images © 2001 PhotoDisc/Getty Images)
Rubber Ball	www.rubberball.com (all images © Rubber Ball Productions)
Stockbyte	www.stockbyte.com

How to use this book

I doubt if any readers of this book are going to start at the beginning and work their way diligently through to the end. In fact, you're probably only reading this section because your computer's just crashed and you can't follow any more of the workthroughs until it's booted up again. This is the kind of book you should be able to just dip into and extract the information you need.

But I'd like to make a couple of recommendations. The first three chapters deal with the basics of photomontage. There are many Photoshop users who have never learnt how to use the Pen tool, or picked up the essential keyboard shortcuts; I frequently meet experienced users who have never quite figured out how to use layer masks. Because I talk about these techniques throughout the book, I need to bring everyone up to speed before we get onto the harder stuff. So my apologies if I start off by explaining things you already know: it'll get more demanding later on.

Each chapter is effectively a self-contained unit, but the techniques do build up as you progress through the workthroughs. Frequently, I'll use a technique that's been discussed in more detail earlier in the same chapter, so it may be worth going through the pages in each chapter in order, even if you don't read every chapter in the book.

A CD icon on a page indicates that the Photoshop file for that workthrough is on the CD, so you can open it up and try it out for yourself. The Movie icon indicates that there's a QuickTime movie on the CD that shows the workthrough acted out.

Most of the examples in this book can be worked through with Photoshop 6 or higher. A few need Photoshop 7 and some need Photoshop CS, the latest version; it's stated in the introductory text when these versions are required for the job.

If you get stuck anywhere, drop me a line. You can find my contact details through the website at www.howtocheatinphotoshop.com.

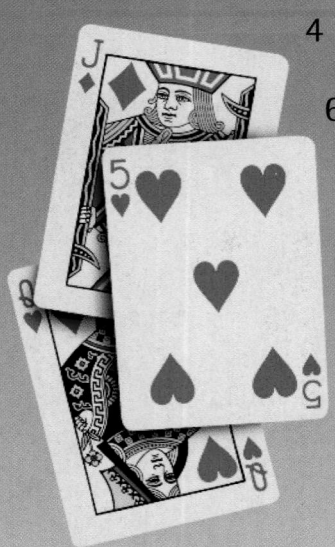

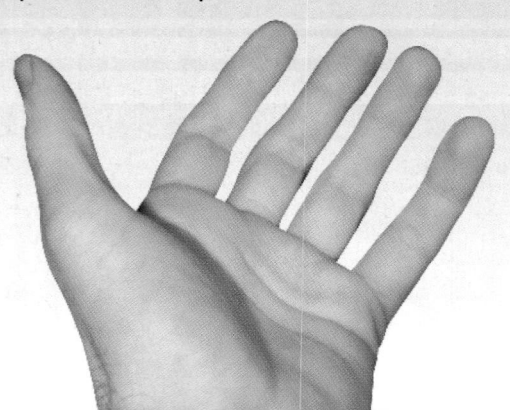

1

Natural selection

THE TECHNIQUES described in this book assume you have a reasonable working knowledge of Photoshop. In later chapters, we'll discuss ways of working that involve modifying selections, and using both QuickMask and the Pen tool to create Bézier curves. The first part of this chapter will serve as a refresher course on these fundamental techniques for those who already know them, and will introduce the concepts for those who have not yet experimented with them.

Later on, we'll go into more detail on how to work with and modify layers and colors without having to pick up a brush first: there are many techniques, such as those for changing colors selectively, that can be accomplished entirely by means of dialog boxes.

Selection: the fundamentals

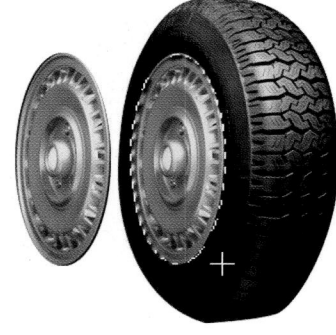 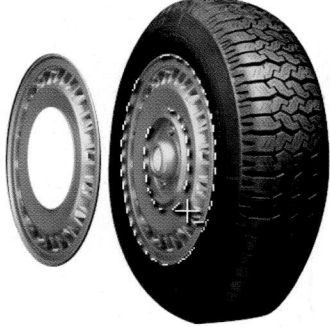

1 Normal drawing with the Marquee tool is from corner to corner. But if you're using the Elliptical Marquee, it's hard to conceive where the imaginary corner might be. Hold down *alt* *after* you begin drawing to draw from the center outwards. The selected region is shown at the side.

2 If you hold *alt* *before* you draw a second selection, you will remove this selection from the original one. Be sure to press the modifier key before you begin drawing, or you'll simply draw from the center. Here, we've deselected the center of the hubcap, leaving just the rim.

ALL PHOTOSHOP WORK begins with making selections. Shown here are some of the basic keyboard shortcuts that every Photoshop user should be able to use as second nature: even if you hate learning keyboard commands, you owe it to your productivity and your sanity to learn these.

Temporarily accessing the Move tool, using the shortcut shown in step 8, works when any other tool is active – not just the selection tools. This makes it easy to move any layer around while painting, selecting or using type, without having to reach for the toolbar.

6 If you find holding down all these keys in sequence hard to get to grips with, consider using QuickMask instead.

To access it, simply type **Q** and you'll go into QuickMask mode – see the following six pages to read about this useful selection method in more detail.

The QuickMask equivalents of the selected areas defined in steps 1 to 5 are shown beneath each step. Selected areas are overlaid in red; unselected areas remain colorless, making it easy to see exactly where your final selection will be. The mask corresponds precisely to the selection area, as can be seen in the examples on this page.

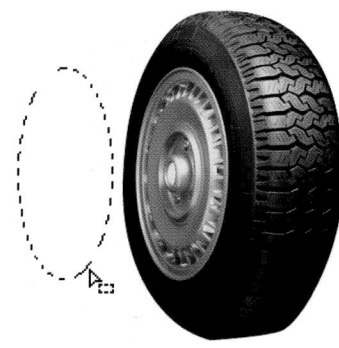

7 If you drag a selected area with a selection tool active (Marquee, Lasso etc), you'll move the selected region but not its contents.

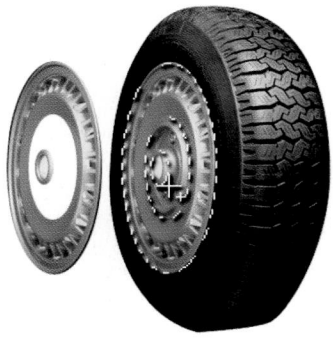 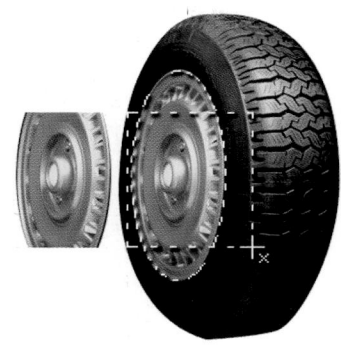 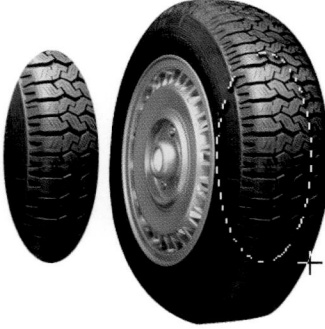

3 Holding ⌥ *alt* subtracts from the selection, but holding *Shift* adds to it. Again, be sure to hold the modifier before you begin drawing. By holding this key down, we're able to add back the middle knob on the hubcap from the section we'd previously deselected.

4 Here's what happens if we combine the two keys. Holding ⌥ *Shift* *alt* *Shift* intersects the new selection with the previous one, resulting in just the overlap between the two. Here, the original elliptical selection is intersected with the new rectangular selection.

5 A little-known modifier is the Space bar, which performs a unique task: it allows you to move a selection while you're drawing it, which is of enormous benefit when selecting areas such as the ellipse of the hubcap. Here, we've used the technique to move the selection over to the side.

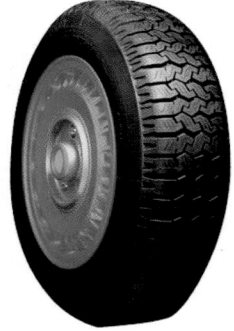 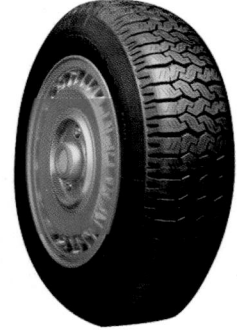

8 To access the Move tool temporarily, hold ⌘ *ctrl* before you drag. Now, the selection itself will be moved when you drag it.

9 Holding down ⌥ *alt* as well will move a copy, leaving the original selection where it was – but be sure to hold the modifier before dragging.

10 You can continue to make several copies by releasing and holding the mouse button while holding the ⌥ *alt* key down.

HOT TIP

Selections can be nudged with the arrow keys, as well as being dragged into position – useful for aligning them precisely. One tap of the arrow keys will move a selection by a single pixel. If you hold the *Shift* key as you tap the arrow, the selection will move by 10 pixels at a time. If you also hold ⌘ *ctrl* you'll move the contents, rather than just the selection boundary.

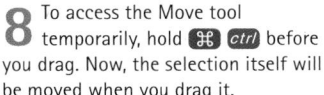

5

The Lasso and Magic Wand

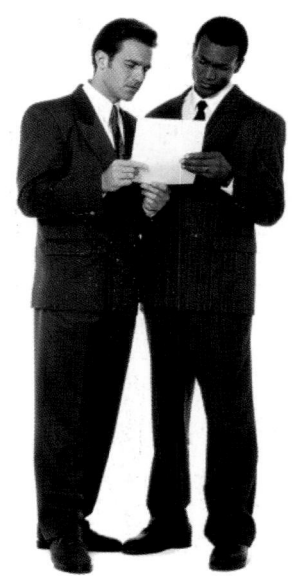

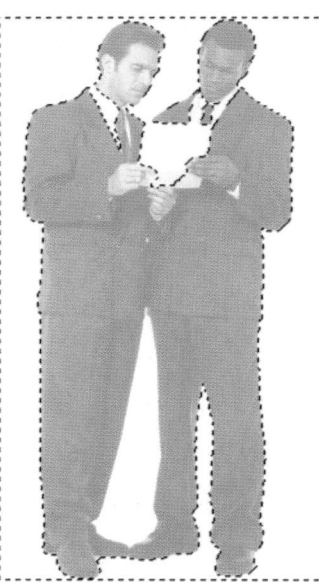

THE LASSO MAY WELL have been the first selection tool to be seen in a digital paint program, having put in its initial appearance 20 years ago, but these days it's far from being the ideal tool. Clumsy and inaccurate to draw with, it's best reserved for tidying up selections made in other ways, as we'll see here.

There is one surprising use for the Lasso tool, however, and that's for tracing straight lines – thanks to a little-known keyboard shortcut. We'll look at this technique in steps 6 and 7.

The Magic Wand tool is a great all-purpose tool for selecting areas of a similar tonal range, and is widely used for removing simple backgrounds. Its tendency to 'leak' into areas you don't want selected, however, means you have to pay close attention to what's actually been selected - and be prepared to fix it afterwards.

1 This straightforward scene should be an ideal candidate for Magic Wand selection: after all, it's on a plain white background. But even simple selections can have their pitfalls.

2 Begin by clicking in the white area outside the two figures. (Note that the main image has been knocked back so we can see the selection outlines more clearly.)

6 Although the Lasso tool may seem the obvious choice when drawing freehand selections, it really comes into its own when used to select objects made of straight lines, such as this fence. Hold the ⌥ *alt* key and then click once at each corner of each vertical post, clicking additionally from the bottom of one to the bottom of the next. By holding this key, we force the Lasso tool to draw straight lines between click points.

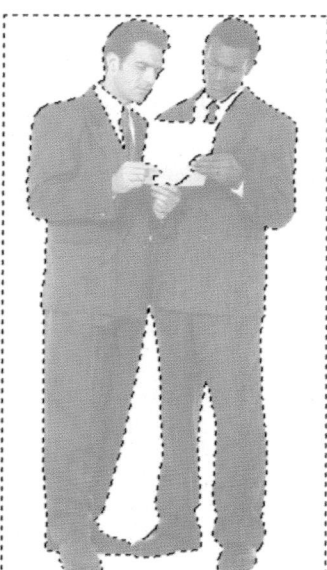 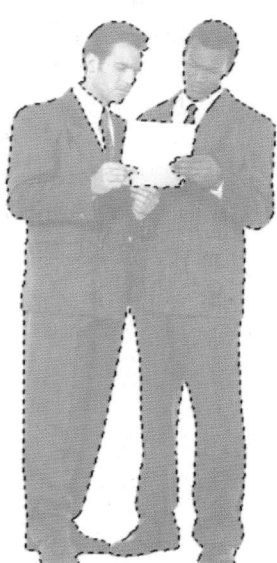 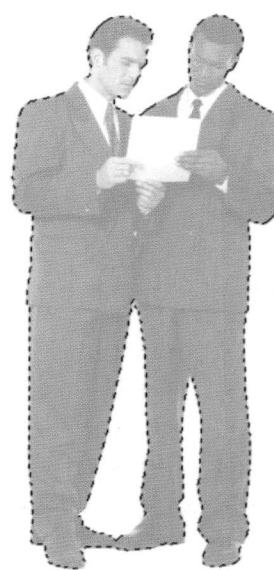

3 The area between the men's legs was not included in the original selection, so we need to hold the **Shift** key and click there to add it to our selection area.

4 So far, we've selected everything except the bodies. We need to inverse the selection, by pressing **⌘ Shift I** **ctrl Shift I**, to select the bodies themselves.

5 Note how the original Magic Wand selection 'leaked' into the paper and the shirt collars. This is easily fixed by holding **Shift** as we add those areas with the Lasso tool.

HOT TIP

The tolerance setting of the Magic Wand affects the extent to which it includes similar colors. The higher the tolerance, the wider the range of shades it sees as being similar to the one you click on. For general use, set a tolerance of 32 and adjust if necessary.

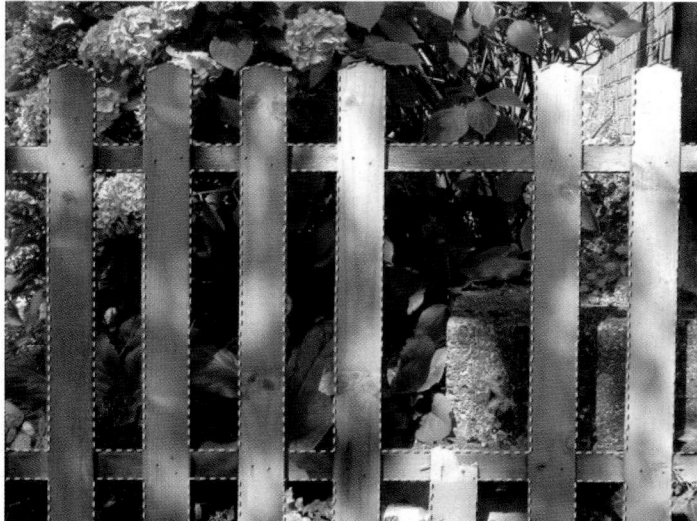

7 Now to add the horizontals. Hold the **Shift** key and then, after clicking the first corner point, add the **⌥ alt** key and continue to click each corner as before. Be sure not to hold **⌥ alt** before beginning to click or its effect will be to subtract the new selection from the old one, rather than adding to it – see the previous page for details on how these modifier keys work. The fence will now be fully selected.

SHORTCUTS
MAC WIN BOTH

QuickMask 1: better selection

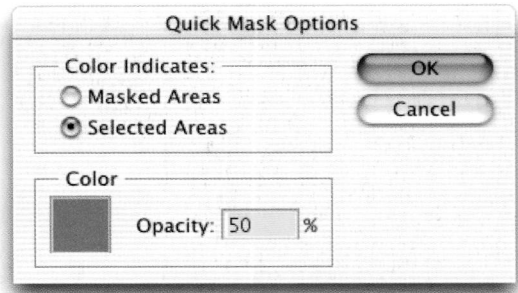

Quick Mask Options

Color Indicates:
○ Masked Areas
● Selected Areas

OK
Cancel

Color

Opacity: 50 %

QUICKMASK IS THE MOST POWERFUL tool for creating selections in Photoshop. It uses a red overlay to show the selected area, allowing you to see the image through it; when you leave QuickMask mode, the painted area will be selected.

In QuickMask, painting with black will add to the selection and painting with white will subtract from it (as long as you're set up as described below). This makes it easy to trace around any object: it's far quicker and more controllable than the Lasso tool, and in situations such as the one shown here it's the best solution.

The default setting is for QuickMask to highlight the masked (unselected) areas with a red overlay, leaving the selected areas transparent: I find it far preferable to work the other way around, so that the selected areas are highlighted. To change the settings, you need to double-click the QuickMask icon (near the bottom of the toolbar, just below the foreground/background color swatches) and use the settings shown above.

1 This image would be tricky to select using the Lasso tool, and impossible with the Magic Wand - the background and foreground are just too complex. Press **Q** to enter QuickMask mode so we can begin.

2 Using a hard-edged brush, begin to trace around the inside of the figure. You don't need to paint the whole figure in one go, so take it at your own pace and let the mouse button up every now and again to take a break.

6 With the basic outline selected, we can address the detail. Lower the brush size using **[** until you have a size that's small enough to paint in the outline detail comfortably.

7 Now the outline is selected, leave QuickMask by pressing **Q** again, and the selection will be shown as a familiar 'marching ants' outline. You can now press **⌘ J** **ctrl J** to make a new layer from the selection.

3 It's easy to make a simple mistake when painting the outline, such as going over the edge by accident – as I've done at the elbow here. Don't simply press Undo, or you'll lose the whole brush stroke; there's a better way to correct the error.

4 To paint out the offending selection area, change the foreground color from black to white (the keyboard shortcut to do this is **X**). Paint over the mistake, then press **X** again to switch back to black to paint the rest of the selection.

5 You don't need to worry too much about fine detail at this stage – just get the basic figure highlighted. Fiddly areas, such as around the ear and the collar, can be left till later.

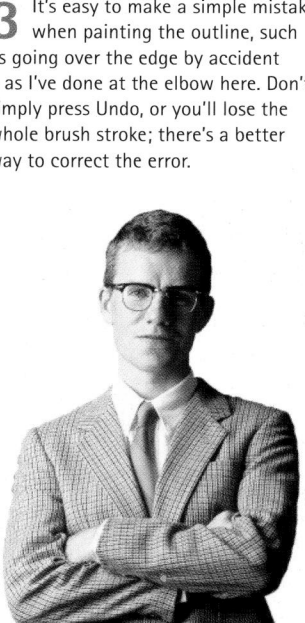

8 When the background is removed, we can see more clearly that the right side of the image is in really deep shadow – too deep to work with. Again, we can use QuickMask to select the shadow area.

9 Enter QuickMask again by pressing **Q**, and this time change to a soft-edged, larger brush. When we paint over the shadows now, we're creating a soft-edged selection; then leave QuickMask with **Q** again.

10 Because our selection has a soft edge, we can use any of the standard Adjustments to lighten up the shadow area (I've used Curves here) without showing a hard line between the changed and unchanged areas.

HOT TIP

You can mix hard and soft brushes within the same QuickMask session. For example, if you're cutting out a picture of a dog, you might use a soft-edged brush to trace around the fur, and a hard-edged brush to trace the outline of the nose and mouth. Soft brushes are the equivalent of feathering Lasso selections, but are very much more controllable.

SHORTCUTS
MAC WIN BOTH

9

QuickMask 2: tips and tricks

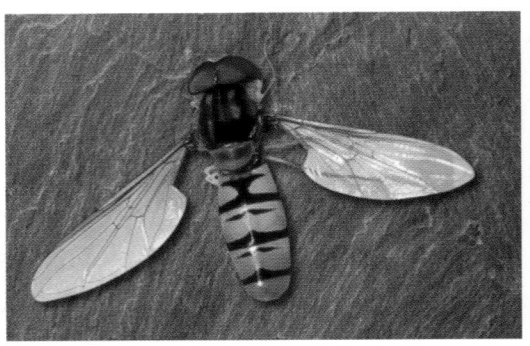

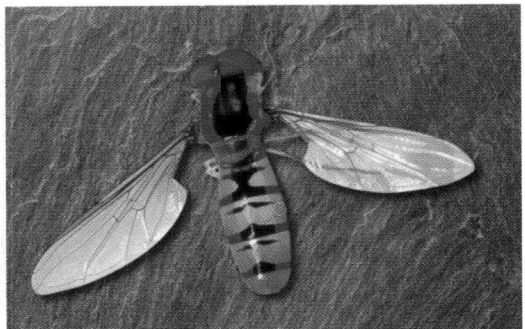

1 Enter QuickMask mode with **Q**. Begin by using a hard-edged brush to trace around the main body of the fly. Don't worry about the legs at this stage – we'll add them in later. Remember that if you make a mistake, you can always swap the foreground color to white and paint it out.

QUICKMASK IS THE BEST TOOL FOR making complex selections, especially of natural or organic objects where there are no hard, straight edges. By switching between large and small brushes, it's easy to trace even the most fiddly of objects with a little patience.

It all becomes more interesting when we look at using shades other than pure black and white to paint the mask. By painting with gray, we create a mask which is semi-transparent: the darker the shade, the more opaque the resulting selection will be. This technique is of particular benefit when selecting objects such as this fly, which has an opaque body and legs but semi-transparent wings. Building that transparency into the selection makes the whole effect far more convincing when we place the fly on a new background: the lowered opacity makes it look far more as if it belongs in its new surroundings.

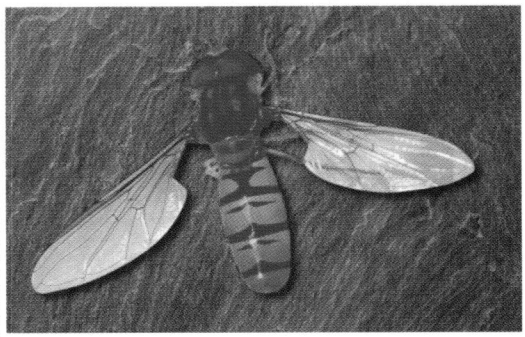

4 Now for the legs. Switch to a much smaller (but still hard-edged) brush, and trace each leg carefully. You can change brush sizes by using **⌘]** **ctrl]** to go to the next size up, and **⌘ [** **ctrl [** to go to the next size down.

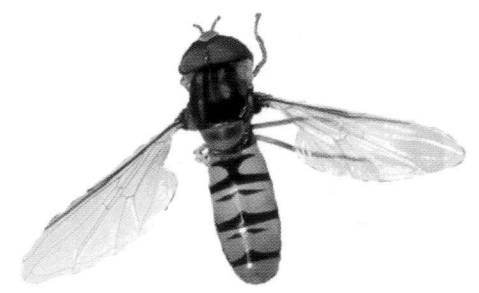

7 Now exit QuickMask by pressing **Q** again, and press **⌘ J** **ctrl J** to make a new layer from this selection. When we hide the underlying layers, we can see a few small errors: a bit of background has crept into the wings.

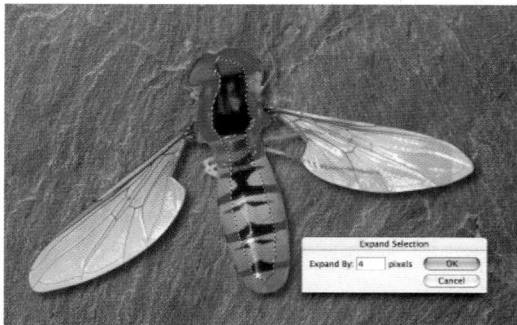

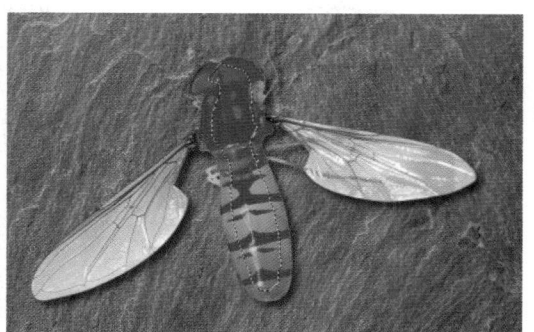

2 We could just paint in the middle of the body - but with a large selection, that would take a while. Here's a shortcut: use the Magic Wand tool to select the middle portion, then expand that selection (Select menu) by, say, 4 pixels to make sure the edges are covered.

3 Now fill that new selection with the foreground color (the shortcut for doing this is ⌥ *Delete* *alt* *Delete*) and then deselect (⌘ *D* *ctrl* *D*) to remove the Magic Wand selection. This is a useful technique for large images in particular.

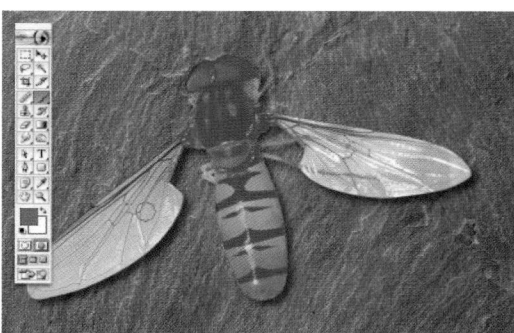

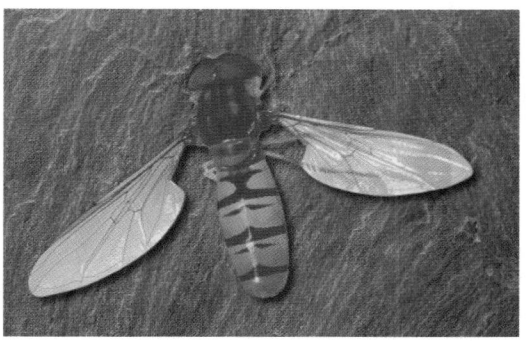

HOT TIP

Why didn't we simply paint with a lower brush opacity in step 5, rather than switching to gray? Because if we had, we would have to have painted the whole of each wing in a single brushstroke, without interruption. Otherwise, the new stroke would overlap the old one, creating a darker area (and so a stronger opacity) in the intersection.

5 Before painting the wing area, we need to switch from black to a dark gray color to give the wings their transparency. Choose a gray from the Swatches palette, and, with a bigger brush, paint over the wings.

6 The wings may need to be semi-transparent, but those fine legs shouldn't be – so switch back to black (press *D*) and, with a small brush, paint in the legs where they're seen through the wings.

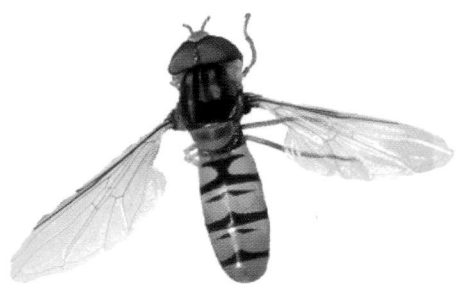

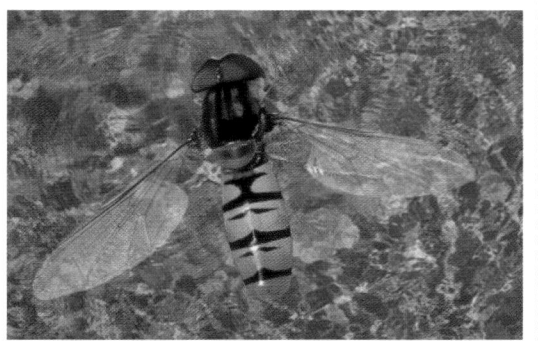

8 The easiest way to fix this is simply to erase the offending areas with a hard-edged Eraser. If you prefer, you could go back to QuickMask and tidy it up there, but it generally isn't worth the extra effort.

9 Because we selected the wing area using built-in transparency, we can partially see through them when we place the fly on a different background, adding greatly to the realism of the scene.

SHORTCUTS
MAC **WIN** **BOTH**

11

QuickMask 3: Transformations

AS WELL AS USING PAINTING TOOLS, you can use any of the standard transformation tools within QuickMask. This can make it easier to select tricky areas, such as the angled hubcaps on this sports car. Even though the hubcap is an ellipse, the angle at which it's been photographed makes it impossible to select with the standard Elliptical Marquee tool. QuickMask, however, makes short work of the problem.

QuickMask can be used for creating all kinds of shapes from scratch. Hard-edged rectangles and smooth circles can be combined to build lozenge shapes far more quickly than toying with the radius settings of the Shape tools, for example.

There are many more uses to QuickMask than are shown here. Get into the habit of using it for your everyday selections, and you'll find it quickly repays the effort.

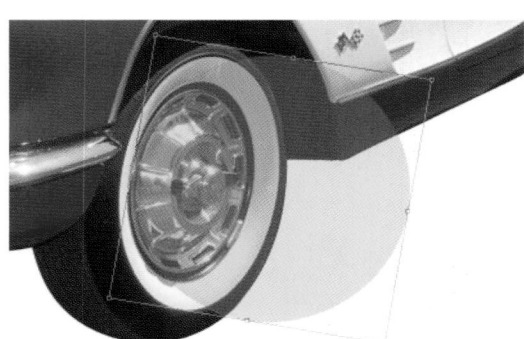

1 The hubcap on this car is a perfect circle photographed from an oblique angle. The Elliptical Marquee tool, however, only works on an orthogonal axis – there's no way to make it draw at an angle, as would be required here.

4 Enter Free Transform mode by pressing ⌘ T ctrl T, and selection borders will appear around the circle – no need to make an additional selection first. Drag the circle so one edge touches the edge of the hubcap, and rotate it to roughly the right angle.

7 Here's a simple and quick way to make a lozenge shape to exactly the size you want. First, draw a rectangle of the right height, and press **Q** to enter QuickMask. Choose the Elliptical Marquee tool, and position the cursor just inside the top of the rectangle; hold the **Shift** key and drag to the bottom edge of the rectangle.

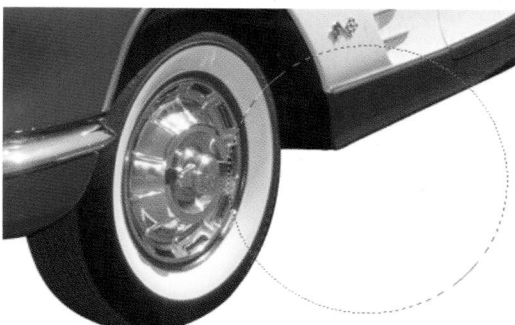

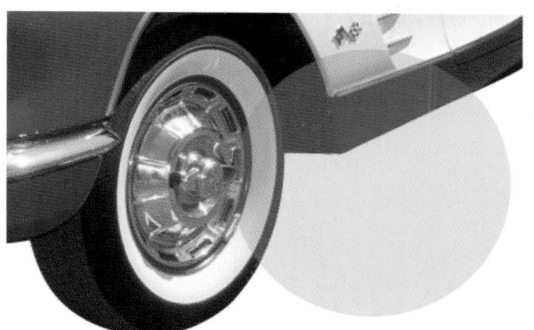

2 To begin, use the Elliptical Marquee tool to draw a circle anywhere on the image (hold the **Shift** key as you draw to constrain the ellipse to a circle). If you can't find the Elliptical Marquee tool, click and hold on the regular Marquee tool in the toolbar and it will pop open for you.

3 Now enter QuickMask mode by pressing **Q**. The circle you just drew will appear as a solid red circle, which will show us exactly where our selection edges lie in the illustration.

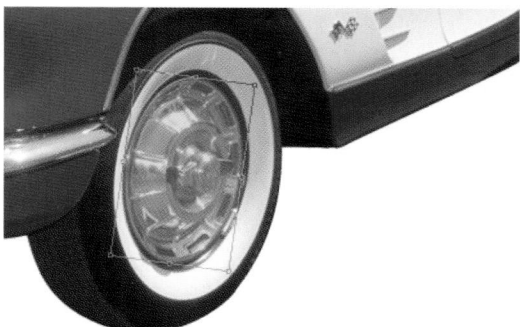

5 Now pull in the opposite handle so it touches the opposite rim of the hubcap, and do the same with the top and bottom edges. At this point, you may need to adjust the angle of rotation of the ellipse so it matches the hubcap perfectly.

6 With the ellipse perfectly positioned, press **Enter** to leave Free Transform, then press **Q** once again to leave QuickMask mode. You can now move the hubcap, or make a new layer from it.

You might wonder why we bother using QuickMask to make this selection, rather than using Photoshop's Transform Selection tool. The answer is that it's really quite hard to make out an accurately positioned border when it's composed of a row of marching ants; using QuickMask, however, shows us the selection as a solid block of red, which makes it much easier to see through to the underlying image.

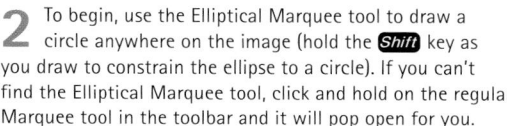

8 Assuming you started and ended in the correct place, your circle should now be exactly the same height as the rectangle. Release the mouse button before letting go of the **Shift** key, then switch to the Move tool (press **V**) and hold **⌥ alt** to move a copy as you drag the circle to the end of the rectangle; add **Shift** to move it horizontally.

9 Now release and then hold the **⌥ alt** key once again, and hold **Shift** as you drag the circle to the other end of the rectangle. When you leave QuickMask (by pressing **Q** again) you'll be left with a perfect lozenge selection, which you can then fill or stroke as you wish.

13

The Pen is mightier...

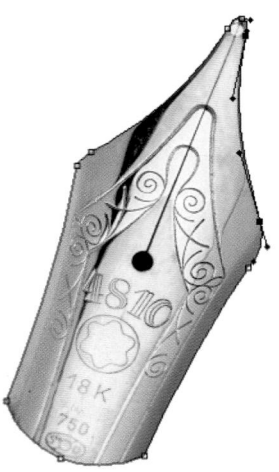

1 To draw straight lines with the Pen tool, simply click each point. If you want to constrain a line to horizontal, vertical or 45°, hold down the **Shift** key before clicking the second point.

T HE PEN TOOL is one of the key tools available to the illustrator – not just in Photoshop but in Illustrator, FreeHand and many other programs as well.

The Pen tool creates paths using Bézier curves (named after the French designer who devised them, so legend has it, to design the outline of the Citroen 2CV in the 1930s). Bézier curves are unique in that simple curves can be made to fit any shape: they're easily editable after they've been drawn, so you needn't worry about getting the curve perfect first time around – it can always be adjusted later.

The paths created by the Pen tool have another great advantage: they can be used to define selections which can then be stored within the document when it's saved. Most of the cutout objects in royalty-free CD collections are defined with paths.

The problem is that the Pen tool has the steepest learning curve of all. Here, and on the following pages, I'll try to help you get to grips with mastering the essential tool for making perfect selections.

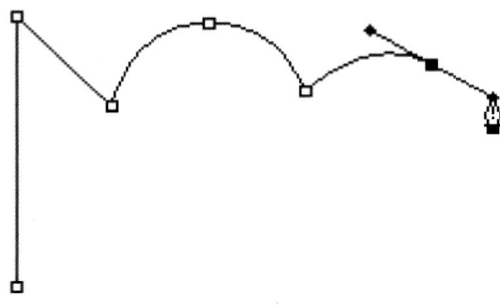

4 Because we clicked and didn't drag in step 3, when the next point is drawn (with a click and drag), the curve coming out of the back of it joins the previous one with a hard corner rather than a smooth curve.

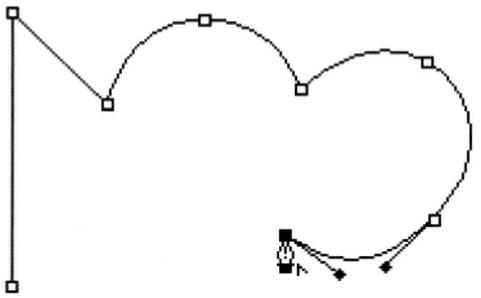

7 If you've clicked and dragged on a point, making a smooth curve, you can turn it into a corner point instead by holding **alt** and clicking on the point again. You can then click and drag on the same point again to make a new curve from that corner.

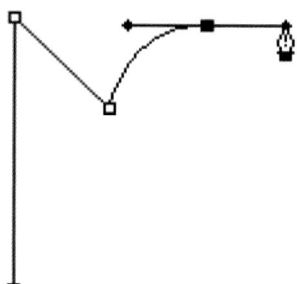

2 If you click and then drag before releasing the button, you'll get a curve. This is the essence of the Pen tool: curves are defined by the anchor points (the dots where you click) and the handles that set their direction and strength.

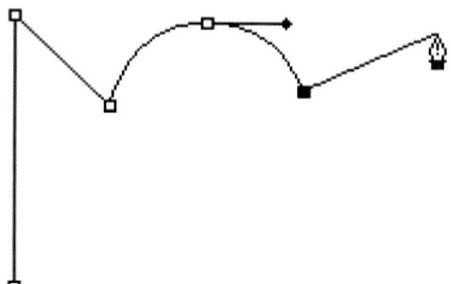

3 Every time you click and drag, you get a curve; and the point clicked in the previous step shows how the curve operates on both sides of the point. But if you just click without dragging, you make a corner point.

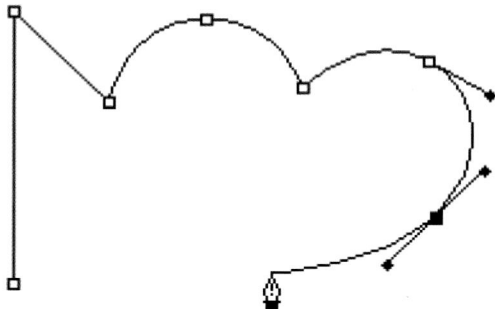

5 The handles operate as tangents to the curve, not crossing it but acting like a surface off which the curve bounces. The points should be placed at positions where the curve changes direction.

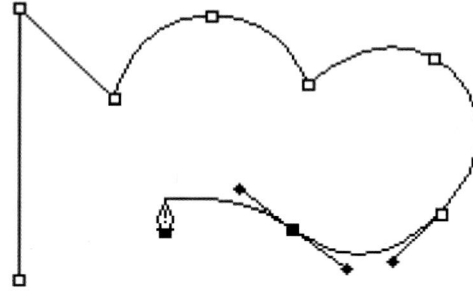

6 Sometimes, the handles do appear to cross the curve – but only in cases where the curve is S-shaped, as appears here. The handles are still really tangents to each side of the curve.

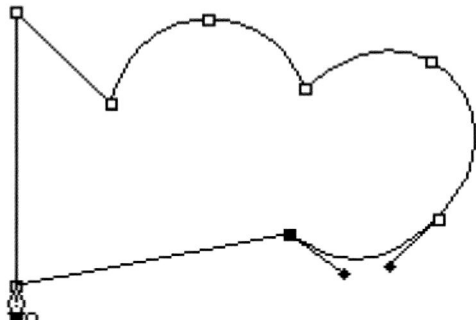

8 When you click on the starting point again, the path will be completed and the anchor points will disappear, showing just the path's outline. You can leave a path open-ended instead, if you like – for example, if you want to stroke it with a painting tool (see Pipes and Cables in Chapter 10).

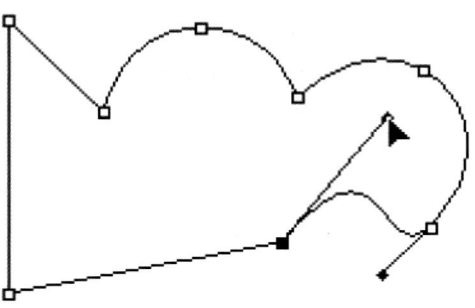

9 A path can be adjusted by moving the anchor points, moving the handles, or dragging on the curve itself. Hold ⌘ *ctrl* to move points with the Pen tool active; or press **A** for the path selection tool – use the filled tool to select an entire path, the hollow version for individual points.

HOT TIP

You don't need to wait until completing a path before making adjustments to it: simply hold ⌘ *ctrl* at any point while you're drawing to access the path selection tool, and use it to move anchor points or their handles. When you release the key, you can just carry on drawing.

SHORTCUTS
MAC WIN BOTH

Putting the Pen into practice

1 Begin by clicking the first point just below the mug's handle, then click and drag down a short way at the bottom of the straight section.

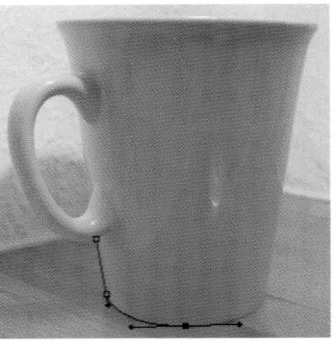

2 Now click and drag at the bottom of the curve: keep your drag horizontal, so it makes a tangent to the curve.

O N THE PREVIOUS PAGE we looked at the basics of using the Pen tool. Here's a short workthrough to take you through the process of outlining a simple object: you'll find the image on the CD that accompanies this book, so you can try it out for yourself.

This is a compound path, in that it includes one element within another. You don't need to do anything to the path within the handle to make it subtract from the main outline: Photoshop will take care of this automatically.

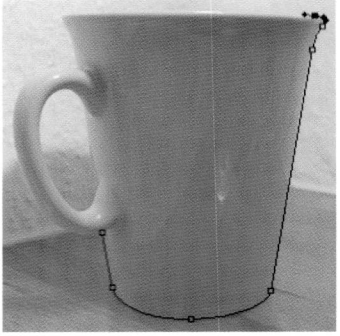

6 Complete this small curve by clicking and dragging just around the corner. Keep the drag parallel to the mug once more.

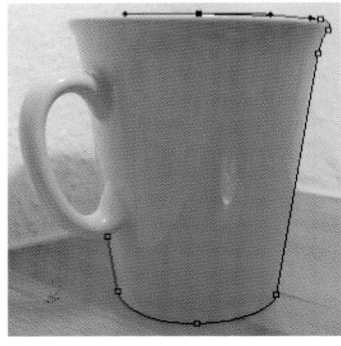

7 Now click and drag at the middle of the top of the mug. This is the mid-point of the curve that makes the mug rim.

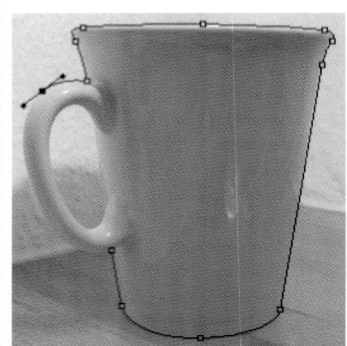

11 Click and drag at the point on the handle where the curve changes direction – just around from the top.

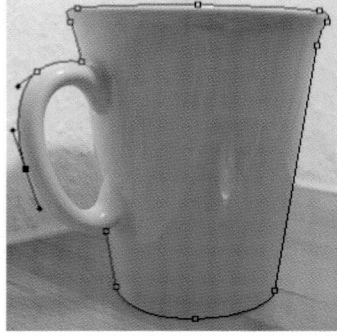

12 Another click and drag, once again where the direction of the curve changes, on the outermost part of the handle.

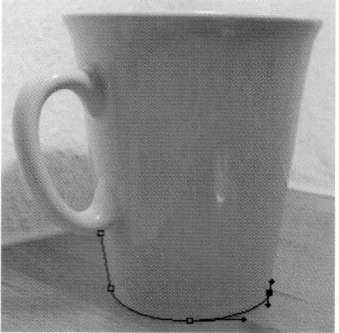

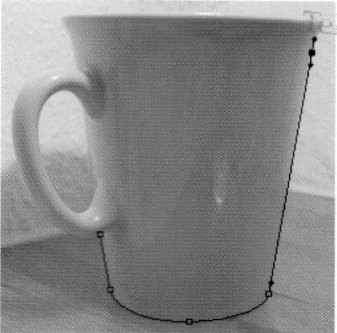

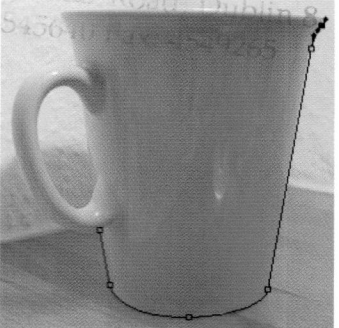

3 Go round the corner, and click and drag a short way up the side of the mug. Drag the handle so that it follows the line of the mug.

4 Now click at the top of the straight section, and drag a short distance to create the start of the curve that follows.

5 Click and drag at the beginning of the lip at the top of the mug: only a short drag is needed to make this curve.

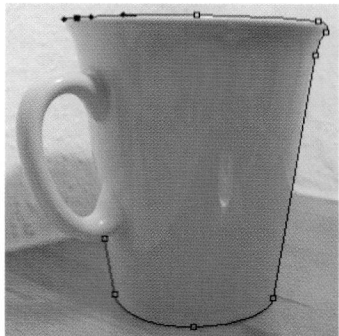

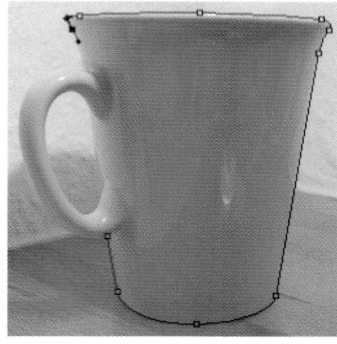

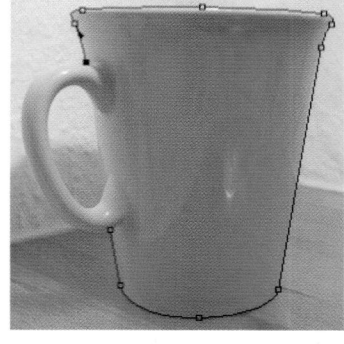

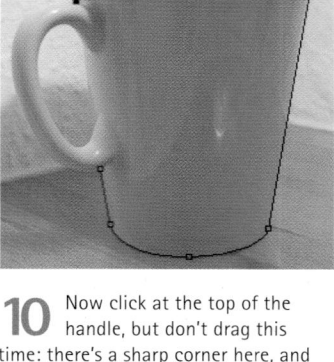

8 Click and drag again at the edge of the rim, just before the lip curve begins.

9 Now click and drag once more just around the lip, again keeping the drag parallel to the side of the mug.

10 Now click at the top of the handle, but don't drag this time: there's a sharp corner here, and we don't want a curve at this point.

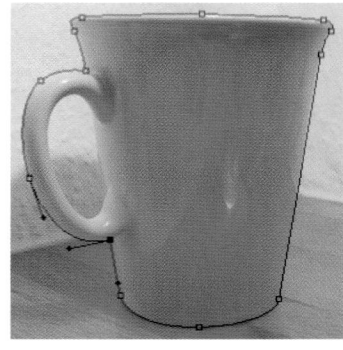

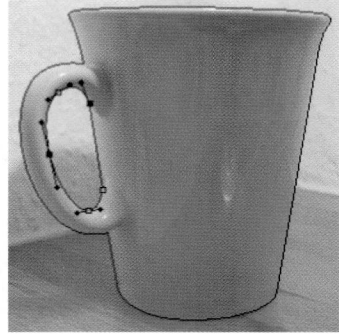

13 Click on the starting point and drag into the mug – it's the back of the handle that defines the curve behind it.

14 Follow the same process to make the inside of the handle, remembering to make corner points where the handle joins the mug.

15 With the path complete, you can turn it into a selection using ⌘ *Enter* *ctrl* *Enter*; inverse the selection and delete the background.

HOT TIP

Don't worry if the curves you draw don't match the mug first time: you can always adjust them later, either by dragging on the curve itself or by dragging an anchor point or handle. You can also edit the anchor points themselves: when you click the Pen tool on an active path, you'll create a new anchor point at that position, but if you click on an existing anchor point you'll delete it.

SHORTCUTS
MAC WIN BOTH

Losing the edges

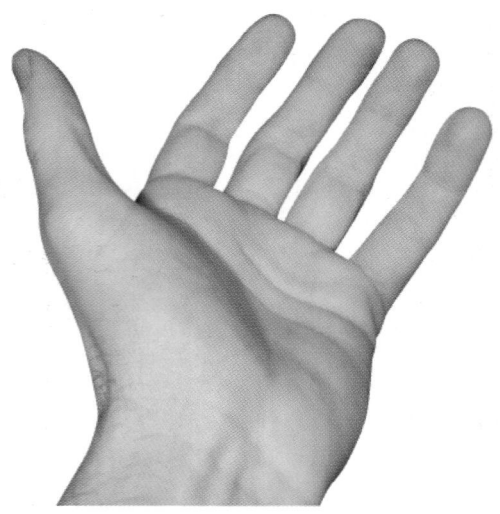

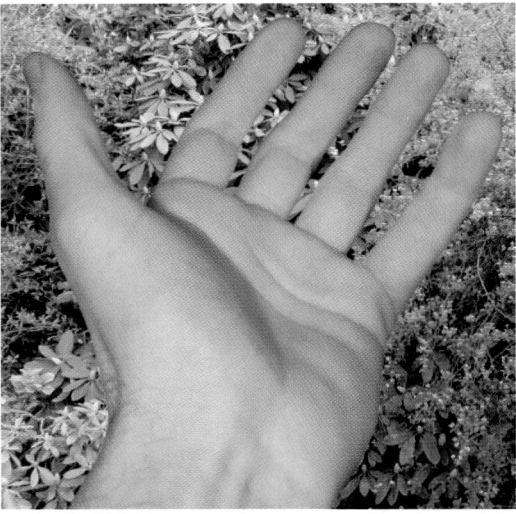

1 When placed against a complex background such as this foliage, the white fringe on the hand is hard to discern: there's so much visual detail going on behind it that the eye is distracted.

WHETHER YOU ISOLATE AN OBJECT from its background using the Magic Wand tool, or by loading a pre-drawn path, you'll frequently find a slight fringe of the background color surrounding the layer. This is due to the anti-aliasing technique used in Photoshop to ensure a smooth edge.

There are two built-in methods for removing this fringe – Defringe and Remove White Matte. Neither does the job perfectly; here, we'll look at the effects of both these techniques, and at a couple of extra methods that I find work more effectively.

All these techniques assume that the cutout object – the hand, in this case – is on a separate layer from the background.

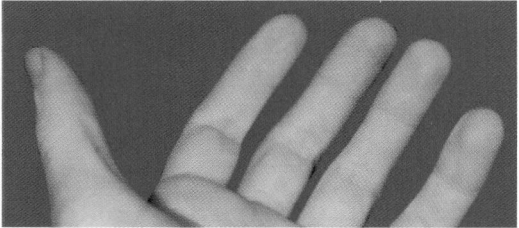

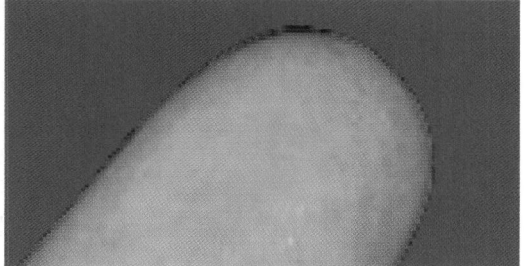

4 The next alternative is Remove White Matte, also found in the Matting menu. Once again, this gets rid of the white area automatically, but tends to result in an unnaturally dark edge on the remaining pixels.

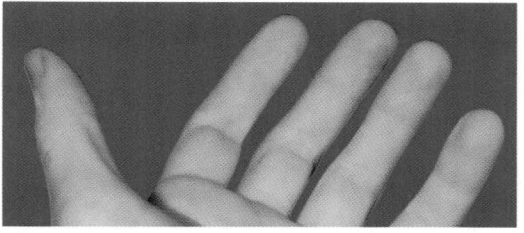

2 Placed against a plain background, we can now see the white fringe more clearly. The lower picture, detailing the tip of the forefinger, shows an enlarged view of the image so that we can see the effect of the different operations we're about to perform.

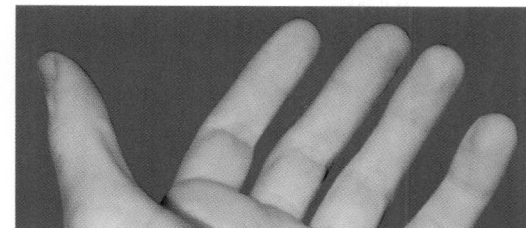

3 The first method of removing the white is Defringe, found under Layer/Matting. Entering a figure of 1 pixel in the dialog removes the white by sampling the colors just inside the radius specified, and pushing those colors outwards to replace those already there. It gets rid of the white, but is a little clumsy: we tend to get hard blocks of unwanted color this way.

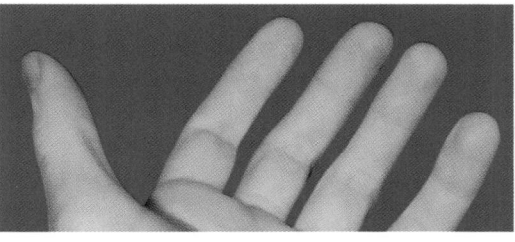

5 My preferred method is to load the layer's selection by ⌘ ctrl clicking on the name in the Layers palette, inversing the selection using ⌘ Shift I ctrl Shift I and then deleting – which has the effect of removing a single pixel from all the way round the image. To save time, you can write an Action to perform this task with a single keystroke – see the Interlude at the end of Chapter 7.

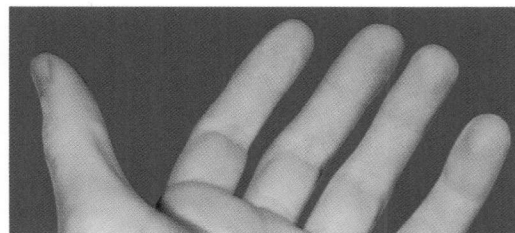

6 There are times when deleting a pixel all the way round doesn't work – if the elements on the layer are particularly fine, for example. In these cases, you need to take a more painstaking approach: lock the transparency of the layer using I and then, using a small soft-edged brush, paint around the edge of the layer, sampling the adjacent colors with the Eyedropper tool frequently as you go.

HOT TIP

The method outlined in step 6 works well for layers of a uniform color range, such as skin tones. But if you're working on a complex patterned layer such as textiles, the painted edge will look false. The alternative here is to use the Cloning tool, sampling just inside the edge as you work your way round.

SHORTCUTS
MAC WIN BOTH

19

Lock and load

LOCKING TRANSPARENCY is an essential capability to learn, as it allows you to paint on a layer without affecting transparent areas. It's a feature we'll be using throughout this book.

Loading selection areas is another shortcut that you'll see used again and again in the chapters that follow, and it's important to understand how it works. In the example here, we're working on a document that includes three playing cards, on separate layers. We want to create a shadow on a fourth layer, above the other three: by loading up the transparency of the underlying card layers, we can achieve our aim with ease. It's worth noting that the shortcuts for adding to and subtracting from selections are the same as those used for standard selections, as described earlier in this chapter.

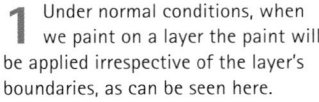

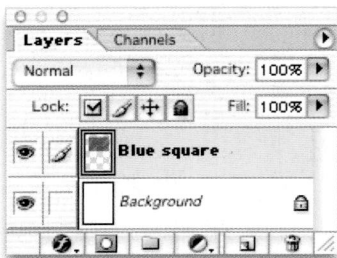

1 Under normal conditions, when we paint on a layer the paint will be applied irrespective of the layer's boundaries, as can be seen here.

2 If we check the Lock Transparency box on the Layers palette, any painting actions are limited to those pixels already present in the layer: they change color, but aren't added to.

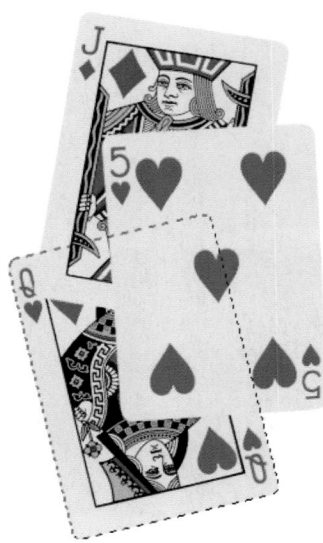

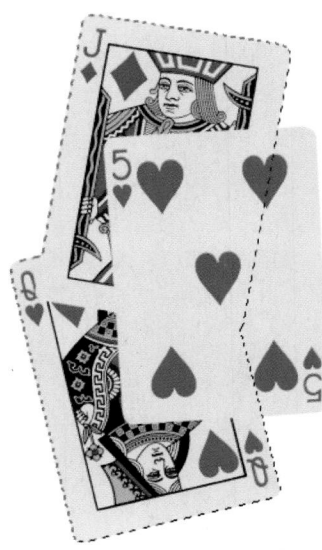

1 To begin with, let's load up the Queen of Hearts layer by holding ⌘ *ctrl* and clicking on the name in the Layers palette. The outlines show that area selected.

2 We want to add the Jack of Diamonds, so now we need an extra modifier key: holding ⌘ *Shift* *ctrl* *Shift* and clicking on the name will add that to the existing selection.

3 So what, you might think. Well, here's a typical example: we want to change the color of this woman's dull jacket into something a little more eye-catching.

4 With the Brush tool set to Color mode, we'd expect the color of the jacket to change without affecting the texture. But the color leaks out, polluting the background as well.

5 Once we lock the transparency of the pixels, we can paint our color directly onto the layer without affecting the rest of the artwork: again, only the pixels present are affected.

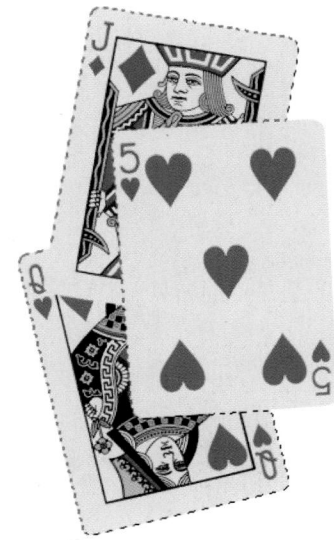

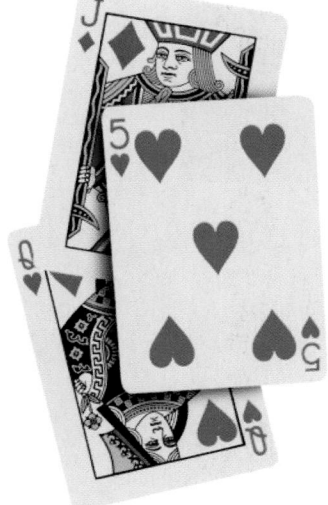

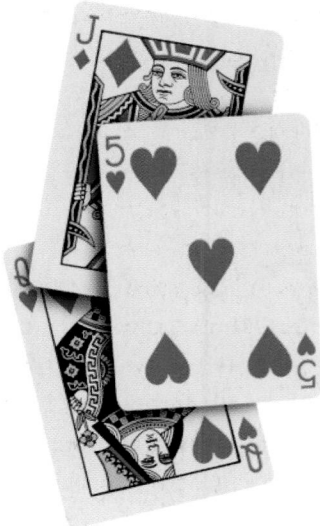

3 We only want to work on the two back cards, so we need to subtract the Five of Hearts layer. Holding ⌥ ⌘ *alt* *ctrl* while clicking on the name removes that layer's selection.

4 With our selection made, we can now make a new layer for the shadow and begin to paint – hiding the selection edges first (⌘ H *ctrl* H) so we can see what we're doing.

5 But the Jack has to cast a shadow on the Queen as well. Holding ⌥ ⌘ *alt* *ctrl* while clicking on its name will remove the Jack's selection, and we can add the shadow we want.

HOT TIP

The shortcut for locking and unlocking transparency is **/**. The trouble is, this is also the shortcut for locking a layer so it can't be painted on, and locking it so it can't be moved. In general, the key will repeat the last action you chose by clicking in the icons on the palette; but if you do find yourself getting a warning that a task couldn't be completed, just go to the palette and uncheck the box.

SHORTCUTS

MAC WIN BOTH

Find and replace

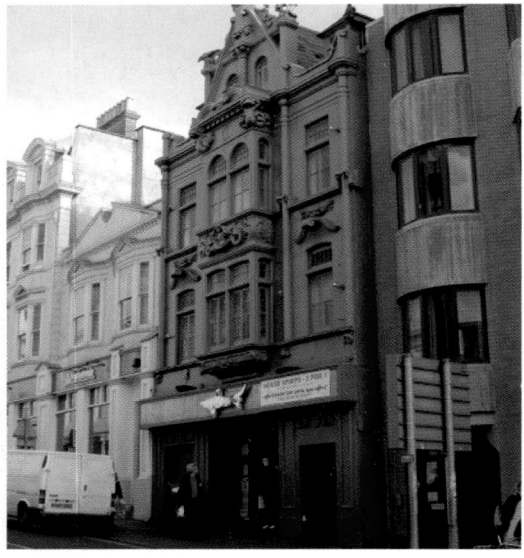

1 The brash blue of this once-elegant Victorian building may not appeal to all tastes. It certainly doesn't appeal to mine, so let's change it to something more environmentally friendly. Choose Image/Adjust/Replace Color to get started.

CHANGING THE COLOR of the car above from red to blue would be an almost impossible task by conventional means: all those railings in the way would make selecting the car something of a nightmare. But by using Replace Color, we can adjust the hue selectively without having to lay hands on a single selection or painting tool.

Replace Color is a hugely powerful tool that turns what would otherwise be a complex task into one that's enjoyable and effective.

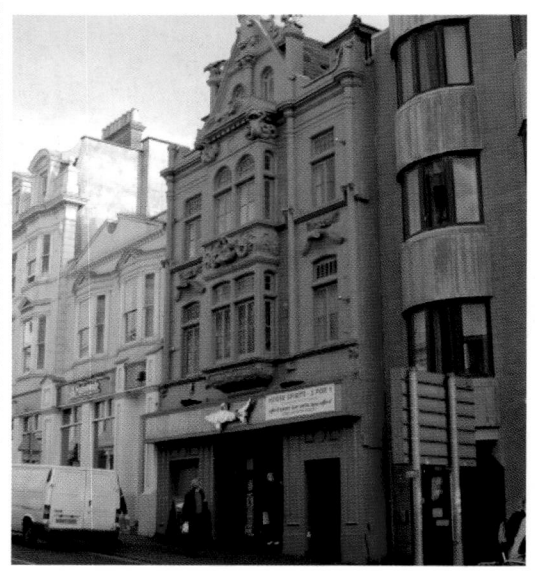

4 To add more colors, hold the *Shift* key and click on an unchanged area, or drag to select a range of colors: that range will be added to the selection, and the color will change in the image. If you select a spot by accident, hold *alt* while clicking to deselect that color.

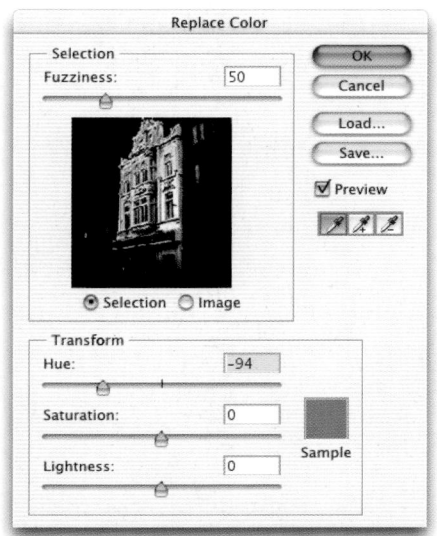

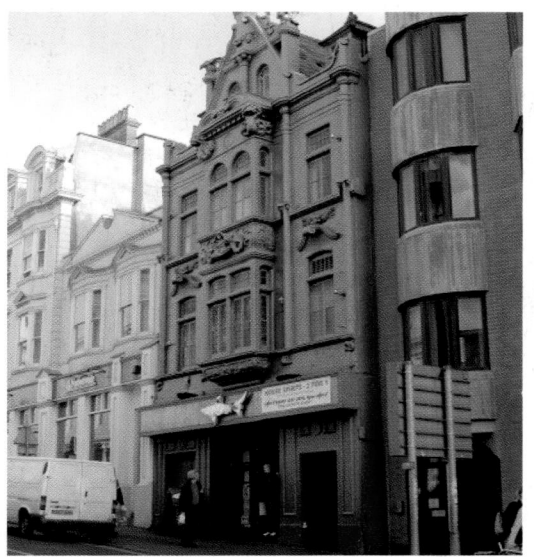

2 By default, the Replace Color dialog shows a monochrome view of what's been selected: white is active, black isn't. By clicking on the image, regions of that color become selected. When you change the Hue value, the image changes to reflect that, as seen in the next step.

3 Here's the result of our initial change, and we're turning the building green. It doesn't matter what color you choose to begin with; go for something bright, so you can see the change. So far, only a portion of the face of the building has changed color.

5 Keep adding more color ranges until the entire building is altered. One way of increasing the range of colors changed is to raise the Fuzziness value; but this draws in unwanted colors in the surrounding area, as can be seen in the color change in the windows of the neighboring building.

6 Now we're sure the building is selected, we can change the hue to a shade more in keeping with its surroundings. It may not be painted white like the building to the left of it, but it certainly blends into the street better than it did before.

HOT TIP

There are often areas in the surrounding image that are close to the target color range, and they will get changed as well. One solution is to duplicate the layer, apply Replace Color, and then simply erase or mask the parts you didn't want to change.

SHORTCUTS

Color by numbers

THE SELECT COLOR command works in precisely the same way as the Replace Color dialog detailed on the previous page, except that rather than changing the hue it returns a selection.

This makes it the ideal tool for changing elements such as the sky, as shown in this example: with the sky isolated from the original image, we can paste in any cloud formation we want to strengthen and add drama to the image. Here, we've taken a sunny day on the Brighton seafront and made the scene altogether more doom-laden simply by replacing the sky with something a touch more dramatic.

1 This image shows a complex skyline, with many fiddly elements punctuating the heavens – from the street light to the strings of bulbs stretched between them, to the ornate roof on the building on the left. An impossible job using the Lasso tool: but there's a better way. Choose Select/Color Range to begin the operation.

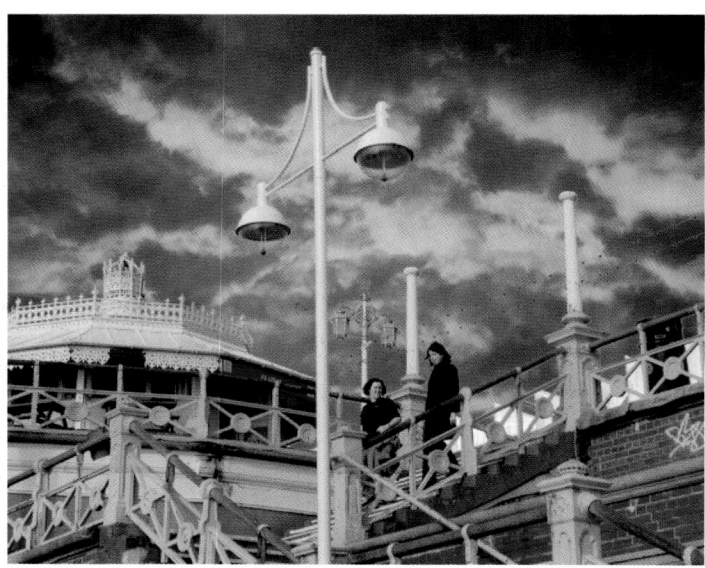

3 With the sky selected, open any other sky you have lying around and paste it inside the selected area: use *Shift* ⌘ *V* *Shift* *ctrl* *V* or choose Paste Into from the Edit menu. The new sky will be positioned within the selection, and you can move or scale it as required; it will move independently of the area you've just pasted it inside.

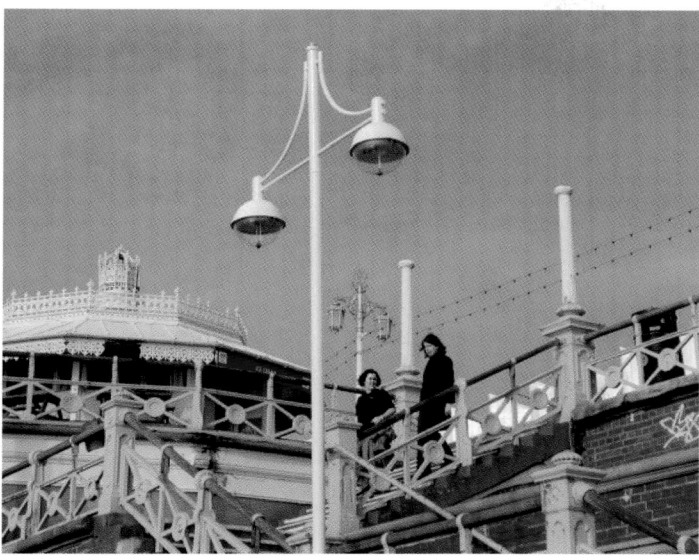

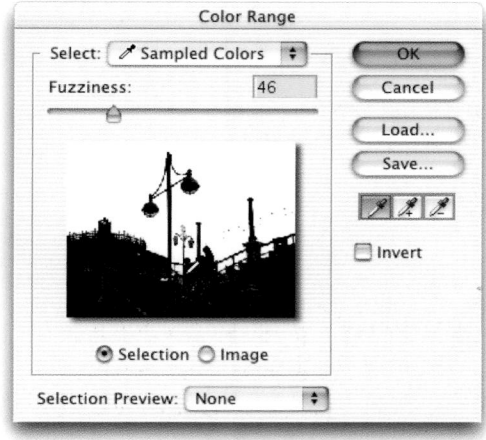

2 The dialog works in the same way as Replace Color: the main difference is that the selected area is shown on the image as a QuickMask selection, although you can change this using the pop-up menu. Use **Shift** and **⌥** **alt** as before, to add and subtract colors to and from the selected range, until the entire sky is selected.

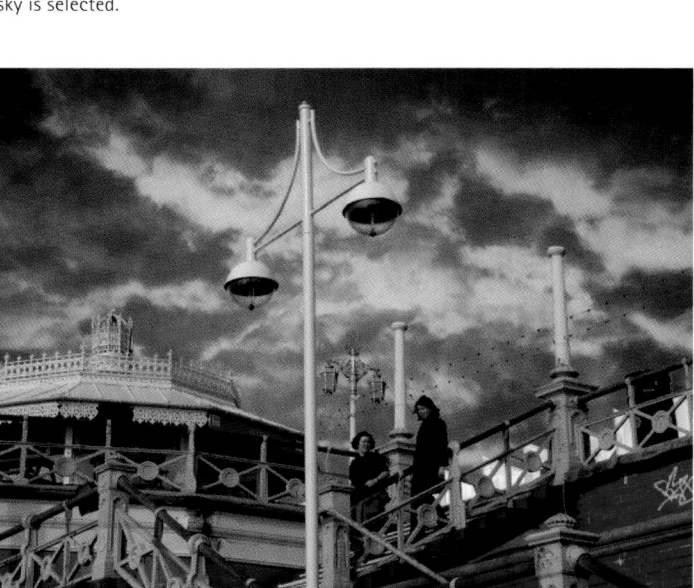

4 Choosing Paste Into creates a layer mask that exactly matches the original selection – see Chapter 2 for more about how to use layer masks. We can now paint on the mask to remove pieces of sky from regions where it shouldn't have appeared, such as halfway up the railings on the left. We'll also take this opportunity to adjust the foreground image to match the new sky's colors.

HOT TIP

If you've performed a Select Color operation and want to repeat it exactly, hold **⌥** **alt** as you select it again from the menu. It will reappear with the same settings already loaded up. Holding this modifier will reload the last settings for any of the color adjustments as well.

SHORTCUTS

MAC WIN BOTH

Brush-on color

ALTHOUGH PHOTOSHOP CS HAS BROUGHT us only one new tool, it's a useful one: the Color Replacement Brush. It performs a task almost identical to the Replace Color dialog, discussed earlier in this chapter, but it has one significant advantage: you can paint the new color directly onto the image, without having to go through a dialog first.

In one way, it's simply more satisfying to paint the new color straight on. But there are many other advantages to the new tool: where Replace Color would globally change one color for another, the brush allows us to mix our colors at will. In addition, we can control the area we color with more precision than we could with the dialog.

The settings that determine the way the Color Replacement Brush operates are the same as those used by the Background Eraser tool, covered later in this book: take a look at the section entitled The Perfect Haircut in Chapter 6 to see how to change the settings for both these tools.

1 Here's our model, wearing a bright red shirt. In color terms, it's pretty close to the skin tones, so the Replace Color dialog would have some difficulty with this image; the Color Replacement Brush is the perfect solution.

2 To begin, choose a color and set a tolerance of around 50%, then paint a test patch. You should watch to see that the color covers all the areas you want, and doesn't leak into unwanted skin regions.

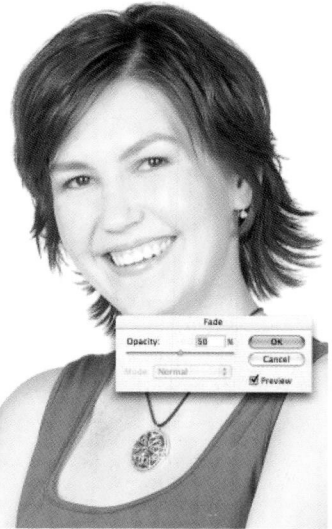

6 Here, we'll use the same tool to change the model's hair color from black to brown. In order to make this process work, you need to complete the whole coloring operation in a single brushstroke. Far too bright – let's fix it.

7 Press ⌘ Shift F ctrl Shift F to bring up the Fade dialog immediately after brushing on the color: now we can reduce the strength of the last operation by dragging the slider, to make it more realistic.

3 Here's what happens if you choose the wrong settings. At the top, too high a tolerance means the skin is being changed along with the shirt; at the bottom, too low a tolerance means not enough of the shirt is changed.

4 Try to change all contiguous areas of color in one go. If you start with a small patch, as we did in step 2, and then carry on with a new brushstroke in the same area you'll get an ugly join which can be hard to get rid of.

5 Because the top half and the bottom half of the shirt are split in two by the arms, we can treat each as a separate region. By coloring each section in one go, we maintain an evenness of color throughout.

8 In general, you'd want to use a soft-edged brush for this tool. Here, we'll paint tiger stripes onto the shirt by using a hard-edged brush. We'll begin by painting the black stripes, in Color mode.

9 Although the last step changed the color, it didn't make the stripes darker. To do this, we need to change the brush mode to Luminosity instead. Now, when we brush over the changed areas, we make them darker as well.

10 Change the brush mode back to Color, and pick a bright orange. We can now change all the remaining red using the new color, to create this convincing tiger pattern on the shirt.

SHORTCUTS
MAC WIN BOTH

The perfect setup

GETTING THE BEST OUT OF PHOTOSHOP means making the application behave the way you want it to. This may mean investing in memory and additional hard disk space, as well as taking care arranging your palettes.

Photoshop needs as much memory as you can give it. RAM is cheaper now than it has ever been: if you're serious about Photoshop, you should be looking at a total system RAM configuration of at least 512Mb – more if you can manage it. The more real RAM (rather than Virtual Memory) Photoshop has available to it, the faster it will run.

Even with enormous amounts of RAM, Photoshop will still write huge temporary files. It deletes these when you quit the application, so you're unlikely to notice them, but they can run into hundreds of megabytes. If your main hard disk is used as a 'scratch disk' Photoshop will be reduced to fitting these files in whatever spaces it can find; they'll be so fragmented that the whole process will become slowed down.

The best solution is to buy a second hard disk of at least 4Gb in size, or partition a larger disk, and assign this to be Photoshop's scratch disk – you do this using File / Preferences / Plug-ins and Scratch Disks. Resist the temptation to put anything else on this disk: keeping a large, clean disk spare for the exclusive use of Photoshop will greatly speed up its processing power (to say nothing of reducing fragmentation on your main hard drive).

Even with a clean scratch disk, Photoshop will still have to wade through its large temporary files, particularly if you're working on big images. Get into the habit of using the Purge All command (Edit menu) every time you're sure you won't want to undo what you've just done, use the History palette or paste an item from the clipboard. This will clear out the temporary files, and can often take a minute or so to accomplish – which gives you some idea of how large these files can get.

You can set up your frequently used palettes by storing them in the Palette Well, so they can be accessed with a single click; they'll also vanish when you

If there are graphic elements, such as logos, that you use frequently, define them as custom shapes and they'll always be ready to hand.

Store your frequently used palettes in the Palette Well. They'll appear when you click on them, and disappear when you've finished.

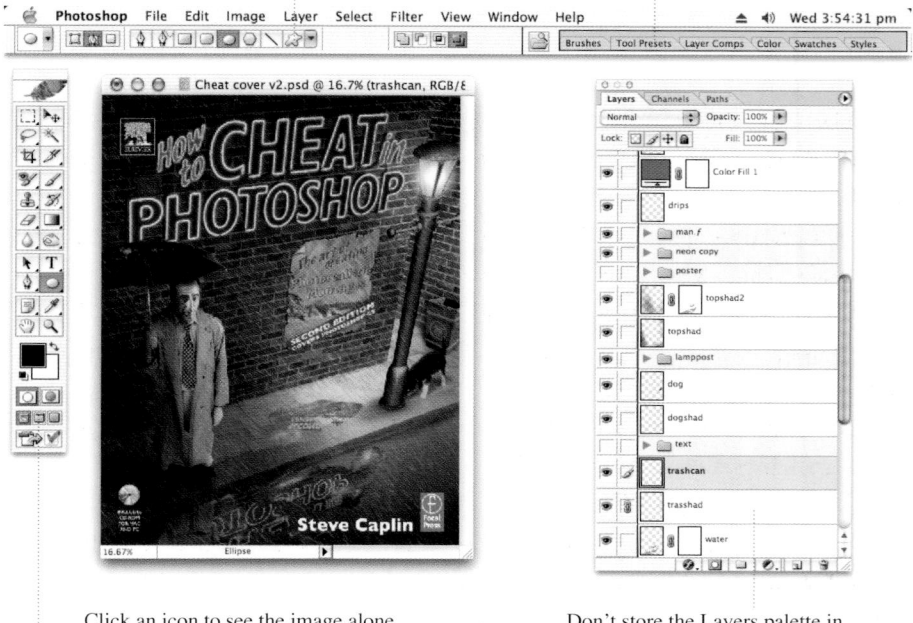

Click an icon to see the image alone against a gray background, or against black with menus hidden: use the F key to cycle through the options.

Don't store the Layers palette in the Palette Well – you'll need this constantly on view.

click elsewhere. But if you want to see the image you're working on uncluttered by any screen debris, press the Tab key and all the palettes, including the Toolbar and Options bar, will disappear. Press the Tab key once more to bring them back. Don't put the Layers palette into the Palette Well, since you won't want that to keep disappearing.

If you're working on complex montages that contain a large number of layers, make new Layer Sets to hold them. If you want to make a new set from existing layers, the simplest way is to link them together and then choose New Set from Linked from the pop-up menu on the Layers palette. Remember that you can also duplicate entire sets, which makes it easy to try out multiple variations in your artwork.

2 Hiding and showing

THE EASIEST WAY of removing part of a layer is to delete
it. But deletion is irrevocable: you can't go back later and
undelete the lost elements. Using a layer mask, however,
forces you into no such constraints. Areas can be hidden,
using hard or soft edges, and then painted back into
place if the need arises. Layer masks are one of the most
powerful devices available to the photomontage artist.

Changing the way two layers interact with each other
is also a vital technique to master. Layer interaction
may involve altering the blending mode to allow the
underlying texture to show through, or selectively hiding
parts of a layer depending on its brightness values;
you can even hide parts of a layer depending on the
brightness of the layers beneath it.

Group therapy: layer modes

1 The jacket has been separated from the figure and made into a new layer. The texture (a piece of wallpaper) is placed over the top, and completely obscures the jacket.

2 It's grouped (Photoshop CS: made into a Clipping Mask) with the jacket by pressing *Shift* ⌘ *G* *Shift* *ctrl* *G*; now, the texture is visible only where it overlaps the jacket.

GROUPING LAYERS together is the easiest way of constraining the visibility of one layer to that of the layer beneath.

It all gets more interesting when you start to change the mode of the grouped layer. Note that in Photoshop CS, groups are now called Clipping Masks: I'll continue to call them groups for the sake of those who haven't upgraded.

6 Lighten mode is similar to Screen, but with a twist: it only brightens those parts of the underlying layer that are darker than the target layer.

7 Darken mode does the opposite of Lighten. Since the background of the pattern is brighter than the suit color, it has no effect; only the relief on the pattern shows through.

3 Layer modes are changed by selecting from the pop-up menu at the top of the Layers palette. This mode is Multiply, which adds the darkness of the layer to the one beneath.

4 The opposite of Multiply is Screen: this adds the brightness of the layer to the brightness of the layer beneath, resulting in an image that's brighter than either.

5 Overlay mode is a kind of mid-point between Multiply and Screen. It's a more subtle effect than either, and allows the full texture of the jacket to show through.

8 Hard Light is a stronger version of Overlay, which increases the saturation of both layers. Some of the underlying layer's detail is often lost using Hard Light.

9 Soft Light is a toned-down version of Hard Light, producing an altogether subtler effect. The textures of the original jacket are clearly visible beneath the pattern.

10 Color Burn darkens the underlying layer, but adds a strong color element to it, producing a deeply hued result that's quite different to any of the others.

HOT TIP

You can use keyboard shortcuts to change layer modes, so you don't have to keep reaching for the pop-up menu. Hold down *Shift* ⌥ *Shift* *alt* while typing the first letter of the mode's name – so use *Shift* ⌥ M *Shift* *alt* M for Multiply, *Shift* ⌥ H *Shift* *alt* H for Hard Light, and so on.

SHORTCUTS
MAC WIN BOTH

33

Layer masks 1: intersections

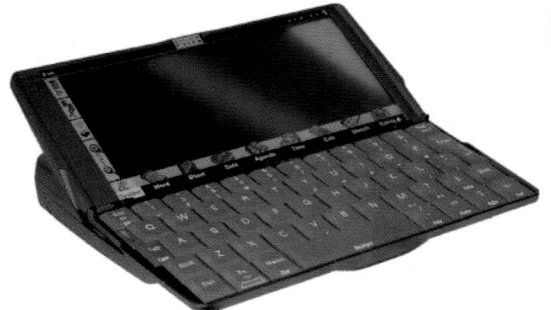

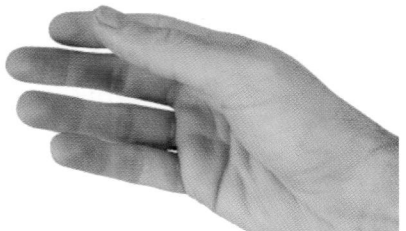

MOST MONTAGES involve combining objects in such a way that they interact with each other. The simplest way of putting one object 'inside' another is to use a layer mask, which allows one object to appear to be simultaneously in front of and behind another.

Layer masks have more uses than this, as we'll see later in this chapter: they're one of the most powerful weapons in the photomontage artist's arsenal, and deserve close inspection to see how you can achieve the best results from them. Here, we'll use a layer mask to place the handheld computer so it's truly held by the hand.

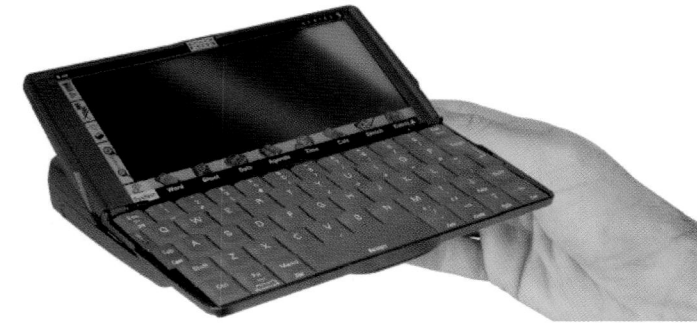

1 With the two elements of this simple montage placed together, we can see the problem immediately. This hand may be in the same scene as the Psion, but it isn't holding it: we need to bring the thumb to the front so that the machine appears to be gripped by it.

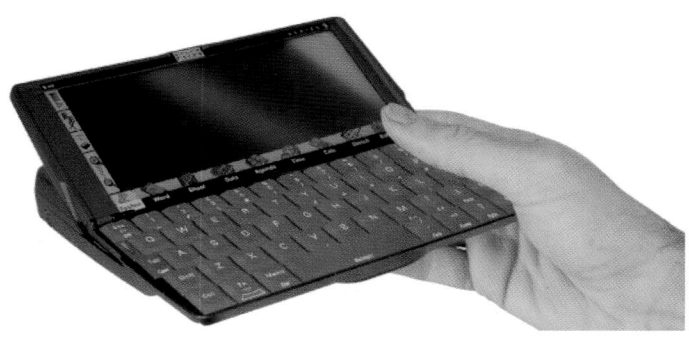

3 Using a hard-edged brush, simply paint with black over the thumb area. Because the layer is being hidden rather than erased, we can always adjust the mask to show the portions we've hidden: simply paint with white to restore the image. At the end, change the opacity back to 100%.

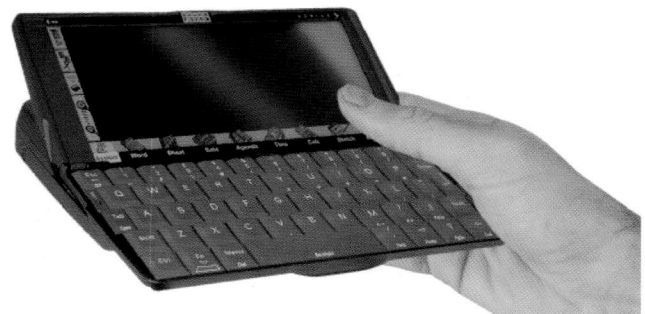

5 With the layer unchained from its mask, we can now move it independently and the mask will remain where it is. The object can be shifted, scaled, rotated or distorted however you choose and will still remain grasped by that thumb, because the mask now stays put.

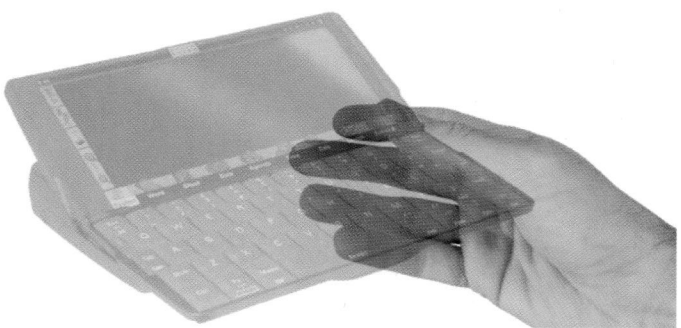

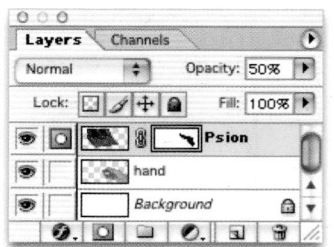

2 One solution would be to erase the thumb area from the Psion. But that would be an irrevocable step, and would mean we couldn't move the machine afterwards without leaving a hole. Instead, choose Layer/Add Layer Mask/Reveal All. The 'Reveal All' bit simply means that we begin with nothing hidden. So that we can see what we're doing, it helps to lower the transparency of the Psion layer first; setting it to 50% lets us see the hand.

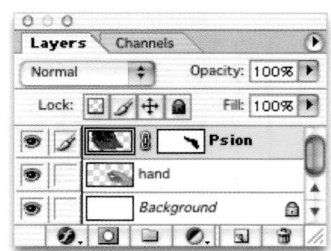

4 The tiny icon immediately to the left of the layer thumbnail will show either a paintbrush or a circle in a gray square, indicating whether you're working on the layer or its mask. When the Psion is moved, the mask moves with it, as can be seen here: this is because the layer is linked to its mask. To unlink it, click on the tiny chain icon shown between the layer thumbnail and the mask thumbnail and it will disappear.

HOT TIP

Painting on a layer mask with black hides the layer; painting with white reveals it. A useful shortcut is to press **X**, which swaps foreground and background colors over. This makes it easy to adjust the mask without having to swap colors in the toolbox.

6 Adding shadows helps the effect to look realistic. Two shadows have been added, one for the Psion and one for the hand: each shadow layer has been grouped with its target layer, so it only shows where the two overlap. Keeping the shadows separate makes them easier to adjust later.

SHORTCUTS
MAC WIN BOTH

Layer masks 2: transparency

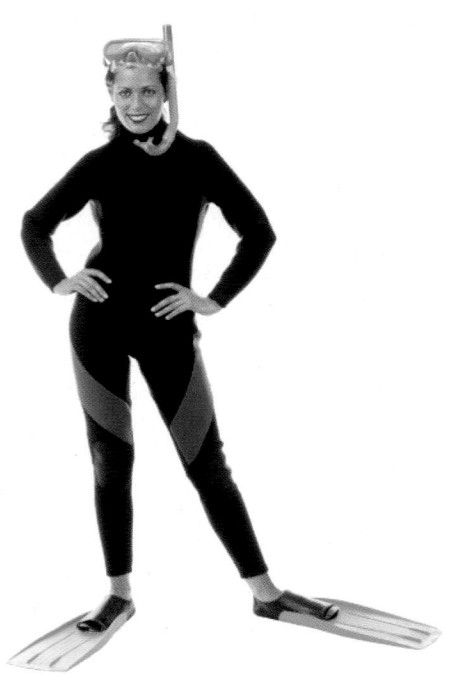

1 This sea and sky have been comped together from two different photographs. The hard line that separates them looks too rigid: this amount of cloud would surely create a hazy effect on the horizon.

PAINTING ON LAYER MASKS with black hides the layer; painting with white reveals it again. But painting with intermediate shades of gray causes the layer to become partially transparent.

Rather than choosing a gray tone, we can simulate gray by lowering the opacity of the brush tool as we paint – which is how the image of the diver's legs as seen through the water is achieved.

As well as lowering the opacity, we can also use a soft-edged rather than a hard-edged brush to paint with. This creates a fading mask, as if we'd feathered a selection and deleted it. But of course, since this is a mask, we can paint the hidden areas back in again at any time – which would be impossible if we'd chosen to delete the area instead.

4 Another layer mask is created, this time for the diver. The bulk of her body beneath the waves is simply painted out with a large brush, to hide as much of the unwanted area as possible in one go.

2 After creating a layer mask for the sea layer, I've simply brushed along the horizon using a small, soft-edged brush – holding the *Shift* key down to ensure a straight line as I painted. This creates the effect of a slightly feathered edge along the horizon.

3 Placing a figure in the foreground looks desperately unconvincing: the diver may occupy the same visual space as the background, but there's no sense of her fitting into it.

5 Switching to a much smaller, soft-edged brush, and painting with white rather than black, we can begin to paint the figure back in around the water line. By following the contours of the figure as well as those of the waves, we can make her look far more part of the scene.

6 But water is a translucent substance. Still using white, choose a larger brush and set its opacity to just 20%. By painting selectively on the mask below the water line, we can now see a hint of the diver through the sea. I've also used the Wave filter to make the diver's legs ripple slightly.

HOT TIP

When painting layer masks, you may frequently need to change brush size to create fine adjustments. Rather than picking from the pop-up list, use the keyboard shortcut: the **[** key selects a smaller brush, the **]** key selects the next larger one.

SHORTCUTS
MAC WIN BOTH

37

Layer masks 3: soft edges

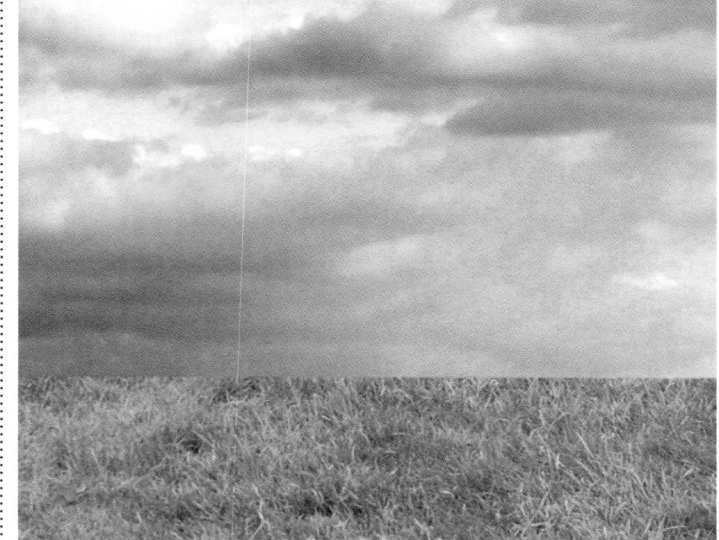

1 A patch of cloud has been placed directly over the top of the grass in this image. The effect is clearly desperately unconvincing, and even raising the horizon line by deleting a section of sky would look like a poor montage. To enhance the misty effect, we'll blend the sky smoothly into the grass.

ANY OF THE PAINTING tools can be used on a layer mask – not just the Brush. If a tool can be used in a Photoshop layer, it can be used on the mask as well.

This greatly extends the scope of masking, as well as allowing us to create some interesting and unusual effects. Here, we'll use the Gradient tool to produce a softly feathered edge to a bank of cloud, looking just as if we'd erased it with a huge Eraser.

More interesting is the second effect, which uses the Smudge tool to create the mask by bringing in the black around the figures, so that the grass appears to overlap them convincingly.

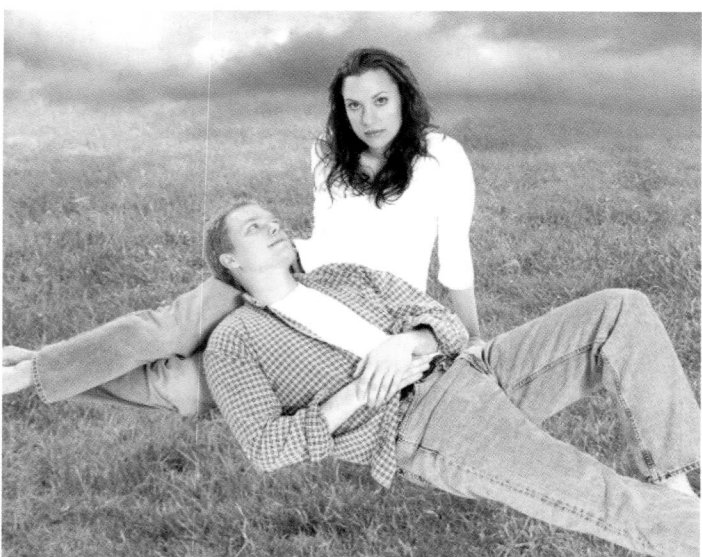

3 This sultry pair seem unaware of the fog rolling in behind them – but we need to make them fit into their environment better. After creating their layer mask, we first hold ⌘ *ctrl* and click on their name in the Layers palette, which loads up the area taken up by the pixels in the layer. Then inverse the selection, using ⌘ *Shift* *I* *ctrl* *Shift* *I*; fill the new selection (which includes everything except the couple) with black. You won't see any change: that comes later.

2 After creating a layer mask for the cloud layer, choose the Gradient tool and set it to Foreground to Background, using black and white as the respective foreground and background colors. Now position the Gradient tool at the bottom of the clouds and drag vertically, holding the Shift key down as you do so to create a pure vertical. The result is a smoothly fading mask: the mask itself is shown inset.

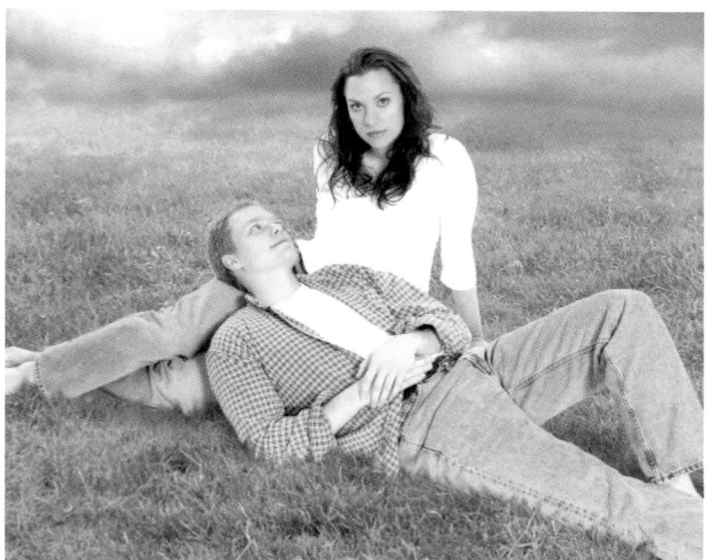

4 The layer mask we just created looks like the inset (above right). Because white is the selected area, the hidden region (black) hides nothing. Now for the interesting bit: using the Smudge tool, gradually streak up the black mask where the bodies touch the ground. Each streak will hide a part of them, and the result will look as if the blades of grass are truly in front of the bodies. The minimal shadow, painted on a new layer behind them, simply adds to the effect.

HOT TIP

Experiment with different brushes and tools on layer masks to see the effect. Using a brush set to Dissolve, for instance, would be a good way of masking these figures if they were lying on sand rather than grass (see page 42 for an example of this technique). For less defined background surfaces, try using the Blur tool instead – set it to Darken, or it will have little effect.

SHORTCUTS
MAC WIN BOTH

39

Layer masks 4: smoothing

CUTOUT OBJECTS CAN LOOK TOO CRISP, particularly if they've been silhouetted using the Pen tool. This hand appears false against the slightly out-of-focus background: it's an obvious montage that wouldn't fool anyone.

One technique might simply be to feather the edges of the hand. But that's an irrevocable step: anything that has been permanently deleted will be hard to put back afterwards.

A better method is to create a layer mask and adjust that, as shown here. This technique makes it easy to get exactly the amount of edge blurring you need, without having to commit yourself at any stage: you can always discard the layer mask and repeat the process with different settings later.

1 First, hold ⌘ *ctrl* and click on the layer name to load the selection. Make a layer mask and inverse the selection, then fill the inverted area with black. Here's how the mask looks: its crisp edges won't affect the layer yet, since it's only masked what isn't visible anyway.

4 This figure suffers from the same problem: the hard edge of that white jacket looks more like plastic than fabric, and his ear is too crisp against the background. Applying the method outlined above will rectify this situation easily.

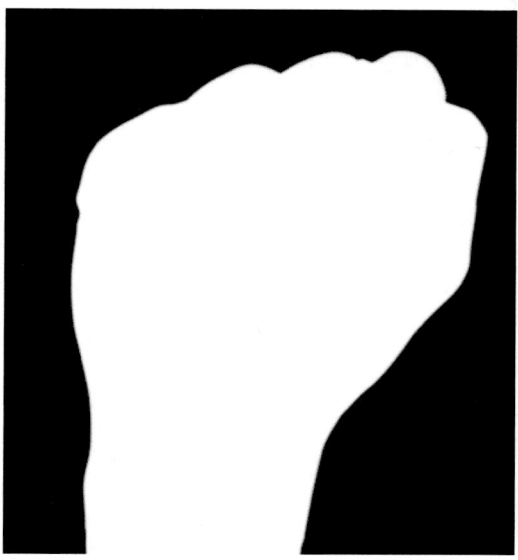

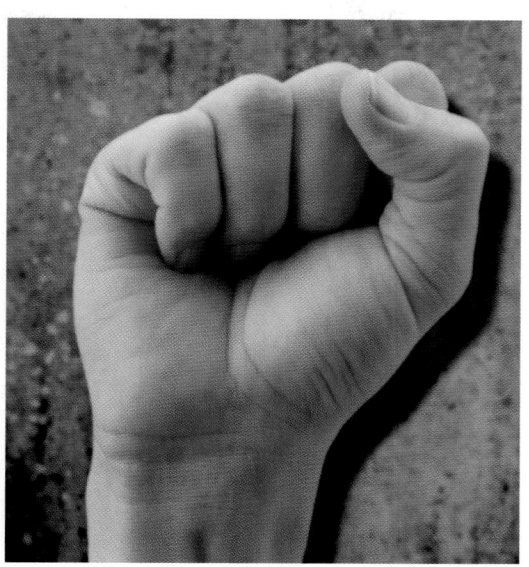

2 Now, with the inverse still selected, feather the selection by using ⌥ ⌘ D alt ctrl D and specifying the feather amount, then fill with black again. A figure of 1 or 2 pixels will be sufficient. Here's how the mask looks afterwards.

3 Now the hand looks more like it belongs with the background: the edges are softened, without a single pixel having been deleted from the layer itself. If the background changes and you need the hand to be crisp again, simply discard the mask.

5 So far, so good: the jacket and ear blend in much better with the background. The hair, however, is another matter. Because the original strands of hair were so fine, the new mask has made the individual stray hairs disappear, while the remainder now looks more like a bad wig.

6 The solution, of course, is to set the foreground color to white and simply paint out the mask around the hair edge. It's always worth checking for details like this when using this masking technique, as any fine elements can easily be lost in the process.

Hiding and showing
The sands of time

U SING LAYER MASKS and groups is a useful way of combining many layers so that they're constrained in visibility. This illustration for ES Magazine was to accompany an article about how time's running out for tropical beach holidays: combining the sand of the beach with the sand of an eggtimer seemed like a good idea. Too bad ES didn't agree: the illustration was dumped.

1 The eggtimer was modeled in Dimensions (see Chapter 10), with the base, glass, and top and legs imported into Photoshop as three distinct layers.

2 A brushed aluminium texture was made by filling a white rectangle with noise and adding motion blur to it: this was grouped with the top, legs and base and set to Hard Light mode.

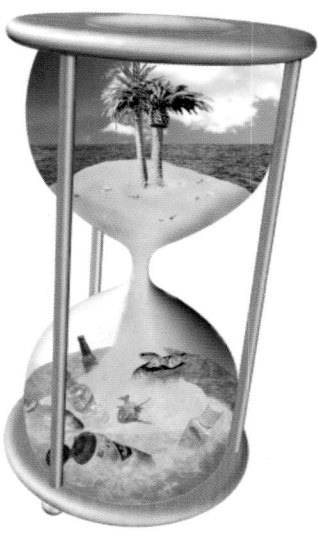

6 All the elements were brought in in separate layers: the objects at the bottom were masked using the Brush tool set to Dissolve to create the sandy effect around their edges.

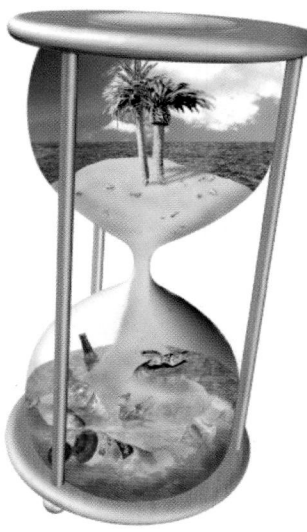

7 Shadows painted around the objects and at the bottom of the glass helped to make all the objects look more like they were part of the same scene.

CASE STUDY

3 The sky and sea were placed on top of the glass layer, and grouped with it so that their visibility was limited to that of the original glass layer.

4 The sand was drawn as plain brown, grouped with the glass layer, and then Gaussian Noise was added; the textures were painted in using the Dodge and Burn tools.

5 The water was added as a single layer in front of the sand. A Layer Mask allowed me to paint it out around the cone of the sand, and to lower its transparency at the front.

8 The original glass layer was duplicated and moved to the top (just before the lid layer), and set to Hard Light mode, with its opacity reduced to 50%.

9 A fine rim was added all the way around the edge of the glass, to give an impression of the thickness of the material. Without it, the glass looked too ethereal.

10 Finally, the legs were copied and curved using the Shear filter; the opacity was lowered to 20%, and a layer mask was used so they appeared to be a reflection in the glass.

HOT TIP

When you need to experiment with different opacity settings for your layers, there's no need to keep reaching for the Layers palette. With the Move tool selected, simply type a number: 5 for 50%, 1 for 10%, and 0 for 100%. To get intermediate values, type two numbers in quick succession: so type 4 then 5 to get 45%.

Blending 1: fire power

THE BLENDING OPTIONS feature, tucked away within the Layer Style palette, is one of the most overlooked features in Photoshop. But it's an enormously powerful tool that allows you to hide or show picture elements automatically, without touching a brush or layer mask.

In the image above, for the Sunday Telegraph, I duplicated the background sky complete with lightning, and placed it in front of the globe; then used Blending Options to remove the sky from the front version.

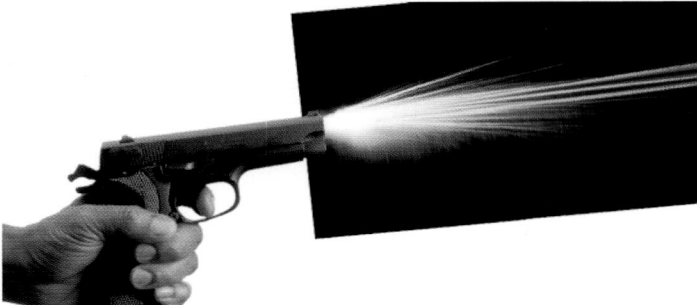

1 Here are the two elements of this montage – the hand holding the gun, and the photograph of the firework which has been rotated to match the gun's angle. Simply changing the mode of this layer to Screen would get rid of the black, but the flame would be pale against a light background – and would become invisible against white.

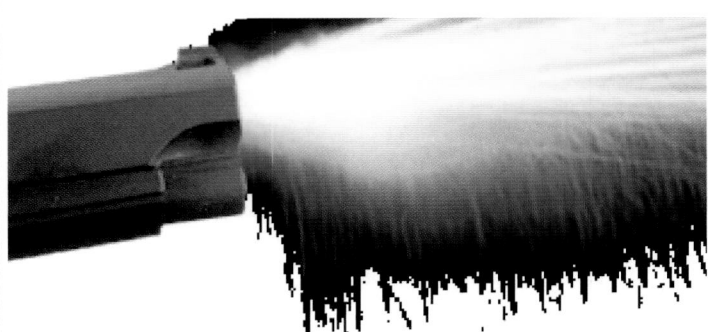

3 When we zoom in on the image, however, we can see that moving the slider produces a sharp cut-off between what's visible and what's hidden. It's an ugly, stepping effect; in order to make the effect more realistic, we need to look more closely at exactly how that black slider operates.

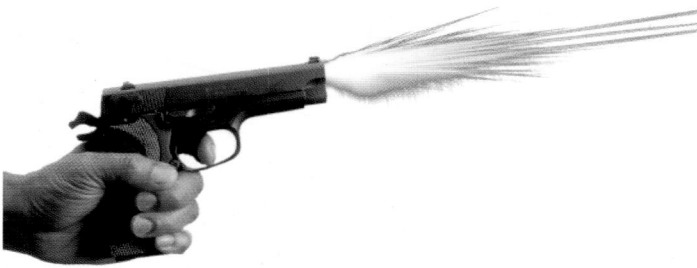

5 Further adjustment of both sliders allows us to set the visibility of this layer exactly as we want it. Now, the left slider is set to 50 and the right slider to 120, which removes exactly the right amount of black without weakening the effect of the rather enthusiastic gunshot.

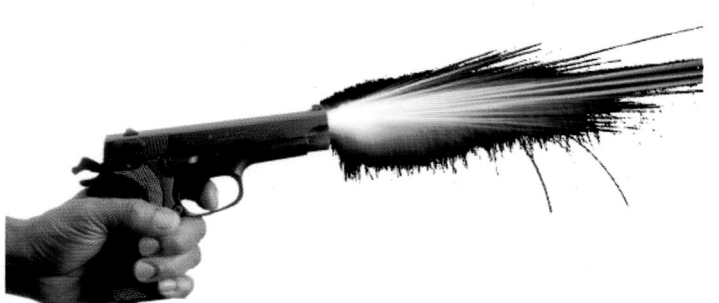

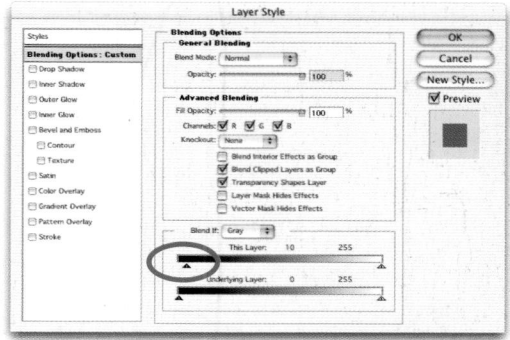

2 Double-click the layer's name or choose Layer/Layer Style/Blending Options to bring up the dialog. It's the bottom section we want to look at, the one headed Blend If. On the This Layer section, drag the black triangle to the right – here, it's at a position of 10 (working on a scale of 0=black to 255=white). This hides everything darker than 10 in the image.

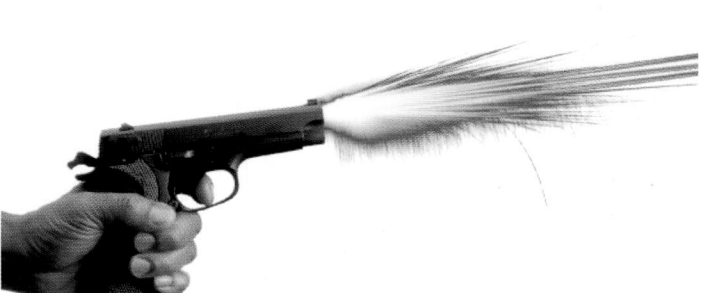

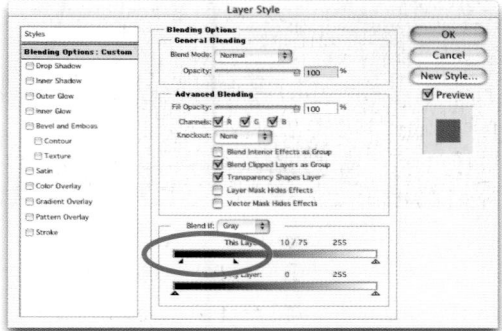

4 What appears to be a single triangle is, in fact, two. Hold down ⌥ *alt* as you drag and it will split into its two sections, which can be manipulated individually. With the left slider still set to 10, we now drag the right one out to a position of 75. This is what happens: everything darker than 10 is hidden, and everything brighter than 75 is fully visible. But now, all the values in between fade smoothly between the two states.

HOT TIP

Blending options can be used to remove light colors as well as dark ones: simply drag the right hand (white) slider to the left instead, and split it into two in the same manner.

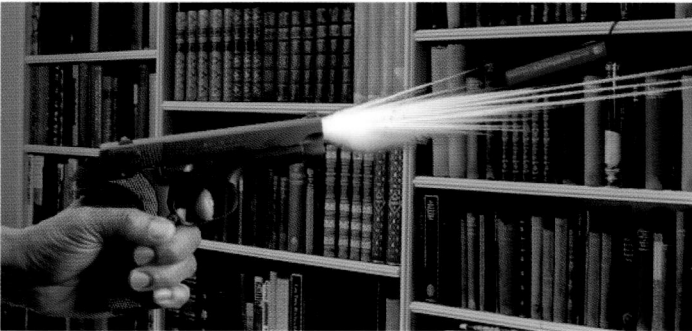

6 When placed against a suitable background (somehow libraries always come to mind when I think of gunshots) the effect is dramatic. I don't believe there's any other way that this flame could have been isolated from its background as convincingly as this in Photoshop.

SHORTCUTS
MAC | WIN | BOTH

Blending 2: plane view

THIS SECTION DEALS WITH the other half of the Blending Options dialog – the Underlying Layer section. This controls the visibility of the target layer depending on all the layers beneath it, not just the one directly below.

The illustration above was for a Sunday Times Magazine cover, illustrating the crowded state of Britain's air traffic. Rather than creating an Underlying Layer adjustment for each plane, I duplicated the cloud layer to the front and removed the blue sky from that layer: seen through it were not only the planes, but the original sky as well.

1 In this example, we're going to make the plane fly through the clouds rather than just sitting on top. Working on the plane layer, it's clear that we don't want to hide that layer depending on its brightness values: unlike the example on the previous page, this isn't simply a case of removing the black element from the target layer.

3 Since we're working with blending values rather than with a layer mask, we can move the plane anywhere we want within the artwork and the effect will still apply. This is a great technique for animation, and works well if you're planning to import Photoshop artwork into After Effects.

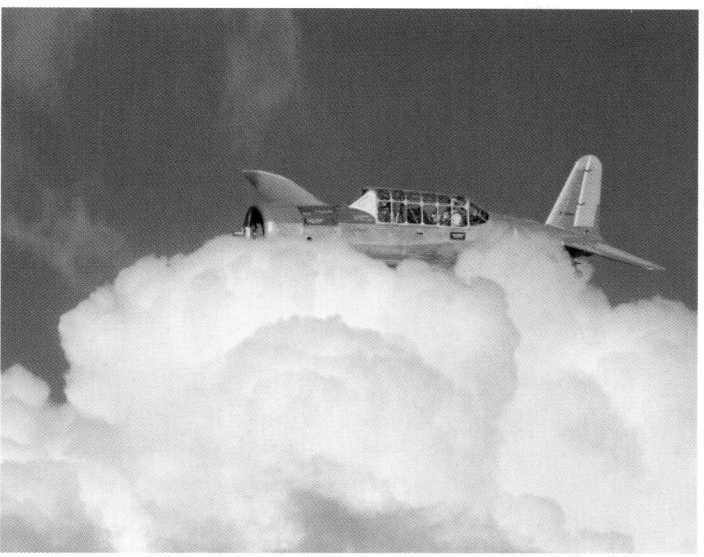

2 Because we want the visibility of the plane to be affected by the presence of cloud in the layer beneath, we need to turn our attention away from the This Layer section of the Blending Options dialog, and look instead at the Underlying Layer section. This works in exactly the same way, except – as its name implies – the visibility of the target layer is determined by what's going on underneath. Here, we've dragged and split the right (white) slider rather than the left (black) one; settings of 118 and 167 do the job well.

HOT TIP

Not all clouds are as obliging as these. If the gray values in the cloud are the same as those in the sky, you'll need to add a layer mask as well, painting out the offending areas by hand.

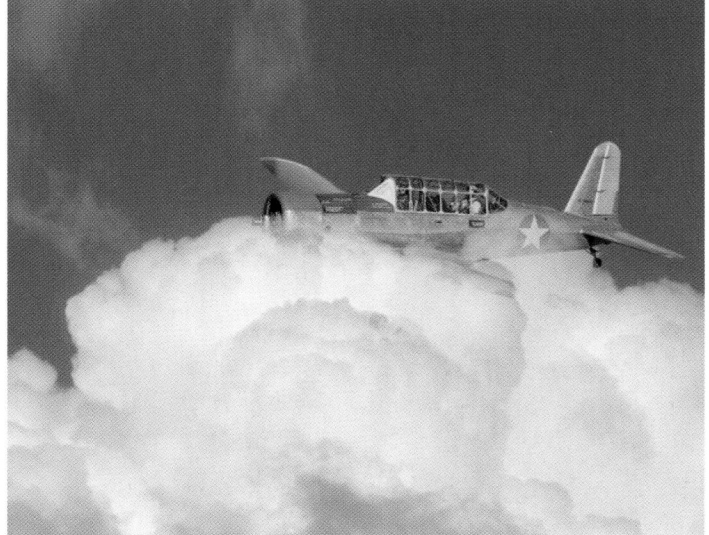

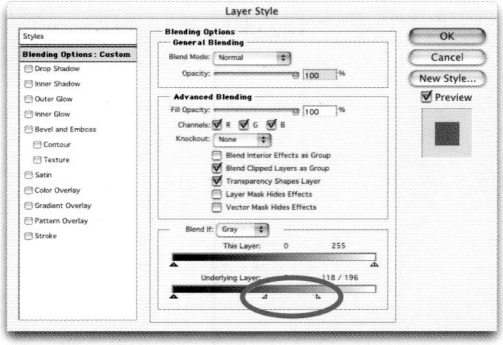

4 Although we hid the plane in the clouds correctly, the overall effect can be made more realistic by allowing a little of the plane to show through – after all, clouds are not solid objects. This is achieved by dragging the right slider back towards the right, increasing the number: in this instance, a value of 196 as the white cutoff point is enough to add just a touch of translucence to what would otherwise be over-opaque clouds.

Graphics tablets

I SPENT SEVERAL YEARS reviewing graphics tablets for MacUser, praising their capabilities and deriding their shortcomings, while all the time secretly wondering why anyone would use such an awkward device. When each new tablet arrived I'd expect a liberating feeling, hoping that I could finally discard my mouse and sketch as if I was drawing on paper with a pencil. And each time I felt frustrated, because drawing on a tablet while looking up at a monitor is nothing like drawing on paper. And then I realized the problem.

Graphics tablets take a lot of getting used to.

Using a stylus is very different to using a mouse. For one thing, it isn't tied to your computer, which means it can roll around the desk, drop into the waste paper basket and have to be rescued from among a pile of junk mail before it ends up as landfill. The stylus could end up anywhere: at least a mouse can't be more than a cord's length away.

My main problem with the stylus, though, was that although it seemed perfectly adequate for shading and painting, it was too clumsy for web browsing and general use. There's also the problem that while a mouse moves the cursor in the direction you choose – and you can site a mouse anywhere on the mouse pad while you drag it around – the stylus and tablet have a one-to-one relationship with the monitor: the top left corner of the tablet represents the top left corner of the screen. You can't simply position a stylus anywhere you want it and expect it to behave like a mouse.

In theory, I could have used the mouse for some tasks, and the stylus and tablet for others. But the mouse wouldn't work properly on the tablet's surface, and in order to use the tablet I had to place it on top of my mouse mat and then take it away again to use the mouse. So the tablet always ended up sitting on the shelf until the PR agency who'd lent it to me sent out a courier to pick it up again.

Then I was sent a combined mouse/stylus combination to review. Made by Wacom, it's the cheapest tablet they produce: at a cost of under $100, I fully

expected it to be more of a toy than the kind of tool a serious graphic artist would give a second glance.

The first thing that surprised me was the mouse. It was cordless, which felt decidedly modern. True, it was no longer chained to my computer, but at least it couldn't roll off the desk like the stylus. There was no ball to clog up, which meant the regular task of scrubbing my mouse ball and scraping the rollers with a fingernail were finally a thing of the past.

The mouse also had two buttons, which was quite a novelty for a diehard Mac user, although I spent many hours trying to decide what to do with the second button (you can customize it to do anything you like, and even change its function depending on the application you're working in). But best of all, the mouse had a scroll wheel that let me zip through web pages, tear down Word documents and whizz through image libraries without having to click on one of those annoyingly small arrow icons at the corners of windows.

I started using the mouse in earnest, glancing occasionally at the stylus as it perched in its holder at the top of the tablet. Once in a while I'd reach for the stylus when I wanted to perform a task for which variable pressure would be useful, such as painting shadows or using the Dodge and Burn tools.

Gradually, over the weeks, I began to feel more at home with the stylus, and found myself using it increasingly often. Now I find that I'd be lost without it: I take it with me everywhere I take my PowerBook, and if I ever have to give a demonstration where I have to use the mouse that comes with the demo computer, it feels clumsy and awkward.

The upshot of all this is that I now recommend a graphics tablet wholeheartedly to anyone who'll listen, to the extent that I consider them an essential tool.

Just don't expect to take to it immediately.

3
Image adjustment

ONE OF THE COMMON problems facing the montage artist is making skintones match. You might place a head on a different body, and then use a new hand to replace the existing one; the chances are that the colors of each component will be wildly different. In this chapter we'll look at the Curves adjustment, the most powerful tool for correcting color, which can also be used to boost contrast within the image.

We'll kick off this chapter by taking a look at Shadows and Highlights, one of the most powerful new features in Photoshop CS. It's an enormously satisfying tool to use, as it's capable of providing a quick fix solution to the problem of over-dark and bright areas in a photograph.

3

Shadows and highlights

1 This figure has been photographed with strong side lighting. If used in a montage, we'd have to arrange all the lighting in the scene to match it; but with Shadow/Highlight, we can make this image look as if it has been lit from the front.

T HE SHADOW/HIGHLIGHT ADJUSTMENT IS ONE OF Photoshop CS's best new features. This bust of Liszt (top) has been photographed outdoors against a dark background. Hard to remedy conventionally, the default settings of Shadow/ Highlight (bottom) produce great resutls. The background is duly brightened, and none of the fine bright detail of the bust has been lost in the process.

4 This figure poses the opposite problem. The lighting on the skintones is fine, but the shirt is very bright – it almost disappears against this white background. We'll use Shadow/Highlight once again, but this time we'll turn our attention to the Highlights area rather than the Shadows section.

52

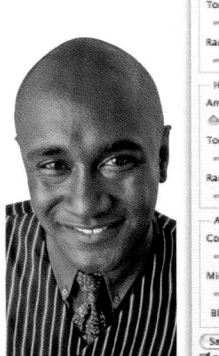
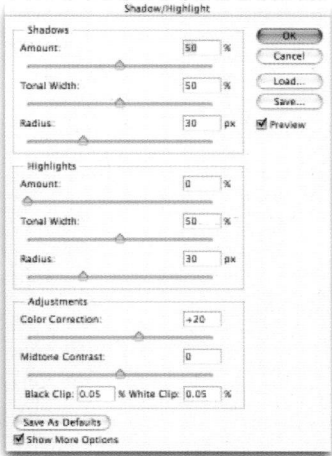
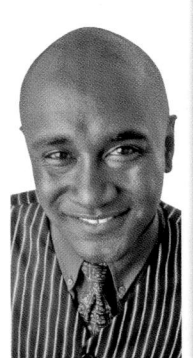
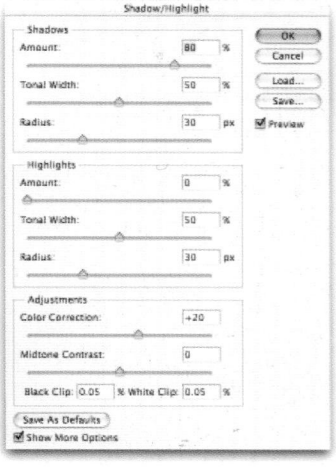

2 The default settings of Shadow/Highlight produce a markedly better image, with much of the detail that seemed to be lost in the shadows being returned to view. Overall, though, we can still see a strong light from his right, leaving the left side of the face in shadow.

3 By increasing the Amount setting in the Shadows dialog from the default 50% to 80%, we're able to balance both sides of the face to give an even lighting overall. The colored lighting still produces a blue sheen on the left, but that can easily be fixed later.

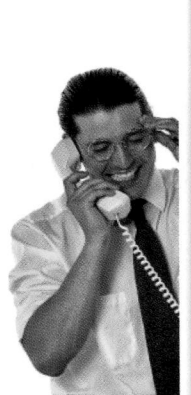
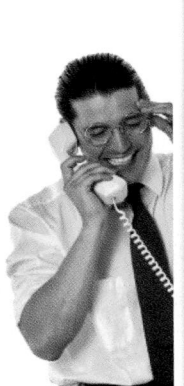
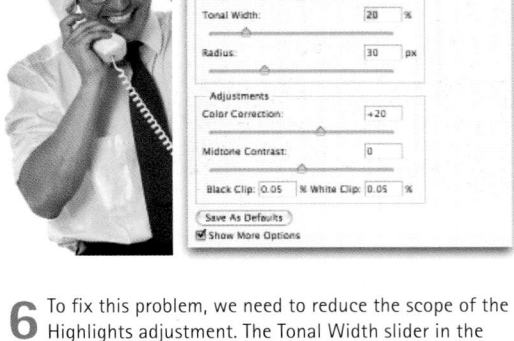

5 To start with, reduce the Shadows amount to zero so there's no change in that area. Now we can increase the Highlights value to, say, 50%, which darkens up the shirt well (but note how that white telephone cord still stands out against the dark tie). The shirt's looking good, but some of the Highlight setting has 'leaked' into the skin, making it too dark and over-saturated.

6 To fix this problem, we need to reduce the scope of the Highlights adjustment. The Tonal Width slider in the Highlights setting has a default value of 50%; by reducing this to just 20%, we're able to limit the range of the effect so that the skintones are not included. Now, the shirt has been reduced in brightness, while the skin has been left pretty much alone.

53

Learning Curves

1 When you open the Curves dialog you see, perhaps surprisingly, not a curve but a straight line. As a default, the input values are the same as the output, so there's no change.

THERE ARE MANY WAYS OF ADJUSTING images in Photoshop – Levels, Brightness & Contrast, Hue & Saturation, Color Balance. The most powerful of the lot is Curves, which allows you to make both fine and sweeping alterations in a single dialog.

The Curves dialog is one which confuses many new users, but it's worth getting to grips with. The graph shows how the input values (the original image) translate into the output values (the result of the operation); by subtly tweaking this graph, we can adjust not only the overall brightness and contrast but each of the red, green and blue channels as well.

Using Curves often involves thinking backwards: so if an image is too red, for example, the best fix is often to increase the blue and green components, rather than to reduce the red (which would result in too dark a result). Subtlety is the key: small adjustments are always the best way forward.

4 As well as clicking in the center, we can also adjust the endpoints. Clicking the top right point and dragging down limits the brightest part of the image, reducing contrast.

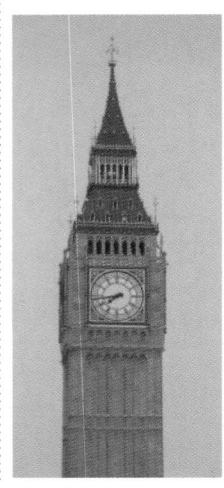

7 We can also adjust each color individually. Choose the color channel from the pop-up menu: we'll correct the red cast by adding green to the image.

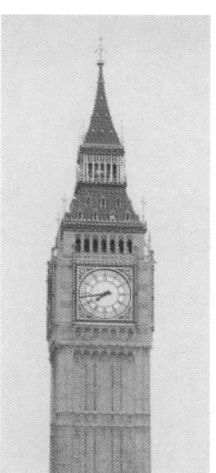

2 By clicking in the center of the line and dragging upwards, we make our first curve. Raising the curve increases the overall brightness of the scene.

3 Conversely, clicking in the center and dragging downwards lowers the brightness, producing an image that's darker overall.

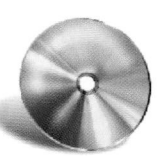

HOT TIP

If you find that Curves behaves in the opposite way for you, make sure the gradient bar beneath the graph is dark on the left and light on the right. If it isn't, click the double-headed arrow in the center and it will be changed for you. To switch between the Red, Green and Blue channels, use ⌘ 1 ctrl 1, ⌘ 2 ctrl 2 and ⌘ 3 ctrl 3. Press ⌘ ` ctrl ` to switch back to RGB.

5 If we drag that top right point to the left rather than down, we produce the opposite effect – increasing the contrast of the image. This is a very useful and controllable quick fix.

6 By dragging the top and bottom points towards the center, we create a stylized, posterized effect that turns any photograph into more of a graphic object.

8 To correct our image further, we need to add more blue. Switching to the Blue channel allows us to raise the blue content. But the image is now too washed-out.

9 Click once in the center of the RGB curve to 'pin' that midpoint; now drag just the top half of the curve to make this S shape, and the result is to increase the overall contrast.

SHORTCUTS
MAC WIN BOTH

55

Matching colors with Curves

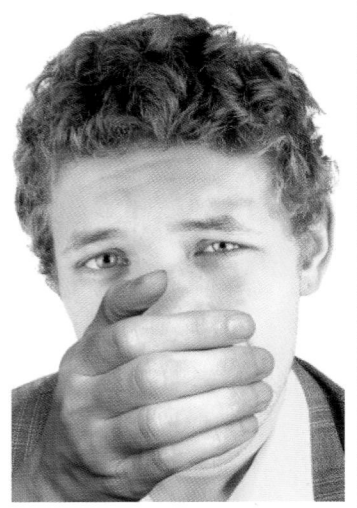

MATCHING COLORS between two photographs is at the heart of the photomontage artist's craft. Variations in lighting can produce enormous differences in color and tonal range, which need to be balanced in order to make a montage work.

While the hand shown here was a reasonably good original digital capture, it looks completely wrong when placed against a face which appears to be a totally different color.

The Curves adjustment is the ideal tool for this job. The process involves several steps, and it's a good way of learning how to manipulate Curves to achieve precisely the results you want.

1 At first glance, the hand needs to have much more yellow in order to match the face. There's a problem here: we have access to each of the Red, Green and Blue channels, but there's no yellow. The trick is to think in reverse, taking out colors we don't want rather than adding colors we do.

It's fairly clear, if we look at it this way, that the hand is far too blue. So open Curves (using ⌘ M ctrl M) and switch to the Blue channel using the pop-up menu. Click in the center of the line and drag down slightly to remove that blue cast from the skintones.

2 Removing the blue from the midtones, as we've just done, helped a lot; but we can still see some blue in the highlights, most noticeable in the shine on the backs of the fingers and in the fingernails. To fix this, click on the right side of the curve and drag vertically downwards. This limits the brightest part of the Blue channel, reducing the highlight glare.

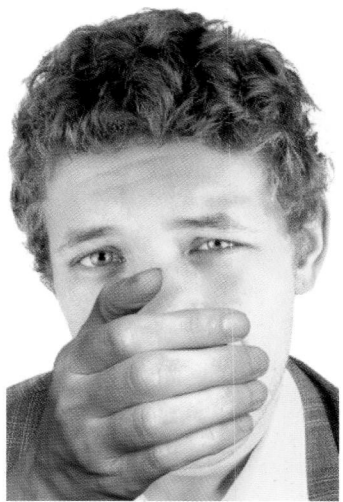

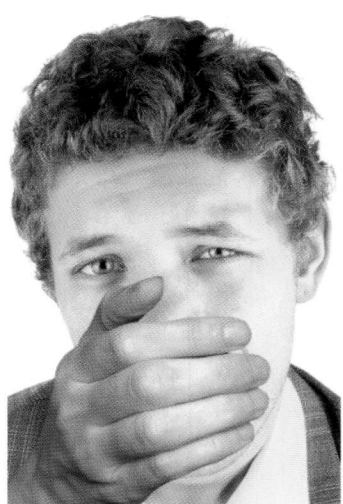

Channel: Red

Channel: RGB

Channel: RGB

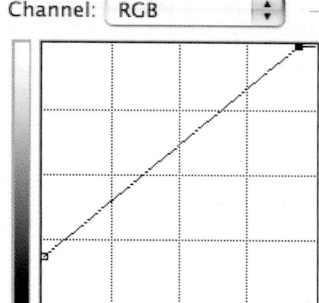

3 So far, so good – but the image still isn't quite the right color. Taking out the blue has left it with a greenish tint. We could simply take out the green, but that would make the whole thing too dark; instead, if we compare it to the face, we see that the face has more red in it. So switch to the Red channel, click in the center of the line and drag upwards slightly to increase the red content in the midtones.

4 The result of the last three operations left us with a hand that is now the right color, but which is too highly contrasted: the shadow on the left of the hand is much darker than anything we can see in the face.

Switch now to the RGB channel, which affects the overall contrast and brightness. Because we want to remove the shadow, we need to click on the extreme left of the line – which marks the darkest point – and drag upwards, to limit the darkness of the layer.

5 Much better – but not quite there yet. By reducing the shadows, we've also left ourselves with a hand which is somewhat lacking in contrast. We can boost this by clicking on the top right corner of the line, and dragging it to the left: the result of this is to compress the tonal range, so boosting the contrast overall. It's important to make only a small adjustment here, as it's easy to go too far. In the end, though, we've got a hand which matches the face almost exactly.

HOT TIP

If you create a point on the curve which you later want to remove, hold ⌘ *ctrl* and click it again to make it disappear. To reset the entire operation, hold ⌥ *alt* to make the Cancel button change to Reset, and then click it.

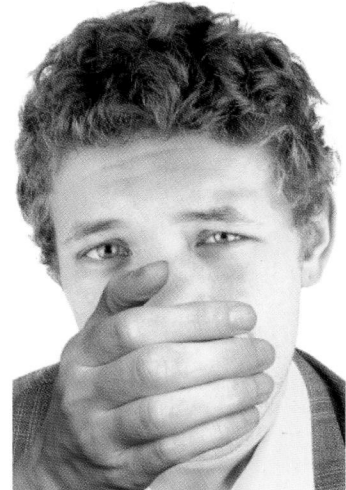

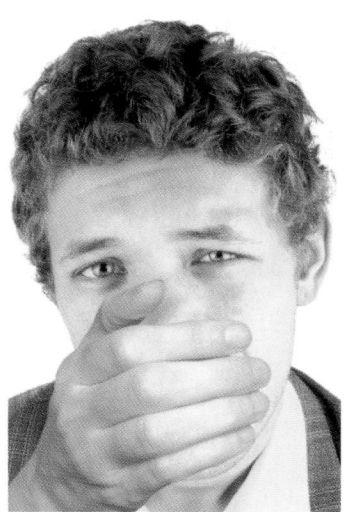

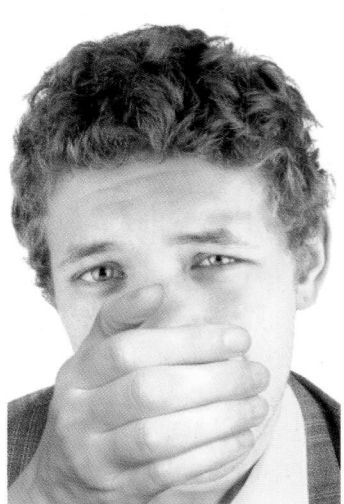

SHORTCUTS
MAC WIN BOTH

3

Major color changes

1 Here's the original car photograph, cut out from its background using the Pen tool. There really is no better tool for this sort of job, and mastering it is an essential skill.

2 The next step was to isolate just the black body, again using the Pen tool. On the version on the CD, you'll find that I've done this for you: just load up the Pen path.

WHEN THE GUARDIAN newspaper ran a cover story about whether Britain was moving towards an American or European ideology, they wanted to show Britain at the crossroads. The gimmick was to use a car with a Union Jack painted on the top, as seen in the Michael Caine film The Italian Job.

In order to see the roof, I had to stand on the top of my own car (after driving round the streets looking for a suitable mini) in order to get the correct perspective. Changing the color from the original black, however, is the technique that most concerns us here.

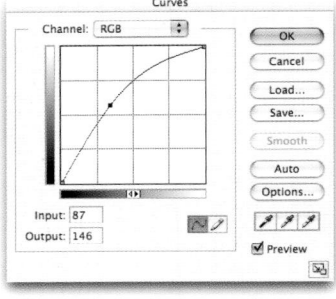

5 A far better solution is to say OK to the Hue/Saturation dialog after you've made the color change, and then use Curves to increase the brightness. By clicking on the midpoint

of the RGB curve and raising it, we're able to increase the brightness of the midtones without affecting either the shadows or the highlights for a more natural result.

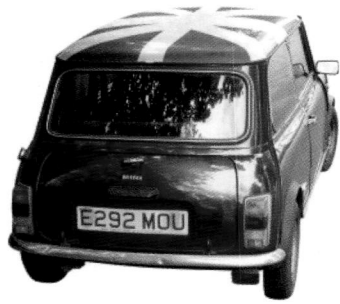

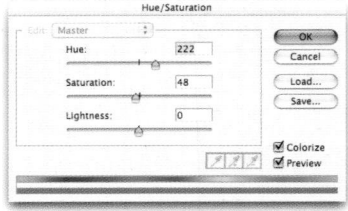

9 With the new layer now isolated, we can apply our blue coloring to it using the Hue/Saturation dialog once again. The procedure is exactly the same as in step 3, using a combination

of the Hue and Saturation sliders to achieve exactly the color you want. Beware of increasing the Saturation slider too far, or you'll produce a color that's unprintable.

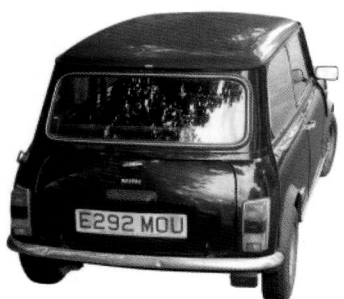

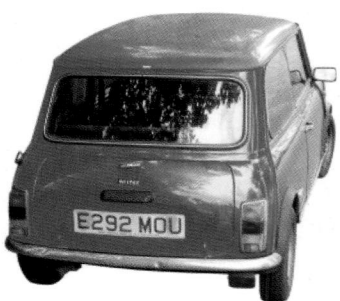

3 Once the body paintwork had been made into a new layer, it needed to be changed from its original black to a strong red. It would have been possible to do this using Curves,

but for an operation like this the Hue/Saturation adjustment is far more suitable. Check the Colorize box, and adjust both the Hue and Saturation sliders to get the right effect.

4 Because the bodywork was too dark, you might think that raising the Lightness slider would be the answer. But this produces a pale, washed-out version of the original.

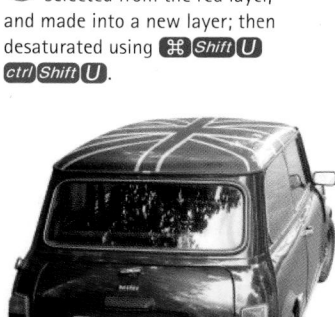

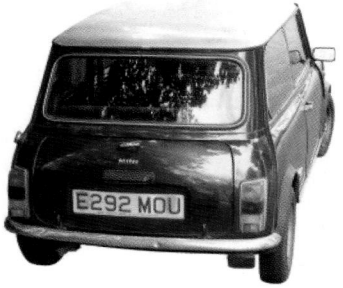

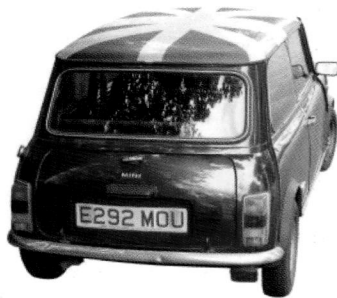

6 Now for the flag. The roof is selected from the red layer, and made into a new layer; then desaturated using ⌘ Shift U ctrl Shift U.

7 With all the color knocked out of the roof, duplicate the layer (we'll need the original later) and brighten it up to near white, once again using the Curves dialog.

8 Now we can return to the original desaturated roof, and draw our Union Jack outline. This is made into another new layer, and moved on top of the white layer.

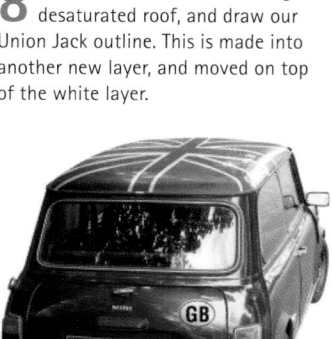

HMP 729G

HMP 729G

HMP 729G

10 The red portion of the flag is created by drawing its outlines, and then deleting that area from the white roof to reveal the red coloring that's already beneath it.

11 For the sake of historical accuracy, I used the number plate from the original film (found by phoning the webmaster of an Italian Job fan website). The lettering was set

in the shareware font CarPlates, which was curved using the Shear filter and then had the EyeCandy 4000 Chrome filter applied – see Chapter 12 for more on this filter.

HOT TIP

When color changes are made using Hue/ Saturation it's easy to create colors that look good on screen, but which aren't within the CMYK gamut and will simply die when printed on paper. The silution is to turn on Print Preview mode using ⌘ Y ctrl Y; toggle this mode on and off when you're working within the dialog, and if you can see a significant change then you're working outside the CMYK gamut.

SHORTCUTS
MAC WIN BOTH

3 Multi-layer enhancement

PHOTOSHOP INCLUDES many tools for enhancing images – all the Adjustments, Unsharp Mask, and others. But sometimes working directly on the image layer produces ugly or over-saturated results; by making a duplicate of the layer, we can apply only the adjustments we want and discard those we don't need, simply by changing the layer mode.

Our original photograph here is of a man walking away from the camera. Shots like this are always useful for the montage artist, as it allows us to add a human element to our images without the reader thinking it's supposed to be anyone in particular. But to photograph someone in motion, you inevitably get some blur and loss of detail; here, we'll look at ways to get some of that detail back.

1 The first step in improving this dull, washed-out image is to duplicate the layer. You won't see any difference, of course: the new layer simply replaces the old one, and looks exactly like it.

2 Now, using the pop-up menu at the top of the Layers palette, change the mode of the duplicated layer from Normal to Soft Light. Right away, we can see an improvement: the image is sharper and stronger overall.

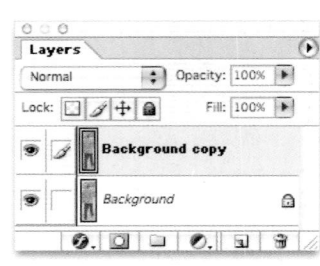

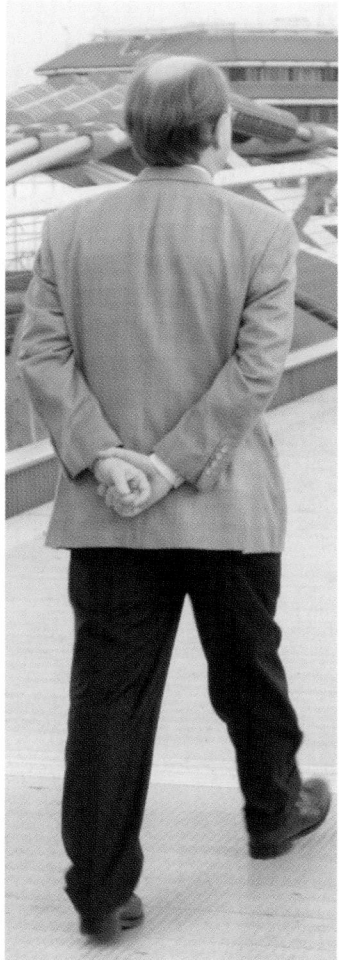

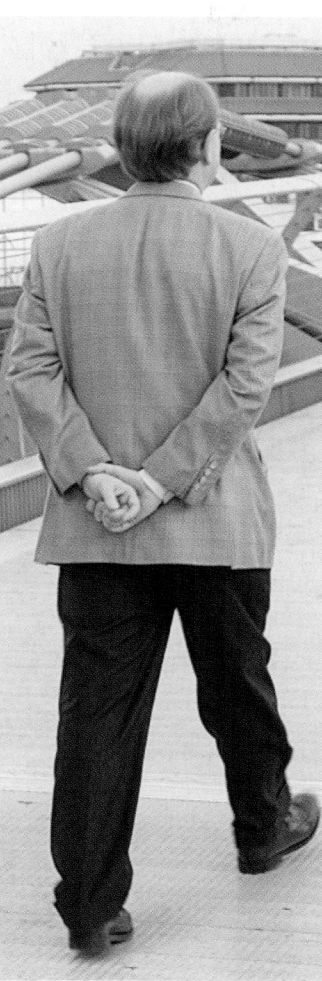

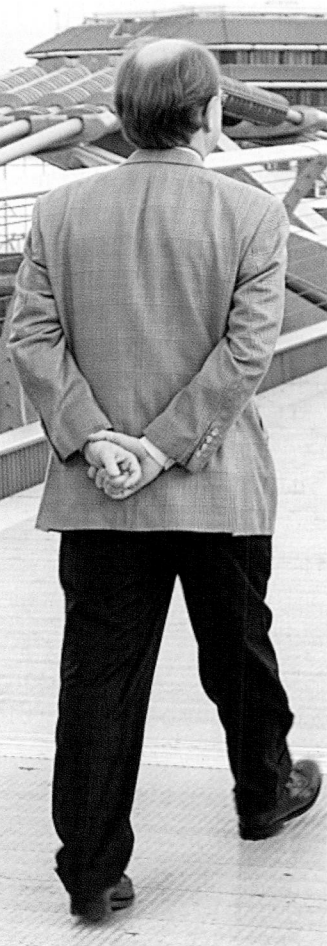

3 The only problem with changing the layer mode is that the colors in the last step became too saturated in the process. Any further adjustments to this layer would only exacerbate that problem. The solution is to knock all the color out of the Soft Light layer, using ⌘ *Shift* U *ctrl* *Shift* U to completely desaturate the image. The Soft Light layer now only affects the luminosity of the base image, which we can see through it: all the color comes from the original photograph, and is not altered by the new layer. We can now get to work on enhancing the new layer even more.

4 Using the Unsharp Mask filter, we can apply an enormous amount of sharpening – here, it's 300% at a 3 pixel radius – without affecting the color at all.

5 For a starker effect, try changing the layer mode from Soft Light to Hard Light. This produces a harder image altogether; the choice of which to go for depends on the final use to which it will be put.

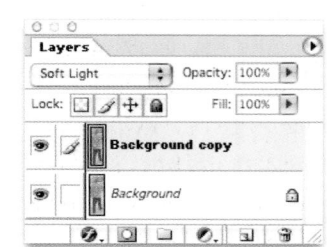

SHORTCUTS
MAC WIN BOTH

Sharpening: Unsharp Mask

SHARPENING MEANS bringing back definition to soft or slightly out-of-focus images. Rather than using the uncontrollable Sharpen and Sharpen More filters, the best way of proceeding is to use the Unsharp Mask filter.

The very name is enough to put you off, let alone the confusing interface. It's the single filter that confuses Photoshop users more than any other. The Unsharp Mask filter works by enhancing border regions between areas of contrasting color or brightness, giving the impression of a more tightly focussed original photograph.

The amount of sharpening you apply depends on the original image – and also on the paper the final image will be printed on. Glossy art paper, such as that used in this book, is capable of reproducing images at high quality; but if your work will end up on newsprint, say, you'll need to sharpen your images twice as much as normal so they don't look fuzzy when they're finally printed.

How Unsharp Mask works

1 Here's our image, shown magnified (above) so we can see the effect. It's simply a dark gray letter placed on a light gray background, with no color to distract the eye.

2 Here's the result of applying 100% sharpening with a radius of 1 pixel. The inside of the dark gray is darkened and the inside of the light gray brightened to increase contrast.

The interface

Toggle the Preview on and off to compare the before and after images before committing yourself

Hold ⌥ alt and click Cancel to revert

Set the Amount first: begin with 100%, increasing to up to 300% for a really dull image

Start with a Radius of 1.0 pixels, and increase if necessary

Adjust the Threshold, if you need to, last of all

3 Increasing the amount to 200% makes the contrast between light and dark even stronger, producing a much crisper result.

4 When we increase the radius to 2.0 pixels, we can see that the lightening and darkening operation now occupies a wider border around the hard edges – 2 pixels wide, in fact.

5 By increasing the Threshold value, we determind how much of the image is affected by the operation – in this case, the darkening doesn't eat into the gray to such an extent.

Putting Unsharp Mask into practice

1 Our original image is fairly soft, especially around high contrast areas such as the eyes. There's also little detail visible in the hair, and we can use Unsharp Mask to bring both of these into stronger focus.

2 In this exaggerated example, I've used an amount of 300% with a radius of 2.0 pixels. But note how the skintones have become over-sharpened by this operation: that's the area we want left smooth.

3 This is where the Threshold feature comes into play. By raising this to 30%, we prevent the filter from acting on the low-contrast skin area, while still enhancing the contrast in the eyes, mouth and hair.

HOT TIP

As well as varying the settings while inside the Unsharp Mask dialog, you can fade the effect immediately after applying it. Press ⌘ *Shift* **F** *ctrl* *Shift* **F** to bring up the Fade dialog, which gives you a slider that can be used to lower the strength of the filter you've just applied.

SHORTCUTS
MAC **WIN** **BOTH**

63

Natural healing

1 To begin, let's take out that large mole above her eyebrow. Hold ⌥ *alt* and click in the middle of the forehead to set the source point, then paint over the mole. The result will look like simply cloning the forehed, until you release the mouse button – then the tool does its magic.

T HE HEALING BRUSH, INTRODUCED IN Photoshop 7, has quickly proved itself to be one of the most popular image correction tools. Far more powerful than the Clone tool, it's able to correct blemishes in images quickly and very easily.

The secret lies in its ability to recognize the inherent texture of the source point, and blend that seamlessly with the lighting around the target area. For getting rid of spots, scratches and wrinkles, there's no better method.

In this typical example, we'll use the Healing brush to remove the moles and spots from this model's face (although, to be fair to the original model, I have enhanced the blemishes to make them easier to see).

The Healing brush works by sampling an area of clear texture to use as a reference point: the forehead is a great choice here, as for most faces, providing a wide expanse of skin uncluttered by facial features or hair.

4 When we try to heal the mole on the side of the model's face, however, we run into some difficulty. The tool works by blending the shades of the surrounding area; here, it's read the white background and blended with that.

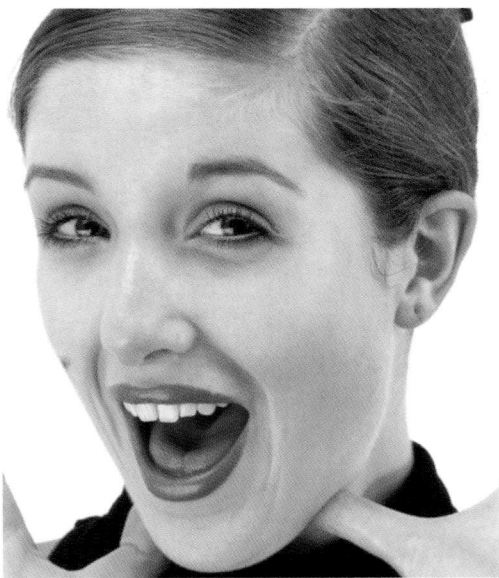

2 You can continue to paint over each additional mole in turn with the Healing brush. No need to reset the source point: the middle of the forehead will be remembered, and will be used for each new painting stroke.

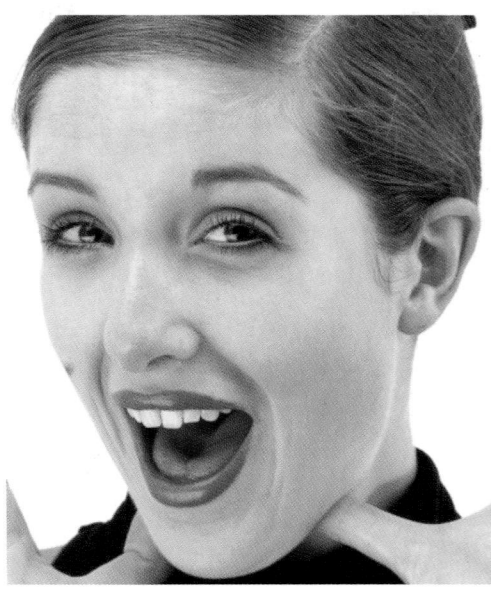

3 The tool is so powerful that we can even take out the hole left by a missing earring. The color here is different, and the ear is in shadow compared to the forehead, but the tool can still patch the hole perfectly using the forehead skintones as the source.

5 To stop the Healing brush looking beyond the edge of the face, we need to tell it where to stop – by making a selection. The easiest way is to make a rectangular selection, and use the Magic Wand to remove the white from it.

6 Now, when we use the Healing brush on that area, it will know not to blend with any colors outside the selected area; and so it removes the mole on the side of the face perfectly.

INTERLUDE

Getting started

WHENEVER I SPEAK IN PUBLIC, either in colleges or at computer shows, there are two questions I'm always asked. The first is the question asked of all creative artists: 'Where do you get your ideas from?' (I generally reply that I get them from the local idea store, except for particularly exotic ideas which have to be bought by mail order direct from Paris.) The second, and more pertinent, question is: 'How do you get started in a job like yours?'

This is a much more serious question, and deserves a less flippant response. What students want to hear is that you go to such-and-such a college, do this or that degree, and then apply through a website along the lines of freelancegraphicartist.com (or whatever) and a plum job will land on your plate. In real life, however, things rarely work out that way. For a start, I didn't go to art college, and therefore feel justified in describing myself as an unqualified success. The truth is that like so many people, I fell into what I'm doing by accident. This, of course, is the last thing a budding illustrator wants to be told.

There is another way. Some years ago, one of the students on a course I taught got a summer job on the picture desk of a national newspaper. It sounded more glamorous than it was: the job mainly involved filing prints in the paper's unwieldy photographic archive. Then, one day, a photograph needed scanning for inclusion in the paper. She pointed out that she'd done some scanning at college, and was allowed to scan the picture.

A short while later, a picture she'd scanned needed some color correction. As she'd studied Photoshop, she volunteered to make the corrections. Then one day a montage had to be done in a hurry – and once again, she volunteered. Today, she has a thriving design business, which combines creating illustrations in her own very distinctive style with working as a freelance designer on the same newspaper.

This example is just one of the stories of illustrators who have made their careers by being in the right place with the right skills. It's one approach: get yourself a job in the right sort of organization, and if you have any talent

people will find out about it. You don't need to be pushy, you just have to make sure those around you are aware of what you can do – and take every opportunity to show them what you're capable of.

To make a career as a freelance artist, you need to prove to prospective clients that you can meet a brief and a deadline. The best way to do this is to show them work you've already had published. Art editors are a cautious bunch in the main, and will be reluctant to be the first to try out an untested artist. With good reason: if you screw up, they'll be left with a hole they'll have to fill at the last minute. But if they've seen that other art editors have trusted you and used you – particularly if they've come back and used you again – then they'll be that much more inclined to put your talents to the test.

So if you're determined to pursue the freelance route, the important thing is to get as much work published as you possibly can. Going straight to national newspapers or magazines may prove to be a frustrating business, and you'll be unlikely to get past the receptionist; so begin with local newspapers and magazines, and offer your services free to charities and publications who would otherwise use a piece of clip-art.

It's also important to evolve your own visual style. While it may be tempting to propose that you can work in any style art editors want, the result will be that they'll never think of you when they want an illustration done; be distinctive, and you'll stick in their minds.

Not so long ago, freelance artists would have to drag their portfolios around the offices of magazines, newspapers and art editors in order to show work. Now, of course, the whole thing can be done far more easily by creating your own website. Don't worry too much about Flash content, Javascript interactivity and Cascading Style Sheets; the important thing is just to get your images there so they can be seen. Even the most hard-pressed art editor should be able to find the time to click on a website, assuming you've taken the trouble to find out their name and email address first.

4
Composing the scene

COMPOSITION, as any art historian will tell us, makes the difference between a good picture and a bad one. So it is with photomontage: the position of people and objects within the montage enables us to tell the story we want to tell. As we'll see in the first few examples in this chapter, the relative positions of characters can completely change the message we're putting across.

One way of making a montage look more realistic is to place our characters so that they interact with their background. Films which use a lot of computer-generated imagery, such as Jurassic Park, always go to great lengths to show their subjects part-hidden by foliage and other foreground elements: it's this incorporation within the picture that makes them more convincing.

Location is everything

1 With the climber positioned right at the top, we can see how far he's climbed. Our view of the mountain shows the task that he's accomplished to date; but we have no way of telling whether he's just started out, or if he's nearing completion. The rest of the climb may be visible to him, but the viewer is left with no sense of the job that awaits him.

THE WAY AN IMAGE IS CROPPED can have dramatic results in terms of the story being told. Here, we're looking at a montage in which the mountain, the climber and the sky are three separate elements that can be rearranged as we choose; but the same principles apply to cropping an existing image. The fact that this image is composed of three layers simply makes it easier for us to arrange the elements to tell the climber's story as we see it.

As it stands, the image above left shows a mountain climber on a piece of rock. Placed bang in the middle of the frame, the positioning tells us almost nothing about his progress: it's a static picture in which the climber is fixed in place, moving neither up nor down. The strong diagonal of the mountainside,

2 Moving the climber to the bottom has the opposite effect. Now we get a good idea of the task in front of the climber, as we can see how far he still has to go. The presence of all that sky, though, positions him some distance up the slope.

3 When we move the mountain down so that the majority of the image is taken up with sky, we get a much stronger impression of the climber nearing the peak. With so much sky around him, we can share his sense of isolation and solitude. All this sky shows us that there isn't another person around for miles.

4 By moving the mountain so that it takes up most of the frame, we position it so that our own viewpoint interacts with the picture. Where before the focus was on the climber, now the viewer can get a sense of the hardship faced. So much rock face highlights the climber's daunting task.

running from top left to bottom right, divides the image neatly in two as it delineates the difference between the land and the sky; but that neatness also takes away all sense of the dramatic.

Cropping a picture enables the viewer to focus on the key image without being distracted by extraneous elements. But it also allows the picture editor, or the digital artist,

to tell the story they want to tell rather than simply reproducing the scene as it originally appeared.

While the use of photomontage in newspapers has attracted much criticism amid claims of it distorting the truth, few readers complain about the way images are cropped – and yet the story is determined as much by cropping as by montage.

71

Relative values: interaction

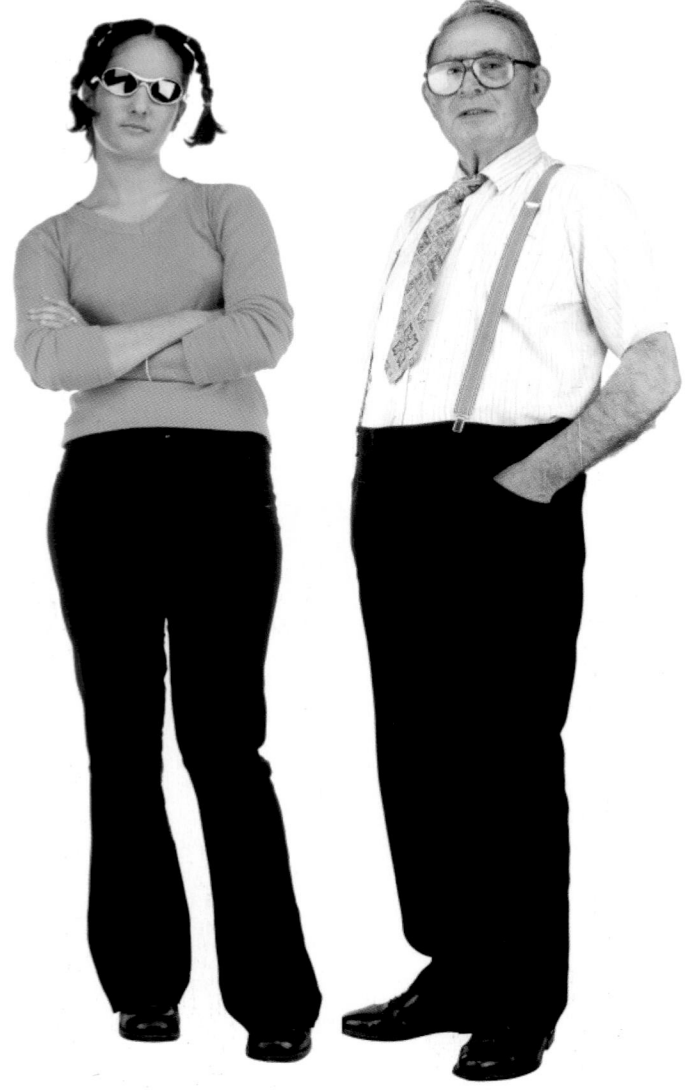

1 Simply moving them closer together so that they overlap helps to establish a link between them. By flipping the girl horizontally, both figures are now angled towards the centre of the image.

5 Now the tables have been turned. It's the daughter who is in the dominant position, while the father remains distanced from her: like most parents, he's now concerned that she's moving away from him.

COMBINING TWO PEOPLE in a montage entails more than just placing them on the same background. You've got to work out the relationship between them, and position them to tell the story in the best way. The image above shows, let's say, a father and daughter. They may share the same space but the reader gets no hint of how they might interact; by varying their position we can make their relationship clear.

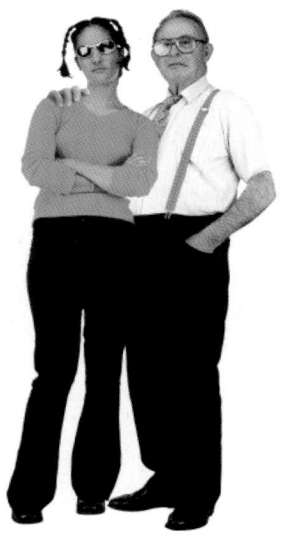 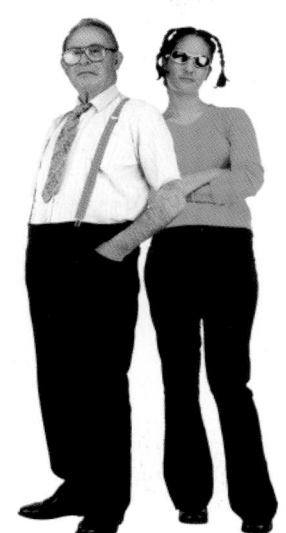 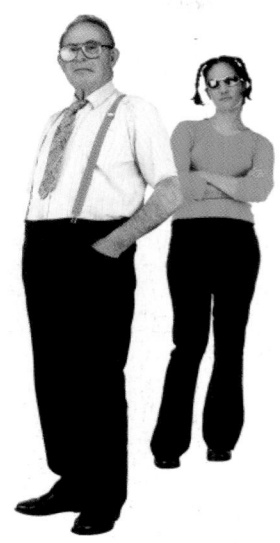

2 A simple additional device such as the hand on her shoulder puts the father in a more protective role. His body language is one of pride with, perhaps, a hint of restraint.

3 Bringing the father to the front still establishes his protectiveness, but now there's a sense that the safeguard is needed: he's shielding her from the viewer, while she is content to take refuge behind him.

4 By moving her towards the back we create an emotional as well as physical distance between them. Flipping her so that her shoulders point away from his accentuates the disparity: she now resents his control.

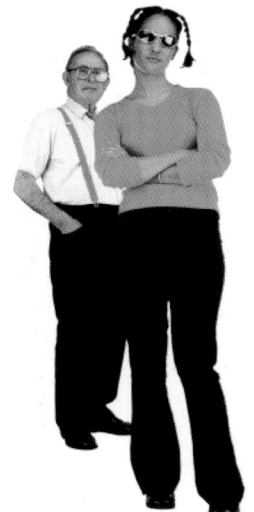

6 When we tuck the father behind the daughter, we strengthen the sense of her supremacy over him. In the previous example, she was merely moving away; now she's beginning to eclipse him.

7 Flipping the father horizontally makes him face away from his daughter metaphorically. His understanding of her is less than in the last example, but her pose shows she's prepared to turn back to him.

8 Flipping the daughter alters her body language as well: the two figures are now opposed, their shoulders pointing in different directions as she now turns her back on him absolutely.

HOT TIP

Varying the size of characters within a montage always places the front figure in the dominant position. The problem comes when you want the two to engage each other: in cases such as this, the interactive work has to be done by the rear figure to prevent the one at the front from glancing nervously over his or her shoulder.

I only have eyes for you

1 With both characters gazing directly at us, there's no contact between them – and we're left with no idea what either of them is thinking.

ON THE PREVIOUS PAGE, WE LOOKED at how changing body position can make a difference to the apparent relationship between people in a montage. But body language is only one way of explaining a relationship: far more subtle – and just as effective – is eye contact.

The photomontage artist often has to work with mugshots of politicians and celebrities, or images from a royalty-free collection. Either way, you're more or less guaranteed that the subjects will be gazing straight at the camera, and probably grinning inanely at the same time. This may suit the needs of the celebrity's publicist, but it's of little help when combining two or more people within a scene.

Here, we've taken a glamorous couple – so glamorous that he's just won an Oscar – and moved their eyes around from frame to frame. Nothing else has been changed, and yet the entire expression alters with the position of the eyes. The nine examples here are just a small part of the infinite range of expressions that can be achieved by simply changing the eyes.

4 He now looks a little over-protective of his trophy, as if someone might be about to snatch it from him: but she's downcast, as if the prize should have been hers.

7 He now gazes excitedly into the future – who knows what doors this prize will open? She isn't so much annoyed with him as just plain bored by the whole evening.

2 He's looking at her hopefully, and the grin has become almost a leer. Her reply is ambiguous, but not wholly negative – she might go along with his plans, she might not.

3 His expression hasn't changed, but hers certainly has. No chance for him tonight: she's fed up with the whole idea and can't wait to be rid of him.

HOT TIP

To change the direction a character's eyes are looking in, you need to create two new layers – one for the eyeball, and one for the pupil: group the pupil with the eyeball, and you can move it around within the eye. For more about working with eyes, see Chapter 6.

5 Now he's gazing up at his adoring audience – a subtle difference from the previous example. She, however, only has eyes for the trophy.

6 Now he's really worried, glancing over his shoulder as if he expects to be mugged - and that grin looks more false than ever. Her mind is somewhere else entirely.

8 He stares in wonder at his trophy as if he can't believe he's really won it. She ponders the situation, wondering if next time the accolade will go to her instead.

9 Now he's thanking heaven for the prize which has been awarded him – whereas she is wondering if she just saw a mouse scuttle across the floor.

4

The politics of plurality

1 The supplied mugshots of Prescott and Mowlam. The original bodies were useless, so were deleted.

2 This body, taken from a royalty-free collection, had the right kind of dynamic pose – with the benefit of one hand being raised, which is perfect for holding a mask aloft. Mo Mowlam's head has simply been placed on top to make sure it would fit.

THIS ILLUSTRATION WAS COMMISSIONED to accompany an article in the Daily Telegraph about how politicians spot themselves in coded form in works of fiction. Only two politicians were mentioned directly in the article – Deputy Prime Minister John Prescott, and former Northern Ireland Secretary Mo Mowlam. The idea of using masks came from the editor, to show the 'real' politicians being revealed beneath the thin disguises.

When compiling an image with several elements, it's important to draw the reader's eye: this is accomplished using the strong diagonal of the masks and faces, reinforced by the angles of the fence and buildings.

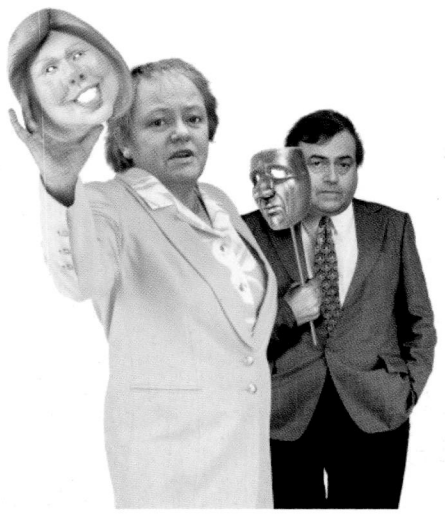

6 By placing Prescott's body behind Mowlam's, I got around the fact that his hand didn't join his arm. Moving Mowlam's eyes creates reader engagement; erasing her left arm made the two bodies fit together better.

CASE STUDY

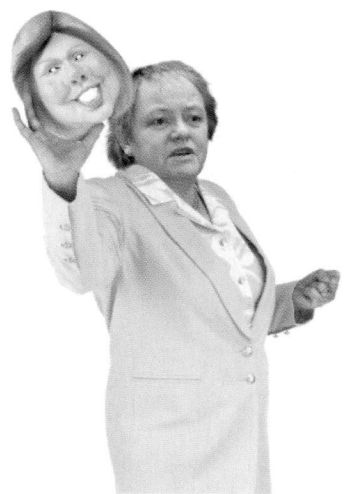

3 Masking Mowlam's neck made the head fit the body perfectly. A new hand was needed to hold the mask – a mock-glamor mask chosen to neatly counterpoint Mowlam's evident lack of glamor.

4 Because Mowlam's body is so animated, I wanted a more passive pose for Prescott to counter it. This casual shirt was all wrong, as was the fact that he didn't have a spare hand; but these were problems that could be sorted out later.

5 Prescott's new shirt was pasted inside the shirt area on the original jacket. The hand was slotted into a section of sleeve made by copying an existing sleeve portion. (The less said about the elbow problem, the better.)

HOT TIP

Fitting heads onto bodies is more than just a question of finding two images taken from the same angle: you need to match the colors and shading of the two so that they blend together well. To find out more about how to do this, see Chapter 6, Heads and Bodies.

7 The image of the Houses of Parliament affirms that these figures are politicians. I took this photograph ensuring that the railings in the foreground would frame whatever I put in front of them.

8 The new sky adds interest to the original overcast image. Two more 'politicians' have been added on the right; placing them behind the railings puts them firmly in the scene, as we'll see on the following pages.

Back to the foreground

1 When the farmer is pasted on top of the background, he looks like he doesn't belong there. Well, he doesn't – this patch of grass is really waste ground in the middle of a road junction. To make the scene work more convincingly, we need to make the farmer become part of the background rather than simply standing in front of it as he does at the moment.

PLACING PEOPLE within a scene is rarely a matter of sticking them on top – because they rarely look like they belong there. To make the image more convincing, the people need to interact with the background to some degree. The easiest way to do this is to take a background element and bring it to the front: it's often a simple task, but it makes all the difference, as we'll see with this illustration of an urban farmer swamped by his modern-day environment.

4 With the pitchfork now in front of the fence, which in turn is in front of the farmer, he looks fully integrated into the scene. A shadow of the pitchfork is painted on the fence, and another shadow created beneath the farmer; finally, small wisps are masked around his feet to make it look like blades of grass are growing up in front of them.

2 The fence is made up of straight lines, so it's a simple matter to select the front half of it using the Pen tool, make a new layer and bring it to the front. If you really can't get on with the Pen tool, use the Lasso instead – hold down ⌥ *alt* to constrain the tool to creating straight lines between pairs of click points (see p 6). Now, the farmer is far more integrated.

3 This is a simple trick: I just selected the bottom half of his pitchfork, made a new layer out of it using ⌘ *J* *ctrl* *J* and brought it to the front.

HOT TIP

The final step requires that the background be selectively blurred – more at the back, less at the front. Go into QuickMask mode and, using the Gradient tool set to black–white, drag from top to bottom. This creates an area that's 100% selected at the top and 0% selected at the bottom: when you exit QuickMask and apply the blur, the image will be affected more at the top than at the bottom.

5 The background in the original image is busy, as befits an urban road system - but so busy that it's distracting attention. So the top half of the background was selected and blurred using Gaussian Blur, to knock it slightly out of focus. To make the fence section fit, the left edge of that layer was also blurred to blend into the background.

SHORTCUTS
MAC **WIN** **BOTH**

Playing with perspective

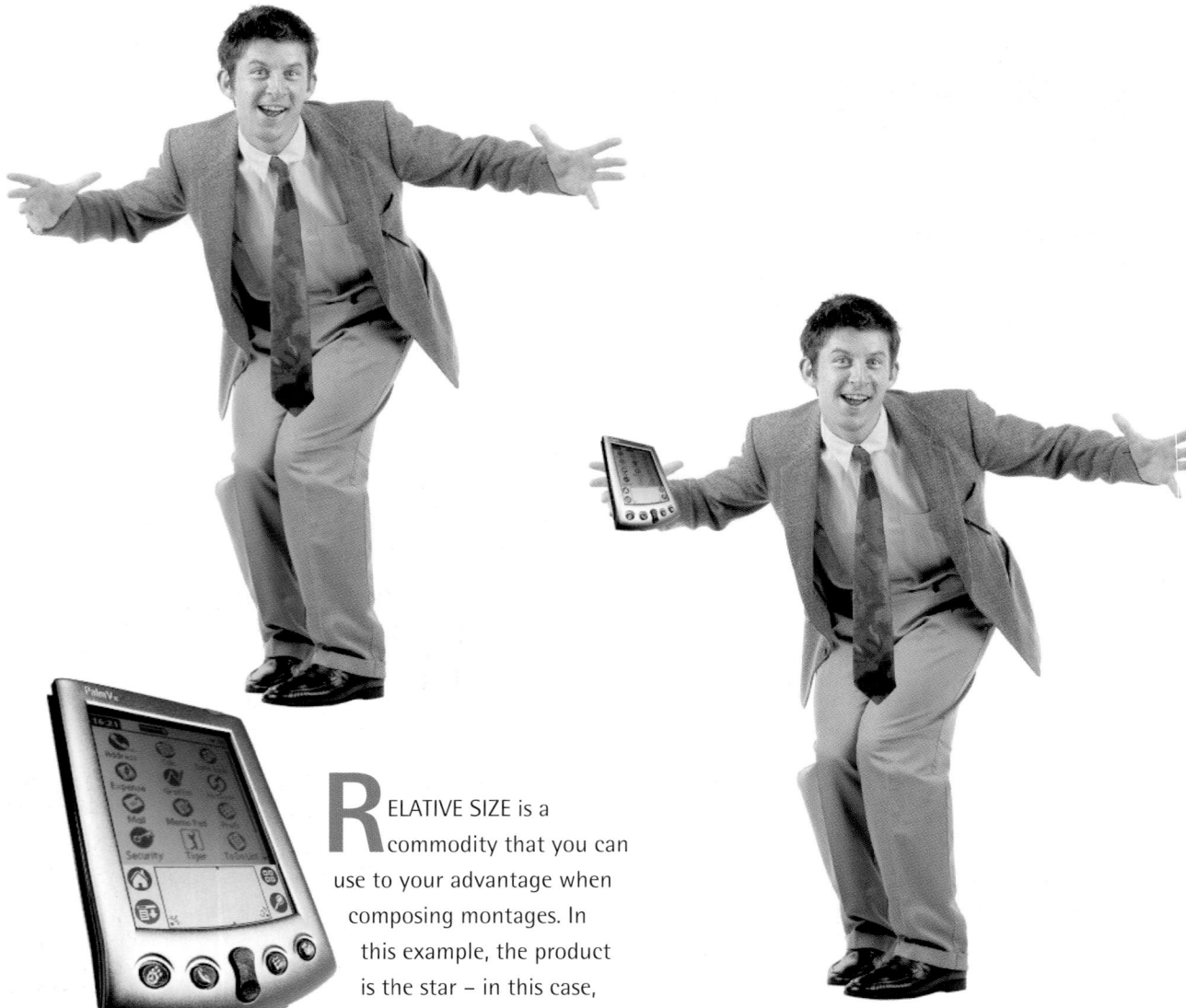

RELATIVE SIZE is a commodity that you can use to your advantage when composing montages. In this example, the product is the star – in this case, it's the PDA that needs to be the prominent object in the final composition. The background figure of the man holding the device is there to provide visual interest: adding him into the mix prevents the final illustration from looking like a mere product shot. As is so often the case, it's the human element that draws the reader into the picture.

1 Simply placing the PDA in the man's hand accomplishes the task to a degree, but the tiny size of the device when included at actual size makes it too insignificant; it's barely visible in the mix.

It might be possible to create this image using just a hand, rather than the whole person. But when working with cutout objects, which always enliven a layout, it's important to ensure that the whole image is shown. Cutting off an arm at the wrist, or fading it away to white, is a poor solution: cut-off elements destroy the cutout's power, and are always a poor compromise.

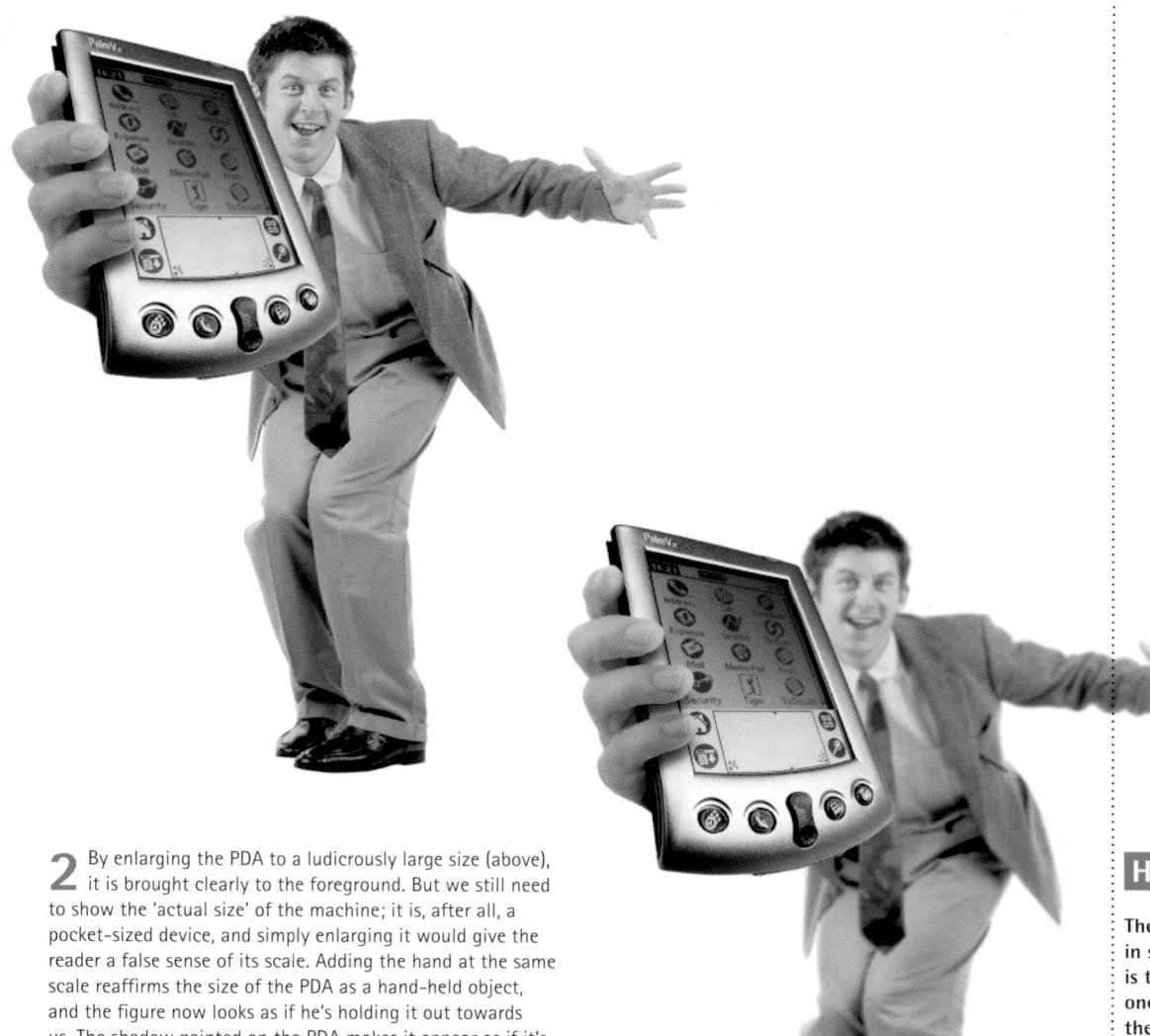

2 By enlarging the PDA to a ludicrously large size (above), it is brought clearly to the foreground. But we still need to show the 'actual size' of the machine; it is, after all, a pocket-sized device, and simply enlarging it would give the reader a false sense of its scale. Adding the hand at the same scale reaffirms the size of the PDA as a hand-held object, and the figure now looks as if he's holding it out towards us. The shadow painted on the PDA makes it appear as if it's being held by the hand.

3 If this composition were a single photograph, an accomplished photographer might be able to devise a means by which both the foreground object and the man in the background were both in focus – although, given the extreme difference in the apparent nearness of the two elements, it would be a daunting task.

For the purposes of convincing montage, we can take the opposite approach: adding a small degree of Gaussian Blur to the background figure (right) accentuates the sense of perspective, and forces the reader's attention onto the PDA. Blurred images are hard to focus on, by definition; adding a degree of blur allows us to direct the reader to the areas of the image we want to highlight.

HOT TIP

The hand used in step 3 here is the same one I used on the daughter's shoulder in the section Relative Values, earlier in this chapter. The hands in original photographs are rarely in the right position for a convincing montage: with a digital camera, it's easy to build up a library of suitable hand poses.

An object lesson

WHEN WORKING with images from a range of sources, the trick is to make them all look as if they belong in the same space. This montage, commissioned by .net magazine, was to accompany an article about online auctions – dealing with the value of the stuff you might find lying around in your attic.

All the elements were photographed separately (the originals are shown along the bottom of this page), and needed to be combined in a convincing manner.

Relative sizes are important in a montage such as this, which needed to look as realistic as possible.

1 The perspective on the mug didn't match that of the rest of the artwork. The solution was simple: an elliptical selection was made of the top of the mug, which was then stretched vertically until it looked right.

2 The toy car wasn't included in the original photographs – but a three-dimensional object was needed to round off the top of the video stack and to bring the height closer to that of the Action Man.

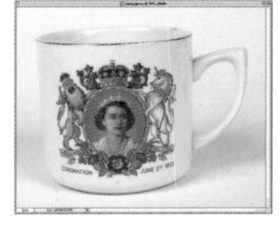

4 Because the illustration was going right across a double page spread, I had to be careful to ensure that none of the important elements were divided by the gutter (the gap between the pages). The blank space above the monkey was left for the headline.

5 The monkey's fur was cut out using the Background Eraser tool, which did a good job of removing all the white background while preserving the detail.

6 The soldier was originally facing left to right, as if he was running off the spread. But by flipping him horizontally he was made to face into the illustration rather than out of it, drawing the reader's eye back into the page.

7 Before the shadows were added, the montage looked flat and inauthentic. As ever, it's the use of light and shade that makes a montage come to life.

Painting shadows directly on the objects would have caused problems if I needed to move them later. Instead, I created a new shadow layer and, for each object, loaded the object's outline as a selection by ⌘ *ctrl* clicking on the object's name in the Layers palette, and then removed the outline of any objects on top of it by ⌥ ⌘ *alt ctrl* clicking on their names. That way, all the shadows could be created on a single, editable layer.

3 The records, comics and stickerbook were all photographed directly from above. By distorting each image using Free Transform, it was possible to arrange them so that they appeared to be lying on the surface.

CASE STUDY

SHORTCUTS
MAC WIN BOTH

Montage in three dimensions

1 Three photographs of chairs provide the perspective view I want (the chair on the left has been duplicated and distorted slightly). It's now just a matter of arranging the chairs so that they look convincing in their position.

CREATING A THREE-DIMENSIONAL scene from scratch means paying close attention to perspective; often, it involves working from given objects and making the rest of the scene match that perspective.

This illustration for the Independent on Sunday was for an article about backbiting gossip in the parliamentary tea room of the House of Commons. The trouble was, the newspaper held no photographs of the tea room; but eye-witness reports described the wood paneling, the type of wallpaper and the green leather color scheme.

The photographs of the chairs came from the Hemera photo library, which frequently includes shots of the same object from several different angles. These provided the base perspective; the walls, floor and other elements were drawn to match it.

4 The wood panels are duplicated, flipped horizontally and darkened slightly – these will be beneath the window, so will have less light on them. We've now built the corner of our room, and the remaining elements can be added.

7 Populating the scene is simply a matter of sticking the relevant politicians' heads onto bodies that could sit and stand in the correct way. The seated figures have been masked where they overlap the chairs, so it looks as if they're sitting in them.

2 A scan of a piece of wood is shaded to give the impression of paneling, and then duplicated to make a row of wooden panels. It looks wholly artificial seen in isolation, but makes more sense when included in the main scene.

3 The row of paneling is placed behind all the chairs, and distorted using Free Transform to follow the perspective of the backs of the chairs. Since two chairs were placed right against the wall, it's fairly easy to match their perspective with some accuracy,

5 A scan of a small section of wallpaper is duplicated, colored to match the green/gold color scheme and distorted to fit the perspective set by the panels. The carpet is drawn by filling a green rectangle with Gaussian Noise; the skirting, dado and picture rails are shaded wooden strips.

6 The door and window have been distorted, again using Free Transform, to match the set perspective. The view outside the window is a photograph of the House of Commons itself – fortunately the building is built around a courtyard, which makes sense of the view!

HOT TIP

This kind of perspective distortion requires the verticals to remain truly vertical. To do this, hold ⌘ *ctrl* as you drag a corner handle to distort just that handle, adding *Shift* to constrain the movement to just the vertical. For more on perspective distortion, see Chapter 10, The Third Dimension.

8 The props – the glasses, teacups, table and monitor showing the debating chamber – help to make sense of the scene as a whole. The monitor also gives John Major, seen on his phone at the back, a reason for turning his head to the side.

9 The final task is to add shadows to make the objects sit more comfortably in the space. A shadow layer is placed above the floor, walls and paneling to add general shading; additional shadow layers grouped with the chairs help to make the politicians sit down.

People and cars

1 Our original photograph of this car was shot in an ordinary street, some of which can still be glimpsed through the windows. The first job was to cut out the background, leaving just the car. (The number plate has, of course, been changed to protect the car's owner.)

4 Now for the driver. Let's have him talking on his cellphone, for the simple reason that it's illegal. Choose a photograph that suits the perspective of the car, and remember that in England we drive on the left.

7 Now for the windscreen. Make sure the car body is at the top of the layer stack, and make a selection with the Lasso tool that includes all the window area. Make a new layer, behind the car, and paint the glass with diagonal white strokes using a soft-edged brush set to a low opacity.

PLACING PEOPLE IN CARS SHOULD BE A relatively straightforward task. But cars always have windscreens, which reflect light and muddy the issue. To make the job work effectively takes some care, involving several steps which are outlined here.

The illustration above was for a feature in the Daily Telegraph newspaper about the draconian contracts car hire companies impose on their customers. The idea of the contract as a bumpy road, causing damage to the car, was easy to come up with; the execution was slightly harder. The road itself was drawn using the 3D Extrude functionality of Adobe Illustrator CS, which was able to map the dummy text onto a bumpy surface made from extruding a wavy line. It's the kind of job that would have been much harder without Illustrator; and if I'd been asked to do it two weeks earlier I wouldn't have had the latest version. Roll on upgrades!

2 Now we need to remove the windscreen. Shown in red is the area highlighted: note that we've left the windscreen wipers in place, as they belong in front of the glass. Tracing around them is fiddly, so I've already done this for you on the version that appears on the CD.

3 Cut that windscreen to a new layer using ⌘ Shift J ctrl Shift J, then erase the windows on the side and the back of the car. We also need to darken the car interior, since it was photographed through reflecting glass - but we're going to add our own glass later.

5 A new steering wheel needs to be drawn in front of the driver, and to make it look convincing we'll stick in a hand holding it. It's the same hand I've used a dozen times in this book, and it can be made to suit most purposes.

6 At this point, we should add a background to see how the final composition will look. Again, it's critical to the success of the project to find one that matches perspective of the car.

HOT TIP

When you cut the interior of the car from the body, as in steps 2 and 3, you may find a fine white line around the car's interior edge. One solution is to use the Defringe command (Layer menu) to remove it; alternatively, apply a fine stroke to the inside of the car to get rid of it.

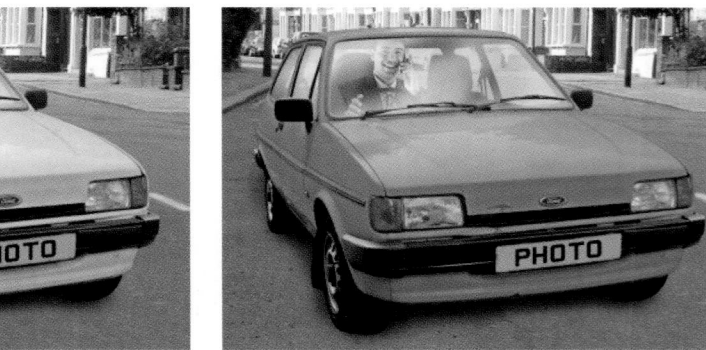

8 The rear windows also need some treatment. With the same area selected, make another layer behind all the car elements and this time paint with a light gray: these windows will appear darker since they reflect some of the inside of the car. A shadow beneath the car also helps.

9 Coloring the car is all a matter of selection. The easiest way is to make a new layer, grouped with the car, and set to either Hard Light or Multiply. Fill this with the color of your choice, and erase those parts that shouldn't be colored, such as the lights, bumper and wheels.

SHORTCUTS
MAC WIN BOTH

Digital cameras

A DIGITAL CAMERA is an essential tool for the Photoshop artist. They've gone from being interesting toys to must-have tools in the space of a few years, and every year or so a new model appears that redefines the field. Having reviewed many cameras for MacUser, I've found myself frequently having to buy the latest model since, after playing with it for a couple of weeks, I've been unable to send it back. I'm now on my fifth camera, and each one has been a significant improvement on the one it replaced.

There are several issues to consider when buying a camera. Image quality is of major importance, and a lot depends on the quality of the lens. Equipment from traditional camera manufacturers such as Kodak, Nikon and Canon tends to be better than that from the electronics giants, simply because they have more experience in making good lenses.

One factor which determines image quality is the amount of compression used to fit the images into the camera's memory. Images are compressed using the JPEG format: the smaller the size the image is squeezed into, the poorer the quality. This 'lossiness', as it's known, manifests itself in a certain blockiness to the pixels seen in large areas of flat color, and in stray pixels of the wrong color, known as artifacts. Better cameras will allow you to choose the level of compression as well as the size of the image; some allow you to save images as uncompressed TIFF files, which take up a lot of memory (around five times the best JPEG quality) but will result in the cleanest image.

The chief consideration when buying a camera is the size of the images it captures, measured in pixels. For comparison, cameras are sold according to their image size in millions of pixels, or megapixels for short. A typical mid-range camera will deliver images of around 3.3 megapixels, which equates to a Photoshop image measuring 2048 x 1536 pixels (proportions are always in the ratio of 4:3, matching the aspect ratio of most computer monitors). In practical terms, this means that you can use the images up to a size of around 10 x 7.5 inches if used at 200 dpi, or around 6.8 x 5 inches if used at the best resolution

of 300 dpi. Which, in rough terms, means that you can use the image in print at around half magazine page size at top quality, or nearly full page size if you're not so fussy. The newer mid-range cameras now boast a resolution of 5 megapixels, with a corresponding increase in the size an image can be printed.

In general, the digital artist won't be capturing images to be used at anything like this size. I use my camera to photograph the sort of things I don't have on royalty-free CDs: bathroom sinks, telephone boxes, swivel chairs and all the other objects which are easy to locate but hard to find pictures of. Most importantly, I use my camera to photograph myself: in my montages I've been the torso of both George W Bush and Al Gore, the body of Prince Philip, and the hands of celebrities from Mick Jagger to Albert Einstein.

Which brings me to my final requirement: an LCD viewing screen that can swivel so it faces in the same direction as the lens. This is a feature not found on all cameras, probably because it's a somewhat esoteric requirement: but when I'm standing with my arms raised in anger wearing a black bow tie while wielding an Oscar, I need to see what's going on before the timer counts down to take the picture. It's for this reason that I've tended to choose cameras from the Nikon Coolpix range, which combine the swivel feature with excellent image quality. The Coolpix 5000, shown here, is my current camera; retailing at around $1000, it has a resolution of 5 megapixels and takes top-quality pictures.

One final suggestion: always carry your camera with you when you go out. You never know when you'll stumble across a rare object, a good texture or an unusual building – or even the back of an interesting head.

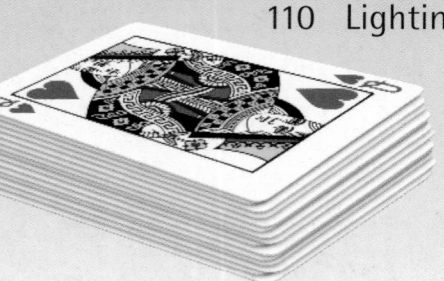

5

Light and shade

SHADOWS ARE THE KEY to placing people and objects within the scene. Without shadows, images can look dull and unconvincing; even the hint of a shadow can make a montage come to life. First, we'll look at some of the ways of creating and using shadows to your advantage.

Light is another matter. Whether it's the beam from a table lamp or the glow around a candle, or the suggestion of sunlight across a scene, visible light can add interest and mystery to a montage. It's easier to create than you might think, although such elements as the flame of a candle can take a little effort to get right.

We'll also look at how to make a neon sign that looks like the real thing, and how to simulate an image on a screen.

Shadows on the ground

1 Duplicate the figure layer, lock the transparency (using the checkbox on the Layers palette, or the shortcut ⧄) and fill the layer with black – use ⌥ Delete alt Delete to fill with the foreground color.

GROUND SHADOWS are among the easiest types of shadow to create in Photoshop. To make them convincing, you'll need to put in a small amount of extra effort: here, we'll look at how to graduate the blurring effect so that the shadow appears to lie in a true perspective plane as it fades away from the viewer, rather than just darkening the background.

Creating shadows directly from existing objects is always easier than trying to paint them to match. They're also more convincing, as they correspond precisely to the object or person being shadowed.

5 The shadow needs to be more blurred at the back to look convincing. But simply blurring the whole shadow, as shown here, makes it far too indistinct at the front, and the man looks like he's floating.

2 Now uncheck the Lock Transparency box (or use ⊘ again) and then use Free Transform to distort the shadow so that it lies along the ground.

3 The bottom of the shadow, where it meets the object, almost certainly won't conform to it – so just use the Eraser and the Brush tool to paint it where it should go.

4 The shadow will need some softening so it doesn't look too harsh. Use Gaussian Blur to add a small degree of blurring: here, a radius of 2 pixels has been applied.

6 The solution is to go into QuickMask mode (press ⓠ) and then use the Gradient tool to drag from the top of the shadow (not the top of the image) to the bottom. This will create a graduated selection.

7 Now, when you exit QuickMask (use ⓠ again), the shadow will be fully selected at the top, and not selected at the bottom. Apply a Gaussian Blur again (8 pixels used here) to see the graduated blurring effect.

8 To make the shadow fade away, make a layer mask for the shadow layer and use the Gradient tool once again, dragging from top to bottom. The higher you start, the more opaque the top of the shadow will be.

HOT TIP

If you're using a layer mask to selectively fade the shadow, as detailed in the final step here, you could spend hours with the Gradient tool trying to get the fade just right. But there's an easier way: after the first application of the tool, you can use Brightness and Contrast on the layer mask to change its balance and opacity – and it will work without changing the underlying layer.

SHORTCUTS
MAC WIN BOTH

93

Shadows on the wall

1 To create the shadow, duplicate the layer and fill it with black in the same manner as shown on the previous page.

S HADOWS ON WALLS are also easy to create – but you have to think about the relationship between the figure and the surface the shadow is cast upon. The closer the shadow is to the figure, the closer the figure will appear to be to the wall.

Under normal lighting conditions, the shadow will be placed slightly below the figure to give the impression of natural daylight illumination. But raised shadows can have a different effect: the immediate impression is to make the figure look more sinister, as if lit from below (which is why the baddies in horror movies often carry candles just below their faces).

The illustration above was commissioned by the newspaper Sunday Business to illustrate how world leaders were shuffling money around the globe via the International Monetary Fund. Placing the shadows on the wall above them heightened the sense of their power, as well as reinforcing the light source – the illuminated map around which they're gathered. Of course, a real illuminated table would never cast shadows as crisp as this one, but it's the overall impression that's more important to the image than optical accuracy.

5 When the shadow is enlarged, the light source looks closer to the figure: when it's raised up, the light source is low down, making the figure look more sinister.

2 Because the surface is flat, an even blur can be applied to the whole shadow. Reducing the transparency of the layer allows the wall to show through behind it.

3 Moving the shadow closer to the figure positions him closer to the wall: here, he's standing with his shoulder almost leaning against the surface.

4 Darkening the wall itself helps to make the shadow look real. A simple black-to-transparent gradient created on a new layer makes the wall look more convincing.

HOT TIP

Create shadows on their own layer, filling them with solid black. Then reduce the transparency of the whole layer until you get the effect you want. This is far more reliable than filling the layer with a low opacity first, as it's easier to change when the illustration is complete.

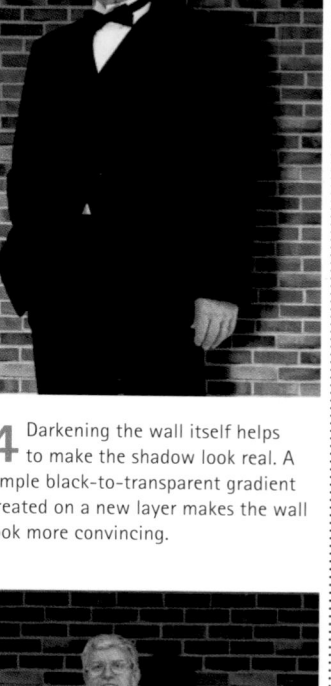

6 With a light source this close, we need some shading on the figure itself. This shadow is simply painted on a new layer, which is grouped with the figure layer so it only intersects it.

7 When the background shows the ground as well as a wall, we need to combine both shadow techniques detailed so far: the shadow must run along the ground, then up the wall.

8 Easily done: the shadow is offset, then the bottom (where it overlaps the wall) is distorted to join the feet. Some extra painting and erasing is needed to complete the effect.

Mood, light and emphasis

1 The road image was taken from a stock library shot. Although the original road wound over a hill, I chopped it off short to make it come to a sudden end.

2 The end of the road was easily fragmented by making jagged selections with the Lasso tool, and deleting. I used a Layer Mask so I could undo it if I needed to.

THIS ILLUSTRATION, commissioned by The Independent on Sunday newspaper, was to accompany a story on the lack of funding for building new roads. Drawing 'the end of the road' could have resulted in a dull image; but by adding a visible light source – through setting the scene at dusk – we're able to bring drama to the image.

6 The Stop and No Entry signs were easier to draw than to source. Again, a little shading using Dodge and Burn makes them look that much more realistic.

7 The indentations around the bases of poles were made by making elliptical selections of the road surface into a new layer, and applying Bevel and Emboss layer effects.

CASE STUDY

HOT TIP

Lens Flare can be a difficult filter to position accurately. The trick is to make a new layer, filled with black, and apply the filter to that. Set the new layer's mode to Screen, and all the black will disappear, leaving the flare alone. Now you'll be able to position it where you like within the montage.

3 The broken road end was given depth, and the suggestion of the concrete reinforcement, using the techniques described in Chapter 11 – Smashing Things Up.

4 The two side walls were originally stretches of pavement, elongated and then curved using the Shear filter to make them fit the perspective of the road.

5 The poles and barriers came from the Hemera Photo-Objects collection. After positioning them, shading was added to make them look less new and less uniform.

8 Once a suitable sky was found (and I tried several), the only change to the main image was to darken the retaining wall on the sun's side, to put it into shadow.

9 Shadows, as ever, are the key to making montages look alive. The only constraint here was to make sure they all pointed towards the sun, the obvious light source.

10 The final step was to add a Lens Flare on top of the sun, to make it burst over the retaining wall. The Lens Flare filter is easy to overuse, but applied with subtlety it works well.

Multiple shadowed objects

1 This photograph of a playing card has been distorted using Free Transform to make it appear as if it's lying on a horizontal surface.

THROUGHOUT THIS CHAPTER I've recommended always creating shadows on a separate layer. But there are times when a shadow should be part of the layer to which it belongs, as in the example shown here.

It would have been possible to create this stack of cards using a separate layer for each card, and then simply flattening all the layers at the end. But since a pack like this could include up to 52 layers (54 if you include jokers), we'd be talking about a document that's unnecessarily unwieldy for the effect we're trying to create. This way, we can draw an entire pack of cards in a single layer.

The technique used to get rid of the overhanging shadows in steps 9 to 11 is a little tricky. Here's how it works: when we go into QuickMask mode, the solid cards are shown as solid red; the partly transparent shadows are a paler pink. Using the Levels control, we can work on the mask as if it were a normal layer. So we adjust the mask so that the pale pink disappears, leaving just the solid red – the fully selected area. When we then exit QuickMask, our selection will be constrained to just the area that was fully opaque initially, so inversing and deleting the rest will get rid of the unwanted shadows.

4 Select the card pixels again. Then use `alt` `ctrl` `D` to feather the selection: with the Marquee tool selected, nudge the selection area down a couple of pixels, set the foreground color to black, and use Fill (Edit menu) to fill *behind* at an opacity of 50%.

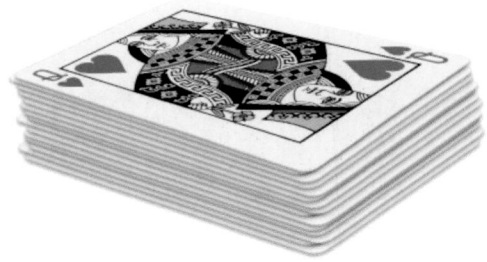

7 Any number of cards can be stacked up in this way: as long as you keep the `alt` key held down, you'll keep moving copies. Don't make the offsets too regular!

10 Now we can 'tighten up' that shadow using the Levels control. Drag the white arrow slider to the right, and the partly selected (lighter red) area will vanish.

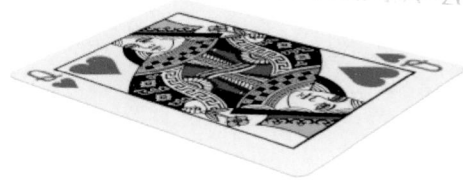

2 The first step is to give some depth to the card. Begin by 'loading up' the pixels in its layer – hold ⌘ *ctrl* and click on the name in the Layers palette.

3 Now hold ⌥ *alt* and nudge the card up a couple of pixels: then inverse the selection using *Shift* ⌘ *I* *Shift* *ctrl* *I* and darken up the edge you've just created.

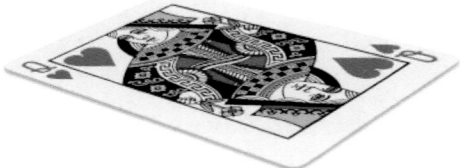

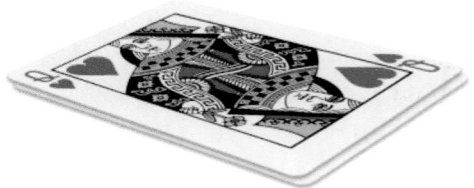

5 This creates a soft shadow beneath the card – but on the same layer as the card. Make a duplicate of this layer to work on, as we'll need the original later.

6 Now Select All using ⌘ *A* *ctrl* *A*. Holding down the ⌥ *alt* key with the Move tool selected, move the card to create a copy on top – and the shadow moves with it.

8 But there's a problem here: if we zoom in, we can see that there are shadows beneath the overhang of the cards where there's nothing for them to sit on.

9 To get rid of the excess shadows, select the card layers by ⌘ *ctrl* clicking on the layer name, and go into QuickMask mode by pressing **Q**.

The nudge keys will behave differently depending on which tool is currently active. If the Move tool is selected, as in step 3, the selected pixels within the layer will be moved: if another selection tool (the Marquee or Lasso, for instance) is active, the selection area will move but not the pixels themselves. You can always hold ⌘ *ctrl* to access the Move tool temporarily while a selection or painting tool is active.

11 All we need to do now is to exit QuickMask and inverse the selection, then press Delete: those extraneous shadows will simply disappear.

12 The last step is to bring back that original card that we duplicated, so we return the shadow beneath the bottom card in the stack.

Concealing the evidence

1 The original board game was redrawn in Adobe Illustrator, substituting appropriate room names for the original drawing room, library, and so on. Redrawing the board also allowed me to condense it so that the whole board fitted into a smaller space.

WHILE ALL THE ELEMENTS OF A photomontage need to be visible, simply arranging the objects within the scene is only the first step. To make the image both realistic and appealing, it's important to add the element of shadow.

This illustration for The Guardian was to accompany a story about the candidates for the top job at the British Broadcasting Corporation. The political in-fighting led to the requirement for a reproduction of a well-known murder solving board game, in which the protagonists were represented as suspects in the crime. In the original game, the props were murder implements – a candlestick, a gun, and so on. To make the image more appealing, I replaced these with TV-related paraphernalia. But without the shadows, this illustration would have appeared very flat indeed.

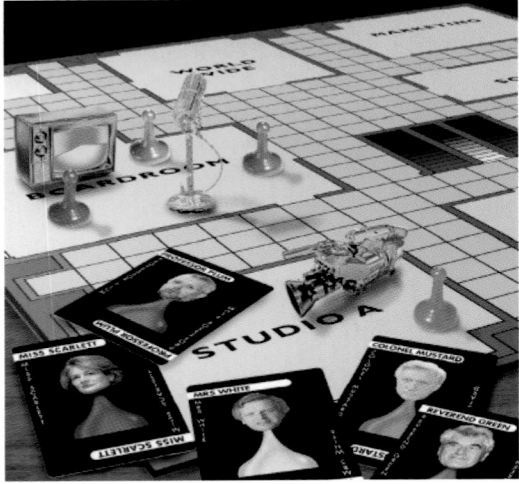

4 The shadows cast by the cards and objects were painted onto a new layer with a soft brush. By using a pressure-sensitive graphics tablet, I was able to achieve the effect of smooth shading: I set the opacity of the brush quite low, and then built up each shadow in the place where it would be cast in real life.

CASE STUDY

HOT TIP

2 The board was distorted using the Free Transform controls. An edge was drawn in to prevent the board looking too two-dimensional; the wooden table and black top were added on new layers.

3 The first suspect card was created in multiple layers, which were grouped into a layer set: this set was then duplicated to create each new card, and the resulting cards were arranged in the foreground in perspective. The TV elements are from a royalty-free collection, made shiny using the techniques described in Chapter 7. Compositionally, the image was now complete; but the whole looks very flat and unconvincing.

Painting a shadow directly onto a layer is an irrevocable step. So while it would have been possible simply to use the Burn tool to paint the object shadows in step 3, it would have made it impossible to move any of the objects afterwards. Always keep shading to a separate layer wherever possible, to keep your options open.

5 The far end of the board is visually less important, since all the main elements are clustered towards the front. Using the Gradient tool, again on a new layer, it was easy to draw a simple shadow fading from black to transparent. This shadow was also useful for the newspaper's art editor, as it gave him a clear space in which to place the headline.

6 The final step was to add 'mood lighting', in the form of bars of shadow that gave the impression of the board being lit through a barred window. Radiating lines were drawn as a selection using the Lasso tool, then feathered (a 20 pixel feather, in this instance) and, on a new layer, filled with black. Reducing the opacity of the whole layer allowed the detail to remain visible.

Visible light sources

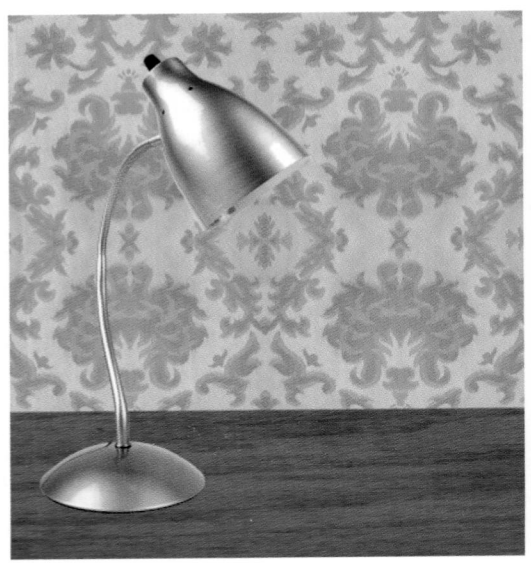

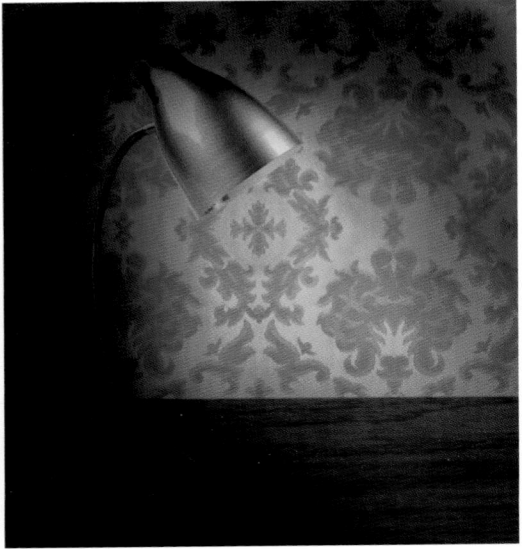

1 Begin by adding a shadow to the scene. This is simply painted on a new layer, using a large soft-edged brush. Setting the brush to a low opacity allows us to paint the shadow on in small stages, being careful to leave an unshaded area where the light will eventually be cast.

S O FAR THIS CHAPTER has dealt with shadows cast by far-off light sources. When the light itself is in the frame, we obviously need to show it. In this workthrough, we're straying into the realms of hyper-realism: by deliberately over-emphasizing the visible light, the montage becomes more appealing than if we simply tried to reproduce reality. In real life, a light source wouldn't cast a visible beam unless the room were full of smoke; but then real life is often far duller than fiction.

Shadows are still important, for two reasons: first, because they add life to the image; and second, because a dark background will make the light itself stand out better. Here, we'll take the simple montage shown above and add both lighting and shadow to make it into a far more entertaining image.

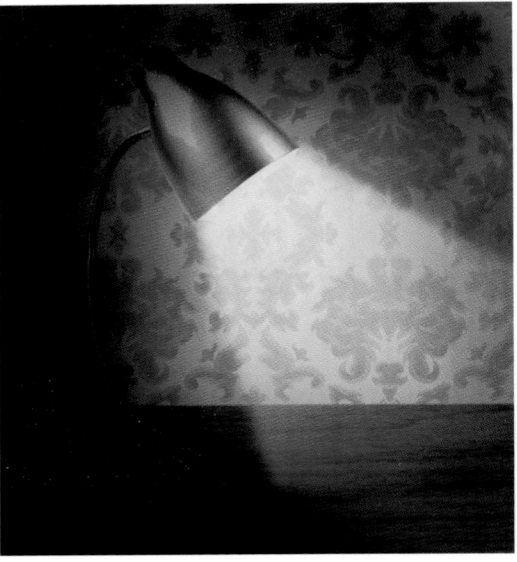

4 Now exit QuickMask and, on a new layer, pick a pale yellow color (about 20% Yellow should do the trick) and then use the Gradient tool, set to Foreground to Transparent. Drag it from within the shade perpendicular to the shade edge, away from the lamp.

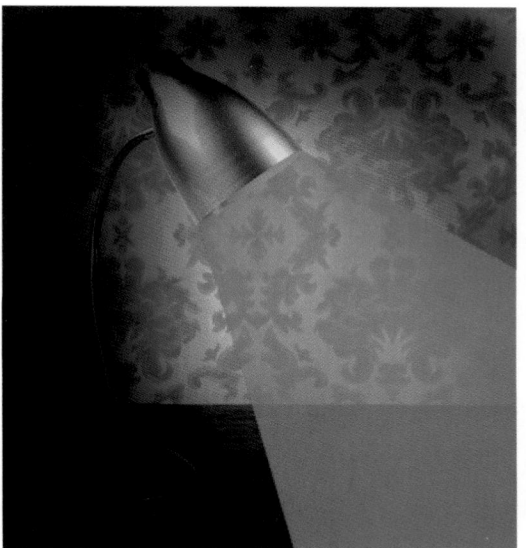

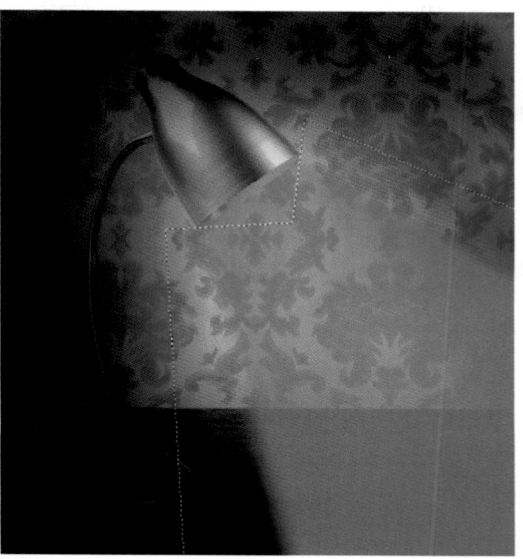

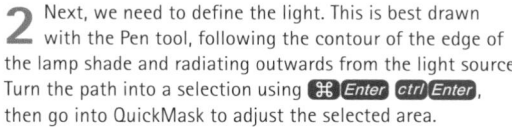

2 Next, we need to define the light. This is best drawn with the Pen tool, following the contour of the edge of the lamp shade and radiating outwards from the light source. Turn the path into a selection using ⌘ Enter ctrl Enter, then go into QuickMask to adjust the selected area.

3 In QuickMask, trace around the edges of the light area with the Lasso tool, omitting the edge around the shade. Then use Gaussian Blur to soften the edge – here, an 8-pixel radius blur was applied. Because the edge by the lamp shade was not selected, that part remains crisp and unblurred.

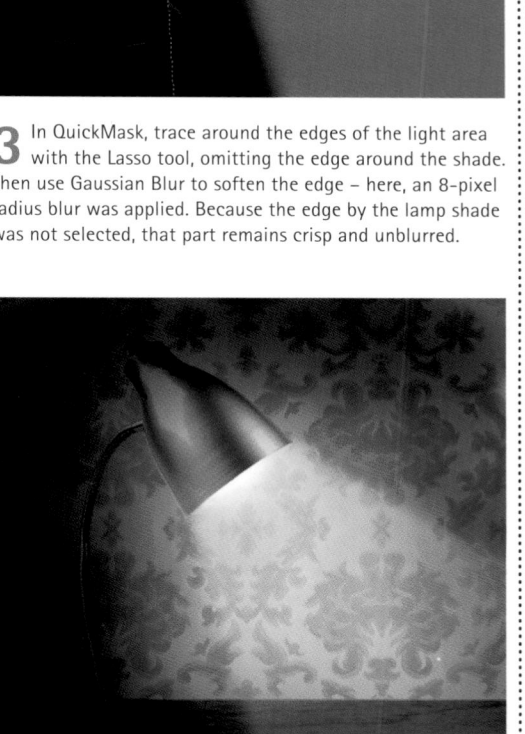

5 We now need an extra glow around the bulb itself. With the light area still selected, use a soft-edged brush to paint a spot of white at the focal point. Don't use a hard-edged brush: although bulbs are solid, you can't look at them when lit without seeing a haze around them.

6 Now we need to show the light acting upon the table surface. Using the Elliptical Marquee tool, draw an ellipse on the table. Feather the selection (an 8-pixel radius was used here), and delete that area from the shadow to return the table to its previous brightness.

103

The romance of candlelight

C ANDLES ARE UNIQUE light sources in that the light they cast is fully visible: you can stare straight at a candle without hurting your eyes. Because they shed so little light around them your eyes remain accustomed to the darkened environment, so when you do gaze at a candle's flame, you see a hazy glow around it.

Unlike metal lamp shades, candles are translucent objects. The light travels down through the candle and exits through the side, as well as radiating from the flame.

It would have been possible to begin this workthrough with a photograph of a candle. But I thought it would be more fun (and possibly more instructive) to draw our candle from scratch.

1 I drew this candle by drawing an elliptical marquee for the base, then duplicating it to create the top. I flattened the top ellipse to create a sense of perspective: the greater the difference between the two, the nearer the viewer is to the scene.

2 To join the two ellipses together, a rectangular selection was made between the half-way lines on each ellipse, and simply filled with the same color.

6 Before we create the flame, we need a background in order to see it. The shadows were added to this table and wall with a soft brush, leaving a fairly blank area where the flame would eventually appear.

7 For the shading on the candle itself, a new layer was created on top with its mode set to Multiply. This is because I used dark brown rather than black to shade it, which matches the candle color better.

3 The shading on the candle was added using the Burn tool set to Midtones: if it had been set to Highlights, it would have created a grayish shadow. The Dodge tool provided the highlight.

4 The dripping wax was drawn as a path with the Pen tool and then filled with yellow, although it would be possible to draw it directly with a hard-edged brush if you really can't get on with Bézier curves.

5 The shading on the drips was added using the Plastic Wrap filter – see Chapter 7, Shiny Surfaces, for more about this technique. The wick was simply drawn with the Brush, set to Dissolve to make a ragged outline.

8 The flame outline was drawn with the Pen tool, then the selection was feathered (a 4-pixel radius here) and filled with a mid orange hue.

9 With the Lock Transparency box checked, the white parts of the flame were painted on with a soft brush. In addition, a tiny blue patch was painted at the base of the flame for added realism.

10 Finally, a new layer was created behind the flame, and a glow added by painting a spot of yellow using a large, soft-edged brush set to a low opacity.

HOT TIP

The Plastic Wrap technique used for creating the drips of wax produced a grayish result that looked out of place. By locking the layer's transparency and using a brush set to Color mode, I was able to sample a color from the candle and paint that over the gray to return it to its true waxen hue.

Shading with Dodge and Burn

PAINTING ON A SEPARATE LAYER is a good technique when adding shadows to walls, floors and many other kinds of inanimate objects, but the technique works badly when you're working with skintones: black shadows, even applied at a low opacity, can easily just turn to gray.

When working on the image of Mick Jagger above for the Sunday Times Magazine, I knew the direction the lighting was coming from – and it wouldn't change. If the positions of elements in a montage are known, then there's nothing to be lost by using the Dodge and Burn tools to add light and shade directly onto the image. But Dodge and Burn have three operating modes – Highlights, Midtones and Shadows; they each affect the image in different ways.

To be safe, work on a copy of the original layer: that way, if things go wrong, you can always get back to where you started.

1 This girl has been photographed with even, direct lighting that's perfect for the photomontage artist: it's far better to start with flat lighting and add shading where you want it, than to have to make the whole illustration conform to one original.

5 The Dodge tool, set to Midtones, brightens up the other side of the face without destroying the original coloring. This is far more convincing for subtle tones, such as skin, than setting the tool's mode to Highlights.

2 Using the Burn tool to darken the side of the face, set to Highlights, results in a grayish tinge that's unappealing and unconvincing: it darkens the image, but also has a muting effect on the original skintones.

3 The Dodge tool, also set to Highlights, has a rather different effect: it brightens up the image, but leaves a drastic impression on the colors. Those soft pinks and browns have turned to a vivid jaundiced yellow.

4 When set to Midtones, the Burn tool no longer loses color as it darkens the skin. Rather, the opposite is true: the shaded area quickly becomes strongly over-saturated as the shading is piled on.

6 Set to Shadows, both tools have an unfortunate effect on skin. The Dodge tool makes the shadows look like they've been doused in talcum powder, while the Burn tool turns the subject into a vision of the red death. Neither effect is what we want here.

7 The best technique is to use a combination of the two. Using a low opacity, use the tools set to Midtones first to retain the color; then switch to Highlights to paint the deep shadows in place. So far, so good; but the finished impression is rather over-enthusiastic, and needs toning down.

8 Lower the opacity of the painted-on layer, to allow the original to show through to some degree (you did work on a copy of the original layer, didn't you?). You can also use a layer mask to selectively hide portions of the shaded layer that now appear too strong.

HOT TIP

To avoid having to reach for the toolbox to switch between Dodge and Burn, there's a useful keyboard shortcut. When either of the tools is selected, holding down ⌥ ctrl will temporarily select the other tool. I've mentioned this tip elsewhere in this book, and will continue to do so every time the Dodge and Burn tools crop up: it's an essential shortcut.

SHORTCUTS
MAC WIN BOTH

Light and shade

Shading with light modes

SHADING USING THE THREE LIGHT MODES – Hard Light, Soft Light and Overlay – can have a far more cinematic effect than shading using the Dodge and Burn tools. But if Dodge and Burn are Nosferatu, then Hard Light is more Saturday Night Fever: shadows can take on a strong hue of their own. There are, of course, more than three light modes, especially in Photoshop 7; here are the main ones.

Rather than painting directly onto the layer, create a new layer and set it to Hard Light mode. You then have the option of filling the layer with 50% gray: this makes a good background when applying the shading to multiple layers. By filling your selection area with 50% gray and then locking the transparency, you can be sure that the light you paint will only be applied within the area where you want it.

If you must paint directly onto the layer, you can set the brush mode to Hard Light (or any of the other Light modes) to get the same results.

1 Be careful to use reasonably muted colors when painting shadows, or the effect will be too bright and unrealistic. This light blue is too bright for use either as shading or as a light reflection: it merely swamps the image with its color.

4 Now for the spotlight effect. Too bright a shade would have the unfortunate results shown in step 1 above; a muted brown gives us a color that lets the original skin texture show through, while adding a good amount of extra color to it.

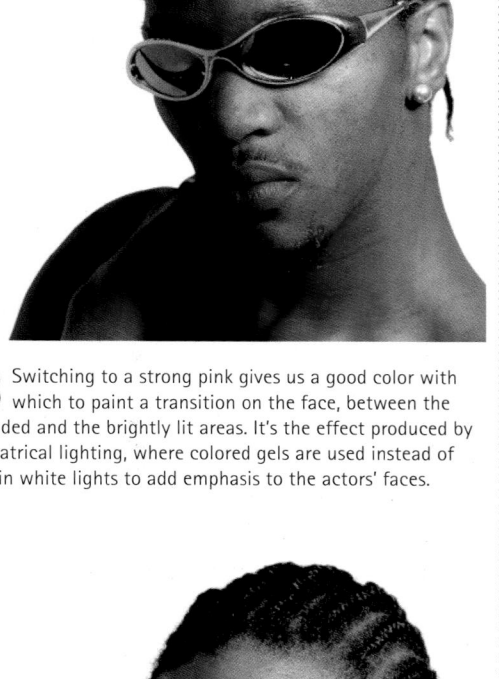

2 Using a darker blue allows us to paint a shadow that's far more moody and evocative. This is the kind of shading that's often seen in films, where day-for-night shooting produces shadows that have a strong blue cast to them.

3 Switching to a strong pink gives us a good color with which to paint a transition on the face, between the shaded and the brightly lit areas. It's the effect produced by theatrical lighting, where colored gels are used instead of plain white lights to add emphasis to the actors' faces.

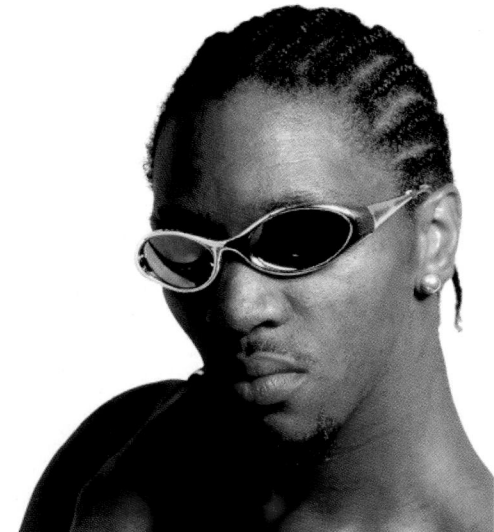

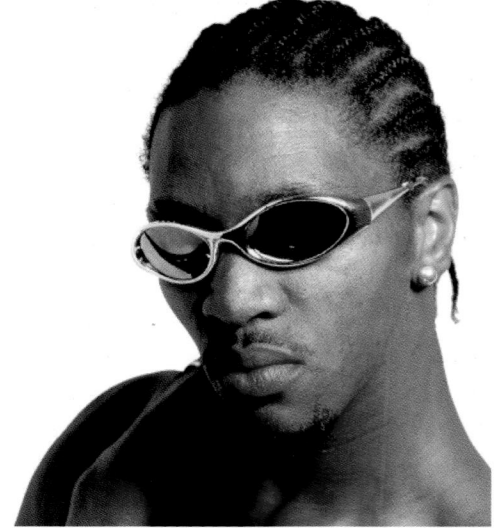

5 Here's the same effect set to Overlay mode instead. This is rather softer: the colors still have their effect on the image, but obscure the shading and texture of the original to a lesser degree.

6 More muted still is Soft Light mode, which produces an altogether subtler result. The three modes are variants of each other, and can be used in combination on different layers to build up the overall lighting effect.

HOT TIP

If you're using multiple colors when painting with Hard Light, as we are here, it's easy to apply the wrong color by accident – there's some trial and error involved in choosing shades that work. To prevent the possibility of losing a good effect, you can work on multiple Hard Light layers so that the effect is produced by the combination of all of them.

Lighting up: perfect neon

1 To begin with, create a new white layer beneath the basic lettering, and then merge the two. Then apply a Gaussian Blur until the hard corners are smoothed away. The actual amount will vary with the size and font chosen; I've used a blur radius of 4 pixels.

3 Select the pixels in the text layer using the Magic Wand tool and then, on a new layer, create a stroke outline using the Edit/Stroke menu. Don't use Layer Effects to make the stroke, or you won't be able to edit the outlines afterwards.

NEON LETTERING is one of those effects you can knock up in a few moments: simply create the outlines and add a glow to them. But to do it properly takes rather more time and patience.

The simplest way to create the smooth outlines for the lettering is to use the Round Corners feature in a program such as Illustrator. But since we're trying to work entirely in Photoshop, the technique described here – that of blurring and applying Levels – works just as well, and has the advantage that no additional software is required.

6 Now's a good time to add a background, with shadows as appropriate. I've also changed the color of the bottom row of text for the sake of interest, using Hue/Saturation. The next step is to make the outline look like tubing: this is achieved by darkening it with the Burn tool (set to Midtones) at the points where it's been strongly bent.

2 Now we can apply the Levels control to tighten up that blur. Open Levels and drag the small white and the small black triangles towards the center, and all the blurred area will turn to either pure white or pure black (see the screen grab, shown above right). If the whole group, including the

gray triangle, is dragged to the left the outlines will thicken up; dragged to the right, they'll thin out. Note that this effect only works when the text has been merged into a white layer: if the text had simply been blurred on its own, the Levels control would have had no effect.

4 Now hide the original text layer, and erase portions of the stroke to simulate the way neon lettering is constructed in the real world. Since all the lettering is made from a single bent glass tube, it needs to break within each letter where it turns to join the next letter.

5 To create the inner glow, select the layer's pixels by holding ⌘ *ctrl* and clicking on the name in the Layers palette. Use Edit/Select/Contract to reduce the selection size by, say, 3 pixels; then apply a 3-pixel Gaussian Blur to it. Now turn on the Lock Transparency checkbox, and fill the selected area with white.

7 The glow is created on a new layer, behind the tubing layer. First load up the pixels as outlined in step 5, then hold *Shift* ⌥ *Shift* *alt* as you enclose it with the Marquee tool to limit the selection to just the top word. Feather the selection (8 pixels used here), and fill with the same color as the tubing; then repeat with the bottom line of text.

8 The last step is to add the details. The wires are drawn on a new layer, shaded and shadowed using the technique shown in Chapter 10. One clip, which holds the lettering to the wall, was created on a separate layer; this clip was then copied around each letter in turn, rotated as appropriate so it appeared to grip the neon tubing.

111

Images on screens

1 This Palm Pilot is our starting point for the montage. The problem is that it was photographed with a screen full of icons: if we're to show just the text we want to display, we'll need to redraw the screen.

2 The first step is to outline the screen using the Pen tool or, if you have a steady hand, the Lasso tool (hold ⌥ *alt* as you go to make straight lines between click points). Make a new layer, and fill with a color sampled from the screen – in this case, I've used a color from the bottom right.

PLACING IMAGES ON TV or computer screens is no difficult matter: in the example above, the screen was curved slightly using the Shear filter and then distorted to fit the shape of the monitor.

When there's already an image on the screen, as in the Palm example on these pages, the problem becomes altogether trickier. Because we want to retain the screen furniture – the title bar and the scroll bar down the right hand side – we need to match the shading of the existing screen as much as possible. Here's how it's done.

MEMO

Remember to take Palm on holiday

6 To make the new screen blend with the old one, add a little Gaussian Noise: here, just 1% noise makes the difference between a screen that looks artificial and one that blends with the PDA. I've also used the Dodge tool, set to Midtones at a low opacity, to blend the top in more effectively. (If this tool is set to Highlights, you'll end up changing the colors of the screen as well as the shading.)

7 Now for our text. Type the text very small, with anti-aliasing turned off so that the result is the kind of jagged edges we associate with low resolution screens. The text here has been enlarged to show the effect. The smaller the text sized used, the stronger the jagged effect will be.

3 Now switch to the Gradient tool, set to Foreground to Transparent. Sample a color from the top right of the screen and drag that towards the center (making sure Preserve Transparency is checked).

4 Getting there - but the shading on the screen still doesn't quite match that of the original. Sample a shade from the left of the screen (you may need to hide the new layer first), and use the Gradient tool once again to drag this color in from the left.

5 Now for some fine-tuning. Using a large, soft brush set to a low opacity, sample some colors from the perimeter where the match is incorrect and dab the new colors in place.

8 Now rasterize the text (choose Rasterize Type from the Layer menu) so that it can be distorted freely. Use Free Transform (⌘ Shift T ctrl Shift T) to enlarge the text, and distort it by holding ⌘ ctrl as you drag each corner to make it match the perspective of the original screen.

9 Nearly there. The black text looked artificially strong; the trick is to sample a 'black' area of the original screen (such as the menu block top left) and fill the text with this color. Remember to check the Lock Transparency box on the Layers palette first, or you'll end up flooding the whole window with the new color.

10 As a final step, we can reproduce the effect of the thickness of the glass. Duplicate the text layer, send it behind the original and lower its opacity to 20% for a faint shadow.

HOT TIP

A good trick for making images on TV screens more convincing is to add a pattern of fine horizontal white lines over the top, distorted to match the perspective of the monitor and reduced to a very low opacity. This reproduces the effect of old black-and-white televisions: even though color TVs don't use the line system in the same way, it's a visual code that signals to the reader that the image is on a screen.

SHORTCUTS
MAC WIN BOTH

113

Sourcing images

DIGITAL CAMERAS have provided Photoshop artists with the single most useful tool since Photoshop itself. They're now of a quality that makes them an essential accessory, and are available at a price that puts them within reach of almost everyone. The ability to capture an object and get it into Photoshop in seconds is unparalleled.

But there are some objects that aren't readily available to be photographed. Such items as space shuttles, polar bears and plates of roast turkey are notoriously hard to lay your hands on in a hurry. Fortunately, there's a solution: there's a huge amount of readily available imagery out there in the form of royalty-free photographic collections.

The images tend to be available in two ways: either as single images downloaded directly from websites, which will cost around $120 an image (but will be available immediately), or on collections of between 100 and 200 images on CD-ROM, costing an average of $400. The latter route obviously offers better value for money, but you have to plan your purchase well in advance of your 5pm deadline.

The quality of royalty-free images is almost uniformly high, but the type of material on offer is generally more suited to the designer than to the photomontage artist. You'll find dozens of CDs of stressed businessmen in high-tech offices, glamorous couples on tropical beaches and maps of the world cast in gleaming chrome – but these are all finished artwork, offering little scope for customizing. There are far fewer collections of cutout people and objects that can be used to form the basis of an original photomontage.

Among the best sets of images on CD are those from Stockbyte and PhotoDisc. The PhotoDisc images tend to feature glossy models who look like they've just walked out of a hairspray commercial, with the exception of one or two discs – their In Character CD, for example, is a collection of 100 people in a variety of costumes from medieval wizards to lion tamers. It's a CD I've used dozens of times, and it's saved me from having to clutter up my wardrobe with

leopardskin thongs, deerstalkers and clown costumes. While it's easy enough to wear a suit and stand in front of a camera, exotic costumes are harder to find.

Stockbyte, on the other hand, produce a range of a dozen CDs in their Busy People series that feature everyday people in a huge variety of poses. The people here are often old, ugly and badly dressed – in other words, just the sort of people you see on the streets. I've used images from the Busy People collection throughout this book. Two other CD-ROMs worth mentioning are Faces 2 from Rubber Ball, which contains 100 images of everyday people, and Bodyshots from Digital Wisdom, which includes over 300 images of businessmen and women in a variety of poses. This collection is one of the few to include a large number of people photographed from the side - although the lack of clipping paths (it's a very old collection) makes it harder to use.

Finding images of rare or even everyday objects used to be one of the hardest tasks of all. Stockbyte and PhotoDisc both produce CDs of office equipment, household items and more; but the range of possible objects is vast, and 100 images per CD can barely hope to supply everything we need. Canadian publisher Hemera publishes three sets of images in the Hemera Photo-Objects 50,000 collections. The lightning-fast visual search engine produces results even before you've finished typing the name of the object you're looking for, and it's a fair bet that almost any object you need will be found among the hundred thousand on offer. Even more astonishingly, each 50,000 strong volume is available for under $100. There is a downside: the images are of uniformly low resolution, supplied up to a maximum of 1200 x 1200 pixels. But when used as small elements in a larger montage, there's no better starter kit.

Hemera has also launched AbleStock (www.ablestock.com), an excellent subscription-based website offering an enormous range of high resolution, cutout objects and people allowing unlimited downloads for an annual fee. You'll find a selection of both AbleStock and Photo-Objects images on the CD that accompanies this book.

6 Heads and bodies

PHOTOMONTAGE ARTISTS are frequently asked to put one person's head on another person's body. In this chapter, we'll look at how to make heads and bodies join seamlessly together. Eye contact, as we discussed in Chapter 4, is crucial to making characters relate to one another. So here's a technique for changing the direction your subject is looking in.

Hair has always been a problem in montage creation. We can't always work with Telly Savalas or Yul Brynner; those flyaway strands always seem to get in the way. In this chapter we'll look at how to ease the pain of cutting hair from its background.

6 Heads and bodies
Making the head fit

1 Begin by cutting out the head, using the Pen tool to create a clean Bézier path. To make the montage work, it's important to make it the same size and orientation as the head on the target body: it helps to place the two side by side, so the new head can be adjusted to fit.

PUBLICITY PHOTOGRAPHS of celebrities and politicians tend to be either highly staged or snatched papparazzi images. Taking the head from one body and placing it on another, as in the illustration of Tony Blair above for The Guardian newspaper, is an essential skill.

When the body you want to use already has a suit and tie, it's a relatively easy job to graft the new head in place – all you need to to do is make sure the head matches any exposed skin on the original body. Overleaf, we'll see how to work with more difficult bodies, such as those which aren't wearing clothes.

4 Next, we need to make a layer mask for the new head. Using a small, soft-edged brush, paint out a smooth line beneath the chin so that the head and neck blend seamlessly together. For more on layer masks, see Chapter 2, Hiding and Showing.

2 The next step is to match the skintones of the body we're pasting this head onto. There are several ways of changing colors - you can use Curves, Color Balance, Levels, and so on. Here, we'll use the Hue/Saturation dialog to make the adjustments we need.

3 Because all fair skins fall within a similar tonal range, only small color adjustments need to be made. Beware of making too large a Lightness change, or the image will quickly start to look washed-out: use Curves instead if you have to change brightness by a significant amount.

5 A soft-edged brush is perfect for blending skintones together, but in the last step the side of the new man's chin above his hand disappears into the neck. To bring it back, switch to a hard brush and use white to paint the mask back in at that point, giving his chin a hard edge.

6 Now we need to hide those parts of the original head that showed through behind the new one. Using a layer mask is the best way to achieve this, as we can always paint back areas we want to keep later. If you feel confident, you can always simply delete the head instead.

HOT TIP

When matching bodies to heads, try to choose combinations that have been photographed from as similar an angle as possible. While you can place just about any head on just about any body, the more extreme differences of view will make the montage less plausible.

119

Matching skintones

1 The somewhat startled look on this bodybuilder's head may imply some prescience that he's about to be decapitated. But we can't let ethical considerations get in the way of a good montage: out with the muscleman, in with the politician.

3 Bush's neck is blended into the body using a layer mask once again. Take care to remove enough of the neck so that no join is visible: remember that when using a brush in the layer mask, you can use the **X** key to switch foreground and background colors, and so paint back areas you've painted out.

WHEN THERE'S NO SUIT to hide behind, matching skintones means making the lighting match as well. With no collar to tuck the neck into, it's more important than ever to make sure the colors and tones blend together seamlessly. Here, we'll give George W Bush a shiny new body.

5 Because the original image was lit directly from the front, with no side shading visible, it's easier to remove the shadow on Bush's head than to try to add shadows to the complex musculature of the body. But using the Dodge tool set to Highlights produces this garish, over-saturated effect.

2 Once again, we begin by matching the size of the new head to that of the old. This time, however, we want to make Bush's head slightly larger than the original, so he doesn't end up looking too much like a pinhead.

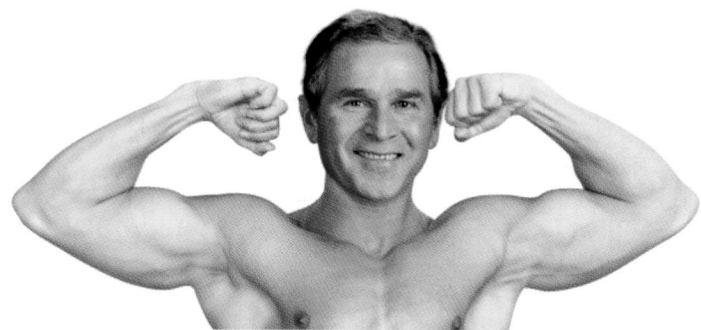

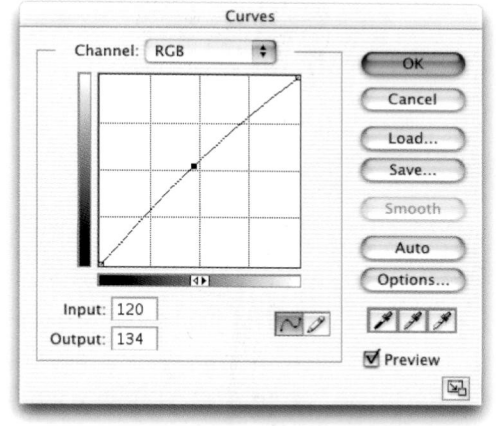

4 The color of Bush's face matches that of the body pretty well: all we really need to do is to brighten it up slightly. Open the Curves dialog, click a point midway along the diagonal line, and drag it vertically upward by a small amount to make the change.

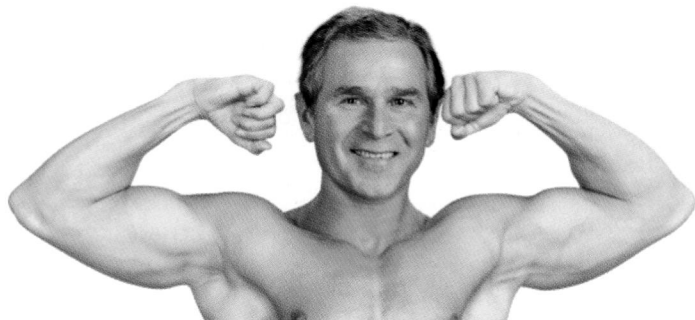

6 Instead, change the mode of the Dodge tool to Midtones by holding *ctrl* *Shift* *Shift* right click and selecting Midtones from the pop-up menu. Stick to a low opacity and paint slowly – you can set the opacity by pressing the number keys, using 1 for 10%, 4 for 40% and so on, up to 0 for 100%.

HOT TIP

If you delete the head from the body before adding the new head, be sure to leave enough neck to graft the new head onto: to be safe, only delete from the mouth line upwards.

SHORTCUTS
MAC WIN BOTH

121

Matching picture graininess

1 The original photograph of Bill Clinton clearly shows the grain in the image. We need to match that to make the montage work successfully.

2 Once again, Bush's head is scaled to the right size to fit this body. His expression is perfect for the new pose.

WHEN ONE PRESIDENT replaces another, why go to all the trouble of getting the photographers in for a special photo session? Photoshop, after all, can do the job just as well in far less time.

This body may suit George W Bush, but there are other concerns here. The original picture was very grainy, and when we zoom in we can see that grain more clearly. As I'll grudgingly admit, I've enhanced the grain using Unsharp Mask to show the problem better – but you don't always expect the truth when politicians are involved.

6 We're lucky here in that there's a large, flat area of the image that we can use to sample the grain: it's the expanse of gray around the seal on the front of the podium. Make a rectangular selection into a new layer.

7 The piece of grain was still too small – but we can't stretch it, or the grain will be the wrong size. Tile it by duplicating the selection and flipping it horizontally, then duplicating the result and flipping it vertically.

3 Bush's head is corrected for color using the Curves dialog, and a layer mask is used to blend the two images. We still need to get rid of the remnants of the previous president.

4 Hide Bush and make a new layer to paint the patch into. Set the Clone tool to sample All Layers, and clone out the parts of Clinton that were visible behind Bush's head.

5 With Bush firmly in place, the glaring discrepancies between the grainy original and the sharp portrait are even more obvious. Time to fix that grain.

8 After grouping the new grain with Bush's head, knock all the color out using the Desaturate command ⌘ *U* *ctrl* *U*. Then brighten it up using Curves so that the overall shade is roughly 50% black.

9 When the mode of this layer is set to Hard Light (chosen from the pop-up menu at the top of the Layers palette), we can see through it to the head beneath: the midtones vanish, leaving just shadows and highlights.

10 Because the effect was a little strong, it needs to be toned down by reducing the opacity of the layer. The amount you choose depends on the individual image: here, I've reduced it to 50% opacity.

Combining body parts

C OMPLEX MONTAGES FREQUENTLY require several bodies to be combined to produce the finished character. The brief for this illustration, for the Sunday Telegraph newspaper, was to show a wheeler-dealer displaying his financial wares in an open jacket. Choosing a right hand that gestured towards the goods on offer gave me something to do with his right hand – and made his pose more dynamic. Below are all the bodies used.

This gesticulating figure will give us the right hand, arm and jacket.

Here's the shirt and tie – but this man's head is far too dull.

A strong perspective shot, but his head will make our figure more dynamic.

All we want from this exuberant figure is the open jacket on the right.

1 The arm and jacket were cut off the first figure and rotated to fit onto the man with the shirt. Because the color of the two skintones was so different, it was necessary to make the hand darker and more saturated – but without changing the jacket color, which matched the 'other half' of the open jacket.

2 The open jacket was copied from the third figure, and distorted and stretched to make it fall open even more. The lining was duplicated using the Clone tool to fill the space: the result was imperfect and rather patchy, but it wouldn't matter as most of the texture would end up being covered by the symbols.

3 The shirt on the second figure was painted out on a layer mask to remove the stray section of arm on the left, and the head. The arm was made to slot into the sleeve hole by painting it out on the mask, which turned out to be a rather easier job than I'd expected. Sometimes things do just work out right first time! The head was simply placed on top and blended with a layer mask, and then desaturated to match the hand.

4 As always, it's the shading that makes all the difference. Shadows, painted on a new layer above the shirt layer help to make it sit beneath the closed side of the jacket; further shadows make the arm disappear inside the sleeve. The hand holding the open jacket is my standard gripping hand, which you've seen before in this book. The company logos were placed on gold-effect backgrounds behind the shirt shadow, so the shadow worked on them as well.

HOT TIP

The hardest part about choosing pieces from multiple bodies is not matching the skintones, but the clothing. I had a perfect open jacket which would have been far easier to use, but it had a herringbone pattern on it that I couldn't match. Plain colors, with as little texture as possible, can be most easily combined. By cropping the figure at the waist, I could get round the problem of the non-matching trousers (sorry, I can't bring myself to call them pants).

The perfect haircut

CUTTING OUT HAIR has always been a tricky task for the Photoshop user. Several third-party plug-ins, such as Extensis Mask Pro and Corel Knockout, have attempted to make the job easier; Knockout comes closer than most, although it still isn't an easy tool to use.

The introduction of the Background Eraser tool in Photoshop made the complex removal of backgrounds easier than it had ever been before. It's a tool that works best with hair and other loose objects photographed against a plain, preferably white background; even then, it can be a fiddly activity, and its success depends in large part upon the kind of background the image will eventually have. Users who find the prospect daunting should skip to the next section, where I'll explain how to cheat with hair.

1 This stock image has been photographed against a plain, near-white background. It's the ideal candidate for cutting the hair using the Background Eraser tool.

4 Start working your way around the head. The crosshairs in the center of the tool pick up the color that will be erased; everything within the circle radius is removed.

9 With all the background erased, you'll probably be left with a figure whose hair has a definite bright tinge to it. It was, after all, photographed against white.

2 First cut out the image loosely, leaving a margin around the hair. I find it useful to make a new layer filled with a solid color, so you can see more clearly what's being erased.

5 Sometimes, the tool will erase areas you wanted to keep – such as the highlights within the shoulder at the right of this figure. That's where Protect Foreground Color comes in.

10 If you're going to end up with your figure on a light or complex background, this may be sufficient: you won't notice that the edges are brighter than the middle.

Brush size: Don't use too large a brush, or you'll erase white areas such as the eyes and teeth.

Limits: Set to Discontiguous to erase background areas surrounded by hair.

Tolerance: Set too low, the brush won't erase the background; too high and you'll lose too much hair.

Protect Foreground Color: Use this to sample skin tones as you work around the head.

Sampling: Stick to Once when working with a plain background, Continuous if the background is varied.

3 Access the Background Eraser tool by choosing it from the pop-up menu that appears when you hold the mouse button down on the Eraser tool in the toolbar. There are several parameters that need to be considered. We'll use the Discontiguous setting, which allows the tool to erase background areas that are totally enclosed by other colors; and we'll set the sampling to Once, since the background is a single flat color. The Tolerance depends on the contrast between the hair and the background: experiment to get the best setting.

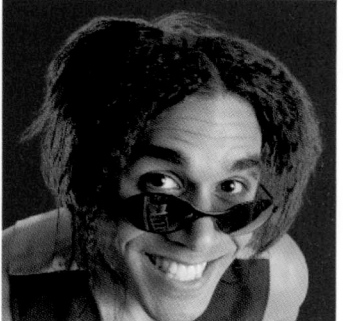

HOT TIP

Using the Clone tool to copy hair texture from one area to another is a fiddly job, because you need to make sure the strands of hair you're copying from lie in the same orientation as those you're copying to. For some tasks, it may be simpler to copy locks of hair to a new layer, group them with the base layer and twist them to make the hair fall the right way.

6 Hold down ⌥ alt and click on the shoulder color: it will become the foreground color, and will not be erased. You'll need to keep resampling as you work round the head.

7 Sometimes, even protecting a foreground color can't stop some bright areas from being erased – such as the highlights around the eyebrow seen here.

8 The solution is to use the History palette. Choose the History brush, and click next to the step immediately before: you can now paint the erased areas back in again.

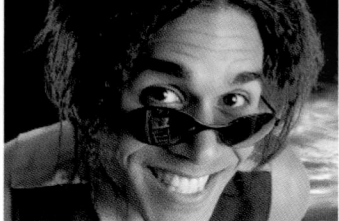
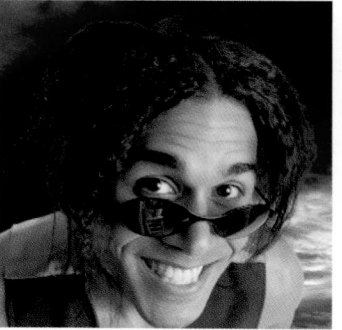

11 If your background is dark, however, the bright hair fringe will look awkward and out of place. There are two ways of solving this, depending on your patience.

12 The easiest way is simply to use the Burn tool set to Highlights, and darken the edges of the hair. With luck, no-one will notice that it doesn't really look like hair.

13 To do the job properly, use the Clone tool. Check the Lock Transparency box and work your way around, cloning hair texture from within the hair to cover the edges.

SHORTCUTS
MAC WIN BOTH

127

The solution for flyaway hair

1 Start by creating a smooth cutout of the hair, being careful not to include any of the background. If you use images from royalty-free libraries or CD collections, you'll find that in most cases the clipping path will cut just inside the hair edge, making them perfect for this technique.

THIS COVER FOR THE SUNDAY TIMES magazine was a surprisingly complex montage – the owl and background were two separate layers, and no less than four images were comped together to make Harry Potter. His original hair was cut out using the techniques shown on the previous pages; but to make it more windswept, I added stray strands using the Smudge tool, as shown here.

The Smudge tool is by far the quickest way of creating a soft hair effect. On the following pages, we'll look at an even faster way of applying this tool: here, though, are the basics of hair smudging.

4 So far, so good: but the hair strands all have the same length. For a more natural feel, increase the opacity of the brush and pull out one or two hairs at random to a greater length. It really helps to use a pressure-sensitive graphics tablet for this job!

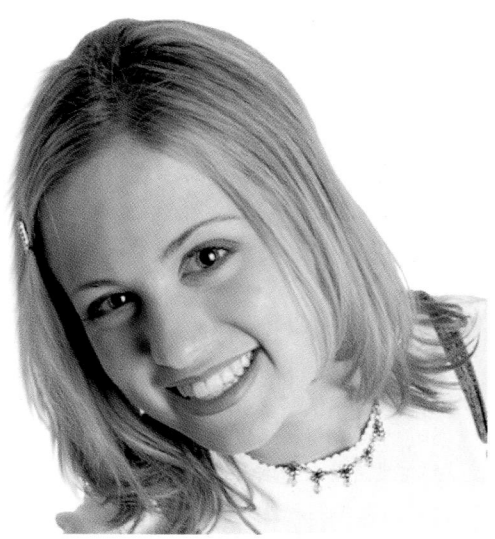

2 Use the Smudge tool, set to a small brush size, with an opacity of around 70%. Begin at the crown and work down one side of the head, smudging from the hair outwards, tweaking out individual strands as you go.

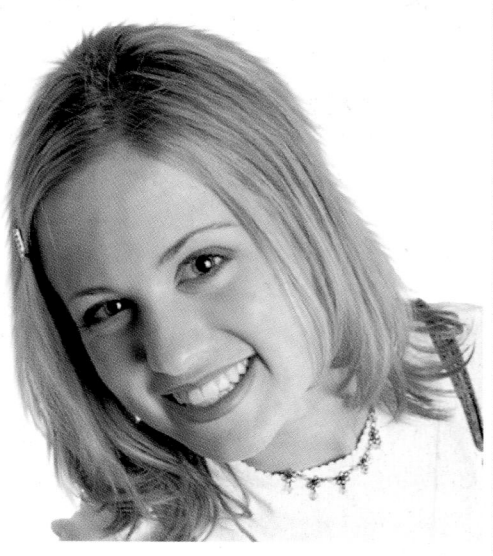

3 Now go back to the crown and work the other way, making sure you follow the direction of the hair as you brush. It helps to have a few hairs sticking straight out of the crown, where there's a transition between the hair growing in different directions.

Work slowly, starting from the top and progressing down both sides of the figure. If you work upwards, you'll find your Smudge strokes will distort hairs you've already drawn, resulting in unnatural kinks and whirls. If the hair you draw looks too wild, it's easy to smooth the edges by erasing them with a soft-edged eraser.

Master Diameter 24 px

Use Sample Size

1	3	5	9	13	19
5	9	13	17	21	27
35	45	65	100	200	300
14	24	27	39	46	59

Spatter 24 pixels

5 When viewed against a white background, hair treated in this way will always tend to look a little fabricated. But when placed against any texture or image, it will blend in perfectly: the translucence of the hair strands will pick up any background it's positioned on.

6 Tweaking out strands one hair at a time can take forever, particularly when working with fuzzy hair or animals. A good alternative is to use a small Spatter brush, which comes as a default in the Photoshop brush set. With this brush tip, you can brush several strands at a time.

The problem of hair loss

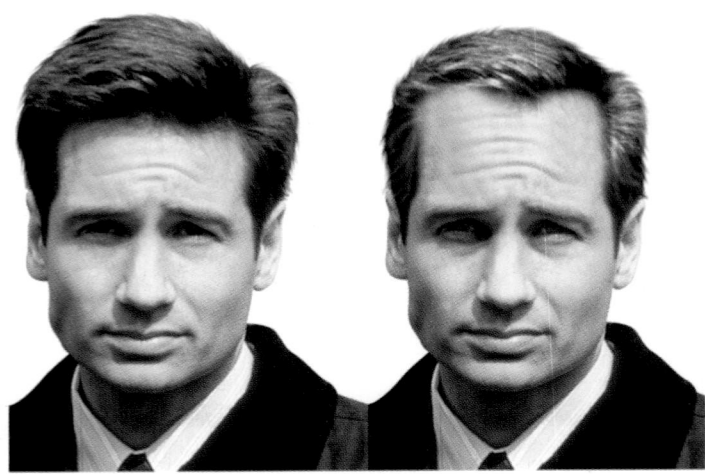

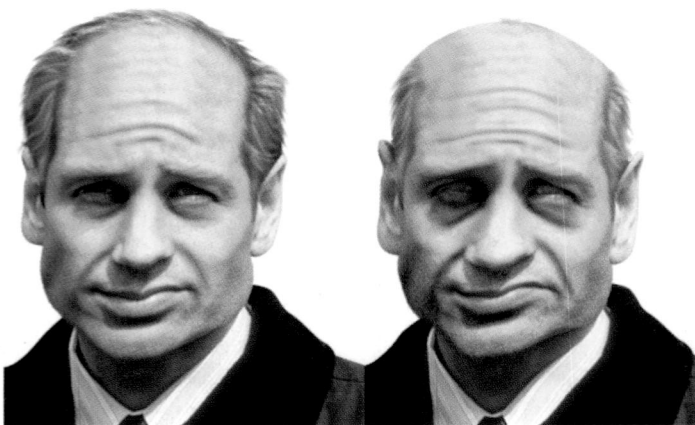

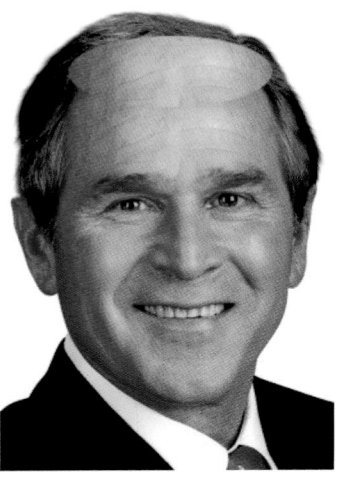

1 Begin by making an elliptical selection from whatever forehead is visible. Make the selection as large as you can without going into the hair line, then turn it into a new layer using ⌘ J ctrl J and place it roughly in position.

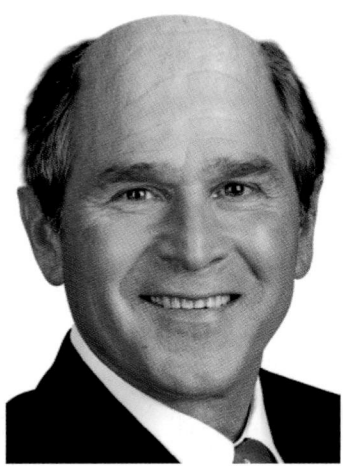

5 Next, we can turn that smoothed-out hair into more realistic strands using the Smudge tool, as described on the previous pages. The difference here is that rather than smudging the hair itself, we're smudging the mask: we're not creating new strands, but revealing those we'd painted out.

DAVID DUCHOVNY growing older, in stages: the image above, for Focus magazine, was always intended to be more cartoony than realistic.

We'll look at how to achieve an ageing effect in a more authentic and plausible manner on the following pages. For now, though, let's just see how easy it is to turn a full head of hair into a shining bald pate, using our customary model. When you're ready, Mr President – and I promise this will be the last time I use George W Bush in this chapter.

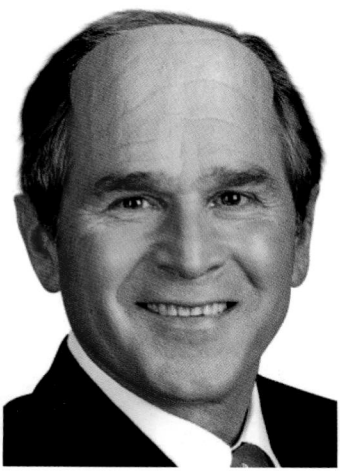

2 Stretch the ellipse to form the shape of the dome of the head. Because we copied the original forehead, we can be sure that the skin tones, textures and lighting will match perfectly.

3 Now make a layer mask and, using a soft-edged brush, paint out along the bottom of the layer so that it blends smoothly into the original forehead. For more on layer masks, see Chapter 2, Hiding and Showing.

4 Now for the hair. Make a layer mask once again, and paint out the hair behind the bald dome so that it recedes in a natural manner. Using a layer mask, it's easy to paint back areas that were erased accidentally.

6 The bald dome needs a little work with the Clone tool to remove the obviously stretched forehead lines. Now is also a good time to add a slight shine to the top of the head, using the Dodge tool set to Midtones to avoid changing the colors.

7 We can now put the newly bald Bush back on his original background. The trouble is, the hair on the original still shows through; but it's easy enough to get rid of, as we'll see in the next step.

8 Even with a complex background such as this, we can use the Clone tool to replicate stars and paneling from one area and place them behind the head. Back on his original background, George W looks more at home than ever.

SHORTCUTS

Beards and stubble

DESIGNER STUBBLE has always been a matter of some consternation for me. How do rugged actors like Bruce Willis and George Clooney always manage to be interviewed sporting just a couple of days' worth of growth? Do they only use blunt razors? Or do they shave with hair clippers?

Fortunately, we don't need to concern ourselves too much with the vanities of Hollywood's finest. We can draw exactly the level of stubble we want, from a simple five o'clock shadow to a neatly trimmed goatee, using a few simple steps.

Here, we'll add some facial fuzz to our own tough guy, and look at how to achieve a more carefully coiffured appearance as well.

1 Our original figure is gazing moodily into the camera, with just the hint of a bow tie suggesting his status as a club bouncer. But he doesn't look tough enough yet; a bit of designer stubble will help.

2 On a new layer, paint the beard area using a midtone gray and a soft-edged brush. Accuracy isn't that important at this stage, as we can always mask out any stray areas later, but try to avoid the nose and mouth.

6 We now need to make that stubble more transparent – and we do this by changing the layer mode to Hard Light, which causes all the midtone gray to disappear.

7 Turning the layer to Hard Light mode allows us to see through to the skin beneath. This level of stubble is OK for a day's growth, but let's see if we can beef it up. Make a new Curves Adjustment Layer, grouping it with the beard layer, and lower the brightness of the beard to bring some more strength back into it.

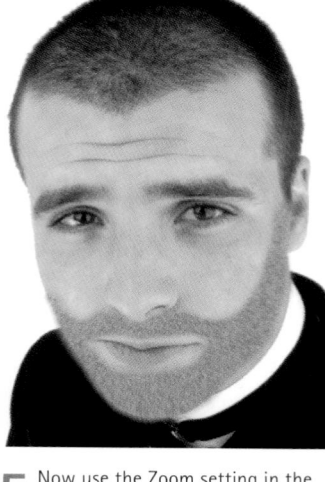

3 Add some Gaussian Noise to the gray you've just painted. I've used about 30% Noise here, but the precise amount you use will depend on the size of the image you're working on.

4 Next, we're going to use Radial Blur to make the stubble; but first, we need to set the midpoint for the blur to act on. Hold ⌥ *alt* as you draw an elliptical marquee from the center out, starting from the bridge of the nose and enclosing the whole beard area.

5 Now use the Zoom setting in the Radial Blur filter at a low setting: around 5% will be appropriate for this length of stubble. (Higher settings will result in facial fur that looks like it belongs on a dog.) Radiating from the bridge of the nose makes the stubble lie in the right direction.

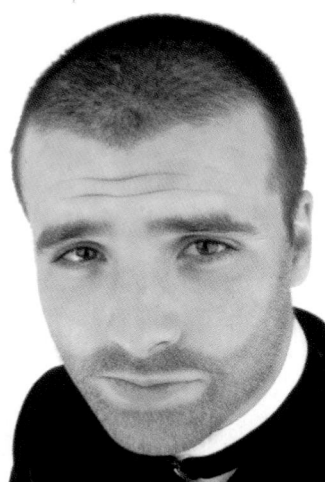

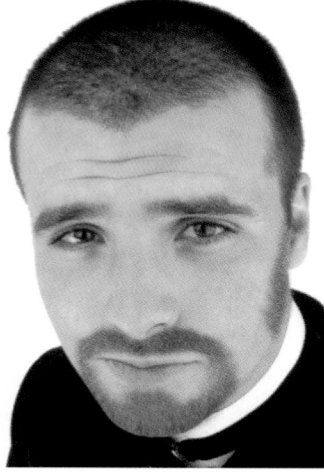

8 The result so far is a beard that looks far too neat. So create a Layer Mask for the beard layer, and paint out some of the harder edges. Painting inside the beard with a low opacity brush also helps the stubble to look more varied in depth, which adds to its realism.

9 As well as creating convincing stubble, we can also modify what we've drawn to make a stronger beard. The effect here is achieved by changing the Curve in the Adjustment Layer to darken the beard further; more sections are painted out on the beard's Layer Mask to give it a more tailored shape.

10 If all you want is to draw a mustache, there's a simple solution: use an eyebrow. QuickMask was used here to make a soft-edged selection of one of the eyebrows, which was then duplicated and distorted to sit on the upper lip. Using the eyebrow ensured that it matched the original.

HOT TIP

When painting the layer mask on a 'real' beard (as opposed to stubble) as in step 9, remember that you can use any of the painting tools on the mask – not just the brush. Added realism can be achieved by using the Smudge tool set to a scatter brush to push hairs into the skin.

SHORTCUTS
MAC **WIN** **BOTH**

133

The ageing process

ADDING A FEW YEARS onto a celebrity's image is a process that involves several steps. Graying up the hair is an obvious starting point; but there are other, more subtle indications of advancing years.

In this workthrough we're going to take a photograph of Prince Charles taken in the days when he was a carefree bachelor, and bring it up to date – and maybe project his image a few years into the future.

Making a person bald as they age is one possibility, but the results can be too extreme – and can often make the image look too jokey. In this case, we're going to age Prince Charles while keeping his full thatch of hair intact.

1 The original image of Charles was taken some years ago, as can be seen from his youthful good looks and chestnut-brown hair.

2 We'll begin by selecting the hair. Go into QuickMask mode by pressing **Q** and select the hair by painting around it with a soft-edged brush. We don't need to worry about being too accurate at this stage. Exit QuickMask, and make a new layer from the selection using **⌘ J** **ctrl J**.

6 As people age, their features coarsen. Ears, in particular, tend to enlarge with time. Select the ear, using QuickMask again, make a new layer from it and then stretch it slightly using Free Transform.

7 Bags under the eyes are a sure sign of age. Rather than drawing a new bag from scratch, it makes more sense to use what's already there. Select the eye bag (QuickMask again) and make a new layer from it; then stretch it with Free Transform so that it reaches further down the cheek. You need to be careful when doing this to make sure none of the original bag is visible, or it will look unconvincing.

3 The hair is brightened up using the Curves dialog (although you could just as well use Levels or even Brightness and Contrast instead). The color is then knocked out of it using the Hue/Saturation dialog: drag the Saturation slider to the left to reduce the amount of color in the hair.

4 In the last step, some of the forehead and ear was brightened up along with the hair. We can now remove this by making a new layer mask, and painting out the unwanted bright areas.

5 Decades of shaving tends to leave its mark on the face. We can accentuate this by selecting the beard area in QuickMask, making a new layer from it, and then adding Gaussian Noise and reducing the saturation so that it appears grayish.

HOT TIP

When creating multiple layers that all act upon base artwork, it makes sense to group each new layer with the base as you create it. That way you'll avoid the problem of fine elements – such as the veins in step 9 or the shading in step 10 – from leaking out around the edge of the head.

8 To accentuate the wrinkles, duplicate the base layer (so you can return to it if you need to) and use the Burn tool to trace in the lines around the eyes and nose. Add subtle lines on the forehead using a low opacity, and add some wrinkles into the neck for good measure. By using the Burn tool set to Midtones, we can avoid the color loss that we'd have got if it had been set to Highlights.

9 The next stage is a subtle one: drawing in the fine veins that appear on the cheek and nose as we get older. On a new layer, use a very small Brush and paint using a dark red. Short, wiggly strokes will create the effect we want with little effort.

10 The final step is to knock out some of the rosy color from his face. Make a new layer, and set its mode to Color: then, using a soft brush set to a very low opacity – around 20% works well – paint with white to reduce the ruddy complexion. Be careful not to overdo it at this stage: we want our celebrity to look older, but not necessarily decrepit. Even British royalty can grow old gracefully.

SHORTCUTS
MAC WIN BOTH

A change of clothing

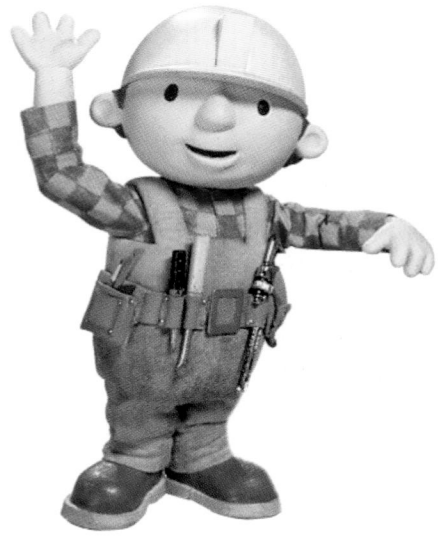

1 The original figure of Bob was cut out from a standard publicity shot. I had several images to choose from, and chose this one so I could drape the arm over the car. Cutting the image from its background was a simple task using the Pen tool to create smooth curves.

WHEN THE GUARDIAN NEWSPAPER ran a cover story for its magazine section on how the British animation series Bob the Builder was making a fortune through worldwide sales, they wanted an image to demonstrate his success.

The car was colored yellow to match his truck, and the headlights and smiling radiator copied from there onto a more sedate vehicle. What concerns us here is the clothing: turning the denim overalls into something akin to a pinstripe suit, complete with club tie, cuff links and shiny black shoes.

In the end, this illustration never appeared. The reason? I did the artwork on the morning of September 11th 2001 – and by the afternoon newspaper editors had more important matters to talk about.

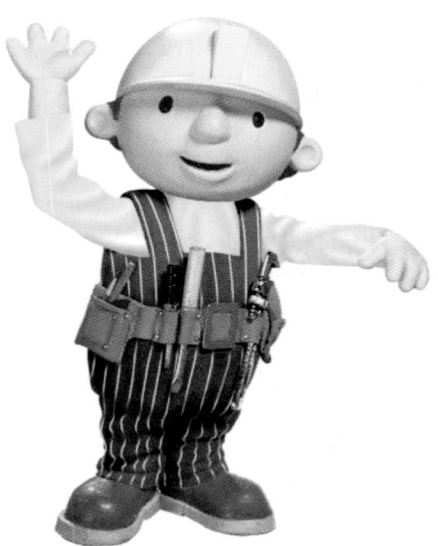

4 It would have been impossible to rescue any shading from the original checked shirt, so the only solution was to trace its outline and draw a new one. The new shirt was filled with a light gray, and shading was added using the Dodge and Burn tools - see Folds and Wrinkles in chapter 9.

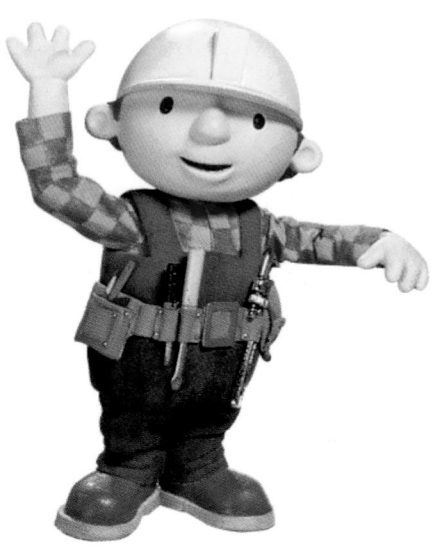

2 The existing overalls were selected, tracing carefully around the tools, and made into a new layer. Turning that bright denim into dark blue serge was a piece of cake using the Curves dialog.

3 It's the pinstripes that make sense of the new clothing, and they took some time to draw. Each stripe was drawn as a path using the Pen tool, being careful to trace bumps over the contours of the folds in the clothing; the path was then stroked with the Brush tool and shaded.

5 The shaded shirt was colored pink using the Hue/Saturation dialog, which can be simpler than Curves for a colorizing job like this. The collar and cuffs were then brightened to make them stand out, and shading added beneath the straps of the overalls.

6 The final elements were all added separately: the cigar, cuff link, and the tie were pinched from other photographs. While it would have been possible to draw a tie, using a real one adds to the realism of the image. The shoes were also desaturated and darkened.

HOT TIP

Drawing the stripes on the overalls was the hardest part of this job. The trick is to keep their spacing as even as possible, and to accentuate the folds in the clothing by making the stripes wrap around them – it's this that makes them look convincing. Shading, using the Burn tool, made them appear to belong to the clothing.

137

It's all in the eyes

T HIS ILLUSTRATION FOR LISTINGS
magazine Time Out shows two
newsreaders slugging it out in competition for
the ten o'clock news program. Both men had
been photographed head-on, and the head of
Sir Trevor McDonald (in the red shorts) barely
fits the profile body. But by moving the eyes of
both so that they stared at each other, it was
possible to create some emotional interaction
between them that would have been lacking if
they'd remained gazing at the viewer.

In Chapter 4, Composing the Scene, we
looked at how important eye contact is – which
means having the ability to move eyes at will.
Here, we'll take one of the figures used in that
chapter and show how to prepare the eyes
so that people can be made to look in any
direction you choose.

IMAGE: STOCKBYTE

1 This figure has eyes that are wide enough for us to be able to position the eyeballs wherever we choose. More importantly, there's enough of the pupil visible to allow us to use it later. Begin by making a circular selection that encompasses the pupil.

4 Turn the path into a selection by pressing ⌘ Enter ctrl Enter, then make a new layer named Eyeball and fill the selected area with white. This will form the basis for our new eyeball.

7 We can now show the pupil layer again. Position it above the Eyeball layer and group it using ⌘ G ctrl G, so that we only see the pupil where it overlaps the eyeball. Select the pupil and drag a copy (by holding ⌥ alt as you drag) until both are looking in the same direction.

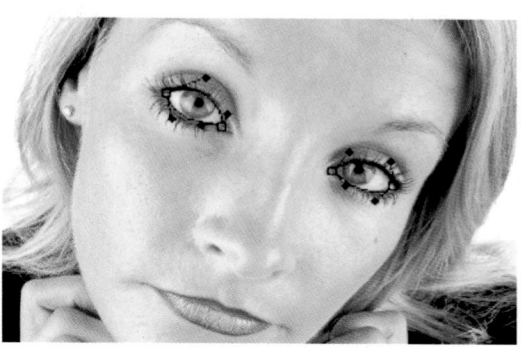

2 Make a new layer from the selection using ⌘ J / ctrl J, then duplicate the layer and rotate it 180°. Now erase the eyelid showing on the new layer, and continue erasing until the two halves of the pupil become one. When the eyeball looks convincing, merge the two layers.

3 Hide the new pupil – we'll come back to it later. Now, using the Pen tool, draw a Bézier path around each eyeball. Use as few points as possible for a smooth outline: I try to use anchor points just in the corners of each eye, making the path handles do all the work.

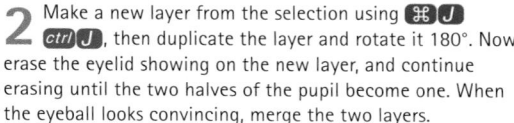

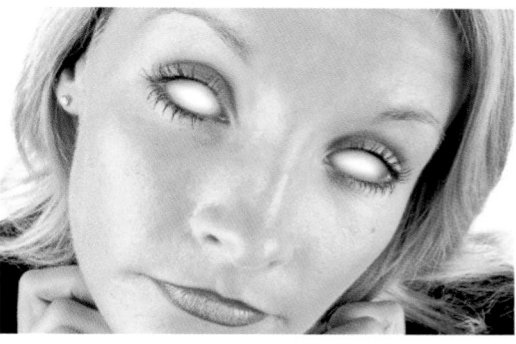

5 Add shading around the edge of the eyeball using the Burn tool set to Highlights, using a low opacity. Build up the shading slowly, so that it doesn't appear too harsh.

6 The original shading will appear to have a bluish tint, although in fact it is purely gray. Use Color Balance to add a little red and a little yellow to the eyeball, then soften the edges using the Blur tool.

8 So far, so good: but the eyes still don't look real. The solution is to change the layer mode of the pupils from Normal to Multiply, so that the shading we applied to the eyeballs shows through onto the pupils. It's a subtle difference, but it completes the effect.

9 With both eyes now complete, we can move the pupils independently of the eyeballs to make them look in any direction we choose. Because the two layers are grouped together, the pupils always appear to move within the range of the eyeballs.

HOT TIP

It isn't always possible to lift the original pupils from a face: sometimes the eyes are just too closed to be able to see them clearly. In cases like these, it's worth taking a pupil from another image (keeping it handy for future use), and simply dragging it into the composition. You can change the color of the eyes using the Hue/Saturation dialog, so that they match the original.

SHORTCUTS
MAC WIN BOTH

139

A change of expression

THE LIQUIFY FILTER is a powerful tool for distorting images – far stronger than the Smudge tool in its effects, and much more controllable.

Liquify is a great filter for creating massive distortions and twists in images. Here, however, we'll look at its more restrained application: that of changing the expression on a face.

The key to getting this technique to work is subtlety. Small distortions can create the effect of different expressions without giving the game away; it's easy to get carried away, and one or two of the examples here verge on the cartoony. Use a large brush at a fairly low pressure for best results.

1 Here's our starting image – a bland, expressionless gaze directly into the camera. Yet from this vapid starting point we can create a huge range of emotions. All the effects here are created using just the first tool in the Liquify toolbox.

2 SCEPTICAL: a downturn on the corners of the mouth, with a slight wrinkle on the lower lip. The eyebrows are pushed down iin the middle, and one is raised slightly at the corner to complete the effect.

6 PEEVED: a slightly cross look, achieved by turning the corners of the mouth down slightly and curving the eyebrows so that they're raised in the center but both corners are dragged down.

7 ANGRY: a stronger version of the previous effect. The eyebrows are curved in a more pronounced manner, and the mouth has a much more definite downwards curl. The effect is strengthened here by stretching each nostril up and outwards to give them that furiously flared look.

3 QUIZZICAL: one eyebrow pushed down in the corner, the other raised in the middle for an asymmetric look. The mouth is narrowed to give a pursed appearance, and one nostril is pushed up slightly.

4 SINCERE: a face you can trust. This subtle effect is achieved by thinning the line of the mouth to make it more hard-set, and pushing the corners of both eyebrows down in an expression nearing a frown.

5 RESOLUTE: an effect that differs in technique only slightly from the previous example, but which results in a more determined appearance. The eyebrows are made thinner, and the mouth is widened with a slight downturn.

In all these examples, we've distorted the mouth and eyebrows but left the eyes largely intact. This is because any distortion on the pupils would make the whole face look false and unconvincing. More powerful results can be obtained by distorting the eyes as well, and then replacing the pupils using the technique described on the previous spread.

8 SMUG: this man knows something you don't, and it isn't to your advantage. It's similar to the Quizzical look, above, with one eyebrow raised dramatically; but the smile, created by raising both corners of the mouth, makes this figure look more in control of the situation.

9 ANXIOUS: this worried expression is produced by raising the corners of both eyebrows and lowering the midpoints of the eyebrows. The mouth is raised slightly on one side, and the nostril above it is also raised to reflect the way the musculature works beneath the skin.

10 HAPPY: the hardest expression to create using a closed mouth. Since we can't make him smile, we have to rely on a broad grin made by widening and raising the corners of the mouth. Both eyebrows are raised significantly to complete the effect.

Sleep and the art of healing

1 The first step in using the Healing tool is to specify the clone target. Hold the ⟨alt⟩ key and click on the point you want to clone from. Choose an area of skin that's relatively free from wrinkles, lines and stubble, such as the cheek in this example.

ONE OF THE MAIN NEW FEATURES in Photoshop 7 was the Healing tool. Designed for the removal of noise and scratches from photographs, it can also be used for more wide-reaching applications: a prime example might be to remove the hole left by the earring in the model on the right.

Here, we're going to use the tool to make this figure look like he's sleeping. If I'd had Photoshop 7 when doing the illustration above for Time Out (about the tedium of royal weddings) I'd have made a far more convincing job of it. Now, in just a few steps, we can close our model's eyes far more easily.

4 Repeat the process for the other eye. There's no need to specify the target point again, since this will be chosen automatically. Once again, the eyelid appears too bright while we're in the process of using the healing tool – but this will be corrected when the button is released.

142

2 Now begin to paint over the area you want to heal. As you paint, the target area will be cloned directly, as shown here – and it will appear badly shaded as a result. Avoid healing over the bottom eyelashes, as they'll mark the closure of the eye.

3 Once you release the mouse button, the cloned area will take on the light and shade characteristics of the area you healed into. Note how the eyelid, previously far too bright, has now toned in well with the area of skin that lies around it.

HOT TIP

Because you don't see the full effect of the Healing tool until after you've finished painting (and after Photoshop has processed the result), you can't always see what you're doing as you go along. It's often best taken in short steps, alternating between large and small brushes as you go, so you can watch the result build up in stages.

5 With both eyelids now fully healed, we can see how the shading closely matches the surrounding skin. The problem now is that the eyelids have taken on the color values of the open eyes, resulting in a grayish hue that looks a little artificial.

6 This is easily fixed by using a soft-edged paint brush set to Color mode, and painting over the eyelids with a color sampled from nearby. Now, our previously wide-awake figure looks like he's sleeping peacefully.

SHORTCUTS
MAC WIN BOTH

Coloring black+white images

1 Our starting image is a great retro photograph taken from a royalty-free collection. Since the original image is, naturally, grayscale, we need to make sure we convert it to RGB before continuing. Even in RGB, it's always worth keeping your swatches in CMYK so they'll work in print.

ALTHOUGH PHOTO LIBRARIES SUPPLY many thousands of color images, there are times when the Photoshop artist needs to color up black and white photographs. It may be to repurpose a historical figure, such as the image of Idi Amin, above, for the cover of Giles Foden's novel The Last King of Scotland.

The more usual scenario is those cases where only a genuine 1950s photograph will supply that retro look. Coloring monochrome images is fiddly, but not difficult; the secret lies in choosing the right colors to work with.

Because painting with color can produce dramatic changes in an image, it's worth always working with a very low opacity brush when painting in color mode: I frequently use just 5% opacity when painting the beard area.

Cyan	8
Magenta	65
Yellow	71
Black	0

4 Now for the blush color. Set the foreground color as shown above and, using the same brush opacity, paint dabs of color on the cheeks, nose, ears and forehead. With a much smaller brush, set the opacity to around 30% and paint the color on the lips.

Cyan	28
Magenta	56
Yellow	70
Black	9

2 We'll start by applying a general flesh-colored wash to the whole image. After setting your foreground color according to the swatch above, choose Fill from the Edit menu and select Color Fill with Preserve Transparency: this will flood the image with our skintone color.

Cyan	28
Magenta	11
Yellow	9
Black	0

3 The next step is to paint the beard area. Set the foreground color as shown, and use a soft-edged brush set to Color mode: make sure the transparency of the layer is locked in the Layers palette. Set the brush to a very low opacity – 10% or less – and paint the beard area.

Cyan	2
Magenta	7
Yellow	11
Black	0

5 We need to color the eyes and teeth as well, but painting with pure white will make them look blue (try it). Set the color as above and use a very small brush, still set to Color mode, to paint those areas. Use the Dodge tool here as well to bring some sparkle into the teeth and eyes.

6 To color the clothing, select all but the skin areas and make a new layer from it using ⌘ J ctrl J. Then use Curves, Color Balance or Hue and Saturation to recolor those areas, making additional selections as necessary. You can still use the brush set to Color for details such as the tie.

SHORTCUTS
MAC WIN BOTH

145

The freelance artist

FOR THE FREELANCER, working at home is one of the main attractions of the job. It can also be one of the major drawbacks.

The advantages are plentiful. No need to worry about bus and train times; no commuting; and above all, no office politics. On the down side, there's the problem that you're always at work, even when you're off-duty. In order to complete this book I had to rent a flat at the seaside simply to get away from the telephone: it's hard to complete a long-term project when the telephone's constantly offering you short-term work.

When you work at home, it's important that you have a separate room in which to work. Partly it's because you need somewhere you know won't be littered with washing, children's toys and bicycle parts; but mainly, so there's somewhere you can go out of in the evening. In the days when I used to have my computer set up in the back of the living room I felt I could never get away from it.

I now never work at weekends. It's a golden rule that I break only two or three times a year, and even then it's only when I'm called out to deliver a talk or work on the help desk at a Mac show. I occasionally have to turn work down that would require me to work over a weekend to meet a deadline, but my sanity is all the better for the restriction.

Try to arrange your workspace so that your desk faces the window, so the light doesn't glare on the screen, and make sure you use sidelights rather than ceiling lights for the same reason. Don't push your desk right up against the wall or window: you'll need to get round the back to plug in cables, and you want to make this as easy as possible.

I'd also recommend renting a water cooler. Partly because water's good for you; but mainly because since I got mine my coffee intake has dropped considerably. And, at the risk of sounding like your mother, I'd also suggest eating lunch now and again. Falling over from hunger at 4.30 in the afternoon will do little to help you meet a 6pm deadline.

There are two main problems with the freelance lifestyle: not having enough work, and having too much. It's hard to decide which is the more onerous: if you don't have enough work, you can always spend the spare time putting up shelves. But if you have too much, at some point you'll get to that dreaded stage when you realize that you'll have to turn a job away.

The first time you turn work down it feels awful: after all, there's a job that needs doing, and if you don't do it they'll get someone else – so what will happen next time? Will they come back to you, or go straight to the person they know could get it done last time? The answer is that if you're any good, people will come back; and if you're too much in demand to do the work one week, they'll be all the more keen next time. But if you take on more than you can handle, you'll do neither job well.

There are many factors that determine whether a freelance artist gets plenty of work: whether your work's any good, whether it's original, whether you can interpret a brief, and so on. But without doubt the strongest factor is this: can you meet a deadline?

Unlike trains, TV shows and your brother's birthday, you can't miss a deadline. Period. If a newspaper phones you at 1pm and requires an illustration delivered by 5pm, then that's the time you have to have it finished. It's no good spending an extra couple of hours turning your illustration into a work of art if the paper's gone to press by the time you've finished: they'll be faced with a blank page, which they'll fill with a stock photograph, and the phone will go strangely silent for the next few weeks.

The tightest deadline I ever had was 45 minutes, for an illustration for the front page of a newspaper: it ended up with me right up against the deadline, asking for an extra ten minutes and being granted five. The next day a quarter of a million copies were distributed around the country, each one showing the bits I hadn't finished yet; the day after that it was lining the bottom of the cat litter tray. So much for posterity.

7

Shiny surfaces

GLASS, WE'RE TOLD, is really a liquid. Which is little consolation when you're traversing a glass-floored walkway, but the resemblance between the two can be a great help when you're working in Photoshop.

Glass and liquids share many properties in common: they both reflect and refract light, and they can both be drawn more easily than you might have thought possible. In this chapter we'll look at some of the different ways of creating glazed objects, from bottles and windows to the floor of a fashion catwalk.

Introducing... Miracle Wrap

THE PLASTIC WRAP FILTER is one of the most useful special effects Photoshop has to offer. Use it to make anything glisten – from beads of sweat on a dancer's forehead to visceral internal organs (see the Case Study on the following pages). Oh, and if you really want to, you can also use it to draw plastic wrapping.

In this workthrough, we're going to use Plastic Wrap to create shiny, dripping paint on the can shown above, although exactly the same technique could be used to draw coffee, blood or just about anything that dribbles.

1 The first step is to draw the drip. The best way of doing this is to use the Pen tool to draw an editable Bézier path: but if you're uncomfortable with that tool, use the Brush instead – although it's harder to create smooth curves with the Brush tool.

Fill with a midtone gray (or paint with gray if you're using the Brush). There's no point worrying about color at this stage; all we need to do is to create a base that's suitable for the Plastic Wrap filter.

2 Now comes the tricky part: preparing the artwork for the filter. The best way to begin is to shade the drips, using the Dodge and Burn tools, so that it looks vaguely three-dimensional. (Remember, if you hold ⎇ *alt* while using the Burn tool, it temporarily Dodges – a real time saver.)

Next, create some random light and dark patches in the larger areas of the paint splash. There's no exact science to this, since the Plastic Wrap filter works in mysterious and sometimes unfathomable ways; only experimentation will show you which techniques work and which don't.

3 Time for Plastic Wrapping. The settings don't make an enormous amount of difference to the end result, but play around with them – you can see the changes instantly.

Because the original shading can affect the filter's result so dramatically you can't expect to just draw, filter and have done with it. So try this: do some shading, perform the filter, and see how it looks. Then undo, shade some more (or step back through the Histories to shade less) and apply the filter again. And again. This one can take some time to get right.

4 Brightness and Contrast always help a filter like this – the more glistening and shiny, the better. The drips look OK, but that pool of paint at the bottom was a little unconvincing; to fix it, I drew an elliptical selection and added ripples using the ZigZag filter (which, for some reason, creates ripples, unlike the Ripple filter, which doesn't).

Because I used Lock Transparency to prevent the ZigZag filter from distorting the edges of my lovely curves, I needed to clone some of the original image back where the filter had filled bits with white. No problem – that's what the History brush is there for.

5 Finishing touches. The blue color was made with a solid blue layer, grouped with the drip and set to Hard Light, 70% opacity. This is a more effective method than simply using Hue and Saturation or even Curves to put the color in, since we want to add a solid wash rather than merely tinting the gray.

Shadows were added both beneath the drips and around the edges to make it look more three-dimensional. Finally, I took the lid off the paint can so we could see some of the paint inside by creating a lid-shaped selection on a new layer, shading it and then adding a drop of paint color.

Plastic Wrap

OK
Cancel

— 100% +

Highlight Strength 15

Detail 9

Smoothness 7

HOT TIP

Performing a filter such as Plastic Wrap will change the look of the base layer completely. Always take a copy of the layer before applying the final filter effect to it, so you can revert and make changes if you need to later.

SHORTCUTS
MAC WIN BOTH

Blood and gore, no sweat

1 The original image, generated from a 3D model, may have been a useful teaching aid – but there was no way this would look like a convincing heart as it stood. As with most basic 3D modeling, this one looks like it's made of plastic rather than flesh and blood. This is the kind of application at which Plastic Wrap excels.

THE BRIEF for this illustration was to produce a realistic image of a heart, to be used on the front page of The Guardian. I was supplied with an image of a basic 3D model; it had everything in the right place, but looked like the model it was. I immediately asked if the illustration had to be accurate enough to fool heart surgeons: 'No,' came the reply, 'it only has to fool Guardian readers.' A much simpler proposition altogether.

2 The first step was to desaturate the image. Then, after locking transparency (so the edges didn't fuzz up), I appled Gaussian Blur to smooth out the veins.

3 The first application of Plastic Wrap picked up the contours and added a shiny, glistening tone to the image – without a brushstroke having been added.

4 The image was colorized using Hue/Saturation to give it a base color on which to build. Already, it was starting to look far more real and organic.

HOT TIP

When working on an image like this, it helps to create multiple layers for coloring and tinting the different areas: that way, the strength of each layer can easily be reduced by simply lowering the opacity of the layer. Group each new layer with the base layer to make sure no color leaks out around the edges.

5 A second application of Plastic Wrap was added, which was then masked out selectively over areas where it seemed too strong - mainly the large expanses of flat aorta.

6 The veins were painted in on a new layer using Hard Light mode, which allowed the underlying texture to show through; the tubes and pipes at the top were painted on a layer set to Color mode.

7 Finally, the plumbing at the top was copied to a new layer (by using a soft brush in QuickMask to ensure smooth edges) and then brightened up and tinted to look convincing.

Water, water everywhere

1 This straightforward suburban scene is about to be flooded by water. The differing angles across the image will involve treating both the water and the reflections to follow the perspectives of the original image, as we'll see over the next few steps.

ART EDITORS LOVE SUBMERGING THINGS. Whether it's a computer (Dotcom Firms Sink Without Trace), a confused businessman (Is Stress Swallowing You Up?) or an entire city (Global Warming: Life in 2050), they just can't get enough of floods.

The image above was fairly trivial to create: the island scene was simply reflected vertically, and the sun and sky reflection placed behind it. The strong ripples in the water helped to conceal any rough edges.

In this section we'll look at a slightly more complicated flood, which involves reflections as well as submerging.

4 Now the water needs to run along the walls that sit perpendicular to the one at the front. Because we made a layer mask in the first instance, rather than simply deleting the water, it's easy enough to paint it back in again, following the contours of the bricks as a guide.

7 Next, the sections of wall that face away from us are copied and again distorted into place. This includes elements such as the pink gate, which clearly lies in a different plane to the front of the wall.

2 First, find yourself some water. This image was taken from a photograph of the sea, from which the sky has simply been deleted: water can be devilishly tricky stuff to draw, so it's worth finding a real picture if you can.

3 The first step in making the water fit the scene is to decide on the level at which it will sit. Make a new layer mask (Reveal All) for the water, and paint it out along an obvious perspective line: here, the brick wall at the front provides a useful horizontal to set the water on.

5 The original water was far too bright: it had been photographed on a sunny day, when there was plenty of blue sky for it to reflect. In this urban setting, the sky would be minimal, so its saturation needs to be reduced using the Hue/Saturation dialog.

6 The background is copied in sections, flipped vertically and grouped with the water, using the techniques described in Glass Reflections later in this chapter. First, the sides facing us – the front of the wall and the wall holding the door – are flipped and distorted into place.

8 But the surface of the water is rippled, not flat; so the reflections need to be distorted as well. Here, the Wave filter (appropriately enough) has been used to add a small amount of rippling to the reflected image. I've also reduced the opacity of the ripples for a better effect.

9 As well as reflecting the scene above it, we need to make sense of the water as a dense medium. Simply placing this duck on the surface helps the eye to interpret the water for what it is, as well as adding visual interest to the scene.

HOT TIP

Although we've added a rippled reflection in this instance, in many cases it's enough just to reduce the opacity of the water along the flood line. Lower the brush opacity to around 30% and paint it out on the layer mask for an instant transparent effect.

SHORTCUTS
MAC **WIN** **BOTH**

Snow and icicles

MAGAZINE DEADLINES BEING WHAT they are, people always want pictures of snow for their Christmas editions – but they need them in September. Every Photoshop artist should know how to add snow to a scene to give it that festive flavor; we'll see how to turn the rather dull photograph (top) into a yuletide experience. We're even going to throw in a few icicles for good measure.

1 To get started, draw the snow shape on a new layer. Use a hard-edged brush where the snow sits on the windowsill, and switch to a large, soft brush to paint the area where it drifts up the side of the wall.

4 Make a new layer, and paint the icicles using a midtone gray and a small, hard-edged brush. Try to make them look as drippy and natural as possible, and don't add too many of them!

7 To add a sprinkling of snow to the walls, choose a large, soft brush and set its mode to Dissolve. With white paint, and the brush set to a very low opacity, it's easy to apply this speckled effect with just a few strokes.

2 Add shading using Dodge and Burn, then add the texture. Begin with a little Gaussian Noise and then, to soften the effect, lock the transparency of the snow layer and use Gaussian Blur to smooth it slightly.

3 There are several ways of adding color: in this instance, it's probably easiest to use Color Balance to up the blue and cyan content slightly. Don't make it too strong – we only want a hint of the color effect.

5 We're going to treat the icicles with Plastic Wrap (what else?), so first we need to add some shading using Dodge and Burn. This can be done in a fairly random way; there's no need to simulate accurate shadow placement.

6 Apply the Plastic Wrap filter as before, erase the tops of the icicles so they merge into the snow. Add a little color, and change the layer mode to Hard Light for transparency, then duplicate to make the shadow behind it.

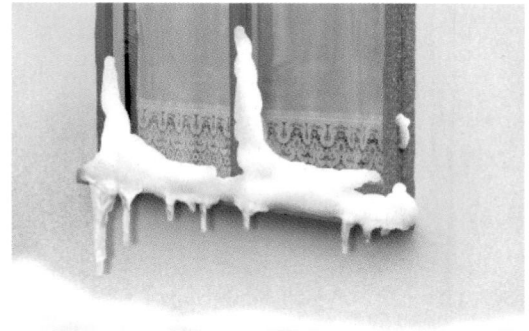

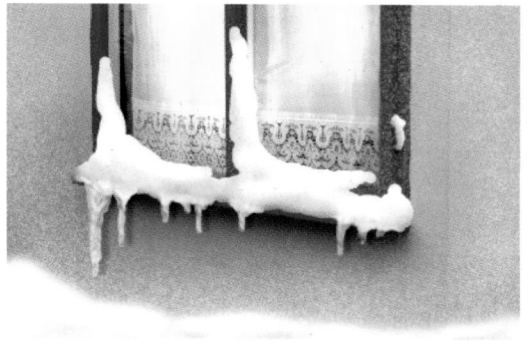

8 The snow we just drew looked rather harsh, so once again we can use Gaussian Blur to soften it. Don't check the Lock Transparency box this time, though, as we want to blur those edges slightly.

9 As a final step, add some color to the walls for a wintry feel. To get a good contrast inside the window, make a new layer from the window and increase the contrast, adding a yellowish hue for that warm interior glow.

HOT TIP

It's easy to get carried away with too much Dodging and Burning, too strong a color and too much snow overall. The key to making this effect work is subtlety; always try to use the minimum possible to get the effect you want, and the result will be that much more convincing.

A cool glass of water

1 We begin by drawing the outline of our first ice cube on a new layer. Use a hard-edged brush and paint with a midtone gray (we'll need to use this color when we change the layer mode later). Aim for an approximation of a rough cube viewed from an angle.

2 Now add a little light and shade using the Dodge and Burn tools. Aim to place a blob of light in the center of what will become each face of the cube. Subtlety is the keyword here: keep the strokes very pale and don't be tempted to overdo it.

GLASS IS ONE OF THE hardest objects you can photograph, as any commercial photographer will tell you. Stylists will spend hours combining plastic ice cubes with piped-in carbon dioxide to get effects such as this – they can't use real ice, which would quickly melt under studio lighting conditions.

Fortunately, there is an easier way. We begin with a straightforward digital image of a glass of water, which was photographed on a curved sheet of white paper so there was no crease visible where the background joined the base.

6 We could draw the bubbles one at a time, but it's a lot easier to let the brush do all the work. Select a hard-edged brush and open the Brushes palette: now set the spacing to a large figure - we've used 500%. Don't worry about 'corrupting' your brushes, since these settings will be forgotten when a different brush is selected from the palette.

7 Using white paint, draw wiggly lines on a new layer to create the bubbles. The spacing we just set will create strings of dots, rather than solid lines. Now reduce the brush size using the **①** key, and paint smaller bubbles as well: these should be placed particularly at the edges of the glass, to give an impression of the bubbles falling away in perspective.

3 Now apply the Plastic Wrap filter, as described earlier in this chapter. If you've applied the Dodge and Burn correctly, the filter should now form the shape of three visible faces of our ice cube. If it doesn't look convincing, undo and adjust the shading before applying the filter again.

4 The Plastic Wrap filter can frequently leave an untreated edge around an object, as seen in the previous step. Rather than trying to correct it, it's far easier to delete that edge. Hold ⌘ *ctrl* and click on the ice cube layer's name, then contract the selection, inverse and delete.

5 Now change the layer mode to Hard Light to make the ice cube shiny and semi-transparent. Moved to the top of the glass, a layer mask can be used to hide the region on the surface where it isn't poking through. The second ice cube is simply a duplicate of the first.

8 To make those strings of dots look three-dimensional, use the Emboss section of Layer Styles to give them some automatic roundness. (You didn't seriously think we were going to shade each bubble individually, did you?) You'll need to set a very small offset to avoid the bubbles looking too fuzzy, but experiment with the settings and you'll get a good result.

9 Now to give those bubbles some transparency. Begin by changing their layer mode to Hard Light once again. In this mode, midtones become invisible, while the highlights and shadows remain; so we need to lower the brightness of the bubbles so that the pure white we drew approaches a midtone gray. Any of the adjustment dialogs can be used to do this.

10 Finally, adjust the color of the glass to make it bluer, since the original indoor lighting looked far too brown. The shadow is created by hiding the background layer, performing Select All and taking a Merged Copy (*Shift* ⌘ *C* *Shift ctrl C*) of the image. This is then pasted behind the glass, desaturated, and knocked back using a gradient on a layer mask.

SHORTCUTS
MAC WIN BOTH

Getting the glazing bug

GLAZING EFFECTS are easy to create, and make the difference between an object looking like it's in a box and looking like it's inside a picture frame. The bug I've used here is in a three-dimensional box, but the technique works equally well for flat pictures in frames – or for windows, museum cases and other glazed surfaces.

Here, I've taken this bug box and added three different glazing effects to it, from simple glass to rippled plastic. The inset pictures show each effect in isolation against a black background, so it's easy to see how it works without the distraction of the main image getting in the way.

1 The simplest way to create a glass effect is simply to paint one on. Create a new layer behind the frame, and use a large soft-edged brush to add white bands. Set the opacity of the brush low – 10% or 20%

– and draw a series of diagonal white strokes. This can be a very subtle effect, and is most noticeable at the edges (where the glass meets the frame) rather than in the middle of the image. Build up the strokes as you go until the effect works. This is one of those occasions when a pressure-sensitive graphics tablet really comes into its own. The glass layer is shown here (inset), although obviously it makes more sense to draw it while viewing the full image.

2 To make the glass more convincing, consider adding a background image. Here, this shot of a room (inset) has been distorted slightly using the Wave filter: without the distortion it would look too flat and

rigid. The opacity of this layer was then reduced to 10% so it was barely visible – after all, you don't want it to swamp the main image. The white bands used in the previous example were added over the top, their opacity reduced to 50%.

Any background image can be used; the choice depends largely on the supposed location of the object in question. For outdoor scenes, such as looking in through a window, a cloud reflection is particularly effective. Remember to keep the opacity low; if necessary, increase the contrast of the reflected image to make it more dramatic.

3 This version uses the Plastic Wrap filter to make the bug look like it's encased in polythene. First, a new layer was created and its mode set to Hard Light: this was filled with 50% gray, which is transparent in Hard Light mode. The brushstrokes (inset, top) were painted on using the Dodge and Burn tools to add highlight and shading to the image; the Plastic Wrap filter was applied (inset, bottom) to show the full effect. In

cases like this, it's worth applying the filter frequently as you paint to check the effect, which can be unpredictable; Undo after each time to carry on adjusting the background.

HOT TIP

Experiment with different layer mode settings – Hard Light, Screen and Overlay in particular – to see the different effects they have on reflected images. Often they can serve to reduce the clutter and intrusion of a reflection, while maintaining its strength.

SHORTCUTS
MAC WIN BOTH

7

Glass: refraction

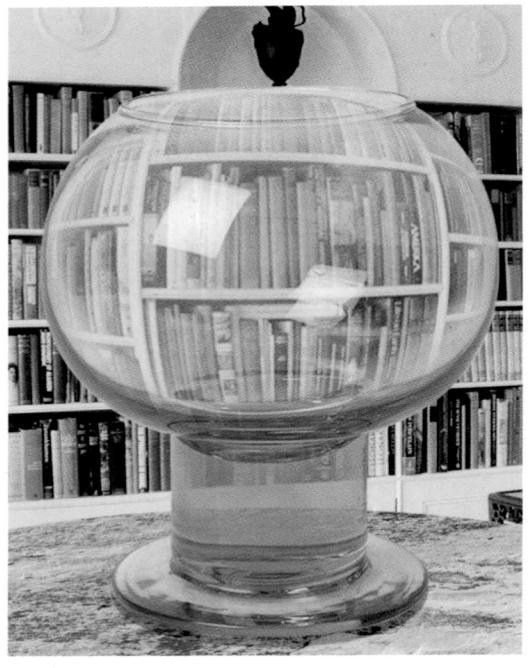

1 In this simple montage the glass vase, the table and the background are on three separate layers. The task is to make the background visible through the vase.

2 Begin by loading up the area taken up by the vase, by holding ⌘ *ctrl* and clicking on its thumbnail in the Layers palette. Then use the Elliptical Marquee tool, holding down ⌘ ⌥ *ctrl alt* to limit the area to just the bowl itself.

GLASS OBJECTS not only reflect what's around them, they also refract the view behind them. This refraction is easy to achieve; the trick to making the montage look real is to bring back the reflections in the original photograph so that they sit on top of the refracted image.

In this workthrough, we'll make this photograph of a glass vase look as if it's sitting within the scene, rather than simply stuck on top of it.

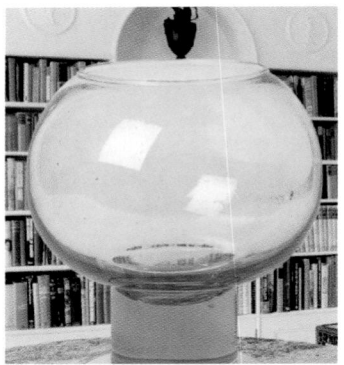

6 Now for the tricky bit – adding back the reflections from the original vase. Duplicate the vase layer, and delete the layer mask (without applying it). It will completely obscure the distorted background. Now choose Layer > Layer Style > Blending Options and drag the small black triangle under the This Layer slider (in the Blend If section) to the right. After a certain point, the vase will begin to turn transparent as all pixels darker than the position specified disappear.

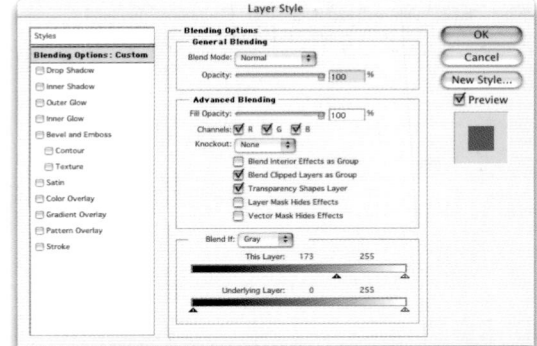

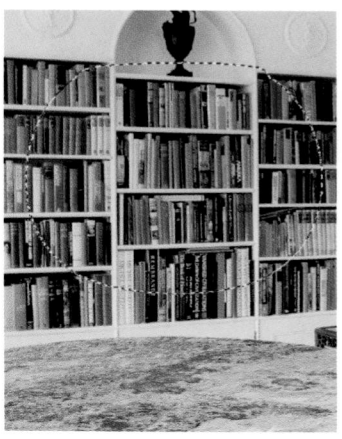

3 Now hide the bowl layer, switch to the background and make a new layer from the selection using ⌘ J ctrl J.

4 Reselect the new layer by ⌘ ctrl clicking on its thumbnail in the Layers palette, and use the Spherize filter to create the refracted view. (If the bowl had been full of water, you'd need to flip this vertically to simulate the solid lens refraction.)

5 Turn on the vase layer so it's visible again, and create a layer mask. Using a large soft-edged brush, paint out the interior of the bowl so that the background becomes visible.

HOT TIP

Spherizing works well with spherical objects, as you'd expect. But if you want to distort the view seen through a cylinder, such as a glass wine bottle, you can still use the Spherize filter; this time, though, change the mode of the filter from Normal to Horizontal Only in the filter's dialog box.

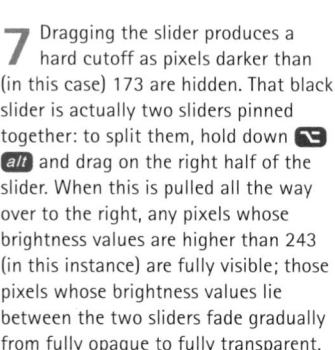

7 Dragging the slider produces a hard cutoff as pixels darker than (in this case) 173 are hidden. That black slider is actually two sliders pinned together: to split them, hold down ⌥ alt and drag on the right half of the slider. When this is pulled all the way over to the right, any pixels whose brightness values are higher than 243 (in this instance) are fully visible; those pixels whose brightness values lie between the two sliders fade gradually from fully opaque to fully transparent.

Using Blending Options in this way to hide and show areas of a layer selectively is an extremely powerful tool: find out more about how it works in Chapter 2, Hiding and Showing.

As a final touch, the refracted background seen through the vase has been given a blue-green tint using the Color Balance dialog; I also painted out some of the stem on the layer mask to make it partially transparent.

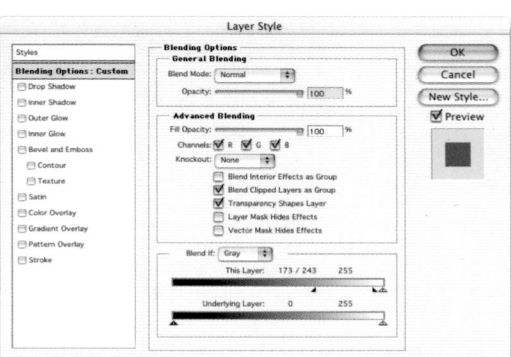

SHORTCUTS MAC WIN BOTH

Glass: reflection

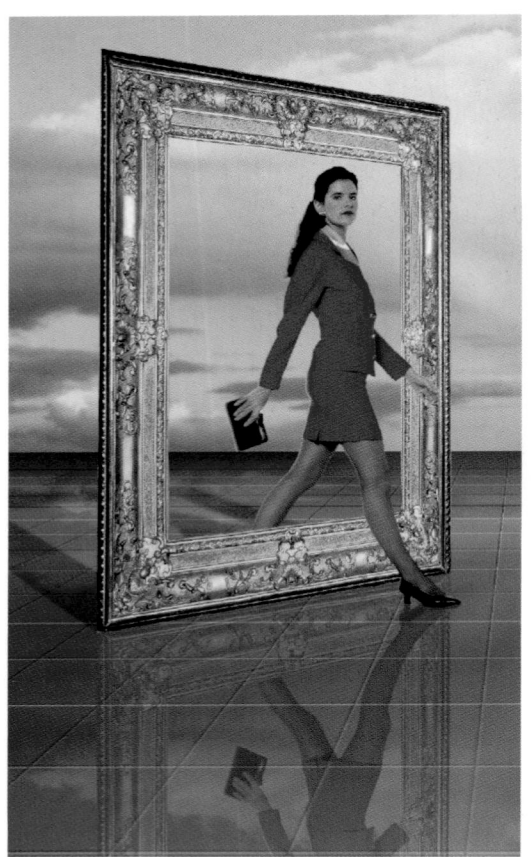

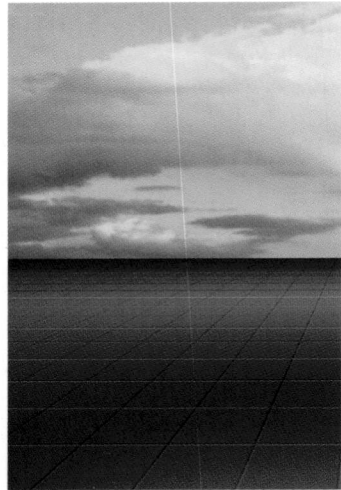

1 This montage consists of two elements so far: the clouds and the grid floor. The first step is to adjust the color of the floor so that it more closely matches the colors of the sky.

2 The reflection of the sky in the floor is made by duplicating the sky layer, flipping it vertically and grouping it with the floor. With its opacity set to 30%, we can see the floor through it – but it looks rather dull.

CREATING REFLECTIONS in floors is easy to do, and can – with a little care – result in the kind of shiny, perfect reflection that looks like it was created in a 3D modeling program.

Here, we'll look at how to turn the dull floor we started off with into a highly reflective, polished surface.

6 Adding this angled frame will present a different kind of reflection problem. First, though, we need to mask the woman's legs so that she's stepping through the frame.

7 Create a layer mask for the woman, and load the frame's area into it by holding ⌘ *ctrl* and clicking on the thumbnail; then hold ⌥ *Shift* *alt* *Shift* as you draw a marquee to limit the selection. Fill the mask selection with black to hide the leg.

3 Changing the reflected sky's layer mode to Hard Light makes its reflection that much more punchy. This mode allows the light and dark in the underlying layer to show through, as in the highlights and shadows on the cracks.

4 This figure is walking parallel to the horizon, and so presents no problem when making the reflection. When the object to be reflected lies at an angle it gets more complicated, as we'll see later.

5 Once again, the reflected figure is lowered in opacity: this time, however, the reflection is set to Overlay mode, which produces a softer and less dramatic result.

HOT TIP

The technique shown here really only works for flat objects (such as the frame) or those parallel to the surface (the woman). To reflect more complex objects, you'll need to break them up into their component parts and distort each one individually. It can be done, but it's not a job for the faint-hearted.

8 Simply flipping the frame to create its reflection clearly doesn't work: it ends up at completely the wrong angle. The solution is to use Free Transform to shear the reflection so that its top edge aligns with the bottom edge of the original frame.

9 To perform the shear, first use ⌘ T / ctrl T to access Free Transform, then hold ⌘ Shift / ctrl Shift while dragging a side handle (adding the Shift key constrains the movement to purely vertical).

10 Now we need to delete (or mask) those parts of the reflected frame and woman that intersect, in the same way as before. Also, the cloud reflection needs to be hidden behind the frame and woman reflections.

SHORTCUTS

MAC WIN BOTH

Putting things in bottles

THE MONTAGE ABOVE shows noted art collector Charles Saatchi in one of the Damian Hirst boxes that make up part of his collection, and was commissioned by the Sunday Times magazine.

Putting things in glass boxes, jars and bottles is a fairly straightforward technique: the trick lies in reproducing the surface of the glass, complete with its reflections and refraction, to make it appear as if the object in question is really sitting inside it. Here, we'll look at the procedure involved.

1 Our glass bottle was originally a much taller and thinner object. It was simply scaled using Free Transform to make it fit the shape of the object we want to place inside it. Most containers are as adaptable as this one: everything scales in proportion, so the end result still looks plausible.

2 Since the bottle was too dark for our purposes, it had to be brightened up – I used the Curves dialog, but Brightness/Contrast would have done the job as well. Some of that strong green hue was knocked out with Hue/Saturation.

6 To make the brain look like it's floating, we need a medium for it to float in. On a new layer, draw a shape that fits the sides and bottom of the bottle, remembering to draw the surface in perspective, and fill with the color of your choice. The top surface is brightened with the Curves dialog.

7 Changing the mode of this layer, as well, to Hard Light not only makes it look as if it's inside the bottle, but makes the brain look much more like it's floating in a supportive liquid. I've chosen to leave part of the brain sticking out to accentuate the overall effect.

3 Now for our brain (well, what else would you expect me to stick in a bottle). Placed on top of the bottle, it looks totally unrealistic; there's no sense here that it lives inside the glass, and looks as if it's sitting in front of it (which it is).

4 To make the ensemble more convincing, we'll begin by duplicating the bottle. Bring this copy to the top of the layer stack, and knock all the color out by desaturating it using ⌘ Shift U ctrl Shift U. As it stands, we can't see through it.

5 Easily fixed: we simply change the mode of the layer from Normal to Hard Light, and we can see through it. Already, the brain is looking like it's inside. The new Hard Light layer has also affected the rest of the bottle, but we can sort that out later.

HOT TIP

Step 10 involves matching a layer mask to fit two different layers. First, load up the distorted brain area by holding ⌘ ctrl and clicking on that layer's name in the Layers palette. We want to subtract the mask from the brain layer, so hold ⌘ Shift ctrl Shift and click on the brain layer's mask icon. Now, to add the area of the original brain, hold ⌘ ctrl again and click on that layer's icon. Now, on the Hard Light bottle layer, choose Add Layer Mask – Reveal Selection to see the result.

8 To make the surface of the brain stick out, add a new layer mask to the liquid layer and paint around the contours of the brain so it looks as though it's poking out through the surface. Use a fairly hard-edged brush to get the most realistic effect.

9 All very well so far - but we need to remember that the liquid will distort as well as color the object inside it. Here, I've duplicated the brain and applied a horizontal-only Spherize to it, then added a layer mask to the distorted version so that it only shows up where it's beneath the liquid.

10 Finally, we can apply the original Hard Light bottle layer just to the brain. But there are two versions of the brain, so we can't just group them; instead, we need to make a layer mask. See the Hot Tip for a good way of making a layer mask to match multiple layers.

SHORTCUTS
MAC WIN BOTH

Reflecting on fashion

1 Each element in this montage is on a separate layer – vital if we're going to make this sort of reflection work. The two Lens Flare effects were created on solid black layers set to Screen mode, so they could be moved around afterwards

WHEN THE GUARDIAN sent their science correspondent to review the Paris fashion shows (I still haven't worked out why) they needed a cover showing a scientist examining a catwalk model. Turning the catwalk from a simple surface into a shiny, reflective one made this illustration come alive.

As a footnote, the science correspondent decided he didn't want his image used in this way. Could I turn him around so we could only see the back of his head? With only 40 minutes left until the press deadline, it was impossible to start again – so the illustration was spiked. Sometimes even the most painstaking work ends up in the trash.

4 To create the reflections of the front row journalists, each one was copied and flipped individually, and arranged to follow the perspective; the overlap on each from the one in front was hidden with a layer mask.

2 The reflection of the row of lights up the side of the catwalk was created simply by duplicating the lights layer, moving it behind the lights and lowering the opacity. No need to flip them: one side of a disk is pretty much the same as the other.

3 The reflection of the model couldn't be simpler: I just flipped the original and lowered its opacity. But because the forward shoe was viewed from above in the original, I had to select that area in the reflection and nudge it down slightly.

5 One of the Lens Flare layers, flipped and grouped with the catwalk, adds useful random reflections to the otherwise plastic surface. At 30% opacity in Hard Light mode, the catwalk is still basically white.

6 The interest comes when that Lens Flare reflection is increased in strength to 70% opacity. Now, the catwalk surface takes on a burnished metal appearance, and looks altogether more appetizing.

CASE STUDY

HOT TIP

Sometimes you can simply flip an object to create its reflection; with a group, such as the front row of journalists set at an angle to the surface, you'll need to create the reflection of each one individually. Always keep those document layers intact!

SHORTCUTS
MAC WIN BOTH

169

Glass: putting it all together

NOW THAT WE'VE LOOKED at different ways of rendering glass, let's finish off this chapter by putting several of those elements together. Starting off with the simple montage above, we'll use the techniques covered in this chapter to glaze everything in sight.

To begin with, the bottle is only a shaped outline: we'll create this (as well as the rest of the glass) directly in Photoshop. The end result, on the opposite page, shows off our glazing efforts to their best advantage.

1 The first step is to glaze the window. This is achieved using the techniques discussed in the section Getting the Glazing Bug: first, a cloudscape is placed behind the window frame and set to 40% opacity, then, on a new layer, diagonal white brushstrokes are added to brighten the edges of the glazing. This technique is clearly a lot simpler if the window frame and the room interior are on separate layers.

The outline of the bottle is drawn with the Pen tool, and filled with mid gray.

Shading is added using Dodge and Burn tools to simulate lighting.

2 The bottle (below) was drawn using the Plastic Wrap technique explained in the section Miracle Wrap; the refractive effect was created using the method shown in the section Glass Refraction. Because this bottle is not spherical, the Spherizing of the background was performed in two stages - one for the neck, and one for the bowl. The steps used to draw the bottle are outlined below.

3 The table was drawn directly in Photoshop, using the Dodge and Burn tools to create the highlights. To make the surface transparent, that section was cut to a new layer and its opacity reduced. The reflections of the bottle and window in the table used the techniques described in the section Glass Reflections; the reflection in the greenhouse needed perspective distortion to achieve the correct angles.

HOT TIP

You can always photograph a bottle or glass rather than drawing it from scratch. The choice of background is critical: you need something bright enough for the glass to be visible, but must make sure the lighting doesn't cast shadows on it. It's also important to avoid reflections in the surface, unless you want to end up in your own montages.

Plastic Wrap adds the glass effect; with nothing reflected, it's unconvincing.

Increasing the contrast helps; the green color is added afterwards.

With the layer mask painted in, the refracted background becomes visible.

The original bottle is copied over the top, and Blending Options applied.

SHORTCUTS
MAC WIN BOTH

Through grimy windows

1 This photograph was taken with a digital camera through the window of a broken-down seaside theatre. I couldn't use a flash, or I would have lost the grime on the windows; so the rest of the walls were in darkness.

4 With all the transparent window selected, either delete it or make a layer mask and hide it. Note how the grime itself, not selected by the Select Color process, remains apparently hanging in mid-air.

7 Before we address the opacity of the windows, we need to delete the broken panes. This is best done using the Lasso tool, with the ⬛ *alt* key held down to constrain it to drawing straight lines. Take out each pane in turn.

ALTHOUGH SO FAR IN THIS CHAPTER we've dealt mainly with the technique of creating windows from scratch, there are times when the texture of real broken glass is simply impossible to improve upon.

That said, photographing a scene through such a window presents a technical nightmare for the photographer. To attempt to light the interior of the building, the glass and the view beyond for a single shot would take photographic expertise beyond the reach of most of us. The solution? To cheat, of course. The only tricky part is to make the glass look as convincing as possible, which means treating it in a number of different ways and adding all the effects together to get a good result.

2 Before enhancing the image, duplicate the background layer – we'll need the original later on (but hide it for now). Adjust the brightness and contrast using the Curves diaog: a lot of the lost detail can be recovered.

3 The easiest way to select the windows is to use the Color Range dialog, and click on a pure white area. This will select the totally transparent regions, leaving the grimy parts alone – and this is what we want.

5 In order to work on the windows further, we need to add a new background. This sunset was, in fact, photographed further down the same beach, and so belongs properly to the scene.

6 Now show the hidden, original background again, which should now be positioned behind the version we were working on. We can now see the original windows (and background) through the panes we deleted.

8 So that we can see through the new glass, we need to change its layer mode. Changing the mode to Screen is the obvious choice, as it makes the glass transparent; but the result is, overall, a little too subdued.

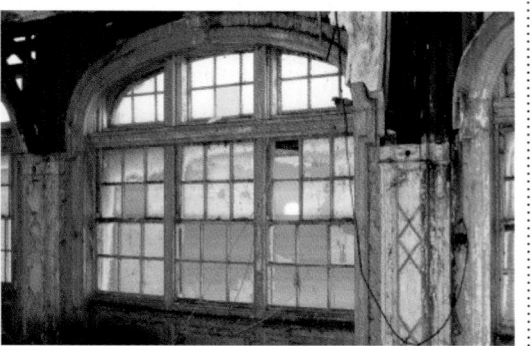

9 Duplicate the layer and change its mode to Hard Light, which adds detail and texture. You may find now that the overall effect is too bright; a simple solution is to reduce the strength of the Screen layer to 50% opacity.

HOT TIP

In the final two steps of this workthrough we used duplicate copies of the same layer, one set to Screen and the other set to Hard Light. This technique of using multiple copies is a useful one, as it allows the strengths of each mode to be added to the strength of another. Don't feel you have to make a single layer do all the work when two can do the job better.

SHORTCUTS
MAC WIN BOTH

Photoshop Actions

THE ACTIONS PALETTE in Photoshop is a feature that most users tend to ignore, and when you look at the Actions shipped with the program it's hardly surprising. They allow you to perform such sequences as generating plastic-looking wood frames, creating dodgy reflections of type on water and filling the screen with molten lead. Which are hardly the sort of everyday tasks that make you want to explore the system further.

But Actions are capable of far more than building questionable special effects. At their basic level, Actions can be used simply to create keyboard shortcuts for tasks that would otherwise have you reaching for the menu bar. I've created Actions to bring up the Image Size dialog, the Canvas Size dialog and the Layers palette. I've also defined Actions to perform a Purge All command without asking me if I'm sure (of course I'm sure, that's why I chose it), to inverse the current selection (assigned to F1 – it only needs one hand, unlike Shift Command/Control I) and to turn a saved path into a selection. This last Action only works when the specified path is named Path 1; so I defined another Action to take the path I've just drawn, save it as Path 1, and then make it into a selection. That way, when I reopen the document I know I'll be able to load the path instantly.

Creating your own Actions is easy: simply choose New Action from the palette, choose a name and shortcut for it, then go ahead and act out the task you want it to do. Every step will be recorded as you go; at the end, press the Stop button and your Action will be saved. You can build in commands to make the Action pause for any variables you might need; and while you can't add menu choices while recording an Action in real time, you can add them afterwards by choosing Add Menu Item from the pop-up menu.

Actions can do far more, of course, than simply replicating menu commands. Among the Actions I use regularly are one to load a layer's transparency as a selection instead of having to Command/Control-click in the Layers palette – and this works even when the Layers palette is hidden.

Click here to build a 'stop' into the Action: this one will simply open the Canvas Size dialog, then wait for me to enter my figures

This is the Action name

Every step is detailed here

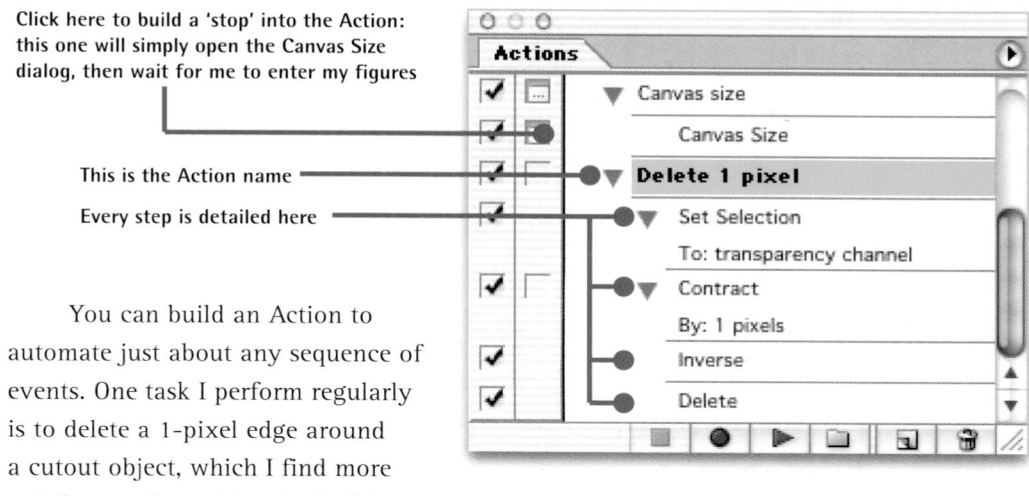

You can build an Action to automate just about any sequence of events. One task I perform regularly is to delete a 1-pixel edge around a cutout object, which I find more satisfactory than either the Defringe or Remove White Matte commands (see the section Losing the Edge in Chapter 1 for my reasons why). This works as follows: first, the transparency of the layer is loaded up; then the selection is contracted by 1 pixel, which was chosen from the Select/Modify menu; then the selection is inversed, so everything else is selected; and then the outside area is deleted. Finally, the selection edges are hidden so that I can see if the result works: but it isn't deselected, so I can undo the deletion if I want to. This is the Action shown above.

The most complex Action I use is to create new eyes for the celebrities and politicians I use in my montages. I have to outline the eyes with the Pen tool first, but then I simply press a key and the following sequence happens: a new layer is created, named Eyeball, and the eye region filled with white. At this point I've built a Stop feature into the Action, so that it asks me for the feather radius I want to apply: I enter a value based on the size of the eyes in question. The Action then continues, locking the transparency of the layer and inversing the selection, then filling the feathered edge with an appropriate brown shading; it then opens the file Eye (an image of a pupil), copies it and pastes it into the document. This new layer is named Eye and is grouped with the Eyeball layer so it only shows up where it overlaps it, and finally the mode of the new layer is set to Multiply so that the shading on the Eyeball layer shows through. And all this is accomplished in a few seconds.

One final word of advice: export your Actions (there's an option in the palette) every time you modify them. Otherwise, if your computer crashes, you'll lose the Action you've just defined.

8

Metal, wood and stone

HARD SURFACES are generally easier to simulate in Photoshop than those with transparency. Often, it's just a case of grouping a surface texture with the object you want to apply it to, and then adjusting the layer blending method so that the contours of the underlying object show through.

Reflective surfaces, such as metal, require special treatment: unlike wood or stone, you can't simply place a scan of a piece of metal on top. But the technique is easy to grasp and, once you get the hang of it, easy to reproduce.

In this chapter we'll also look at different ways of making lettering appear to be cast in the surface of a variety of materials.

Instant metal with Curves

1 Begin by opening the Curves dialog using ⌘ M *ctrl* M and click near the left-hand side of the diagonal line: drag vertically upwards

3 Now click again, further along the curve, and drag up again to make the high point for the next step. Once

THE SIMPLEST WAY to create an instant metallic effect is to use the Curves dialog. Metal differs from non-reflective surfaces in that it reflects the light in unpredictable ways: the light and shade aren't simply created by a single light source, but vary across the surface of the object.

We can simulate the effect of metal by drawing a stepped curve that reproduces the way metal reflects the light. On the following pages we'll look in more detail at how to get the best out of this technique; here, we'll simply turn this dull plastic monitor into a chrome-plated version.

5 Click further along the curve once more, and drag upwards to make the high point for the final step. At this

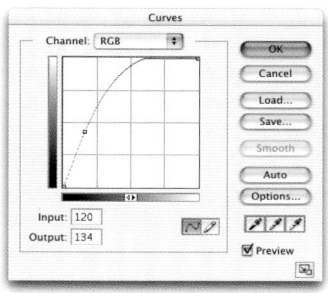

to make this steep curve. The image will appear very washed out at this stage, but it's just the initial step – it will all make sense later.

2 Now click a little further along the curve, and drag downwards as shown in the dialog. This will now make the image very much darker and

more contrasted. So far, we've created the first of what will become three peaks; we'll go on to build the other two to make the metallic effect work.

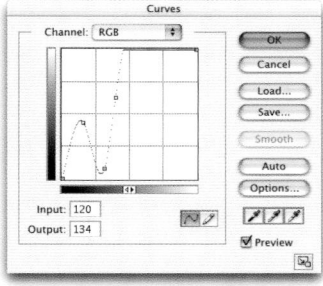

again the image will appear washed out: but the data is all still there, and we can continue to manipulate it.

4 Click further along, and drag down to complete the second step of our staircase. Now the image is beginning

to look far more shiny; but it still looks like it's made of plastic rather than metal.

stage, we can begin to see the metallic effect taking shape, although the image still looks too bright.

6 Finally, click in the middle of the remaining part of the curve, and drag downwards. Now we've completed

the effect, and that dull metal monitor looks like it's made of gleaming chrome.

MAC WIN BOTH

Metal with Adjustment Layers

1 This original Dalek model has been painted using what the tin claimed was a metallic paint. But when it was photographed, the result looked dull and lifeless. We can use Curves again to bring the shininess back.

CREATING METALLIC EFFECTS using the Curves technique described on the previous pages works fine, but gives us little control over the result. It's far better to draw the Curves on an Adjustment Layer: not only can we mask and change the mode of the effect, we can always go back and change the shape of the curve at any time. Here, we'll use this system to make our plastic Dalek look more like the real thing.

4 As expected, the Curves effect has produced some harsh pixellation. But because we applied it on an Adjustment Layer, we can modify the target layer to fix the problem. After locking the transparency of the Dalek using ▨, apply a small amount of Gaussian Blur (a 1-pixel radius maximum).

2 Create a new Curves Adjustment Layer by selecting it from the pop-up menu at the bottom of the Layers palette, and draw the same curve as we used on the previous pages. Here's the problem: the Curves effect has altered the color component as well, resulting in an ugly rainbow effect.

3 Because it's an Adjustment Layer, the problem is easily fixed. Simply change the layer mode (from the pop-up list at the top of the Layers palette) from Normal to Luminosity. Now, the Curves effect only affects the brightness and contrast of the underlying layer.

5 Each Adjustment Layer comes with its own mask, which works precisely like a standard layer mask. We can use this to paint out the Curves effect on unwanted areas – the end of the suction cup, the orange light and the highlights in the black hemispheres on the Dalek's body.

6 The skirt still looked rather dull and lifeless. Easily remedied: we simply use the Burn tool to add a little shading to that area. Because we're looking through the Adjustment Layer, we can see the effect of the Curves as we paint with this tool.

181

Metal with Layer Styles

MAKING CONVINCING METAL TEXT IS often seen as a kind of Holy Grail among Photoshop artists. Here, we'll look at how to make metal with Layer Styles alone. The advantage of this method is that the text remains editable; and the style itself can easily be adapted to suit any purpose.

If this process seems a little long-winded, you can always cheat – after all, that's what this book is all about. I've included this style on the CD that accompanies this book, so you can just load it up into your copy of Photoshop and start using it straight away.

1 Begin by creating your base layer - in this case, it's live text. Open the Layer Style dialog and add an Inner Bevel, sized to suit your artwork. I've also added a drop shadow for a more three-dimensional effect.

4 To give some sheen to the inside of the lettering, click the Satin tab and apply a bowl-like contour. You'll need to experiment with the distance and size to get the right combination, so just drag the sliders until it looks right.

5 To apply a gold color, we'll make a new gradient. Click on the Gradient Overlay section, and make a subtle gradient of alternating bars of light and dark yellow to complete our gold effect.

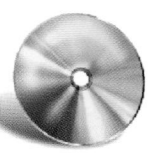

You'll find the metal style in the CD folder for this chapter, called Cheat Metal.asl. Use Photoshop's Preset Manager to load this style, and it will appear in your Styles palette. It's preset for silver, as in step 6; to turn this to gold, uncheck the Color Overlay component in the Layers palette. Note that you'll almost certainly have to adjust the Bevel size, as in step 7, to suit the size and resolution of the illustration you're working on.

2 Now to liven it up. In the Shading section of Bevel and Emboss, click on the Gloss Contour icon and change it to a bumpy map such as this one, which adds sparkle to the lettering's bevel.

3 Next, we're going to add some reflection to those bevels. Click on the Contour section, and use the pop-up Contour icon to choose this sort of shape for our curve. That plastic image is beginning to look more like metal.

6 To turn the gold into silver, add a Color Overlay. Go to the blue section of the spectrum, and choose a gray with only the smallest hint of blue in it to avoid too much color creeping in.

7 Because we're working with live text, we can change the lettering or font as we need to. Here, I've also increased the size of the bevel to make the lettering look lumpier; the choice is up to you.

183

Metal with Lighting Effects

THE LIGHTING EFFECTS FILTER is a useful tool for adding light and shade to an image: simply point the spotlights where you want them and adjust the settings. But the hidden function of Lighting Effects is its ability to use Alpha channels as bump maps to simulate three-dimensional images.

An Alpha channel is an additional channel (in addition to Red, Green and Blue) that Photoshop uses to store selection data. Some image libraries distribute CDs with their cutout information stored as Alpha channels rather than paths, because the channels can include transparency and fuzzy edges rather than just hard outlines.

The illustration above accompanied an article for PC Pro magazine about the man who invented the mouse: the graphic border was produced using the method shown here.

1 First make a new Alpha channel by clicking the icon at the bottom of the Channels palette. Since Lighting Effects only works in RGB, this will be Channel 4; its default name is Alpha 1. All the elements can be drawn directly on the channel, although you'd find it easier to create them as standard layers and then paste a merged copy into the channel afterwards. A faint application of the Clouds filter has been added to the background disc, as we'll see later.

4 Here's the result of applying the filter to our Alpha channel: those simple shapes and letterforms now look convincingly three-dimensional. Notice the difference in texture between the flat vertical bars and the background of the coin, to which the Clouds filter had been applied: this filter prevents large flat areas from looking too shiny and synthetic.

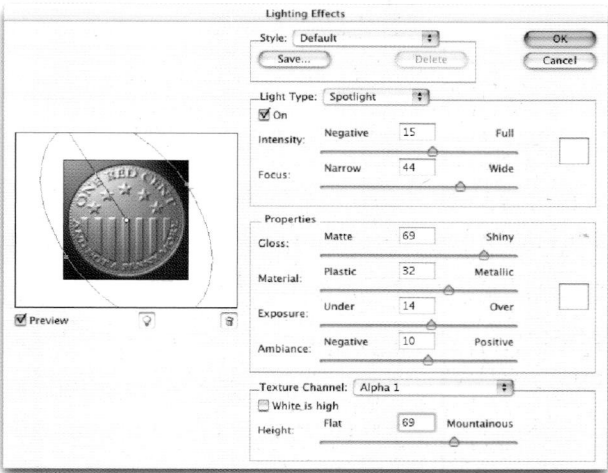

2 The next step is to blur the Alpha channel. This is necessary to prevent the final image showing hard edges around the contrasted elements; on the next page, we'll look in more detail at the effect of applying different amounts of blur to a bump map image. Now go back to the main RGB channels (you can use ⌘ ~ ctrl ~), create a new layer and fill the disc area with white – Lighting Effects won't work on an empty selection.

3 Open the Lighting Effects dialog, and specify the channel Alpha 1 from the Texture Channel pop-up list at the bottom of the dialog window. The default setting is White is High, which means that lighter areas will appear more raised than dark areas; I find it easier to work the other way around, so uncheck this box. Adjust the settings using the sliders until you get a clear effect with no burned-out hotspots.

5 Applying the same Curves technique as described on the previous pages brings out the shininess in our coin, making it look less like plastic and more like metal. That Clouds texture is also accentuated by the Curves process, giving the coin a pleasing battered effect.

6 Since the elements were all created as separate layers, it's easy to select them by holding ⌘ ctrl and clicking on each layer name in the Layers palette, holding *Shift* as well to add new layer outlines to the selection. Now the selected areas can be recolored using Color Balance (or any of the other color tools) to make our coin come to life.

HOT TIP

Lighting Effects only works on RGB images, so if you're working in CMYK you'll need to convert to RGB first. Even if you're creating a black and white illustration, you'll have to change it to RGB to use the filter, then change back to grayscale afterwards.

SHORTCUTS
MAC WIN BOTH

185

More on Lighting Effects

ALMOST ANY TEXTURE can be used as the basis for a Lighting Effects operation, as is shown here: Clouds and Noise are just two ways of generating natural-looking surfaces. Notice, as well, how the simple repeated screw heads shown in the final example produce an array of screws that are all lit slightly differently as their distance from the virtual light source varies.

The key to making artwork render well in Lighting Effects is to use just the right amount of blur on the Alpha channel that will be used as a texture map. So first, we'll look at how different amounts of blur affect the final appearance of the rendered artwork.

1 When no blur is added to the Alpha channel (above), the result after applying Lighting Effects (top) is harsh, with ragged, stepped edges.

2 Applying a 1-pixel radius Gaussian Blur to the Alpha channel softens the edges, and results in a far smoother image after Lighting Effects is applied.

6 The Clouds filter (above) produces a pleasingly random surface (top) when used as the basis of a Lighting Effects channel. It's a useful way to create an instant stone effect, which can be easily modified until it produces exactly the result you want.

7 Because the Alpha channel stores selections, we can press ⌥⌘4 *alt* *ctrl* 4 to load up the lighter areas for us (top). We can now recolor them, then inverse the selection and recolor the rest to create a more dynamic effect (above).

3 The greater the amount of blur, the more raised the result will be. Here, a 2-pixel blur results in a significantly taller object.

4 Increasing the blur to 4 pixels produces a result in which the edges thicken too much: this looks like it was cast from an old mold.

5 An 8-pixel blur is clearly a blur too far: Lighting Effects has trouble making sense of this, and the result is merely fuzzy.

8 Even the tiniest variations in shade can have dramatic effects. The 2% Gaussian Noise (above) is too faint to be seen clearly here; but the result (top) is a grainy, textured surface.

9 Increasing the Gaussian Noise amount to 20% produces a far more striking result: here, we've produced a rough, stony surface in just a few seconds using this technique.

10 The screws around this perimeter were created by dabbing a soft brush once, then drawing a diagonal line across it. Because the letter M is brighter than the background, it appears to be recessed rather than raised.

187

Rust, grime and decay

So FAR, WE'VE LOOKED at ways of using Lighting Effects to make bright, shiny objects. But it can just as easily make metal surfaces that look as if they've been knocking around for a few years. Making objects appear to be old and used can greatly add to the realism of an illustration.

Starting with this simple sign, above, we'll run Lighting Effects a couple of times and hopefully end up with something that looks like it belongs in the real world.

1 The first step, as always, is to blur the artwork after it's made into a new channel. Because our sign is supposed to be pressed out of a sheet of metal, we don't want too much variation in height: there are basically just two shades here, black and white.

4 Now we'll return to our Alpha channel, and add some noise to it. This will form the basis for the rust, but we don't need a lot of noise: as ever, a small change in a channel makes a huge difference when Lighting Effects is applied. Here, a Gaussian Noise amount of 6 has been used.

2 Here's the result of applying the Lighting Effects filter after the previous artwork was saved as a channel. So far, it looks more like plastic than metal; but since we want it to look painted rather than polished, we won't apply the Curves as in the previous examples.

3 Because the channel that Lighting Effects used can also store selections, we can press ⌥⌘4 alt ctrl 4 to load up the white areas as a selection. This is tinted using Hue/Saturation; the selection is then inversed using ⌘Shift I ctrl Shift I and the raised areas brightened up.

If you don't want your rust to look as extreme as this example, stop after step 3 and create a new layer, set to Hard Light mode and grouped with the sign layer. You can now paint on this layer using oranges and browns to create rust-like shading on the layer beneath.

5 On a new layer, the Lighting Effects filter is applied again. This time the result is tinted brown, once again using the Hue/Saturation dialog. There's no need to load up specific areas using the channels: we want to tint the entire image.

6 Now it's just a matter of making a layer mask for the new brown layer, and painting it out selectively to reveal the original sign beneath. After using the Brush tool to paint out large areas, turn to the Smudge tool to fine-tune the result by smudging streaks of rust into the mask.

SHORTCUTS
MAC WIN BOTH

189

Embossing with EyeCandy

1 Here's the original bottle, complete with plastic tube. It would have been hugely difficult to erase the tube without damaging the logo; so I ignored the logo.

2 The tube and logo were both cloned out, and the overall contrast increased to make the bottle more appealing. I also added a slight red tint to the perfume inside.

WHEN PERFUME company Amouage wanted a new series of advertisements for their products, they had all the bottles photographed in a studio. But the photographer couldn't get the plastic tube out of the bottle without breaking the bottle; so I had to remove it in Photoshop.

To get the metallic effect on the logo, I used the plug-in filter EyeCandy 4000, which produces gleaming chrome. You can read more about this innovative and useful tool in Chapter 12, Carry on Spending.

6 The original logo was gold leaf placed onto molded glass, so I had to reproduce that effect too. The logo area was enlarged by a few pixels, smoothed and made into a new layer, then embossed using Layer Effects.

7 When the gold was put back into position, I was able to reduce the opacity of the glass embossing from its original rather overstated appearance to something that would look more plausible.

3 I redrew the Amouage logo in Adobe Illustrator, using some flat artwork as a template. Of course, I only needed to redraw one half; the other was made simply by mirroring the first.

4 This logo was then brought into Photoshop, and the EyeCandy 4000 Chrome filter was applied to get the shiny effect. It's the fastest way of making shiny metal that I know of.

5 The logo was distorted on the bottle to fit the viewing angle of the original logo, and tinted so that it matched the color of the shiny gold lid of the bottle.

HOT TIP

If there's one lesson to be learnt from this example, it's that you don't always have to do things the obvious way. I spent a long time trying unsuccessfully to remove the tube from around the logo before I realized that I could simply replace the logo. The object was to produce a beautiful and appealing image, rather than to show photographic truth.

8 Although the bottles had been photographed from several angles, I didn't want to have to go through the clean-up process for each one. So I split the bottle into three components, and distorted each separately.

9 Matching the new perspectives of the front and side of the bottle was easier than might have been expected: the reflections and refractions in the glass worked even when distorted.

10 The only element I took from the other photographs was the lid: it would have been almost impossible to make the existing lid fit the new perspective, given its complex geometry.

191

Reflection on a knife edge

1 The knife blade and the handle were first drawn as two separate layers, using the Pen tool to create the outlines. The hole in the blade was made with the Elliptical Marquee.

THE MOST ABSTRACT CONCEPTS are often the hardest ones to illustrate. This illustration for the Sunday Telegraph was commissioned to accompany a feature on how directors of top companies were facing pay cuts. Rather than going down the obvious, cartoony route of showing a miserable exec pulling out his empty pockets, the art editor came up with this idea of a sushi knife slicing through a pile of banknotes.

The property that makes flat metal look metallic is the reflections seen in it: but here, I didn't want any extraneous elements to confuse the issue. So the effect had to be created simply using light and shade, with only the copied banknotes making the reflection element.

4 After increasing the contrast on the blade, I selected a band at the bottom with the Lasso tool and added strong shading with Dodge and Burn to make the knife edge.

7 The banknotes were stacked up and shaded using the techniques shown in the Lock and Load section of Chapter 1, Natural Selection.

2 Basic shading was added using the Dodge and Burn tools; the strong diagonal slant gives the impression of light on a reflecting surface.

3 The blade selection was loaded up by ⌘ ctrl clicking on the layer name, and then nudged down and to the right; the inverse was shaded using Dodge and Burn again.

5 A new layer was filled with white, grouped with the blade and set to Multiply. The Noise filter was followed by vertical Motion Blur to make the brushed steel effect.

6 The first of the banknotes was simply distorted using Free Transform so that it lay in a convincing perspective across the knife blade.

8 The top banknote was cut in half, stepped up, and the process repeated each side of the blade: an additional couple of notes were distorted to fly up from the pile.

9 Copies of the top note and the sides were flipped and distorted and then grouped with the blade, and their opacity lowered so that they looked like dull reflections.

CASE STUDY

HOT TIP

The hardest part of creating this image was making the reflection of the topmost banknote marry correctly with the original: because the note had been distorted, it was difficult to handle the reflection. The solution was to cheat: different sections of the reflection were distorted separately, so that the key elements matched those in the original note.

SHORTCUTS
MAC **WIN** **BOTH**

Photographing shiny objects

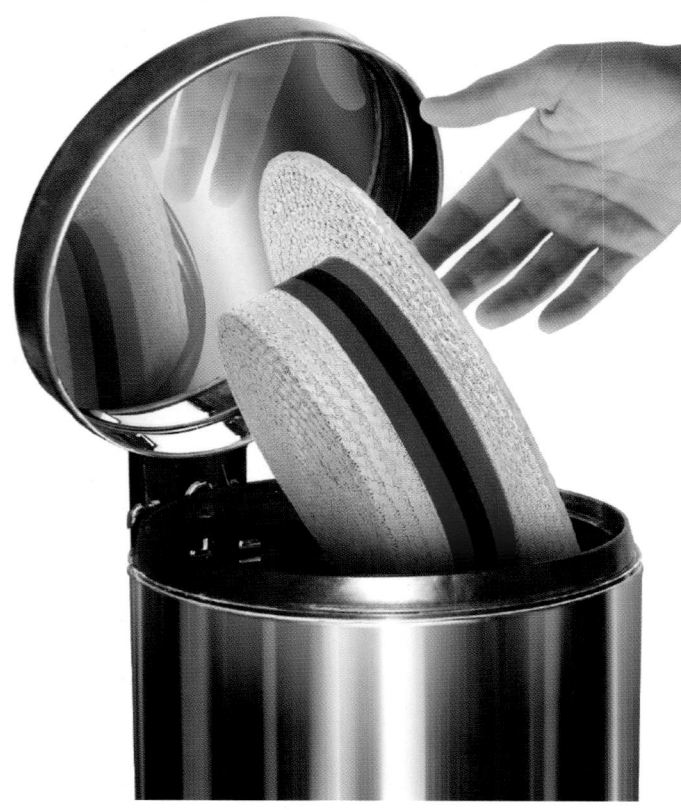

1 When you photograph a metallic or other shiny surface, the one thing you can't do is use a flash: the resulting glare would overwhelm the image. Instead, I dragged this trash can over to a window, holding the pedal down with my foot while I leant back and took the picture (memo: must invest in a decent house brick).

WHEN THE GUARDIAN RAN A FEATURE about a lifelong socialist taking the decision to send their child to a private school, the cover image was a simple cutout of a boater – the kind of hat traditionally worn in selective girls' schools. The following week, they countered with a story by a journalist who had recently taken his child out of the private sector, and decided to illustrate it with an image of the same boater being tossed into a trash can.

Although this was in many ways an easy montage to create, the texture of the trash can was the hardest element to reproduce. Photographing shiny objects can be a test for even the most hardened photographers; there is a simpler method.

5 Getting rid of the reflection of the carpet in the lid involved a couple of stages. First, a new 'mask' layer was made, drawn with the Pen tool to fit exactly the shape of the inside of the lid (minus the reflection of the can itself). A copy of the blurred front was then grouped with this mask layer, and some Gaussian Blur applied to make the reflection less sharp.

2 Cutting the background out was an easy enough process using the Pen tool to draw a smooth path, and the image needed just a little brightening with Curves to lighten it up. But the reflection remained smeary, and showed my hallway and carpet all too clearly. For a perfect image, it was necessary to clean up all those distracting elements.

3 The solution was to take a section of the front of the can and make a new layer from it, and then apply Motion Blur to it. I then stretched the result until it was tall enough to cover the whole front of the can. By using the original as the basis for the blur, it was possible to keep the same color range as appeared in the rest of the object, so it would blend in well.

4 The blurred texture was moved into position, and a layer mask made so that it exactly fitted the front curve of the trash can. Because the can had been photographed slightly from above, it was necessary to apply a slight perspective transformation on the blur to make it taper towards the bottom. The result is a convincing brushed metal effect.

HOT TIP

Rather than using Motion Blur to create the brushed metal effect, it would have been possible to either draw the surface from scratch, or use a photographed section of a shiny pole. But although the can's surface is, in theory, just black and white, there's actually a huge range of colors that define it. Using a blurred copy of the original is the best way to ensure that the color range matches the rest of the can.

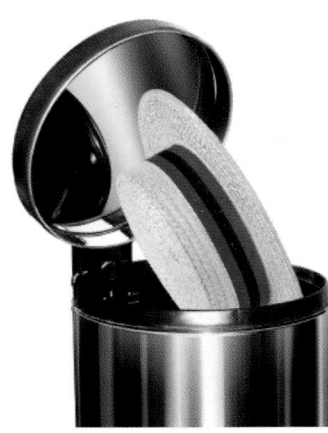

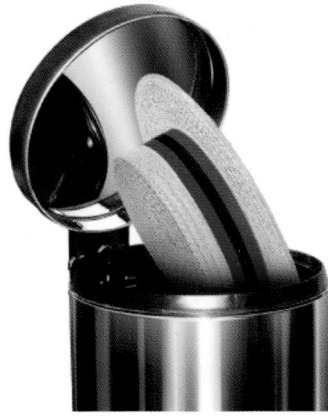

6 Placing the hat in the trash can was achieved by drawing a layer mask that exactly fitted the front of the can, up to the plastic rim. By clicking on the link between the hat and its mask in the Layers palette, the hat was separated from the mask, and so could be moved around independently.

7 Because the original hat had been photographed the right way up, the light naturally fell on it from above. Turned upside down, the top – previously the brightest part – now had to be darkened up. Rather than using the Burn tool, I made an elliptical selection of the top and used Curves to darken just this section until it looked convincing.

8 The reflection of the hat was added on top of a new mask, this time a copy of the entire inside of the lid. The hat was then masked where it would be hidden by the rim of the lid, and shading applied to it with the Burn tool. Finally, a third copy of the blurred front was placed above the reflected hat and grouped with the lid mask to dim the reflection slightly.

SHORTCUTS
MAC **WIN** **BOTH**

The art of woodturning

1 This plinth has been created using Adobe Dimensions, and imported into Photoshop, For more about that program see Chapter 10: The Third Dimension.

2 A scan of a piece of wood is placed on top of the plinth layer, and grouped with it by pressing ⌘ G ctrl G or by clicking the line between the layers in the Layers palette.

ALMOST ANY OBJECT can be turned into wood simply by wrapping a piece of wood around it and changing the layer mode so the original object shows through. Unlike other textures, though, wood has a grain which needs to follow the contours of the base object. To see how the bust was made, see The Philosopher's Stone later in this chapter.

6 A new section of wood is taken using a circular selection, which is then rotated 90° and Spherized to make it wrap around the base better. The circle is then squeezed to make this ellipse, which fits the base dimensions.

7 This base section of wood is then grouped with the plinth layer, and a new layer mask is added. We don't need to draw the mask again: simply duplicate and invert the mask that was created for the column layer.

3 Now we need to make the base layer show through, by changing the layer mode using the pop-up menu at the top of the Layers palette. This is Multiply: it's far too dark.

4 Changing the layer mode to Overlay produces a far better result. We can clearly see all the contours of the underlying object, while maintaining the wood texture.

5 Having the wood grain running vertically is fine for the column, but looks wrong on the capital and base. Using the Pen tool, I've created a layer mask to hide the top and bottom.

8 Once again, we set the mode of this layer to Overlay. The Spherized wood now fits the shape of the base perfectly; and because we inverted the column's layer mask, the two match together without a visible join.

9 To make the capital, we simply duplicate the base layer and then unchain the link between the layer and its mask. We can then drag the wood ellipse up into place, and the layer mask is already there for us.

10 All that's needed now is to add a little extra shading beneath the capital, and around the far side of the base of the plinth. This is painted directly onto the underlying plinth layer using the Burn tool.

Making a better impression

1 This may be an accurate representation of the Presidential Seal, but as it stands it's hardly a beautiful object in its own right. Let's take this flat artwork and make it a little more attractive by embossing it.

W E CAN USE THE TEXTURE of a wooden surface as the base for any artwork, turning a two-dimensional design into one that looks as if it's been carved in wood. In the example above, I've used the complex outlines of this coat of arms to create a solid-looking object. The original design for this crest was in black and white, so the embossing has to do all the work.

The Seal of the President of the United States, by contrast, has no interest in its outline – it's simply a round disk. Unlike the crest, it does have the advantage of color to create more interest, and we can make use of this.

4 Now that the seal detail is in our Alpha channel, we can load it as a selection using ⌘ ⌥ 4 *ctrl* *alt* 4; the brighter areas will be more fully selected than the dark areas. Returning to the wooden disk, we can now make a new layer from that selection using ⌘ J *ctrl* J. This layer will appear with the bevel from the disk applied: as it stands, it's far too blobby.

2 To begin, we'll take the same piece of wood as we used in the previous example. After stretching it so it covers the seal, hold ⌘ *ctrl* and click on the seal's name in the Layers palette to load up its selection; then inverse the selection using ⌘*Shift* *I* *ctrl**Shift* *I* and delete the outside. The bevel is applied using Layer Effects, with a 15-pixel bevel to give the disk a sense of three-dimensionality.

3 Now we're going to turn the original seal into a selection. Copy it, then make a new Alpha channel by clicking on the icon at the bottom of the Channels palette; then paste the copy in place, where it will appear in grayscale. This can now be used as a workable selection.

5 Double-click the layer effect in the Layers palette to open the dialog, and change the numbers. Here I've increased the depth from the default 100% to 200% to make it stronger; but I've also reduced the bevel size to just three pixels, so that the detail remains crisp. Some of the detail has failed to appear after the selection process, such as the wings of the eagle; but the next step will fix that.

6 Finally, move the original seal layer to the top. We need to change its layer mode so that the wood and beveling show through. Once again, we have a choice of layer modes open to us: although Overlay worked on the example on the previous page, it's too strong here. Instead, I've opted for Soft Light, which brings back much of the original color while retaining the subdued sense of stained wood.

199

Timber floors with varnish

I HAVE A CONFESSION to make: I only have one piece of wood. At least, there's only one piece I tend to use for all my wooden needs: it's this image of the back of an old pencil box I scanned in 1989. You can still see the screw holes that held the base to the sides – it wasn't even a particularly sophisticated pencil box. The point is, though, that you really don't need a lumber yard full of different types of wood; as long as the piece you're using has a strong enough grain, it can be put to most purposes fairly well.

1 To turn this piece of wood into a floor, the first step is to mark out the planks. It's easiest to draw a rectangular selection in QuickMask and fill it, then copy it across: that way you can be sure they're all the same size.

2 Make a new layer from the selection. I've used the Bevel and Emboss section of Layer Styles to add the shading lines. Be sure to keep the Highlight value fairly low, or you'll find it too glaring when the floor is finished.

6 Adding the nails is optional, but can help with the sense of flooring. On a new layer, make a small circular selection, fill with a mid gray and add a little shading to it; then duplicate three times (you can see the nails on the fifth plank from the left).

7 Copy that group of nails to all the other wood joins by holding ⌥ *alt* as you drag with the Move tool. Be sure to hold the mouse down within the nail area before dragging, or you'll create a new layer each time you drag. Finally, merge all the layers.

3 Now inverse the selection, and make a new layer from the wood base: apply the same beveling by dragging the layer effect from the previous layer onto this one. Finally, flip the new layer vertically so the grain lines don't match up.

4 Split one set of floorboards into irregular lengths by making rectangular selections, and make another new layer using ⌘ J ctrl J; the bevel will automatically be applied to the new layer.

5 Repeat the process for the other set of planks, and adjust the brightness of both to make more irregularity in the planks.

HOT TIP

Applying a perspective distortion to the wood necessarily makes it narrower at the top than at the bottom. If your target image is wider than the original wood flooring, duplicate the layer and move it horizontally so the two overlap by about an inch; then make a layer mask to blur the join lines and merge the two layers to make a floor that's nearly twice as wide.

8 Your floor is now ready to be inserted in whatever document you want. Use Free Transform to make it fit the space: hold down ⌘ ⌥ Shift ctrl alt Shift while dragging one of the top corner handles to create the perspective distortion. A floor like this can be made to fit in just about any space you want to fill. This wall, incidentally, was easily made using the Texturizer filter.

9 With the shading in place, the floor looks very much more realistic. Applying the varnish is far less messy than working with the real thing: simply make a reflected copy of whatever object you're placing on the floor, and set its Layer mode to Soft Light for that glossy appearance. For more on how to achieve this effect, see the reflection sections in Chapter 7, Shiny Surfaces.

SHORTCUTS
MAC WIN BOTH

The philosopher's stone

1 Choosing the original photograph was the key to the success of this project. I immediately rejected one that showed the philosopher smiling: the ancient Greeks never bared their teeth. This image showed the right sort of side lighting, without any strong shadows.

2 The first step was to cut out the head, and knock out the color using the Desaturate command ⌘ *Shift* Ⓤ *ctrl* *Shift* Ⓤ. I then copied a section of his forehead to get a suitable shade and texture, stretched it and cut it to the shape of his neck and shoulders.

WHEN THE INDEPENDENT newspaper wanted to run an article comparing ancient and modern philosphers, they had busts of the ancient Greeks – but only a photograph of contemporary philosopher Alain de Boton. It seemed like a good idea to turn him into stone to match his predecessors, and achieving the task in Photoshop was obviously going to be quicker and cheaper than finding a sculptor who could reproduce his likeness in marble in time for a 5pm deadline.

6 The pupils were painted in by making elliptical selections within the eyes, and using the Dodge and Burn tools once again to make them look recessed. Care was taken here to make the shading match the surrounding area as closely as possible – the shading had to be kept subtle.

7 This scan of a chunk of marble would add both texture and color to our bust. Because the head and shoulders are two layers, I couldn't simply group the marble with the base; instead, I made a layer mask encompassing both the underlying layers.

3 Carved hair is very different from the real thing, so I took another section of forehead and this time shaped it to cover the hair and eyebrows of the original. I also patched the forehead using the Clone tool to hide the stray hairs there.

4 Adding shading using the Dodge and Burn tools made the hair look carved in stone: I also added muscle lines to the neck. Remember you can temporarily access the Dodge tool while using Burn by holding ⌥ alt as you paint.

5 The eyes also needed painting out, again by cloning texture from the forehead; shading was added afterwards to make them look more three-dimensional. I also cloned over the lips at a low opacity to tone them down slightly.

HOT TIP

Figures carved in stone show light and dark areas only where these are caused by direct light and shadow: unlike real faces, there's no variation in skin tone or hair color. Highly contrasted original photographs don't work well; you should choose a fairly evenly lit image if possible, adding extra shading where you want it later.

8 Multiply, Hard Light, Overlay and Soft Light modes would all have allowed the image to show through the marble. The choice is determined by each instance; in the end I chose Soft Light, reducing the opacity to 70% so that the strong texture in the marble didn't swamp the image.

9 To strengthen the whole image, I made a new Adjustment Layer and increased the Contrast while reducing the Brightness. Adjustment Layers have the advantage of being editable later, which meant I could always remove it if it needed altering or wasn't working.

10 Although I wanted the bust to look like pale marble, it's just as easy to make it appear to be modeled out of granite or any darker material. Here, I've taken the same piece of marble and changed its mode to Multiply to get an altogether stronger effect.

SHORTCUTS
MAC WIN BOTH

Carving words in stone

THIS ILLUSTRATION WAS FOR THE COVER of the Sunday Times Magazine. The shape of the plinth was modeled in Dimensions (see Chapter 10), and the stone texture wrapped around it. The pigeon perched on the top is simply there to add a sense of scale.

Carving text in stone is now easier than ever, thanks to the Emboss feature in Layer Styles. Here, we'll look at how to make a gravestone from scratch, in just a few simple steps.

1 This piece of stone is nicely mossy at the bottom, and will do perfectly as the basis for our grave. I tend to carry my digital camera with me whenever I'm likely to stumble upon an interesting building or texture.

4 After creating your text, render it into a layer and then distort it using Free Transform to match the perspective of the tombstone. This text is loaded as a selection by ⌘ *ctrl* clicking on its name in the Layers palette, and the selection made into a new layer from the stone layer.

2 Because we want this grave to be somewhat rough around the edges, draw the outline using the Lasso tool to get the unevenness that couldn't be achieved with the Pen tool. This selection can then be made into a new layer using ⌘ J *ctrl* J .

3 The same selection is copied from a different part of the original stone material, and offset to make the edge. Shading can be added using the Dodge and Burn tools, making it darker on the undersides of the edge, and lighter on the upper faces.

Choose an appropriate typeface for your lettering to make the whole effect more convincing. Sans serif lettering is virtually never used on graves, for good reason: it's the serifs that are carved first, and which prevent the stone from splitting as the thick letters are incised. This is, in fact, the reason why the ancients invented serif lettering in the first place.

5 After darkening the stone lettering slightly to make it stand out better, use Layer Styles to create the carved effect. Use Emboss rather than Bevel for this, as it makes a more convincing carved effect; remember to set the position to be Down rather than Up, so it's lit from above.

6 When the background is added, it's simply a matter of blending the stone into its surroundings. Darken the edge slightly, and add a shadow on the grass behind it; the grass is brought in front of the base of the stone using the technique described in the Chapter 2, Hiding and Showing.

SHORTCUTS
MAC WIN BOTH

205

The point of illustration

BRIEFS FOR ILLUSTRATIONS come in three basic varieties. There are those who will send you the copy for the article in question, and wait for you to come up with a visual idea to accompany it. There are art editors who will work out the idea on their own, get it passed by the editor, and sometimes even supply a rough sketch of what they want. And finally there are editors themselves, who will insist on the first idea that pops into their heads and expect it to be turned into a work of art.

I have nothing against newspaper editors. Many of them are charming individuals who are great conversationalists and probably make outstanding parents. But they frequently lack the ability to think in visual terms. One of the illustrations I'm frequently asked to create is a montage showing a politician taking money out of someone's pocket (this usually happens around budget time). I pause, take a deep breath and explain patiently that the problem is that newsprint technology has yet to embrace the wonders of animation. There's no difference, in a still image, between a politician taking money out of someone's pocket and putting money into it. This has to be explained with great tact, of course, since ultimately these are the people who pay for my children's overpriced trainers.

It comes down to a question of what's desirable, what's visually interesting and what's humanly possible. The purpose of an illustration in a magazine or newspaper is to draw the reader into the piece and to make them want to read the article to which it's attached. It should express the sense of the article without giving away the punchline, and without prejudging the issue (that's best left to the journalist who wrote the story). An illustration in a printed publication is not a work of art; it's an advertisement for the story, and its job is to sell the story to the reader. Sometimes – at the best of times – it can be a work overflowing with artistic integrity and perfect composition. But if it doesn't relate to the story in question (and make that story seem interesting) then it's failed to do its job.

Those taking up photomontage for the first time frequently fall into the trap of piling on evocative imagery in the hope that the result will be poignant. I've seen student artwork that incorporates a baby, a flaming pile of dollar bills, a nuclear explosion and a McDonald's wrapper within one image. Look, they say, all human life is here: it must mean something. But this is the visual equivalent of Tchaikovsky's 1812 overture with added reverb and a drum'n'bass backing: the cacophony simply prevents us from seeing the issues.

Labeling, above all, is to be avoided at all costs. The days when you could depict Uncle Sam wearing a hat with Government printed on it rowing a boat labeled Economy while tipping out a handful of urchins labeled Unemployed rightfully died out in the early nineteenth century – and yet illustrators are still asked to label their artwork today. I nearly always refuse, unless the wording can be incorporated into the image in a meaningful way. The destruction of a building bearing the sign Internet Hotel seems, to me, to be a reasonable request; the sinking of a boat labeled Fair Deal does not.

When you execute an original idea successfully, you can confidently expect to be asked to reproduce it within a few months. I've drawn cakes for the 20th birthday of Channel 4, the 10th birthday of Sky television, the carving up of Channel 4 and the first birthday of satellite channel E4 – all for the same newspaper. I've blown up computers, telephones, televisions and video recorders, and I've tattered the flags of at least half a dozen of the world's top blue-chip companies. And I've completely lost count of the number of company logos I've pasted onto the backs of poker cards.

The hard part is keeping each new version as fresh as the first. I've often made the mistake of assuming that readers will find the repetition of the same idea tedious: but it is a folly, for the stark truth is that readers of publications cast barely a glance at the image that an illustrator has sweated blood over. Illustration, for the most part, is simply the ephemeral wrapping that's discarded once it's done its job.

Paper and fabric

IN THE LAST CHAPTER we looked at hard surfaces – metal, wood and stone. Paper and fabric, by contrast, are floppy, malleable substances that bend, crease and crumple. It's getting these creases and wrinkles right that's the key to making paper look like it's really made of paper, and that includes banknotes as well as letters and documents.

The fabric section of this chapter covers clothes, flags and banners; all the objects that hang or flutter in an irregular manner. We'll examine the easiest way to make a flat, PostScript drawing of a flag look like the real thing fluttering in the breeze, using simple shading techniques combined with distortion filters.

9 Paper and fabric

How to make a load of money

SCANNING BANKNOTES is easy: you just lay them on a flatbed scanner (but watch out for copyright – some governments take a dim view of reproducing their currency). Making them look like they exist in the real world takes a little bit more effort.

To add more interest and realism to banknotes, we can use the Shear filter to give them a bit of a twist. This useful filter makes objects ripple convincingly, adding a pleasing third dimension to otherwise flat artwork; when appropriate shading is added, a single banknote can be made to look like a whole pile of separate notes. Here, we'll work on a 500 Euro note.

1 The Shear filter only works horizontally, so before you apply it you need to rotate the artwork by 90°. Increase the Canvas Size, if necessary, to allow extra space at the sides for the image to distort into.

2 When you first open the Shear dialog, you'll see a straight line. Click in the middle of this line and you'll create an anchor point: drag this point, and you'll make a smooth curve that precisely bends the artwork.

5 Repeating the Shear filter with different settings can make the banknote ripple in different ways. Here, two different applications of the filter show how the same bill can be distorted into different forms. The Shear filter is far more controllable than the Wave filter, as it allows us to draw precisely the curve we want; and the preview's large enough to see.

3 If you're working on an element within a larger montage, draw a marquee selection that encompasses the layer you want to work on, so the Shear filter only affects that area of the artwork.

4 Shading added to the result, using the Burn tool, gives the sense of the sheared object being truly three-dimensional. Rather like those gestalt optical illusions, you can choose to see the image in one of two ways. The eye will interpret shaded areas as being recessed, and unshaded areas raised: so in the top example above, the raised ripple is on the left; in the lower example, it appears to be on the right. In fact, it's the same bill both times.

HOT TIP

You don't need to apply the Shear tool separately for every banknote in a pile: three or four sheared versions are usually sufficient. Distorting the notes using Free Transform will be enough to make them all look different. When you combine several notes in one montage, add shading using the Burn tool to enhance the effect.

6 This illustration for the Sunday Telegraph was to accompany an article about the increased cost of motoring following a rise in the price of crude oil. The banknotes were all distorted using the Shear tool, as described here: those coming directly out of the pump's spout were also sheared horizontally. Each note was then distorted using Free Transform to achieve a sense of perspective, and shading was added beneath each note to make it stand out from the note below. Adding the coins simply made the result look more dynamic.

SHORTCUTS
MAC WIN BOTH

211

Judging a book by its cover

1 The paper is created in the same way as the cards were stacked up in Chapter 5. The difference here, of course, is that the pages are stacked neatly rather than randomly: select a shadowed page and then nudge it up and left a couple of times with the cursor keys, holding ⌥ *alt* to make the copies.

WHEN AUTHOR SALMAN RUSHDIE visited New York, he expected to be fêted: instead, he was slated. For the story about his mishap in The Independent, I was asked to produce a book cover showing the headline for the article, in the style of Rushdie's latest volume.

But hardback books are hard objects to photograph. Apart from the problem of getting the right angle, the close trimming of the paper makes it look like a solid block rather than individual pages: so there was no option but to draw the book from scratch. And here's how it was done.

4 A copy of the cover is made, moved behind it and filled with a dark blue. This is the edge of the board beneath the paper wrapper: it's only just visible, but it makes the difference between a paperback and a hardback. We'll use a similar technique for creating the back cover.

2 The cover is assembled using as many layers as required; these are linked and made into a new layer set. Duplicate this set and merge its contents; then distort the resulting composite layer to fit the shape of the book cover. The reason for this seemingly tortuous route is that the original cover is kept intact, so changes can be made later.

3 Shading on the edges of the cover helps to make it look as if it wraps around the hard boards. Using the Burn tool, click just above a corner, then hold **Shift** and click at the bottom of the same edge. A burn line will be drawn as a straight line between the two click points.

HOT TIP

Creating the cover as a separate element is the best way to build a book such as this. Sometimes, though, you don't know one element, such as the title, before you start. To make it easy to align new text and objects to the same perspective, first make a simple grid and distort it to fit the cover; then it's easy to align the new objects with that grid, which can be hidden afterwards.

5 Now for the shadow of the cover cast on the pages. It's worth creating this as a separate layer, grouped with the paper layer: paint straight lines with the Brush tool, set to a low opacity, in the same manner as outlined for the Burn tool in step 3 above.

6 The final elements are added to complete the book: the back cover, the spine, and the flaps that tuck beneath the board covers. I've also added some general shading to the cover using the Dodge and Burn tools to prevent it looking too flat and two-dimensional.

SHORTCUTS
MAC WIN BOTH

Paper: folding and crumpling

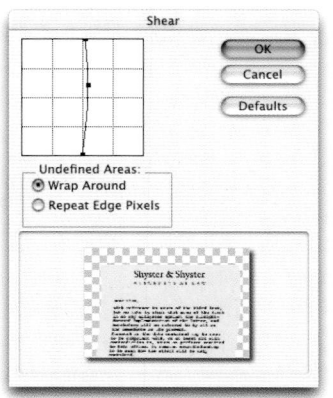

WHEN ART EDITORS are stuck for a visual idea, they fall back on a piece of paper with the concept written on it. An executive might hold a paper entitled Restructuring Proposal; a real estate agent might wield one with the word Contract emblazoned on it in red ink.

Whatever the wording on the paper, the last thing you want to do is to leave it as a flat sheet. Simply distorting it into perspective is rarely sufficient: this is paper, after all, and not a sheet of plastic; it bends, creases and deforms as it's handled.

Here, we'll look at a couple of different paper treatments: a simple fold, and the crumpled effect seen on a piece of paper that's been stuffed in a back pocket for too long.

1 Here's the business letter we'll use in both our examples. If you're going to use a letter, you'll obviously need some text on it. It doesn't usually matter what this is, as long as it doesn't begin Lorem Ipsum: readers may not recognize the fake Latin text, but the person who commissioned you certainly will.

2 Select just the top half of the letter and apply the Shear filter to it, using the technique described earlier in this chapter. When working on the top half of the paper, be sure not to move the anchor point at the bottom of the dialog box or the two halves will no longer match up.

6 To begin the Crumple effect, we'll use the Wave filter to distort the basic letter. This can be a confusing filter at first glance, because there appear to be so many variables: but it's quite controllable. The number of Generators determines the different number of waves; set to 1, the effect will be too regular and phoney. Because we want long, sweeping curves, raise the Wavelength levels: the higher the levels, the greater the length of each wave. You can use the Amplitude sliders to determine the wave height, but you'll get far more control by simply lowering the horizontal and vertical scale to make the wave effect less extreme.

3 After applying the filter, leave the top half of the paper selected and use the Burn tool with a large, soft-edged brush to add gentle shading above the crease line. Add a little more where the paper turns away at the top to give the impression of it bending over away from us.

4 Now select the bottom half of the paper, and apply the Shear filter again. You'll need to click the Defaults button to reset the tool to a vertical line; you can then add whatever distortions you want.

5 Now, with the bottom half distorted as well, add some shading to that half of the paper, again without deselecting it. You can also add a little shading elsewhere on the paper to give the sense of a gentle ripple.

7 Now use the Lasso tool to make irregular vertical selections. Don't make the lines dead straight: hold the ⌥ alt key and click points at intervals along the letter to make the tool draw straight selection lines between each point you click.

8 Now use a large, soft brush with the Burn tool to add the shading. Keep the brush on the deselected side of the selection line, so that only the edge of the brush has an effect on the paper. Don't paint exactly along the lines, but fade off away from the edges for an altogether more realistic appearance.

9 Now deselect, and use the Lasso tool once more to make a series of horizontal selections. Use the Burn tool once more to add the new shading within the selected area, once again being careful not to overdo the effect.

SHORTCUTS
MAC WIN BOTH

Folds and wrinkles

1 The original artwork was created on a rectangular banner, and the text layers were merged into it. This banner was then rotated and curved slightly using the Shear filter (see earlier in this chapter); Free Transform was then used to make the bottom corners fall together slightly.

FABRIC NEVER HANGS STRAIGHT. It's the folds, creases and wrinkles that give it its distinctive quality. But it's an appearance that's surprisingly easy to reproduce in Photoshop.

Glancing at the composite image above, commissioned by the Sunday Telegraph, you might think that the lettering had been distorted using some complex system to make it follow the fold lines in the checkbook. In fact, the illusion of creased text and a crumpled book is created entirely by the play of light and shade across it.

Here, we'll look at how to paint folds and creases into fabric to make it look like it's hanging down, using just the Dodge and Burn tools to create the effect.

4 Now for the shading. Use the Burn tool, and choose a medium sized, soft-edged brush. Lower the opacity to between 20% and 40% so the effect isn't too strong, and paint a shallow curve running from corner to corner, dipping into the banner.

7 Hold the ⌥ alt key again to use the Dodge tool, and paint another highlight above that shadow. It may take a few attempts before you're able to paint the Dodge strokes in the right way; if you make a mistake, just Undo and try it again.

2 To add the texture, the Texturizer filter was used with the Canvas setting. It's a simple way to make smooth, flat artwork look more natural. Any grayscale document can be used to generate the textures used by this filter, so you can define your own easily.

3 The result of the Texturizer filter was too strong, so we'll reduce its effect. Rather than going through the dialog again, there's a simpler way: after applying this (or any) filter, use the Fade command (Edit menu) to reduce the opacity. Here, it's been taken down to 30% of its original strength.

5 Now hold the ⌥ *alt* key to get the Dodge tool and paint a parallel curve directly above the one you just drew. This will brighten the artwork, where the Burn tool darkened it: used together, the effect will be of a highlight above and a shadow below the fold.

6 Using the Burn tool again, paint a second curve below the first, again running roughly from corner to corner. It really helps to use a pressure-sensitive graphics tablet for a job like this, but it can be done with the mouse – just use a lower opacity and build up each shadow.

8 Continue in the same fashion until you've made a series of curves running right to the bottom of the banner. The flat artwork we started with now looks more like a piece of fabric that's hanging from its corners.

9 To finish off, add more folds in the corners of the banner. These won't reach right to the corners, but follow the same lines to make the edges of the banner look more realistic. Now's also a good time to strengthen those highlights and shadows that don't show up well enough.

HOT TIP

Using the Texturizer filter to add the canvas texture to fabric can result in a blocky, repetitive tiled pattern. If you have a digital camera, it's worth instead photographing a piece of real canvas (the back of an oil painting works well) and simply overlaying that on top of your artwork using Hard Light or Multiply mode, and a low opacity.

SHORTCUTS

Ripping and tearing

1 The initial poster was created using text distortion to bend the lettering; the figure was stylized using the Watercolor filter. As it stands, it's a brash image that looks nothing like a real poster.

THE POSTERS IN THE ILLUSTRATION ABOVE, created for .net magazine, needed just a little distressing to make them look more realistic. Here, we'll take the process several steps further to turn this flat, artificial poster into something that looks as if it's been hanging around on the wall for a long time.

In most cases, you wouldn't want to add this much destruction to a single poster – I've gone to rather extreme lengths to illustrate the techniques involved. Often, only the smallest amount of shading is required to make a poster convincing: in the illustration above, the Internet Toasters billboard has been shaded in vertical strips to make it look as if it has been pieced together from multiple sheets. Only one tiny corner turned down gives any hint of destruction.

4 The corner is folded down by first masking the corner of the poster – a layer clipping path does the job without interfering with the layer mask. Now, on a new layer, draw the outline of the fold. Fill with a neutral color, and add a little shading with Dodge and Burn; then apply the Plastic Wrap filter to give the impression of sticky glue.

2 The first step is to create the tears. Make a layer mask for the poster layer, and make ragged selection using the Lasso tool. If you set the background color to black, you'll be able to remove chunks of poster simply by pressing *Delete*. Because we're working on a mask, we can always undo any deletions that seem inappropriate later.

3 Simply removing pieces of poster isn't enough. We need to show the torn paper around each rip. Make a new layer, grouped with the poster layer, and paint on it using a small, hard-edged brush to trace roughly around each tear. It's important not to try to be too precise here: the rougher the painting, the more convincing the effect.

5 The folds and creases are added using Dodge and Burn, using the same technique outlined on the previous pages: first add a dark shadow using the Burn tool, then hold the *⌥* *alt* key (to temporarily access the Dodge tool) and paint above it to add the highlight. The lettering, which previously appeared flat, now looks rippled.

6 The lighting is added by making a new layer set to Hard Light mode, and filled with a neutral gray (it's an option when creating a Hard Light layer). Lighting Effects then adds both light and shade transparently through the layer. The drop shadow and the slight remains of old glue on the wall are both added as separate layers.

HOT TIP

Using a layer mask to create the tears, rather than simply deleting holes from the poster, meant it was always possible to reconstitute the original at a later time. This is a key principle: try not to make irrevocable changes to your artwork unless you're sure you want them. Before adding the folds and creases in step 5, I duplicated the poster layer so I'd have an earlier version to return to.

SHORTCUTS
MAC WIN BOTH

219

Making aged photographs

WHILE IT'S POSSIBLE TO DRAW wrinkles and scratches directly in Photoshop, sometimes the best results come from using a photographed original. Here, we'll turn this straightforward shot of an old ghost town building into a photograph that looks like it's been hanging around in a drawer for years.

1 This is the texture we'll use to make this montage work. It's actually the inside cover of an old paperback book, which has yellowed naturally with age; some of the creases come from natural wear and tear, and some were applied manually before photographing it with a digital camera.

2 The photograph of the building is grouped with the texture layer, so that it only shows up where the two coincide. The mode of the building layer is then set to Hard Light, which allows a little of the texture to show through - but which, more importantly, brings that sepia color into play so that the photograph now looks old and somewhat washed-out.

3 Now to add some more texture. The original texture layer is duplicated, and brought to the front. You'll find that when you duplicate the layer, the photograph will now be grouped with the new layer; when you drag it to the top of the layer stack, the original photograph will lose its grouping so you'll need to group it with the original texture layer once again. Set the mode of this new texture layer to Hard Light as well, so we can see through it to the photograph beneath.

4 All we want from this second texture layer is the folds and wrinkles, and none of the color. So begin by desaturating it using ⌘ Shift U ctrl Shift U, which knocks all the color out of it. Now we need to increase the contrast, which can be done using any of the Adjustment dialogs; but I find plain old Brightness and Contrast is the easiest way to proceed. Lower the brightness and increase the contrast until you get the effect you want. The original and contrasted versions are shown across the split here.

5 Now for the border. There's an easy way to make a uniform border, even from such an irregularly shaped outline. First, hold ⌘ ctrl and click on the texture layer's name in the Layers palette. This loads up its area as a selection. Now contract that selection by a suitable amount (say, 16 pixels) using the Modify section of the Select menu. That gives us our smaller inner. To make the border, inverse the selection using ⌘ Shift I ctrl Shift I and make a new layer; fill this selection with white, set its layer mode to Hard Light again and group it with the original photograph, beneath the second texture layer.

HOT TIP

The inside cover of a book is a good starting point for our texture since it contains no text or pictures. Similarly, if you want to photograph a book to mock up a cover on it, take the existing cover (as long as it's a hardback) and simply turn it around so that the white side faces outwards.

SHORTCUTS
MAC WIN BOTH

221

Waving the flag

1 PostScript flags, banners and crests of all kinds are widely available, both on the internet and as part of clip art collections. Photographs of real flags are harder to come by, especially as cutout objects; but it's relatively easy to make our own.

THE ILLUSTRATION ABOVE was commissioned by the Sunday Telegraph to accompany a story about the tribulations of Freeserve, the internet service provider. The holes in the flag were made by selecting ragged areas on a layer mask with the Lasso tool and filling with black; the rough strands at the edges of the holes were created by smudging with the Smudge tool on the mask itself.

Any flag, banner or flat artwork can be made to ripple convincingly in the breeze using the technique outlined here. I've started with a PostScript flag, but it's easy enough to apply any company logo instead.

4 The Shear filter is applied once again, this time horizontally. This makes the left edge of the flag look as if it's being held by the top and bottom on a flagpole; it also prevents the edge of the star panel from looking too rectilinear.

7 Now we can add the intricate creases and folds to the flag, following the Dodge and Burn technique described earlier in this chapter. Because we lowered the brightness in step 6, the Dodge tool still has its effect: if we hadn't done so, it would have made no difference to the white stripes.

2 As a first step, we'll apply some texture to the flag using the Texturizer filter. On the previous page we used the Canvas effect; here, though, we'll use the looser weave of Burlap instead, set to a small size and applied at a fairly low opacity.

3 The flag is rotated 90° and waved using the Shear filter (see earlier in this chapter), then rotated back again and distorted using Free Transform to make the right edge smaller than the left. This gives it a better sense of perspective.

5 Because there's so much white in the flag, we need to reduce the overall brightness or our shading won't show up properly. Use the Curves or Levels dialogs to bring the highlights down slightly.

6 Basic shading is added in the same way as on our Euro banknote earlier in this chapter. This simply accentuates the gross waves of the flag, showing us which parts are rippling towards us and which are rippling away.

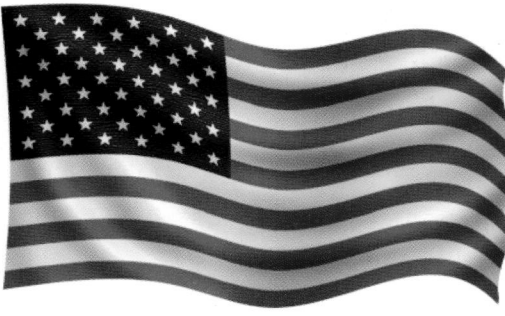

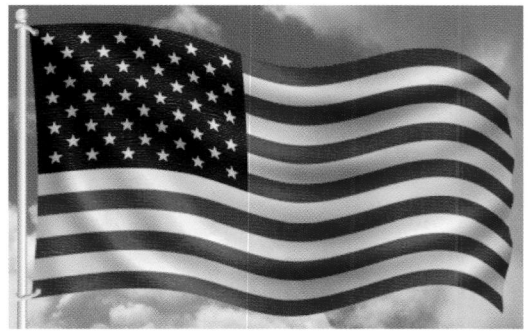

8 While the left edge of the flag looks convincing, the right edge appears too straight and uniform. This end isn't being held by anything, as the left was, and needs to flutter more. This is achieved simply by drawing a wavy path with the Pen tool, and hiding the edge with a layer mask.

9 When positioned on a pole and placed on a suitable background, the flag will still tend to look a little artificial. This is because flags are not solid objects: to blend it into the background, reduce the opacity of the layer slightly. Here, an opacity of 85% merges it in well.

HOT TIP

If you open an EPS illustration of a flag as a new Photoshop document, it will default to opening as a CMYK file. You may not notice anything wrong until you start to add texture, when you'll find that the Texturizer filter (along with several others) is dimmed out. Change the mode to RGB, or import it as an RGB file in the first place, to make these filters usable.

SHORTCUTS

MAC WIN BOTH

223

Making custom fibers

THE ONLY WHOLLY NEW FILTER IN
Photoshop CS is Fibers, which creates
natural-looking textures. Here are some ideas
on how to make the most of this new feature,
using different settings to generate a range of
results for a variety of purposes.

1 Starting with the basic black outline, above, we can use the Fibers filter to turn it into a reasonably convincing curtain. Set the foreground and background colors to red and black, and use a low Variance setting combined with a medium Strength setting.

2 Now for the floor. To simulate a woodgrain effect, we begin by selecting dark and light browns as our foreground and background colors. To make the grain strong, we now want a high Strength setting to increase the contrast, with a medium setting for the Variance.

3 Now for the sign. This board is a flat, featureless object that looks entirely artificial. Using default black and white as our foreground and background colors, we combine a medium Variance with a very low Strength setting to get a lumpy effect.

4 Applying the filter to the sign board made the whole thing disappear beneath the strong texture. So before doing anything else, immediately press ⌘ Shift F ctrl Shift F to bring up the Fade dialog: here, we can change the mode of the filter to Color Burn for a distressed effect.

5 All we need to do to complete the picture is to set the board in perspective and add an edge to it (see the technique in Chapter 10) and place shadows both behind the board and beneath the curtain.

HOT TIP

The Fade command allows us to apply Fibers in a variety of ways. Experiment with the different modes, as well as the Opacity slider, to see how to change the way in which the Fibers filter acts upon the underlying layer.

SHORTCUTS
MAC WIN BOTH

225

Ribbon and tape

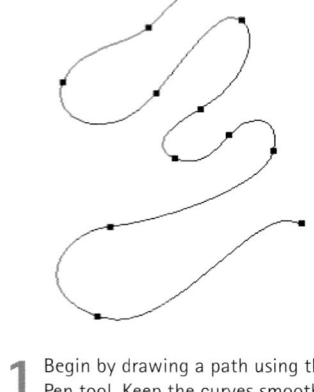

1 Begin by drawing a path using the Pen tool. Keep the curves smooth, avoiding tight turns and corners. When you've finished, save the path and duplicate it before continuing – we'll need this half of it later.

2 Now make a second path by selecting the original, and holding ⌥ *alt* as you offset it. Join the two starting points to make the two paths into one (holding ⌥ *alt* again, this time to force a corner at the join).

THE ILLUSTRATION ABOVE is part of a much larger montage for .net magazine about online stalkers. Dozens of photographs had to be fixed to the wall; shading on each one helped it look like it sat in place. The tape across the corner of some of the photos helped fix them to the wall in the reader's eye.

Ribbons can be used for a variety of purposes – from festooning partygoers to wrapping birthday presents. They're easier to draw than you might think; the trick is all in duplicating the Pen path.

1 We're going to fix this photograph to the wall using sticky tape. Begin by tracing the outline with the Lasso tool, holding ⌥ *alt* to draw straight lines between the sides. Keep these sides parallel!

2 We don't need to make this tape solid, since it's made of translucent plastic. Let's fill the selected area with 50% gray. (It would also be possible to fill with solid gray, then reduce the layer opacity.)

3 Turn the path into a selection by pressing ⌘ *Enter* *ctrl* *Enter*. The ribbon will have some bumps where the paths crossed; these need filling by just painting across them. Dodge and Burn add some basic random shading.

4 We now need to add shading in the hollows. Activate the original path and turn it into a selection: nudge the selection down, and you'll find that the areas beneath the folds are selected ready for Dodge and Burn.

5 All that's needed now is a bit of color. The Hue/Saturation dialog, set to Colorize, is one of the best ways to add dense color to a gray image.

HOT TIP

When the ribbon path was offset in step 4 of the first workthrough, I didn't align it precisely with the right edge of the ribbon. By offsetting it by just a pixel or two, it was possible to use the shading to give the ribbon a slight thickness simply by leaving the edge unshaded.

3 Now add a little random shading, once again using Dodge and Burn. This is only a preliminary stage before we apply the Plastic Wrap filter. I've shown the tape isolated as well, for extra clarity.

4 The Plastic Wrap filter makes that shading look convincingly like reflective plastic. This useful filter is covered in more depth in Chapter 7, Shiny Surfaces.

5 Now color is added using Color Balance, which I find useful for subtle color effects; a lot of yellow and a little red does the trick. Brightness and contrast are increased slightly to make the tape shinier.

SHORTCUTS
MAC WIN BOTH

Upgrade and replace

THE FIRST COMPUTER I ever bought was a Sinclair Spectrum, which I purchased in 1980. It was a state-of-the-art machine, and I remember debating whether to choose the 16K version or opt for the massive 48K model. After much soul searching, I chose the 48K version: after all, I reasoned, this one was future-proof. Today, that computing power would barely run a singing greetings card.

The classified ads columns of newspapers and computer magazines are littered with advertisements from readers who have decided it's time to upgrade their equipment, and want to recoup the cost of their original purchase. Frequently, the prices demanded are well in excess of the aged computer's true value: often, readers will ask for more than it would cost to buy a new machine that offers twice as much power.

Their reasoning runs as follows: I bought this computer three years ago, and now it's obsolete thanks to the software developers, in league with the Devil and Bill Gates, who have upped the requirements for their new versions so much that they won't run on my old machine. And I'm damned if I'm going to shell out that much money simply to run Photoshop 8, so I want my money back before I commit myself to buying a new computer.

It's a fallacious argument, for several reasons. The first is that there's nothing wrong with their old computer. It will still run the software they used on it when they bought it, it will still access the internet at the same speed and it will still enable them to do their job in the same way as they have for the last three years. If they want to take advantage of the tempting features the latest software versions have to offer, then they'll need compatible hardware; otherwise, they can just stick with the software they already have.

You can't blame software for needing a higher specified operating platform each time it brings new functionality: if this wasn't the case, we'd still be editing images one black and white pixel at a time on our Spectrums. The demands made by Photoshop are colossal in terms of processing power,

disk access and chip speed; only the most diehard Luddite would advocate the withdrawal of new features simply in order to ensure compatibility with antique equipment.

But the main problem I have with those who complain about the cost of upgrading is that they rarely take into account how much work their computer has done for them in the intervening period. My Mac enables me to do all my illustration work, as well as letting me do my accounts, watch DVDs and play Tomb Raider, for a relatively tiny cost compared with the revenue I generate from it. At the end of its three-year lifespan I reckon it now owes me nothing; the only hesitation I have in deciding when to upgrade is the knowledge that it will take a week for me to transfer all my applications and get the new machine running as smoothly as the old one. In return, I'll get a computer that's more than twice as fast, with a hard disk vast enough to hold the library of Alexandria.

Many computer users resent the fact that not just computers but memory and hard disks now cost just a fraction of what they paid for them several years earlier. They feel cheated in retrospect: if only they'd held on another couple of years they'd have been able to buy more power for less cost. What they ignore is the amount of work their equipment has done for them in the intervening period, which can usually be valued at far more than the few hundred extra they may have spent on it.

I now consider the ownership of my computer to be more like a rental than an outright purchase. I need to top up my payments every few years, in return for which I get a pristine new piece of technology that has none of the grouchiness my old computer acquired over the years, and offers blistering speed in return. And I even have the opportunity to pass my old machine on to an aged relative or impecunious acquaintance – or, failing that, to convert it into a state-of-the-art fishtank. And I only resent the cost of the new one for a week or two.

10

The third dimension

Talk to many Photoshop artists about 3D and they'll start screaming. That's because the intricacies of conventional 3D modeling programs are so unforgivingly awkward that the mysteries of Nurbs and B-splines are better suited to engineers than artists.

But who said anything about convention? There's a lot that can be achieved directly in Photoshop, without recourse to any other applications. Simulating 3D needn't be a nightmare.

There are times, however, when Photoshop alone just isn't enough. Dimensions, that cranky old application ignored by Adobe for so long, can be just the job for creating quick and dirty 3D models that provide the base for stunning Photoshop artwork.

Adding depth to flat artwork

ONE OF THE MOST common tasks the photomontage artist has to contend with is changing the viewpoint of an original photograph. Sometimes you can get away with simply rotating an object to make it fit in the scene; usually, it's a little more complicated.

The problem comes when an object has been photographed head-on, and you want to view it from an angle. Not all objects lend themselves to the kind of three-dimensional amendments shown here, but the principle used on these pages can be applied to a wide variety of source images.

1 This guitar has been photographed directly from the front, in common with many objects sourced from stock photography collections. In real life, you'd hardly ever see an object in this position: and placing it in a montage will always look flat and unconvincing.

2 The simplest way to change its perspective is to use Free Transform, holding ⌘ ⌥ Shift / ctrl alt Shift while dragging one of the corner handles to get a perspective distortion. The problem is immediately clear: there's no side to this guitar.

1 This old coin has been photographed directly from above; with close-up photography, an angled view would have made it difficult to keep the entire coin in focus. But we can create any view of this object we like with just a few actions.

2 The first step is to use Free Transform to squeeze the coin vertically: if you hold ⌥ alt then it will squeeze towards its centre. You may wish to add perspective distortion as well, but it isn't really necessary.

3 Then select the coin by holding ⌘ ctrl and clicking on its thumbnail in the Layers palette. Using the Move tool, hold ⌥ alt as you nudge this selection up one pixel at a time using the Arrow keys, and you'll create this milled edge as you go.

3 The side is best drawn with the Pen tool on a new layer, although you could also use the outline of the guitar as a starting point to get the curves correct. Here, the shape has simply been filled with a flat color to see if the perspective works.

4 A section of the guitar front is copied, duplicated and then flipped vertically to make a seamless tile. This is then used to fill the new side by grouping it with the side layer and repeating the pattern until it fills the space.

5 The key to realism lies, as ever, in the shading. The Burn tool has been set to Midtones to add the shadows – setting it to Highlights would have a more extreme effect, but would lose the warmth of the wood. Start slowly, and build up the shading.

HOT TIP

Boxy objects such as computer CPUs are easy to transform, even if photographed head-on. Simply copy a plain portion of the front of the unit, and distort it to form the side and top (if required). Adding appropriate shading means you can get away with a lot with little effort.

4 That milled edge is perhaps a little too strong. To fix it, use *Shift* ⌘ *I* *Shift* *ctrl* *I* to invert the selection and make a new layer from the edge. Preserve transparency with *I* and fill with a color picked from the coin itself.

5 Now use the Dodge and Burn tools to add highlight and shadow to this new edge, using thin vertical strokes to create the illusion of light reflecting off the edge.

6 Since this was created on a new layer, we can simply lower its opacity to allow the 'original' milled edge to show through underneath.

SHORTCUTS
MAC WIN BOTH

An open and shut case

A TRICK THAT EVERY PHOTOMONTAGE ARTIST NEEDS TO learn is how to make photographed objects do what he or she wants them to do – which means ignoring the perspective of the original image and adapting it to suit the needs of the job in hand.

The ability to open a closed door is a technique that every Photoshop professional should be able to achieve. Opening the drawer of the filing cabinet in our second example takes a keener eye, since it's important to match the rather distorted view present in the original photograph. But in Photoshop, if it looks right then it is right: you just have to trust your eye.

1 This door has been photographed closed, but opening it is simple. To begin, use the rectangular selection tool **M** to draw a rectangle that includes just the door itself, and not the frame. Cut this to a new layer using *Shift* ⌘ *J* *Shift* *ctrl* *J*.

1 The technique used to open the bottom drawer of this filing cabinet can equally well be applied to a wide range of tasks. Unlike the door, above, the drawer front doesn't hinge, so we can't use the perspective distortion in the same way.

2 Select the drawer front, and make it into new layer using ⌘ *J* *ctrl* *J*. It needs enlarging slightly, since it will be nearer to us; and a small amount of perspective distortion is required to match the extreme angle of the original.

3 Now reload the original selection by selecting the path and pressing *Enter* (the advantage of having created a Pen path) and make a new layer for the inside of the cabinet. Fill it with a dark gray, and add shading using the Burn tool to give the sense of depth.

2 Now use Free Transform ⌘ T / ctrl T to distort the door to its new position. If you hold ⌘ ⌥ Shift / ctrl alt Shift while dragging a corner handle you'll get a true perspective distortion; use the center handles to make the door narrower.

3 The thickness of the door is easy to make: draw a rectangular selection that includes part of the front edge of the door (but not the handle), make a new layer from it and flip it horizontally. Drag it into place, and then just darken it up.

4 The doorknob didn't take well to its perspective distortion, but it's easy to make an elliptical selection of the knob and distort it back to its correct shape. Since the door is a separate layer, darkening the interior on the layer below is child's play.

HOT TIP

When you use perspective distortion to open a door, you'll also need to reduce the width of the door to match: the more open it is (and the stronger the distortion), the narrower it will have to be. There's no solid rule for how to do this – just make sure it looks right.

4 The drawer side is drawn on a new layer placed behind the drawer front by simply outlining it with the Lasso and filling with a mid gray. The three ribs are then drawn by selecting with the Lasso, and the areas between darkened with the Burn tool.

5 Once an object is placed in the drawer, the whole scene begins to make more sense. You need to choose objects to fill the cabinet that have a similar perspective to them; filling it with objects photographed head-on will look unconvincing.

6 The final stage is to add the shading – behind the folder in the drawer, and beneath the drawer itself. Make a new layer, grouped with the base cabinet layer, and paint on this using a soft-edged brush with black paint set to around 40%.

SHORTCUTS
MAC WIN BOTH

235

Matching existing perspective

1 This shuttered shopfront is an ideal surface on which to place our sign. Not only does it have strong perspective lines, which will allow us to place the text accurately, it also includes a good bumpy texture that will make the finished result more convincing.

I N THIS ILLUSTRATION for the Sunday Telegraph, I aligned some of the elements with the perspective of the shutters. But the large Closed sign was placed at a deliberately skewed angle, to make it look as if it had been pasted on in a hurry. The sign still had to appear in perspective, but this was achieved purely by eye using Free Transform. (See Chapter 8 for details on shading the paper sign.)

In this workthrough, we'll look at how to make a shop sign that looks like it was photographed with the original shop.

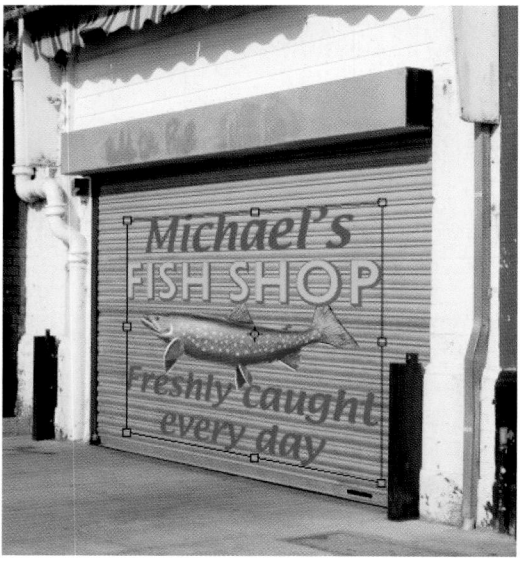

4 Select Free Transform (or press ⌘ T ctrl T). Hold ⌘ ctrl and grab a corner, then hold Shift as well after beginning to drag to constrain the movement to vertical. Align the top and bottom so that they line up with the ribs on the shutter.

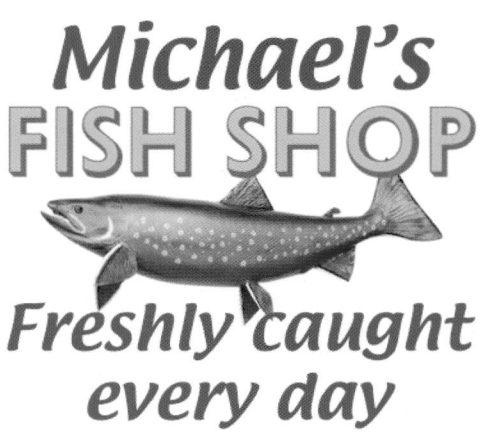

2 The sign consists of four elements: the three sets of words, and the fish. Although it would have been possible to create all the text in a single block, you get far more control over size and spacing when they're kept as separate chunks of text.

3 Link all the sign elements together, and choose New Set From Linked in the pop-out menu on the Layers palette. Duplicate that set by dragging it onto the folder icon at the bottom (or choosing Duplicate from the pop-out menu), and then merge the new set so it becomes one layer.

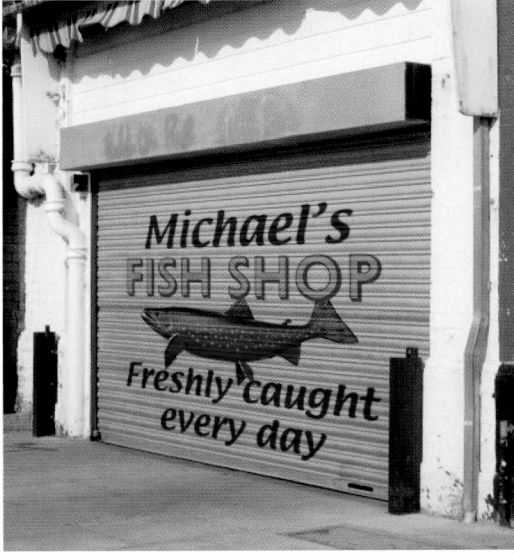

5 The previous step got the sign into perspective, but it didn't look as if it was part of the image. Changing the layer mode to Multiply (use the menu at the top of the Layers palette) allows the original texture to show through, which looks far more convincing.

6 Placing the figure in front of the sign achieves two things: first, it adds a human element to the image; and second, by obscuring a tiny part of the sign it makes the sign look far more integrated into the final image.

Building boxes

1 When preparing your flat artwork, remember that in most cases you'll be seeing the side of the box as well as the front, so you'll need to draw that as well. Keep a consistent color scheme on the side, and reuse some of the original artwork such as the Choco Flakes logo.

DRAWING BOXES IS EASY – it's simply a matter of distorting flat artwork using Free Transform, and adding a few finishing touches. The illustration above, for ES Magazine, was made slightly more complex by the fact that the box had a window in it, which meant drawing the polythene (see Chapter 7, Shiny Surfaces) and giving the inside of the lid a little thickness (using the techniques described earlier in this chapter). But the principles are exactly the same as with the breakfast cereal box used to demonstrate the process on these pages.

4 Darken the side of the box to make it stand out from the front. Then add some shading to the entire artwork using the Burn tool: a small amount of shadow helps it to look more like a real object and less like distorted flat artwork.

2 Create a merged copy so that you've got all the elements in one layer - that is, one for the front and one for the side. Then simply distort the front using Free Transform, holding ⌘ Shift ⌥ ctrl Shift alt and dragging a corner handle to make the perspective.

3 Now simply repeat the process for the side layer. If you only distorted the front of the box on the left-hand side, the side layer will still be the correct height and can be distorted in the opposite direction to make the box look three-dimensional.

5 Since this box is made of cardboard, you won't get a perfectly sharp edge where it bends around the corner. Here, I've selected a couple of pixels down the left-hand edge of the side and brightened that strip up to give the impression of the cardboard bending.

6 What makes an illustration like this work are the elements that break out of the planes, such as the spout on the right. And where would any self-respecting cereal be without a plastic toy? The wrap for this was created using Plastic Wrap - see Chapter 7 for how to do this.

HOT TIP

You can't keep text editable when applying perspective distortion – it needs to be rasterized first. So make sure you (and your client) are happy with the base artwork before turning it into a 3D object, or you'll have to repeat the process all over again after they've made the changes.

SHORTCUTS
MAC WIN BOTH

239

Wrapping labels round curves

1 This view of an oil drum presents a tricky problem for label wrapping. First, it's a curved rather than a flat surface; and second, that surface has been photographed in perspective. So here's how it's done.

2 The label is created using suitable text and graphics. Although these were necessarily made on separate layers, it's important to merge them into one so that the distortions can be applied to everything together.

WRAPPING LABELS around curved surfaces can be a tricky proposition. In the illustration above for The Independent, I had to break the text into several chunks and distort each one using the Wave filter in order to make it look as if it was wrapped around the plastic surface.

5 Now rotate the canvas back again, and use Free Transform to apply a simple perspective distortion to the label. Don't expect it to look perfect; a close fit will be enough at this stage. To avoid fiddling around, it's easier to apply final tweaking to the misfit characters afterwards.

6 To make the lettering fit the perspective of the barrel, we need to select the troublesome letters (the beginnings and ends of each word) individually, and shear them vertically until they fit. A bitty font like Stencil is easiest to work with, as you can distort letter sections in chunks.

BARREL IMAGE: HEMERA PHOTO OBJECTS

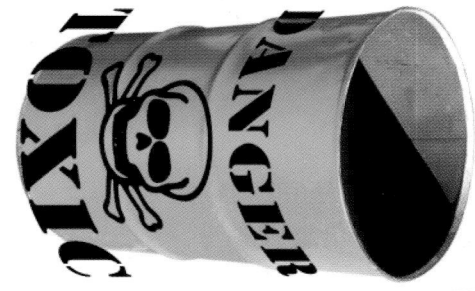

3 The first distortion is to Spherize the label, so it looks more as if it's wrapped around a cylinder. In the Spherize dialog, use Horizontal Only rather than the full Spherize, so that it's only distorted in the horizontal dimension.

4 Now to bend the label using the Shear filter. This filter will only distort horizontally, so we must first rotate the canvas 90°. The filter works by drawing points on the straight line, which can be dragged out into curves; the preview shows the distortion.

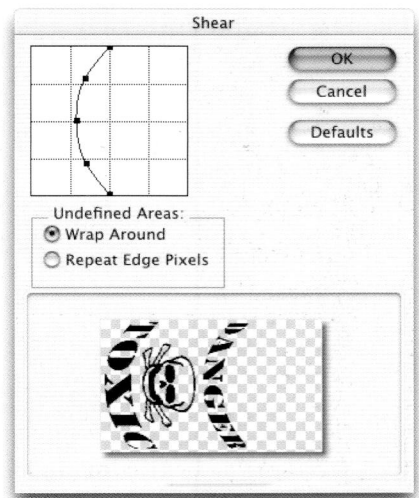

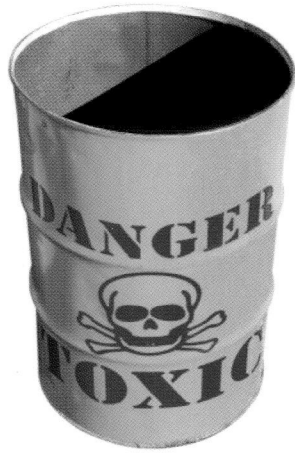

7 To retain the texture of the original, load up the area of the distorted label (⌘ ctrl click on the name in the Layers palette), hide it, switch to the base layer and float the selection using ⌘ J ctrl J. Now simply use Hue/Saturation to colorize the label.

8 The label still looks a little unconvincing, so to strengthen it up change the Layer mode from Normal to Multiply – this will accentuate the shadows, making the finished label look far more like it's sitting on the object in the real world.

Editable text on 3D surfaces

THE WARP TEXT FEATURE introduced in Photoshop 6 is seen by many as a flashy special effect with little practical application. But it's a useful tool for fitting text onto curved three-dimensional surfaces, as we'll see in this example using a medicine bottle as the base object.

Because the Warp Text effect works with live text, we can go back and edit the text at any point – changing the wording, color, font or type size as we wish, without having to go through any of the steps outlined in the previous pages.

I discovered this technique while working on the job above, in which the client couldn't be certain about the precise wording needed, but wanted to see how the effect would look before continuing. The ability to change just the text at the last minute made it possible to complete the job on time.

1 The basic label text (below) has been distorted using the Warp Text feature. The Arch setting has been given a Bend value of –57 (see screen shot at bottom), so it curves downwards. As it stands, the text doesn't fit the label; the next step will bring the fit closer.

DRUGS-R-US

Aspirin

To be taken as directed – follow the instructions on reverse.

2 Now, simply shearing the text box vertically using Free Distort enables us to pull the left side of the text down so that it more closely approximates the label. Grab a center handle to add the shear effect. Because it's not a perspective or free distortion, we can perform it while the text remains editable: simple shearing is one of the distortions (along with scaling and rotation) that's 'allowed' on live text.

3 Because the bottle has been viewed from above, with a strong perspective, the label appears narrower at the bottom than at the top. To fix this, we can use the two additional distortion sliders.

A negative value for the Vertical Distortion (see below) makes the text taper inwards at the bottom; and a tiny negative value for the Horizontal Distortion makes it slightly wider at the left than at the right.

In practice, you'll find yourself tweaking all the sliders several times until the correct curve is found; but most surfaces can be conformed to with this technique.

4 Because the text remains editable throughout, we can go back at any point and alter what it says. As long as the longest line remains the same width, the distortion will remain the same; if it's short, add spaces to fit.

5 To make the text more convincing, duplicate the layer, rasterize the text and blur it. Since we've kept the original unrasterized version, we can still edit that if necessary.

Warp Text

Style: Arch

OK Cancel

● Horizontal ○ Vertical

Bend: −57 %

Horizontal Distortion: −1 %

Vertical Distortion: −5 %

Drawing pipes and cables

WHETHER IT'S MICROPHONE CABLES, sewage pipes or chrome cylinders, it's fairly easy to create any kind of tubular object directly in Photoshop.

Cables are drawn using the technique of applying a brush stroke to a Pen-drawn path: as long as the path is visible, any of the painting tools can be easily made to run a smooth stroke along it.

Pipes can be created at any length. Since the shading is applied evenly along the pipe by holding the Shift key as you paint with the Dodge and Burn tools, it's then easy to stretch them to any length you want simply by selecting half the pipe and dragging a copy where you want it to go.

Bending pipes around curves is another issue entirely, and the final step here shows a simple way to achieve this effect.

1 Drawing cables and wires is easier than you might think. Start by using the Pen tool to draw a Bézier curve that follows the line you wish the cable to take.

4 By nudging vertically and inversing the selection, only the feathered bottom half of the cable is selected. We can now use Brightness and Contrast to darken the edge.

1 Begin your pipe by drawing a simple rectangle with the Marquee tool, and filling it with a mid-tone gray (you can always add color later).

4 With the ⬧ *alt* key still held down, drag the ellipse to the other end: hold the *Shift* key after dragging to move it horizontally only.

6 With the Marquee tool selected, nudge the selection a couple of pixels to the right and fill with the same mid gray. The bright rim looks better than a hard edge.

8 Draw a new selection with the Elliptical Marquee that's smaller than the original one, and add shading to make the inside of the pipe – darker at the top and on the left.

2 Now, with the Pen path still selected, switch to the Brush tool and choose a hard-edged brush of the right diameter – here, a 9-pixel brush was used. Now hit the *Return* key, and the path will be stroked with that brush.

3 Next, load up the pixels in the cable layer by holding *⌘* *ctrl* as you click on the layer's name. Feather the selection (a 3-pixel feather used here), and, with the Marquee tool selected, nudge the selection up 3 pixels.

5 Now nudge the selection down twice as many pixels as you nudged it up (that makes 6, in this instance) and brighten up the top half in the same way.

6 After coloring the cable, it's time for the shadow. Modify your original path so that parts of the cable rise up from the floor, then stroke the path with a soft-edged brush.

2 Using the Dodge and Burn tools set to Highlights, hold the *Shift* key to constrain the motion to horizontal, as you drag from end to end of the rectangle.

3 Now use the Elliptical Marquee tool to select an ellipse in the center of the pipe. Hold *⌥* *alt* to make a copy as you drag it to the left to form the end of the pipe.

5 Now brighten up the selected end of the pipe, using Brightness and Contrast or Curves. It's brighter than we need, but this will just form the rim around the edge.

Polar Coordinates

OK
Cancel

33%

Options:
- Rectangular to Polar
- Polar to Rectangular

7 With the end cap still selected, add some more shading using the Burn tool. Bear the lighting position in mind: we want more shadow at the bottom right than at the top.

9 By applying a step effect using the Curves dialog, we can make this pipe look more metallic. See Chapter 8 for details on how to achieve this effect.

10 To bend the pipe into a curve, make a square selection around it and use the Polar Coordinates filter (Rectangular to Polar) to distort it. If the pipe is positioned at the top of the square selection, the result will be a very tight curve; if it's positioned in the center, you'll get a larger curve. Make sure the initial selection is square or the curve will be distorted. You can now take a section of this curved pipe to join two straight pieces together.

HOT TIP

When using shading techniques such as those shown here, it's always better to work with gray objects rather than colored ones: shading can affect the color as well as the luminance of an image. When the shading is exactly how you want it, you can put the color in using Color Balance, Curves or your favorite tool.

SHORTCUTS
MAC WIN BOTH

245

3D Transform filter: boxes

PHOTOSHOP'S 3D TRANSFORM FILTER, found under the Render section of the Filter menu, is a poweful tool for changing the perspective viewpoint of objects. It's also one of the hardest filters to get your head around.

The filter works best with boxy objects, such as this – er – box. But it can also be used to distort bottles, glasses and symmetrical objects of all shapes, as we'll see on the following pages, provided you have the patience to (a) figure out how the odd controls work, and (b) put up with the desperately clumsy interface.

In the dialog, images are shown in black and white, as they are here. The guidelines are shown in pale green, which I've changed to a thick red so they're easier to see in print. Otherwise, all the elements of the interface will appear on your computer screen exactly as you see them here.

1 When you first open the filter, you'll see your object converted to grayscale. Make sure the object is in the middle of the document, or the perspective viewpoint will get horribly confused.

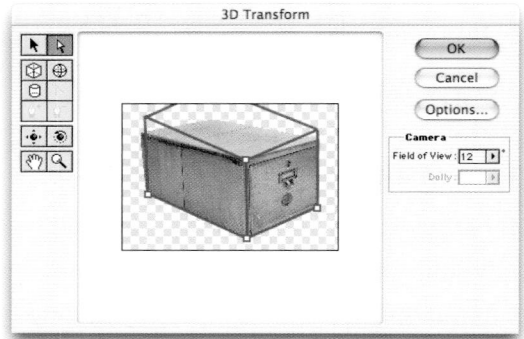

4 Now grab the remaining handle, the one right in the middle of the box, and move it into place. Nothing fits! And there are no more handles to drag! What can have gone wrong this time?

7 Drag on the Field of View slider once more until you can see the entire object in the preview window. At this point, it's worth clicking the Options button to raise the quality, and hide the background view.

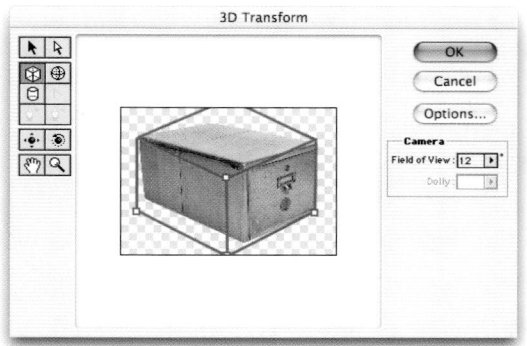 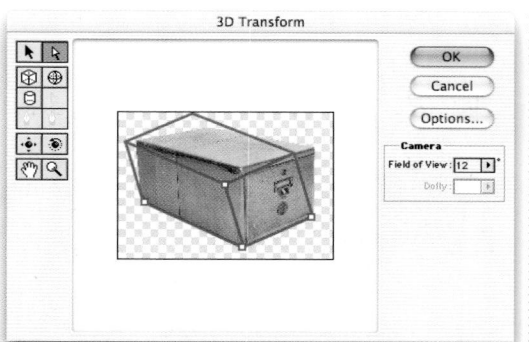

2 Pick the box tool and draw a box around the object, from corner to corner. It won't fit at all at this stage; we'll use the corner handles, shown as hollow squares, to adjust the fitting.

3 Switch to the hollow pointer tool and grab the bottom center handle and move it into place; then repeat the process with the bottom left handle, until all three lower handles correspond exactly with the corners of the object.

5 In fact, nothing has gone wrong – it's just that the perspective viewpoint is completely wrong. Drag the slider that pops out beneath the Field of View number and move it until the box fits the object.

6 Now click on the Rotate tool, which you'll find at the lower right. It's likely that you'll now see a view like this, showing a close-up of an irrelevant part of the object. We need to adjust that viewpoint again.

8 Now use the Rotate tool to drag the object to change its viewpoint. You can also use the Move tool, next to it, to move your object around within the preview window if your chosen rotation angle puts it outside the space.

9 You can even choose to view the object from an entirely different angle, as we've done here: in this case, the top face of the original object disappears from view as it's completely hidden from this viewpoint.

3D Transform filter: cylinders

THE 3D TRANSFORM FILTER, WHICH we looked at on the previous pages, is capable of applying different viewpoints to far more than mere boxes. But as the object in question becomes more complex, so the shortcomings in the filter become more apparent. The original bottle, above left, was distorted to produce the result shown center; but it didn't take a lot of retouching skill to patch it to produce the final result, right.

Irregular shapes take a little more thought than plain boxes, but the results can be impressive. It's worth pointing out that the restrictions of this filter mean it's really only suitable for use on symmetrical cylindrical objects, which have been photographed head on. Here, we'll look at how to change the viewpoint of a beer glass.

As on the previous spread, the original fine green outlines in the 3D Transform dialog have been replaced with a thicker red to make it easier to see on the page.

1 Objects opened in the 3D Transform filter can sometimes appear far too small. There seems to be no consistent reason for this; but as it stands, it's too small for us to see what's going on.

4 Grab the bottom handles and drag them so that they touch the base of the glass. The top corner handle shouldn't need adjusting if you drew the cylinder correctly in the previous step.

7 Next, change to the hollow Arrow tool and drag that new anchor point until it touches the side of the glass. With some objects, you may need to create several anchor points; the bottle, left, required three additional points.

2 To see the glass bigger, you'll need to zoom in. In fact, you may have to zoom in and out quite a lot in this exercise, to make sure all the anchor points are placed correctly.

3 Now use the Cylinder tool and draw a cylinder that goes from the top left corner of the glass straight down to the correct height. It's the overall bounding height and width that we need to get right here, not the detail.

HOT TIP

Getting the initial cylinder right is crucial to the success of this operation. If you don't draw it right first time, press Delete and try again. As well as the cube and cylinder tools, there's a sphere tool in 3D Transform. In fact, it does little more than spherize the image; but you can get interesting results by drawing loads of cylinders and spheres at random, and then changing the viewpoint with the Rotate tool to generate weird background textures. Try it!

5 Now's a good time to adjust the perspective. As in the previous spread, drag the Field of View slider (it will pop up when you click the number) until the top ellipse matches the angle of the top of the glass. Nothing else will change.

6 Next, we need to make the outline fit the glass. Using the Pen tool, click to make an anchor point on the side of the cylinder. Don't drag as you click – the Pen tool doesn't work that way here.

8 With the outline shape drawn to fit our object, we can click on the Rotate tool to enter this section of the dialog. As before, the glass can be rotated by dragging in the preview window.

9 One thing you can't do here is rotate in any direction other than directly forwards or backwards, or you'll be able to see a side of the glass that doesn't exist – and the tool isn't clever enough to wrap around the back.

249

3D modeling applications

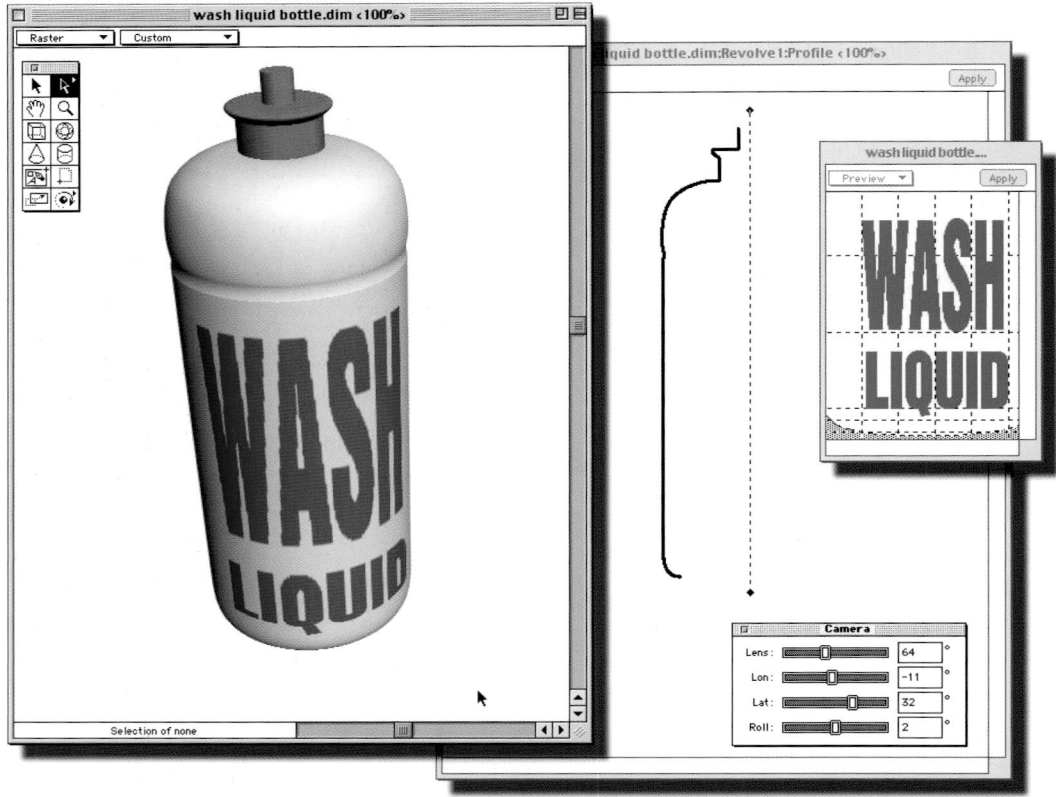

WHILE YOU CAN DRAW just about anything you can imagine directly in Photoshop – if you have the time and the skill – there are times when a basic 3D modeling application can help you out of a tight spot. First of all, let me lay my cards on the table: I hate 3D modelers. I loathe the intricacies of Nurbs and B-splines, and resent the time taken sitting around waiting for models to render.

That's why I like Adobe Dimensions, the elderly 3D program. It can perform just two basic functions: extruding (adding depth) and revolving (lathing a profile). But where it really scores is that it's the only 3D program to export

PostScript artwork – in the form of Illustrator objects. This means they're infinitely scalable, and so can be enlarged to any size you like. Rendering time is just a few seconds; after that, you can take the model into Photoshop and enhance it.

Dimensions hasn't been updated since 1997, and suffers a number of drawbacks: it's clumsy, buggy, and none of the keyboard shortcuts work with recent operating system releases. That said, it still performs its task admirably – and you can always use a macro program, such as QuicKeys, to replace the keyboard shortcuts for you.

The trick with Dimensions is not to expect too much from it. While it is capable of rendering shading from multiple light sources, because it exports PostScript artwork the shading is created as stepped blends; some blurring is often needed afterwards in Photoshop to fix this.

Dimensions illustrations occasionally go wrong: bits will be missing when the illustration is rendered, for instance. There's no support for transparency, and the texturing is so laughable as to be completely unusable.

Much of Dimensions' functionality has been built into Adobe Illustrator CS, the latest release of the popular illustration program. But what Illustrator's missing is the ability to group several objects together and change their viewpoint as a whole: you can only work with one 3D object at a time. Which makes it fine for simple tasks such as the washing-up liquid bottle shown here, but means it couldn't be used for more complex jobs – such as creating the lamppost on the cover of this book.

Then there's Amorphium (www.play.com), the bizarre modeler that creates organic images – and renders them at enormous size in seconds. Fun to use, it can be hard to make it do what you want; but what you end up with is usually worth the struggle.

If you really want to get into 3D modeling, there are dozens of applications available – including Carrara, 3D Max and Swift 3D, up to the heavyweights Maya, Lightwave and Electric Image. These dedicated programs will produce stunning results, assuming you have both the time to learn them and the time to sit around waiting, often for many hours, while

the finished image is rendered.

For the Photoshop user who simply wants to get a quick model to work on, Dimensions – despite its many shortcomings – remains the best choice. Over the next few pages we'll look at some of the artwork created using Dimensions models as their base. Even if you're only exporting a basic outline model, creating such objects as a perspective box can be done in seconds in Dimensions: the same illustration might take hours to create in Photoshop.

The illustrations I'll discuss in the rest of this chapter all use Dimensions as their starting point, but I'll stress that the program can't generate anything near finished artwork. I won't go through a step by step tutorial showing how to create the models in Dimensions itself; instead I'll discuss how to make these simple PostScript models come to life, using the tools and techniques in Photoshop. If you want to try Dimensions for yourself, you'll find a demo copy on the CD that accompanies this book.

Amorphium is a 3D modeling tool that's by turns fun, exhilarating and infuriating. But if you want organic forms, it's a good choice and is easy enough to learn.

Remote, but in control

1 This was a simple model to create in Dimensions: a curved bevel was added to the remote's outline to give the rounded effect. The model was then saved in two parts: first the buttons were hidden, the model rendered as a PostScript image and then saved as an EPS file; then the buttons were revealed and the base hidden, and exported as a separate image.

THIS IMAGE was created for the Radio Times magazine to accompany a story about two new BBC television channels. The remote control's buttons had to be oversized to get the point across: the four BBC buttons were to be made the most prominent, with buttons for the other channels hidden behind the hand holding it.

While photographing an existing remote control might have seemed the obvious choice, the task of getting rid of the original buttons made this an impractical route. Adobe Dimensions was the obvious choice to construct the basic model, providing a good starting point with which to work.

5 I keep a selection of hands (many of them my own) to use for holding a variety of objects. This one fitted the remote perfectly, and a layer mask was used to tuck the bottom of the remote behind the base of the thumb. This is exactly the same technique as that outlined in Chapter 2, Hiding and Showing.

2 This is the basic model imported into Photoshop in two layers. By creating the model in two parts we've managed to keep the elements separate, so that they can be treated individually.

3 The buttons were given a degree of shininess by brushing over them with the Dodge and Burn tools. An area was then defined within the remote and a new layer created; this was then filled with a dark gray, followed by Gaussian Noise and then Gaussian Blur to soften the effect. The slight blue tint was simply added using Color Balance.

4 The Noise/Blur layer was selected and its perimeter expanded by 3 pixels; on a new layer, this rim was shaded using Dodge and Burn to create an inner bevel. The red plastic cover at the top of the remote was created by making a new layer from an elliptical selection that intersected the base. This was then filled with a dark red, and the leading edge was brightened up.

6 Because the hand was simply dumped on top of the remote, it looked artificial and unconvincing. The bottom edge of the hand was shaded using the Burn tool; then a new layer was created beneath it, onto which a soft shadow was painted using the Brush tool set to 50% opacity - this allowed me to build up the shadow gradually where needed.

7 The glow effect within the lit-up buttons was added using the Dodge tool to highlight them; the edges, previously very dark, were brightened considerably. The buttons were then each colorized using the Hue/Saturation dialog. The seating for the buttons was added by creating a Pillow Emboss using Layer Effects, which made the bed of the remote look like it was cut to receive the buttons.

8 The text and symbols were typed and drawn as appropriate, and skewed into the correct perspective to fit the buttons. Placed below the shadow layer, they allowed the shading to appear on top of them. In order to give the impression of the text being incised into the buttons, the Emboss feature in Layer Effects was used again – this time, the usual direction was reversed to give the impression of depressed rather than raised buttons.

HOT TIP

Since this image was destined for the printed page, it was important to ensure it would work in CMYK. This was particularly relevant when adding highlights to the colored buttons, since these are areas where an image can easily go out of gamut. After highlighting each one, I used Hue and Saturation to colorize it: by flipping in and out of CMYK Preview mode (⌘ Y ctrl Y) I could check when the button was too bright, and reduce the saturation accordingly.

SHORTCUTS
MAC WIN BOTH

10 A piece of cake

1 The model was created in just a few minutes in Dimensions. A rolling bevel was used to give a slight undulation to the edge of the cake. In the end result, almost nothing remained of the original model – but it served its purpose as a useful template to build the illustration around.

OFTEN, THE MOST BASIC 3D MODEL can be used as the starting point for a realistic illustration. In this instance, the brief was to draw a cake in the shape of the Channel 4 television logo for a story about a proposed sell-off (carving up the cake — when in doubt, pounce on a ready-made metaphor). While it would have been possible to create this illustration entirely in Photoshop, using the Free Transform tool to create the perspective, the ability to generate a simple 3D model makes it easier to get started.

This illustration uses a combination of drawn elements (the cake and the icing) and real photographs – notably the cake texture. While it would be possible to draw this texture, it would be hard to do convincingly; and after all, that's what digital cameras are for.

5 The cake was then merged into a single layer, and the tip cut off in a jagged line using the Lasso tool. This was made into a new layer to allow the two elements to be handled independently. The crumbs around the cake were made by drawing small selections over the original texture in QuickMask, then moving them down to their new position. The rectangles making up the logo were also strengthened to make them easier to read.

2 I started by creating a selection using the top and wavy edge of the cake to make a new layer, which was then colored pink, to which a small amount of Gaussian Noise was added. Noise prevents forms drawn in Photoshop from appearing too shiny, which would detract from their plausibility as real-world objects.

3 A scan of a piece of real cake was placed beneath the icing layer, and grouped with the base model so that it only showed where it overlapped the model. The icing layer now looked too pasty by comparison, so its strength was increased simply using Brightness and Contrast.

4 Plastic Wrap was used in moderation to add a shine to the surface of the cake, giving it an additional gloss. The cream was painted on a new layer using a soft-edged brush; this was then filled with a small amount of Gaussian Noise, and shaded using the Dodge and Burn tools set to Midtones.

HOT TIP

There are times when too many layers just get in the way – such as when we want to cut a slice off, as in step 5. Rather than merging the layers irrevocably, it's better to create a Layer Set using all the elements so far, duplicate that set and merge the duplicate to create a single layer. An easy alternative is to hide all but the layers you want to merge, make a new layer, then use ⌘ ⌥ Shift E / ctrl alt Shift E to make a merged copy of all the visible elements in the new layer.

6 Cake texture and cream were copied from elsewhere in the cake and placed behind the cutoff section, following the perspective made by the slicing. A silver cake slice placed behind this gave it a reason to be floating in mid-air.

7 The background was a solid fill of 50% Cyan, 25% Yellow: on top of this, a Black to Transparent Gradient Adjustment Layer was placed to create the shading. By keeping this shading on a separate layer, it was possible to adjust it later for both position and opacity.

8 These seemingly complex reflections were surprisingly easy to create. The cake was duplicated, and a Wave filter applied: this was then dragged to the back of the artwork, and the opacity reduced accordingly. The reflections of the crumbs, cake slice and sliced cake were created in the same way.

SHORTCUTS
MAC WIN BOTH

255

Dimensions: bits and pieces

1 This exploded Union Jack was for a story in The Guardian about suggested redesigns for the national flag. Once I'd conceived the idea for the illustration, Dimensions was the natural choice: I simply imported a Union Jack and twisted each section individually. In this case, rather than rendering a finished model I copied the PostScript outlines and pasted them directly into Photoshop as paths: that way, I could isolate each section and color and shade it separately from the rest.

MODELS BUILT IN DIMENSIONS don't always need to form the bulk of the illustration. Often, there's just one element that is either difficult or impossible to photograph, yet is easy to create as a 3D model. The advantage of making simple models is that, unlike photographed objects, there's no fiddly cutting out to be done; in the case of the wireframe globe on the facing page, even if there had been a suitable photograph, tracing

around each strut of the wire would have been an endless task.

The images on this page were all commissioned jobs which would have been tricky to create without a 3D modeler on hand. Since newspaper work is always completed to tight deadlines – often just a couple of hours – the speed of Dimensions in rendering even large images makes it a better solution than waiting for a high-end modeler to finish.

2 This illustration was for a Guardian feature about dumbing down – specifically, the horrors of globalization. The wireframe model was created as a series of semicircular hoops: the entire model was then rotated 180° about its axis to generate the wireframe in two sections. To get the metallic effect, I used the EyeCandy 4000 filter (see Chapter 12).

The countries were drawn by wrapping a drawing of a globe around a sphere model, also in Dimensions, and then coloring and shading the result accordingly.

By creating the wireframe in two halves, I was able to place one at the back and one at the front, making it easy to arrange all the

objects between the two. This trick of splitting a model in half is a useful one for a large variety of purposes: drawing a bottle or jar, for instance, in two halves makes it easy to place objects inside it without having to worry about complicated masking procedures.

Splitting things in half is also a useful technique for items like shopping baskets and trash cans.

3 Modeling this sun bed (for an illustration for .net magazine) was simply a matter of placing a series of beveled tubes next to each other: those ugly overlaps seen along the side in the original model were easy to smooth out in Photoshop. The shading wasn't as complex as it looks: it's the reflection of the man's arm and legs that makes the surface look like polythene.

The Poser phenomenon

This image for MacUser magazine was to illustrate a feature I wrote on Poser. Models need a fair amount of work after you import them into Photoshop, cleaning up jagged edges around knees and elbows, and smoothing out odd wrinkles in the skin; but it makes a good starting point for cases where you can't find the right pose elsewhere.

POSER IS A UNIQUE 3D MODELING application. It has just one purpose: to produce images of people, as realistically as possible.

The realism of the application's output increases with each new release, and it's getting to the stage where the figures generated look almost real. Almost, but not quite: you can still tell that a figure has been generated rather than photographed. Nevertheless, with a bit of work in Photoshop it's possible to get

acceptable results from Poser without having to go to the expense and inconvenience of hiring models (or the embarrassment of asking them to take their clothes off).

With its quirky interface, Poser (www.curiouslabs.com) looks and feels like no other program. As well as being a powerful modeler, it's also fun to use, as long as you've got enough RAM: the latest version requires at least 200Mb assigned to it, and is far happier operating with a whole lot more. Poser comes

Poser's interface may be confusing to new users, but it's easy to use once you get the hang of manipulating your figures using the modeling tools. Rendering the final image only takes a few minutes, resulting in a TIFF file with an Alpha channel that can be used to isolate the figure from its background.

with a range of reasonably convincing figures of its own; but if you want greater realism, you'll need to purchase additional models from Daz3D (www.daz3d.com) who, under the name Zygote, developed the original Poser models.

For the digital artist interested in generating photorealistic images, Poser is useful in that it's quick and easy to model any pose you like; using the Daz3D models, you can even change the physiognomy of the faces and bodies of your models to suit your needs.

Version 5 of Poser added the ability to model faces on portrait and profile photographs of real people, adding an extra dimension to the program's power: several interface

enhancements make it better than ever.

Poser is a little frustrating in that the figures never quite look real enough to fool even the most casual of readers, even though it improves with each new version. But Poser is great for generating crowds of out-of-focus people to populate your backgrounds, for creating roughs or for building wireframe models for cases where you want a computer-generated look.

A wide range of clothing, hair and tools is available, both from Daz3D and from many third party and shareware sources – one of the best is www.renderosity.com, who distribute free and low-cost clothing, props and models from their website.

Reality overload

REALITY IS ALL VERY WELL, but it can be a little dull. Photoshop gives us the opportunity to make real life more exciting, more vivid and more dynamic. Throughout this book I've concentrated on techniques for making images look as realistic as possible; but we shouldn't let our desire for realism get in the way of a good picture.

We instinctively know when something looks plausible, and when it doesn't. We've all seen old films showing flying cars, rockets and men falling out of airplanes, and have sensed that the real thing wouldn't look that way. But how do we know what the real thing would look like? Most of us have never seen a rocket from space, or someone falling from a plane. It's likely that the 'real thing', when filmed, wouldn't look convincing either: in many cases, creating a plausible image is more important than one that adheres rigidly to the confines of reality.

Often, the way we remember an object or scene is of more importance than the prosaic reality. Let's say you wanted to draw a time bomb, to be incorporated in a montage. You could spend hours researching bomb construction on the internet, and end up with a dull, colorless device that readers would find hard to interpret. Or you could simply draw two orange sticks attached by curly wires to an analog alarm clock, and you'd have an instantly recognizable image.

Let's take a different example. You're creating a montage of the President of the United States at his desk in the Oval Office. Without suitable reference material, you must rely on your memory – and the collective memory of your readers – to make the picture work. So you assemble a large desk, a high-backed chair, and a window with flags hanging either side of it. But what of the view through the window? It's likely that, should the President turn in his swivel chair, he'll gaze out over a dull stretch of White House lawn. For the reader, though, such a scene wouldn't help to place the location. If you instead opt for a view of another government building, perhaps with a glimpse of a

dark-suited man in black sunglasses with a curly wire over his ear, you'll give the reader many more clues to where your scene is located.

Cartoons, both in print and in animation, have educated us to recognize a host of artificial visual devices designed to accentuate the action. So we'll always see a puff of smoke as Road Runner suddenly takes off for the hills; and we're so used to seeing characters carry on running in mid-air as they leave a cliff top (before suddenly plunging to their doom when they realize their predicament) that we don't think twice about the logic. In printed cartoons, we've come to interpret a series of wavy lines behind a running figure as indicating speed, and straight lines emanating from a central point as a sign of explosive activity.

These metaphors have become so much part of the public consciousness that we can adapt them for use in photomontage. The result will tend towards illustration, and few readers would be fooled into thinking these were actual photographs: but, sensitively used, the cartoonist's techniques can add life to an otherwise static composition.

In real life, explosions are scenes of chaos and confusion, usually so wreathed in smoke that you can't see what's going on. In Photoshop, we can start with the elements of the destruction and add fire, smoke and sparks to illuminate the scene; we're not so concerned with recreating the effect of a real explosion as we are with communicating to the reader that an explosion is taking place. Which means dipping into the collective subconscious to retrieve the sense of exploding material we've gathered from action movies.

If what you want to do is fool your public into thinking they're looking at a real photograph, then none of these techniques will apply. But if your aim is to create an illustration that's entertaining and that tells a story, then don't let the constraints of reality get in the way.

In the next chapter we'll look at a few ways of making reality just that little bit more exciting.

11

Hyper realism

FOR TIMES WHEN REALITY becomes too much to bear, we need to add illustrative elements that make a static picture look more dynamic. These move an image towards hyper realism: what we're depicting is no longer gritty realism, but a graphic illustration.

Real blurred photographs may give the sense of speed, but it's at the expense of clarity. By creating blurs and showing them selectively, we can give the impression of a fast-moving object without losing the detail. In this chapter we'll also look at how to make explosions and other scenes of destruction, as well as how to make complex scenes comprehensible. And in the most complex workthrough in this book, we'll see how you can turn yourself into the Terminator with minimum pain.

Blurring for speed

1 Here's the proud owner of a new photomontage shop, photographed outside his premises. He's been positioned so we can see the sign behind him, but it's all rather lacking in dynamism; the empty space to the left of him badly needs filling.

T HE ILLUSTRATION ABOVE was to illustrate a Sunday Telegraph article on the proposed merger of American Airlines and British Airways. It was a simple enough job: fitting the heads of the two airline bosses to the bodies, and placing the logos on the backs of seats. But I felt that as it stood, the image was too static: so I added a Radial Blur to give the impression of speed.

In this section we'll look at how to use blur techniques to give the impression of movement, and how to get the best results from the filters.

4 Here's a model of a space shuttle taking off into the skies. It's clearly not the real thing, and looks little better than a child's toy suspended against an unconvincing sky. Motion Blur, once again, can help bring this static image to life.

IMAGES: BODYSHOTS (PEOPLE), HEMERA PHOTO OBJECTS (SPACE SHUTTLE), COREL (SKY)

2 Placing a passer-by in the scene helps with the composition of the montage, and her bright red suit adds a much-needed splash of color. The trouble here is that she's too strong an element: she draws the eye away from the main focus of the picture.

3 Applying a small degree of Motion Blur to the figure makes it appear as if she happened to be walking past while the photograph was being taken, and knocks her more firmly into the background. Of course, in reality a person wouldn't be blurred as evenly as this; but the effect works.

5 The shuttle layer is duplicated – we don't want to lose its sharp outline, only to add a blur on top. This layer is then blurred using Motion Blur. But the filter works in both directions: to make the shuttle look as if it's speeding forwards, we need to move either it or the blur.

6 By moving the shuttle to the top end of the blurred layer, the whole of the blur takes place behind it. The flames shooting out of the rocket boosters help: these are simply fireworks, merged in using the techniques described in Chapter 2, Hiding and Showing.

More blurring techniques

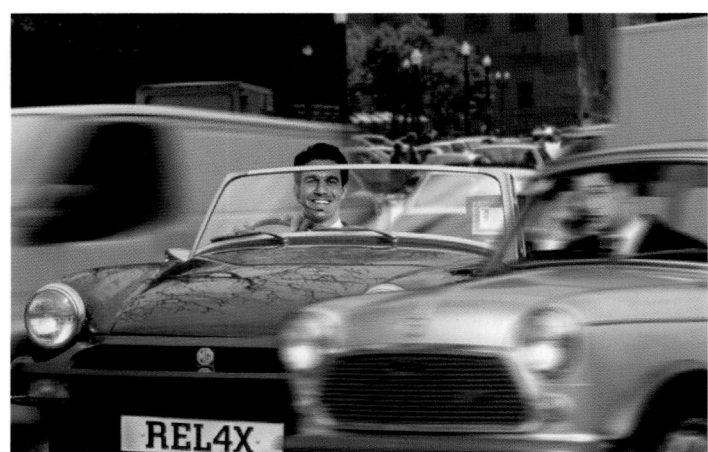

1 Here's our driverless sports car, careering out of control on a shopping street. The immediate problems are apparent: first, the car clearly isn't moving; and second, the angle of view of the car bears little relation to the street on which it's been placed.

BLURRING GIVES THE IMPRESSION of speed, but can also help to focus the reader's attention. The illustration above was for Men's Health, to show how wearing a hands-free headset would help to lower stress levels while driving (this was before it was suggested that hands-free headsets might fry your brains while you're chilling out). The car we want the reader to look at is buried amongst the traffic, but by blurring the vehicles around it I could ensure that the reader wouldn't be distracted by them.

On these pages I'll discuss how to make both Motion Blur and Radial Blur work together, to give the impression that a static car is really moving.

4 The first way to give an impression of movement is to add Radial Blur to the wheels. A circular selection is made into a new layer, which has Radial Blur (Spin) applied, as seen on the left; this is then masked (right) so that the car body is no longer blurred.

7 Motion Blur, as I explained on the previous page, works in both directions. But we only want the blur to show behind the car – not at the front, where it hasn't been yet. So the whole blurred layer is simply moved to the right so that it trails behind the vehicle.

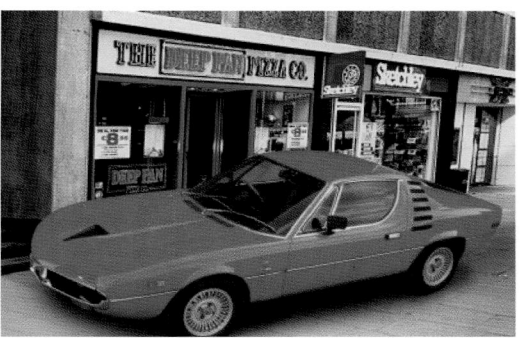

2 Cars are complex shapes, and distorting its perspective would have been a laborious and probably impossible task. But it's easy to change the perspective of the street to match the car: Free Transform is all that is required. The shadow beneath the car also helps to position it.

3 Although the car has been cut out, the original backdrop was still visible through the window. Making a layer mask, we can hide the view through the window so the street is visible. Then, by reducing the contrast of the mask, we can make it appear as if we're looking through glass.

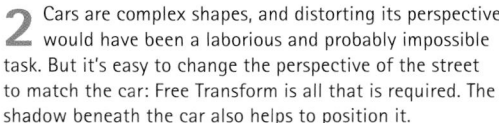

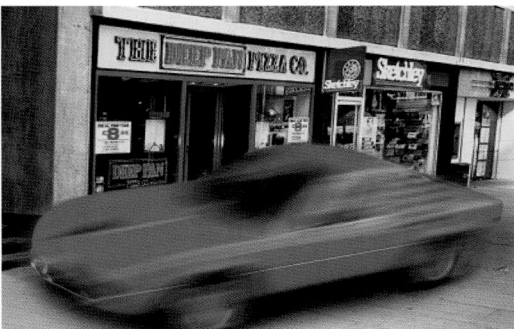

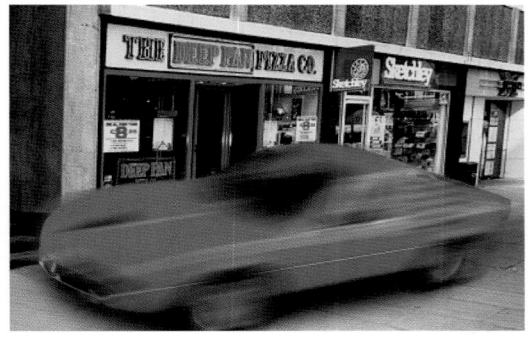

5 The whole car is then duplicated, and Motion Blur applied to the new layer. It's fairly easy to adjust the angle of the blur to match the dominant angle of the car, as the filter gives you a full-screen preview of its effect.

6 Because the car is viewed in perspective, the straight lines of the blur no longer match all the angles of the car. Using Free Transform, we can distort the blur to make it follow the perspective of the car reasonably well.

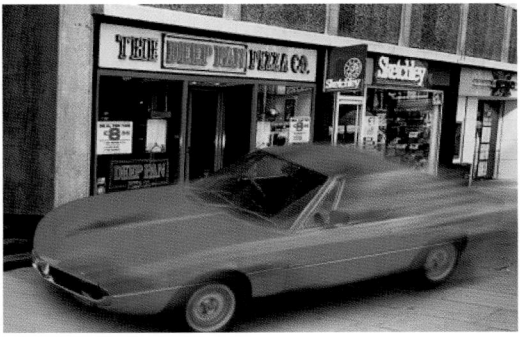

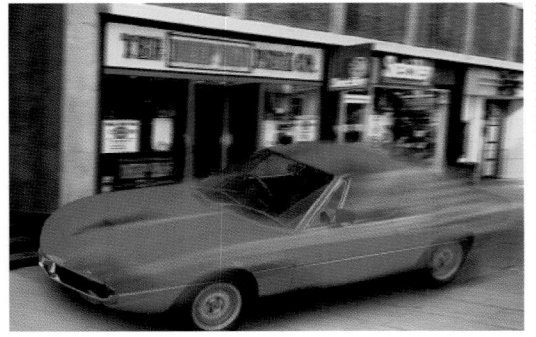

8 The blur hid too much of the original car, and blurred elements such as the wheels didn't look convincing. So we can simply make a layer mask for the blurred layer, and paint out those areas we want to hide: now we retain much of the car's detail, while keeping the sense of movement.

9 The whole image still looked too static: the car was clearly moving, but the sense of speed didn't come through. The answer is to add a little Motion Blur to the background as well, as if the photographer had tried to follow the car's motion but didn't quite manage it.

Breaking glass

1 The original screen on this television has been replaced by a new layer, tinted blue and accented using the Dodge tool to make it more appealing. Since the days of black and white TV, we're used to screens looking bluish.

BREAKING GLASS IN PHOTOSHOP has little to do with broken glass in real life, which tends to look dull and lifeless. We want to give the impression of serious damage, as in the illustration above for The Independent: the violence of the act must be more apparent than the actuality.

Here, we'll look at the process of smashing the glass on the front of a television screen: the glass will explode outwards to heighten the effect. In real life, of course, smashing a screen would cause the glass to implode inwards, to fill the vacuum inside the tube; but real life is sometimes too dull to reproduce.

On the following pages, we'll look at how to turn this broken screen into an explosion.

4 In the last step, we reduced the selection area to the original Lasso selection minus a thin border at the right edge. When we now exit QuickMask and delete, we're left with just the brightened edge of the glass to give some thickness to the broken edge.

7 Nudge the selection down a couple of pixels (don't use the Move tool or you'll move the layer), and use the Brush tool set to Behind to add some thickness to the glass. There will be some awkward double spikes at the pointed ends; these can be removed using the Eraser.

2 Using the Lasso tool, select an irregular shape on the screen and brighten it up. If you hold ⌥ *alt* while clicking points on the screen you can draw straight selection lines between the points.

3 Enter QuickMask mode by pressing ⓠ and select the red mask with the Magic Wand. Nudge the selection up and left a couple of pixels; then inverse the selection and delete, so only a fraction of the highlight remains.

5 On a new layer, draw individual shards of glass with the Lasso tool – simple triangles work best. Using a soft brush at around 50% opacity, paint some color from the screen into these shards, but don't fill them completely.

6 Don't deselect, but use the Dodge tool to brighten up those shards so that they look more reflective. Again, use the tool unevenly so that the pieces don't end up looking too uniform in appearance.

HOT TIP

If you don't see the broken screen highlighted in step 3, but see the inverse in red instead, it's because you've got your QuickMask settings set to default (Masked Areas). Double-click the QuickMask icon and change the settings to Selected Areas, which is easier to work with.

8 Duplicate the glass shards layer, and use Free Transform to shrink the new layer towards the centre of the screen (hold the ⌥ *alt* key as you drag a corner handle). Lower the opacity of this new layer to around 50% to give the impression of movement.

9 Make another duplicate of this layer, and reduce that in size even further – you can add a small degree of rotation as well if you wish. Reduce the opacity of this layer still further, to around 20%, to complete the explosive effect. Finally, paint a little smoke inside the screen.

SHORTCUTS
MAC WIN BOTH

Smashing things up (1)

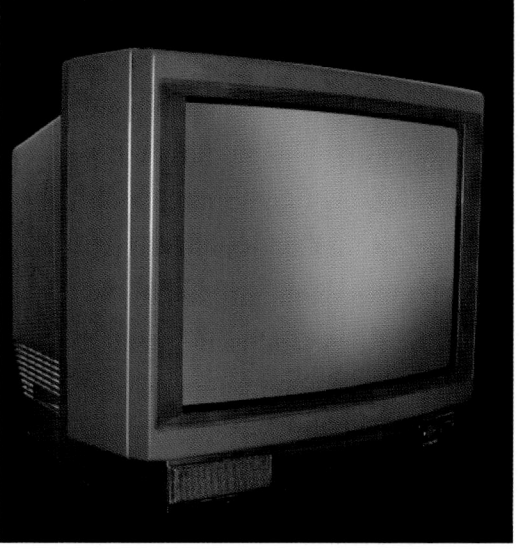

1 Here's the same television we used before, placed against a black background. If you're going to use explosions and flying glass, the effect always works best against a dark background; explosions rarely show up well against white.

WHICH OF US HASN'T WANTED, at some time or other, to take a sledgehammer to our computer when it freezes? Or to our television during an election broadcast? With Photoshop, it's easy to vent your anger without voiding your insurance.

The illustration above was for a Sunday Telegraph article about the end of so-called internet hotels. The fires and explosions simply add to the sense of chaos.

The principles of breaking up technology apply equally well to televisions as to hotels: it's a matter of making holes and then filling the gaps. Following on from the previous page, we'll look here at how to make a television explode.

4 Now we can bring in the flying glass and broken screen from the previous page, rotating it to fit the new angle of the screen border. That's the basics of the television finished: all we need to do now is to add the elements that will make the destruction look more explosive.

2 Begin by selecting the front panel, then cut it to a new layer using *Shift* ⌘ *J* *Shift* *ctrl* *J*. It's now easy to distort it to a new position: although I've kept it close to the original, there's no reason why you shouldn't have it flying halfway across the room.

3 Repeat this process with the side, rotating it in the opposite direction. Add some shading with the Burn tool to give the effect of a shadow. You'll also need to draw the inside of the frame, on a new layer: simply fill the outline with a color picked from the TV, and shade it.

5 Fireworks make great explosions. This firework has been placed just in front of the rotated side, and the black background knocked out of it using the techniques described in Chapter 2. The back edge of the side was painted out on a layer mask so that the firework spilled out behind it.

6 The firework layer is duplicated to make a second explosion, and a bunch of other electronic material is added to give the impression of the guts of the TV flying out in disarray. Next time you upgrade your computer, remember to photograph the boards before throwing them away.

Smashing things up (2)

O N THE PREVIOUS spread we looked at an explosion in the act of occurring, complete with sparks and flying glass. Here, we'll step forward in time to view the destruction after it's happened.

This piece of artwork for the Sunday Telegraph was for a story about the break-up of the telecommunications company Energis, graphically illustrated by a smashed telephone. It's a fiddly job, as each of the buttons on the handset needs to be isolated and distorted individually; but it simply takes a little patience to ensure that all the pieces fit where they belong.

Never having studied the interior of a telephone, I have no idea if they contain printed circuit boards or this sort of wiring. But this is artwork, not technical illustration; such niceties as factual accuracy need not concern us.

1 To begin with, I simply photographed a phone with the receiver off the hook. By placing it on its side, a small sense of chaos is already achieved. I chose a phone with the keypad in the receiver so that I'd have the base free on which to place the Energis logo afterwards.

4 The interiors of the base and the handset were drawn and filled with a flat color to fill the gaps where the tops had been broken off. This was simply a matter of inventing the new shapes using the Pen tool to draw the smoothly curved outlines.

7 The speaker is simply a loudspeaker from a stereo system, photographed and distorted to fit; the printed circuit board is actually a computer logic board cut to fit the interior of the phone.

8 Opposite is the finished illustration, with background and shading added. The Energis logo was taken from their website and redrawn, then distorted using the Shear tool; the shading was added using the Emboss feature in Layer Effects.

2 The first step was to separate the two halves of both the receiver and the handset, exactly as shown in the television example on the previous spread. While it would also have been possible to break the handset into shattered fragments, it adds to the sense of realism if the constituent parts remain intact. If you (or your children) have ever tried to break a telephone handset, you'll know how resilient they can be.

3 Each button was isolated using QuickMask, and then cut to a new layer using *Shift* ⌘ *J* *Shift* ctrl *J*. The button background was recreated, and then the buttons rearranged individually.

HOT TIP

Outlining the buttons was the trickiest part of this illustration. It would have taken too long using the Pen tool: instead, I entered QuickMask mode and used a hard-edged brush of the same diameter as the end of a button. Clicking at one end, then holding *Shift* and clicking at the other end, drew a smooth lozenge that exactly fitted the shape of each button. If you're using a graphics tablet, this method will only work if you have pressure sensitivity turned off.

5 To make the interiors look more realistic, shading was added using the Burn tool to give a sense of depth and roundness. The horizontal ridges inside the back of the handset were added because the flat interior looked too dull without them.

6 The disk covering the mouthpiece was cut to a new layer, and both the disk and the hole given depth using the techniques described in Chapter 9.

SHORTCUTS

MAC WIN BOTH

Chaos and complexity

1 The student was clearly going to be the key figure in this image, so it was important to find the right one. Many royalty-free photographs of people are shot from up a ladder; this one had enough action to make him appear to be struggling with his task.

WHEN AN IMAGE IS TO BE PRINTED right across a spread, it can help to pack a lot of detail into it. This illustration for the student magazine Juice showed a student struggling to write his curriculum vitae (résumé) amid the chaos of his untidy living quarters.

I decided on the top-down view of this illustration simply to add dynamism to it: plus, I knew I had a picture of a desk and chair viewed from above. All the other props were either photographed or distorted to fit.

4 The next major props were the computer, the trash basket and the guitar. The guitar was given depth, and the desk drawer opened, using the techniques described in the first two sections of Chapter 10. With the big stuff in position, I could place the smaller items.

2 The desk and chair were the next major props. Originally the chair was facing the desk, but it didn't take much to move it; the only constraint was positioning it so that its perspective matched that of the rest of the scene. The props on the desk were too business-oriented, but they'd all be covered up later.

3 The carpet was simply a scan of a piece of wallpaper cut to an irregular shape. The image needed a solid base, but I didn't want to square it to maintain the visual interest of the scene. I also changed the student's expression and recolored his T shirt.

5 All the other props were added and positioned where they fitted best. You need a fairly comprehensive library of images in order to find all these elements; most of the elements used here came from the Hemera Photo-Objects 50,000 collection.

6 The final stage, as ever, was to add the shadows. These were created on several layers – one above the carpet, one grouped with the top of the desk, and so on. There's no point adding shadows until the composition is more or less complete, since they can be awkward to edit afterwards.

HOT TIP

Creating an irregular outline for an illustration is an easy way to add life to the image when it's printed: this is far more appealing on the page than a squared–up picture would have been. The key is knowing which elements need to be included, such as the carpet, and which can be missed out: I originally put a wall behind the desk, but removed it when it became clear it wasn't needed.

SHORTCUTS
MAC **WIN** **BOTH**

The fall of the house of cards

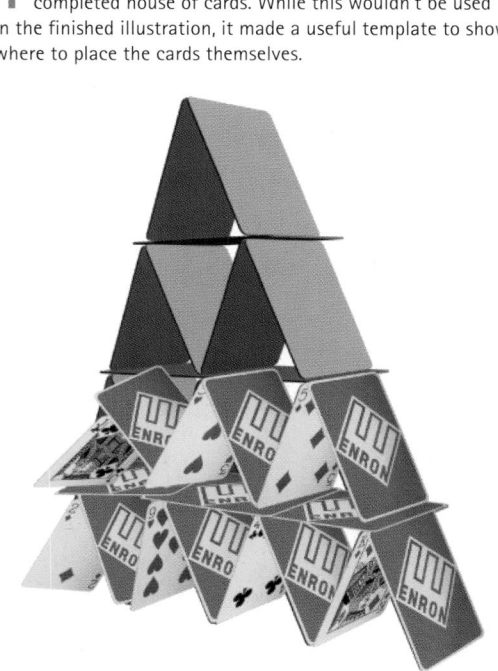

1 The Dimensions model showed the formation of a completed house of cards. While this wouldn't be used in the finished illustration, it made a useful template to show where to place the cards themselves.

MAKING THIS HOUSE OF CARDS appear to be in the process of collapse – while still looking like a house of cards – meant that each card had to be carefully placed to show it in the act of falling.

The illustration was for The Guardian, relating to an article about the demise of energy company Enron. Their distinctive logo, placed on the back of each card, tied the illustration to the story.

In this instance I made the original card house model in Dimensions (see Chapter 9), a simple task which took just a few minutes to put together. This formed the template around which the cards were built.

4 A few cards were added that break out of the line of the template. At the bottom of the pile, the cards were only slightly disarrayed: any misalignment here would cause more chaos higher up the stack. Each card was simply distorted to look as if it was falling.

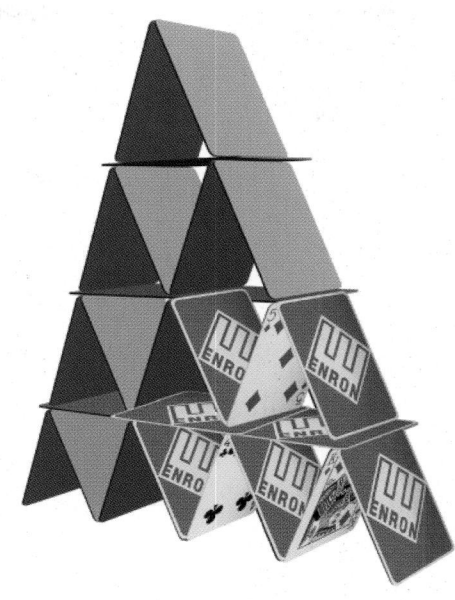

2 The Enron logo was placed on a card-shaped background, drawn with the Shapes tool. The patterned area outside the logo was filled with a cross-hatch pattern that I created for drawing fences, and colored.

3 The first few cards were put in place, following the template. Each card was distorted using Free Transform to fit the template and placed behind the card in front of it: it was easier to work from the front backwards.

5 With all the cards in place, the template could be hidden so that we can see the full effect. No shading has been added yet, although the cards were given some thickness by selecting each one and holding ⌥ *alt* as it was nudged up and right a couple of pixels.

6 Each card was shaded using the Burn tool to add realism to the scene. In addition, the falling cards were duplicated and rotated, and their opacity reduced: those at the top were set to 30% opacity, reducing to just 10% at the bottom of the stack.

HOT TIP

Using a simple modeling program such as Dimensions can greatly help in the placement of objects in a 3D environment, even when the template is discarded at the end. Matching this sort of perspective viewpoint would have been a much trickier task if the cards had all simply been placed by eye: I know this to be true, since this was the way I originally attempted to do the illustration.

SHORTCUTS

MAC **WIN** **BOTH**

277

Enter the Terminator (1)

EACH CHAPTER IN THIS book has dealt with a separate technique. In the real world, however, a single montage may easily combine many different skills to make the image work.

This workthrough was requested by a reader of the first edition of this book, who wanted a way to make himself look like the Terminator from the movies. It's a complex operation, requiring several of the methods described earlier in this book; so we'll take the unusual step of running this workthrough over four pages, rather than the usual two.

1 Begin by creating a new layer to make the base for the skull as seen through the hole in the face. Draw a ragged selection with the Lasso tool, and fill with a mid-tone gray.

2 Now for the clever bit. Make a new Curves Adjustment Layer from the bottom of the Layers palette, and draw a curve like this one: group the Adjustment Layer with the skull layer so it doesn't apply itself to the face as well.

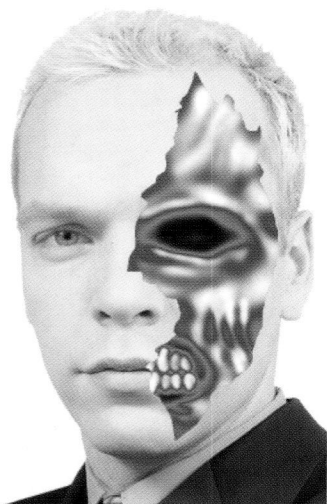

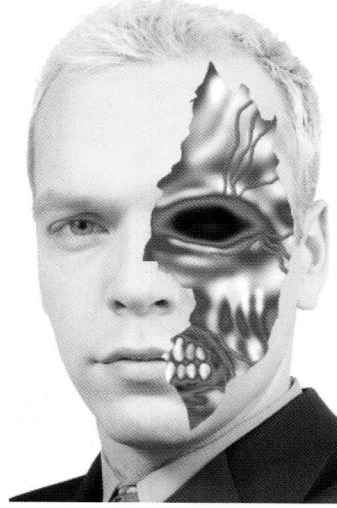

6 To draw the teeth, first make a new layer above the skull layer and then use a small, soft-edged paintbrush loaded with white to paint each tooth in turn. Because this layer will also be affected by the Curves layer, the teeth will look metallic.

7 The veins on the head are drawn in red on another new layer, using a soft-edged brush – again, beneath the Curves layer. By adding embossing using the default layer style settings, the veins look three-dimensional even as they're being painted.

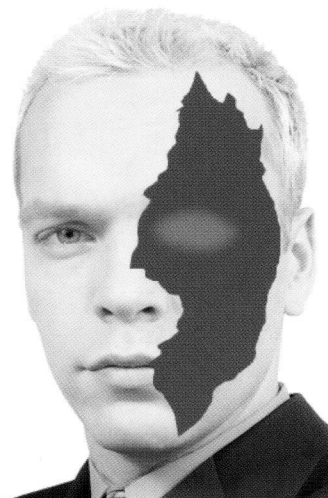

3 The hole will appear to darken. Use the Burn tool to begin creating the skull, using a soft-edged brush and a low opacity – around 40% is best. The results will be odd at first: the Curves layer will mean that areas you think you're darkening begin to look brighter at first.

4 Keep on with the Burn tool, and the areas which have got brighter will begin to darken again. Because of the Curves layer, we're creating a metallic effect as we paint; see Chapter 8 for more on how this effect works.

5 By working with a low opacity, you can build up the contours of the skull bit by bit. Remember that if you hold ⌥ *alt* while painting with the Burn tool, you'll temporarily access the Dodge tool to brighten the layer. With a bit of patience you can create a convincingly shiny skull effect.

HOT TIP

Painting with Dodge and Burn while viewing the layer through the Curves Adjustment Layer often produces surprising results. The trick is to work with a low pressure, making several small adjustments, to produce a convincing effect.

8 Now for the gore. Make another new layer, this time above the Curves layer (but still grouped with it). Paint the rough area in gray with a soft-edged brush, and add some random highlight and shadow using the Dodge and Burn tools.

9 Apply the Plastic Wrap filter two or three times to build up the strength, and then tint the layer using Color Balance to add a reddish hue to it. As it stands, the gore is a little too opaque; we can fix that in the next step.

10 To make the gore stronger but more transparent, change the mode of the layer to Hard Light. This lets us see through it to view the detail of the skull beneath, without losing any of its strength.

CONTINUED OVERLEAF

SHORTCUTS
MAC WIN BOTH

279

Enter the Terminator (2)

11 Now we'll create some thickness for the skin. Hold ⌘ ctrl and click on the name of the skull layer, then switch to the base layer and make a new layer from the selection. Load the selection again, and nudge it to the left by a few pixels.

12 Delete the selection, and you'll be left with just a rim on the right. Move this rim to the top of the Layers stack, so it appears above everything else, and darken it up using the Burn tool.

13 Now to give the edge of the hole some thickness. Load up the skull area as in step 11, then expand the selection by 8 pixels; load the selection again and delete it, leaving just the 8-pixel border, and make a new layer from the face. Apply a default Emboss to give it some depth.

17 To complete the eye, draw the pupil on a new layer (above the Curves layer) by placing a blob of black, then a blob of red inside it, using a soft-edged brush. A tiny blob of white acts as a highlight and gives the eyeball additional realism.

18 At this stage, we can add some blue to the skull to make it more steely in appearance. Make a new Adjustment Layer, this time using Color Balance, above the Curves layer and grouped with it. A touch of Cyan and Blue is all that's needed here.

19 To make the hole look more blasted-open, draw a rough tear on a new layer beneath the skull layer, fill it with a flesh tone sampled from the face, and add shading with Dodge and Burn. The shadow is added on a new layer behind this one.

14 The border, with the Emboss layer style applied too it, looked far too regular. Using the smudge tool set to a low opacity, wiggle it around so it looks more natural and scar-like.

15 Now make a new layer above the Curves layer and grouped with it. Using a soft-edged brush loaded with black, paint a shadow inside the skull area. This makes the hole look far more recessed.

16 The eyeball is drawn on a new layer just above the skull layer. Once again, the Curves effect will be seen on it as you paint, giving it that same shiny, metallic effect.

HOT TIP

By using three Adjustment Layers – Curves, Color Balance and Brightness and Contrast – we can apply these effects in such a way that they can be edited later if necessary. The fact that they're all grouped with the skull layer means that they don't operate outside its bounds, so the original face remains unaffected by them.

20 As it stands, the face looks too calm and unthreatening. Make a copy of the face layer, and add shading with the Burn tool around the hole and elsewhere, for effect. Set the Burn tool to Midtones to avoid simply adding gray shadows.

21 With everything that's going on in this picture, the skull seems to be lacking in contrast. We can boost it by adding a new Contrast Adjustment Layer above the Curves layer (and grouped with it) to strengthen all the skull and metal layers together.

22 Finally, we can use the Liquify filter to distort the face slightly – adding a frown to the eyebrow, and pushing the lips apart so that they wrap around the split. You may need to use the Smudge tool on the scar layer as well.

SHORTCUTS
MAC WIN BOTH

The cover of this book...

THE COVER OF A BOOK, ACCORDING TO conventional wisdom, should not be a work of art but an unashamed advertisement for the product. Which may well be the case with a book on, say, structural engineering or the reproductive cycle of earthworms – but I wanted this book to appeal to Photoshop artists, who tend to have finer sensibilities.

The aim was to produce a cover that looked at a glance like a photograph but which, on closer inspection, clearly couldn't be anything of the kind. It's partly for this reason that I used the head of Humphrey Bogart on the central character, to add to the sense of unrealism. The idea was to intrigue the casual bookshop reader enough to pick it up and see how it was done: in your case, it's obviously worked. I don't know how many dozens of readers passed their gaze over it without a second glance.

I also wanted the cover to be a showpiece for the techniques described in the book, so I included as many of the ideas in the book as I felt I could get away with. An earlier version had banks of snow and ice covering the ground, which I thought gave the book a festive look – but which were removed when my publisher kept asking me what all that mist was doing there. No point arguing the case: if it didn't look like snow, it wasn't snow. It was a complex cover, and here's how it was done.

1 The first step was to set the viewpoint of the cover. I had an image in mind for the main figure, which I'd used in the first edition of this book; I chose this extreme, top-down view because it's hard to create, and because it looks good on the cover. Here, it was simply a matter of tiling the brickwork and distorting it using Free Transform.

2 The sidewalk was placed on top, and angled so that its back edge matched a line in the brickwork. This, too, was distorted using Free Transform, and proved to be a horrendously difficult job: the strong perspective angle of the wall behind it was hard to match in a plane set at 90° to the wall. It took several attempts to get right.

6 I'd had this figure, taken from the Stockbyte collection, knocking around for some years and rarely found a use for him before. The trouble with these up-the-ladder photographs is that they're devilishly difficult to incorporate in a montage without making everything match their extreme perspective.

7 The figure had to be distorted slightly to match the perspective of the wall exactly, which is why the hand holding the umbrella looks so stretched. That would be easy enough to fix later: in the meantime, I had to do something about the fact that he looked so horribly miserable. Would you buy a book from this man?

3 To give the sidewalk some depth, a copy of the front edge was placed on a new layer and darkened appropriately to the scene. The road surface is an expanse of asphalt I photographed last year, and it's been pressed into service many times since.

4 The wall and sidewalk were both duplicated and adjusted in perspective to make the return wall and the floor adjacent to it. The shading is simply a black-to-transparent gradient on a new layer, and it's a simple way to make that flat wall look more convincing.

5 The lettering was made using exactly the techniques described in the Lighting Up: Perfect Neon workthrough in Chapter 5. Getting it into the correct perspective for the wall was simply a matter of distorting it using Free Transform, and aligning the transform handles with the appropriate layers on the brickwork.

HOT TIP

When planning a complex piece of artwork such as this one, you should always create your preliminary designs away from the computer, on a sheet of paper. Or at least that's what we're always told. Personally, I think better with my stylus in my hand than I do with a pencil. The trouble with photomontage is that you can't always find images to match your rough sketches: if you start with the images, you know you've got every element you'll need.

8 After trying out almost every head in my collection – including my own, since I figured people would probably assume it was me anyway – I settled on Humphrey Bogart, who seemed to match the film noir mood of the cover setting well. I needed to find a picture of him looking up, and of course it was in black and white.

9 Coloring Bogie was a fairly straightforward matter, and you can read about the techniques involved in the section Coloring Black + White Images in Chapter 6. His head didn't match the body perfectly yet, but a lot of that could be fixed through shading.

10 As well as adding mood and emphasis to the piece, strong shading does wonders when it comes to masking those irritating joins you'd rather people didn't see. The shading was painted on several layers, guaranteeing that I'd be able to edit each one individually should the need arise later.

...the cover of this book...

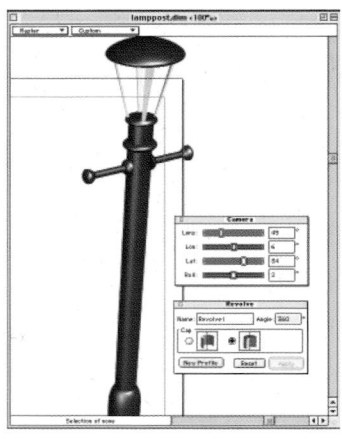

11 There was no way I'd be able to find a photograph of a lamppost from the right angle, so I made this simple 3D model in cranky old Dimensions (see Chapter 10). The main pole and cap are a single revolve object, and the ladder bars and struts are added as separate objects. It's not the most sophisticated 3D modeler, but it does the job.

12 In the event, the perspective viewpoint of the lamppost didn't match that of the image as exactly as I'd hoped. But it was easy enough to distort it using Free Transform, using the corner of the wall as a guide to get the right angle.

13 This photograph of a lightbulb came from the Hemera Photo-Objects collection, and needed only a little distortion to fit the lamp. It would almost certainly disappear under the glow later, but I felt better knowing it was there – and the tiny extra effort it took would make up for the potential horror of seeing the printed cover with a hole where the bulb should be.

17 The glow from the bulb was painted on a new layer in two stages: first, a large, soft-edged brush was used to paint a dab of yellow on the image. Then I switched to a smaller brush size and painted a blob of pure white in the middle of the yellow. It's a fiendishly simple process that never fails to get great results.

18 To move the glow inside the lamp, I first made a layer mask for the glow using one of the struts I'd made into a separate layer earlier. This would have worked OK, but blurring the mask slightly gives a far more realistic impression of light behind a thin object.

19 The glass was made by drawing a selection with the Lasso tool, holding the ⌥ *alt* key while drawing to constrain it to making straight lines between click points. It was then an easy matter to use a soft-edged brush loaded with white, at a low opacity, to sketch in the impression of glass panes.

14 Because the bulb obscured one of the struts holding the lamp roof, I copied it to a new layer and brought it to the front. I also took this opportunity to brighten up the inside edge of the other struts, to make them look as if they were lit by the bulb.

15 Although I'd added a little Gaussian Noise to the body of the lamppost to give it some texture, it still looked far too clean. To dirty it up I made a new Hard Light layer, grouped with the post, and painted dabs of gray and brown onto it with a small brush, which looks convincingly like rust. Simple, but it works.

16 I knew I'd want to add rain to the image – after all, there's Bogie holding an umbrella – so I painted a few drips onto the lamppost. These were painted on a new layer, set to Hard Light mode, and rough shading added; the Plastic Wrap filter (see Chapter 7) makes the result look shiny.

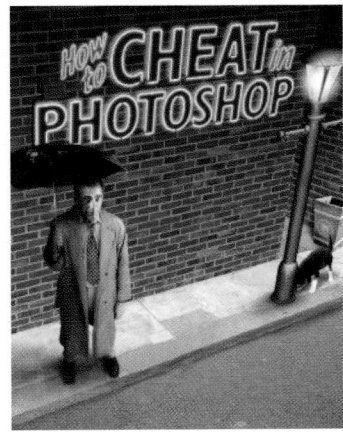

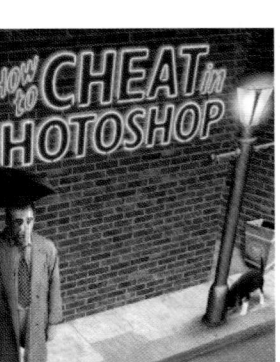

20 With all the elements of the lamppost complete, I felt that something was missing. Anyone who lives in a big city will recognize the need to pick your way through dog dirt – but rather than drawing a steaming pile I stepped back a stage and added just the dog sniffing at the base. Someone's bound to complain.

21 Rain is surprisingly easy stuff to create in Photoshop. Start with a layer filled with a mid-tone gray, and add some Gaussian Noise to it. Then use the Motion Blur filter to blur that noise at an angle, and the result will look like this. Not too convincing so far, but we've one more step to make the rain work.

22 And that step is to turn the layer's mode to Hard Light so that all the gray disappears, and we're just left with the light and dark. Here, I lowered the opacity of the layer to 60%, and painted it out on a layer mask where it overlapped areas I didn't want obscured such as the light and the lettering.

...the cover of this book

23 The poster which carries the subtitle of this book was created on separate layers so that each element could be modified and adjusted as needed. I'd originally designed this poster with a swimsuit-clad couple lying on the beach, but was told to take it out. Something to do with harming sales in the mid West. Honestly!

24 After I'd finished the poster, I made a merged copy of it using ⌘ Shift C ctrl Shift C and then placed the copy on the brickwork, aligning it to the perspective of the bricks using Free Transform. At first I placed the poster at an angle so it looked more hand glued, but the result was just confusing.

25 The tears in the sides of the poster were made by creating a layer mask for it, and hiding selections made with the Lasso tool. That way, I knew I could bring them back later if I needed to. The corner curl was made by drawing the outline with the Pen tool, and adding shading to it with Dodge and Burn.

29 The water was painted on the ground on a new layer, using a hard-edged brush with light gray. When painting irregular shapes such as this, it can be difficult to judge the perspective; one clue is given by the angle of the surface on which the water lies. As long as the dominant angle follows the angle of the surface, it will look convincing.

30 Random shading was added to the water's surface, followed by the Plastic Wrap filter again. Then, elliptical selections on the surface were distorted using the ZigZag filter – which, unlike the Ripple filter, is the best way to create pond ripples in a surface. In this instance, they're showing where the raindrops hit the surface of the water.

31 The water layer was set, once again, to Hard Light mode to make it clear. A duplicate of the layer was then used as a mask, which would have all the other elements of the water surface grouped with it: the water I'd just drawn would be on the top level of the group.

26 To make the creases, I first created a new Hard Light layer filled with a neutral midtone gray (this is an option when you make a new layer and set its mode to Hard Light). The creases were painted on using Dodge and Burn once again; because they were on a separate layer, the poster itself remained intact.

27 The banner was easy to make: the lettering was set by itself, then a new layer created and a marquee selection just larger than the lettering filled with a deep red. This layer was moved behind the text, and the text layer merged down into it. Placed at an angle, as it stands it looks conspicuously neat.

28 The wrinkles in the banner were made in exactly the same way as the creases on the main poster: painting with Dodge and Burn on a new Hard Light layer placed on top and grouped with it. The technique is otherwise the same as that described in the section Folds and Wrinkles in Chapter 9.

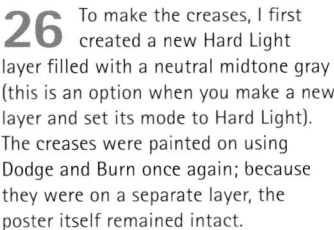

32 All the significant elements in the image – the neon, the wall, the man, the poster – were duplicated individually and distorted to fit the reflection. It was an extreme distortion, in some cases, since simply flipping the images vertically wouldn't have made them lie in the correct plane with respect to the wall; there were no guidelines, so it had to be done by eye.

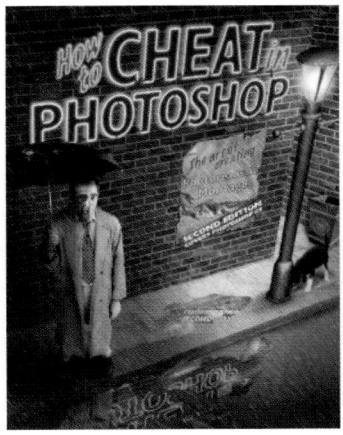

33 With all the elements in place, some fine tuning was called for. A line of cement was painted at the join of the wall and the sidewalk to make it less hard; the background gradient was painted out around the lamp; shadows were tickled to make them behave better. I also added an additional glow to the neon where it reflected off the wall.

34 The image as it stood had all the pieces in the correct position, but it didn't look enough like it was set at nighttime. The simple answer was to create a new Color adjustment layer, adding a subtle blue shade to the figure, wall and background – but behind the neon and the lamp glow layers.

Photomontage ethics

A COUPLE OF YEARS AGO the issue of photomontage was brought into question when a photograph of prominent left-wing politician, on a night out with his wife, appeared in a London newspaper. In front of him on the table were a couple of bottles of beer, the kind that has a foil-wrapped cap. Someone at the newspaper had enlarged one of the beer bottles so that it looked like a bottle of champagne – a deception magnified by the headline 'Champagne Socialist' that proclaimed his decadence.

As distortion of the truth goes, it seemed like a minor infraction. But the issue made national news. I was interviewed about it on radio, and asked whether I condoned this sort of underhand trickery. I pointed out that, had the photographer merely rearranged the scene, moving one of the bottles to the foreground so that it obscured less of the politician in question, there would have been no debate; yet the results would have been identical. It's only because the change was made in the cold light of the newspaper offices that it caused an outrage. That's all very well, opined the interviewer, but how would I feel if he took the interview he'd just done with me and rearranged it back at the studio to suit his own purposes? But that, I pointed out, was exactly his intention: he was going to boil down 40 minutes of interview into a five minute segment, choosing the parts that told the story he wanted to tell. My comment never made it into the final broadcast.

There's a lot of confusion about photomontage, much of it stemming from the misconception that photographs somehow tell the truth, as if there's an absolute truth out there that can be captured in one-sixtieth of a second; any tinkering with that truth must be a lie.

But photographs don't tell the truth any more than words. The photographer may take several rolls of film, each frame capturing a slice of time; the photo editor will then choose the picture that tells the story his newspaper wants told. The sub-editor may then crop the picture to fit the space available, and in doing so will again retell the story.

The photograph above left shows an idyllic view of a small cottage, set amid verdant foliage. But it's a lie: the picture has been cropped from the original image, above right, which tells a very different story. Anyone who had rented this as a holiday home after seeing it on a website would have every right to feel cheated by the reality: and yet there's been no Photoshop trickery involved, simply a selective decision about how much of the 'truth' to tell.

We may take a roll of film on holiday, from which we choose half a dozen to go in the album. The rest are discarded – one person has their eyes closed, the expression isn't so appealing, a tourist got into shot in the background. Yet we are just as guilty of editing the truth as if we'd montaged the elements together in Photoshop: we're telling the story we want told.

I once argued this point with a photographer who had just produced an image of newly released hostage John McCarthy outside his home, with a rainbow glistening in the sky behind him. He'd had to wait all day for the right image, he told me, and just caught the rainbow in time. But, I said somewhat facetiously, I could have put the rainbow there for you and saved you the trouble. He was horrified: his picture was the 'real thing'. And yet John McCarthy doesn't run outdoors every time a rainbow appears: this image was as contrived as if I'd montaged it myself.

I'm not saying there aren't limits to what should be done with photomontage. But if obvious montages make more people realize that the camera nearly always lies, then the world will be a better place.

Carry on spending

Powerful though Photoshop is, there are some effects you simply can't achieve with the built-in tools and filters. Over the years third party developers have brought out plug-in filters that enhance the potential of Photoshop in some way: some are useful, everyday tools, others are weird and amusing but have little practical application.

Because this book deals with reproducing reality, I'm going to concentrate on the filters which offer specifically real-world effects. Included in this section are my personal favorites; some are from major graphics corporations such as Corel, others are shareware offerings made by one person and sold through a website.

We'll begin by looking at the new features in Photoshop CS, the latest version of everyone's favorite image manipulation program.

Adobe Photoshop CS

EVERY TIME ADOBE BRINGS OUT A NEW version of Photoshop there's a mixed reaction from users: some complain that features they want aren't there, others applaud the innovations. Photoshop CS brings us many interface enhancements, as well as some new tools and techniques that may change the way we work forever.

Earlier in this book, we've looked at the Shadows/Highlights adjustment (p 52) and the Color Replacement Brush (p 26). For many, the big new feature will prove to be the revised File Browser, which now displays thumbnails of images in folders many times faster than before. It also allows us to apply batch processing commands without having to open the images first, and includes the ability to save and search by keyword and to store favorite folders in a menu for quick retrieval. It may not be sexy, but it's certainly going to change the way we work. Below are six more compelling features in the new version.

You don't, of course, have to upgrade. All except two of the examples in this book will work with Photoshop 7; and almost all the rest will work with earlier versions still. Upgrading is an expensive business, especially if you're a Mac user – Photoshop CS won't run on anything less than OS X. So take a look at what's in it, and decide if the upgrade is necessary for you.

Manufacturer: Adobe Systems, Inc

URL: www.adobe.com

WHAT ELSE IS NEW

Filter Gallery
Choosing the right filter used to be a hit-or-miss operation. Now, the Filter Gallery displays most of the available filters with thumbnails showing their effects: multiple filters can be put together and tried out within a single dialog window.

Photomerge
Although this feature appeared in Photoshop Elements a while back, it's taken some time to make it into Photoshop. Photomerge takes a series of views of the same scene and builds near-perfect, seamless panaromic images from them.

Text on a path
It's been a long time coming, but now you don't need to leave Photoshop to place text on a path – or inside a shape. Draw a circle with the Shapes tool, and run text around the perimeter: it's great for mocking up labels and packaging.

Layer Comps

Where the History palette can store multiple versions of a document, Layer Comps can now remember which layers are visible and which are hidden, where they're located and whether they have Styles attached. Trying out multiple versions of artwork was never easier.

Match Color

The Match Color dialog is designed to make the color tones of one image match those in another. It's a tricky adjustment to get right, and often produces unexpected results; but given the right starting images, this adjustment can work wonders.

Crop and Straighten

Still scanning images from conventional photographs? This new feature lets you scan several images together, and then automatically crops and straightens the result to place each image in its own new file. Absolutely brilliant.

Alien Skin EyeCandy 4000

EYECANDY 4000 is a suite of plug-in tools that offers a wide range of real-world effects. Where many plug-in developers concentrate on the weird and the wacky, EyeCandy specializes in tools that simulate reality.

The most immediately impressive filter in the set is Chrome, which can turn any object into gleaming metal that can be fully customized to resemble a variety of surfaces. Custom bevels can be drawn to suit any purpose, as well as chosen from the wide range of presets that come with the product.

But EyeCandy can also create such difficult effects as fire, smoke and water drops with surprisingly good results; it also has the ability to make selections drip and melt in a convincing and appealing way.

The interface is simple but comprehensive, with separate panes for controlling every aspect of each filter. Previews are as large as you want them to be, since you can enlarge the window to fill your monitor – although the larger the window, the longer complex effects will take to preview. Most useful of all is the Random Seed button, which changes the way the effect is applied while retaining all the parameters you've set: it's easy to keep clicking the button, changing the effect slightly each time, until you get precisely the effect you want.

Manufacturer: Alien Skin Software

URL: www.alienskin.com

HOW TO USE IT

1 Begin by setting up your type, and rendering it as a layer (EyeCandy can't work with type layers). Here, we've applied the Drip filter to make the type look as if it's melting.

2 A second application of the Drip filter makes the distortion look more random. By changing the parameters, I've made larger drips that are more widely spaced. The ability to build up multiple effects by varying a filter makes EyeCandy far more flexible.

3 Now, that dripping metal is taken into the Chrome filter. This allows us to set any bevel size and type we want, as well as specifying both the type of metal (determined by the image reflected in it) and the surface properties. By adding a 'flaw' to the surface, we make it ripple.

Chrome

| Basic | Lighting | Bevel Profile |

Reflection Map

Beach.tif
Blue Sky.tif
Brick Wall.tif
Earthtones.tif
Outdoor.tif
Roadside.tif
Shiny Penny.tif

Bevel Width (cm) 0.45

Bevel Height Scale 0

Smoothness 27

Ripple Thickness 34

Ripple Width (cm) 1.90

Bevel Placement
⦿ Inside marquee
○ Outside marquee

Random Seed 1

OK
Cancel

This is the preview window 100%

4 Next up comes the Fire filter. There are several ways of applying this, and it's possible to generate convincing flames by choosing the right method. Here, I've set flames to start at the far edge of the selected object, rising almost vertically.

5 The Smoke filter works in much the same way as the Fire, but creates wispy streams that really do look like smoke. Of course, it's possible to change the color and type of the smoke to represent just about any flowing material you want to reproduce.

6 Here's the finished image, with all the filters applied cumulatively. It's the kind of illustration that would have taken hours to produce by conventional means, and still wouldn't have looked half as good. Buy EyeCandy for the Chrome filter alone, then find out what else it will do.

Alien Skin Xenofex 2

XENOFEX 2 is another set of plug-ins from Alien Skin, who make EyeCandy 4000 – and the similarity of the interface can be seen by comparing it with the previous spread.

Xenofex 2, like EyeCandy, offers a selection of tools with real-world applications. The main shot here shows Puzzle, which is the best and easiest way of generating convincing jigsaw puzzles: you can determine the number of columns, the size of the connectors, the width of the groove between pieces, and much more. Best of all, any piece can be removed from the puzzle by simply clicking on it, making it easy to build half-finished jigsaw puzzles.

As well as the filters shown below, the Xenofex bundle includes a reasonably convincing Flag filter that adds ripples, distortions and wind effects, and a great Television filter that makes any image look like it's on an old TV by adding scan lines, ghosting effects, screen curvature and noise. Other effects include Constellation, which makes a selection look like it's made of starts or fairy dust, and Stain, which gives the appearance of a coffee mug leaking onto a photograph.

The Xenofex collection is another of those must-have filter sets that can save you an enormous amount of time; and the elegance of its interface means that you can be up and running with it in minutes.

Manufacturer: Andromeda Software, Inc.

URL: www.andromeda.com

HOW TO USE IT

1 Rip Open makes tears in artwork, and you can set the size and number of tears, the background color, and even the raggedness of the tears themselves – so the rip can look like smooth metal or raggedly torn paper.

2 Classic Mosaic is an extraordinarily powerful filter. Where Photoshop's built-in Mosaic filter will simply impose a tesselated outline on an image, Classic Mosaic makes the tiles follow the contours of the underlying image so that it really does look like it's been painstakingly made from real chips.

3 Shatter makes images look as if they're in the process of being blown apart. You can control the size and thickness of the pieces, the background color and the shadow size and color; you can even 'move through time', showing different stages in the explosion process.

Alien Skin Xenofex 2 Puzzle

Basic | Lighting

Columns | 7

Knockout 10% Remaining
Restore All Pieces
Invert All Pieces
Randomize Connectors

Connector Length | 50

Groove Width | 50

Knockout Fill
- Fill with solid color
 Fill Color
- Make knockouts transparent

Connector Shape Random Seed | 1

OK
Cancel

Randomly set which direction the connectors face. Use the Adjustment Tool to flip individual connectors. | 100%

4 Crumple gives flat images the appearance of having been scrunched up and then smoothed out again. We've looked at ways of doing this in this book, but this is the simplest solution; it would be hard to achieve an effect as good as this by conventional means.

5 The Cracks filter makes an object (or a selection) look as if it's corroding from the edges inwards. It's a great effect to use on stone, and the full degree of user control means you can achieve exactly the effect you want with minimum effort.

6 Like its companion, Lightning, Electrify creates sparking edges around selections, making them look like they're aflame with St Elmo's Fire. Perfect for those mad scientist images, and – like all Xenofex filters – very easy to use and control.

297

Flaming Pear

DESPITE BEING ESSENTIALLY a one-man outfit, Flaming Pear have generated many useful filters over the years. These shareware plug-ins each perform a single task, and usually do so to perfection.

Flood, shown in the screenshot (right), has the ability to submerge any scene: in the preview seen here, the water is entirely artificial. Flood offers a high degree of user control, including the facility to set such parameters as the perspective, altitude, waviness, complexity and brilliance of the water.

A useful extra touch is the ability to be able to set a pond ripple on the water's surface. Simply click the preview at the point you want the ripple – it may be where you plan to place

a boat, for example – and the ripple will appear. You can also set the size, height and undulation of the ripple.

Flood works best with images shot head-on, since the horizon line is always horizontal. This makes it difficult to work with scenes photographed at an angle, although it is possible to build up multiple reflective effects from each object in a montage and then blend them together.

Some of Flaming Pear's other filters, described below, continue the natural elements theme, allowing the creation of stars, planets and suns; others offer interesting bevel effects.

Manufacturer: Flaming Pear Software

URL: www.flamingpear.com

OTHER FLAMING PEAR FILTERS

1 Solar Cell generates vivid suns, with definable flares, spikes, haloes and bows. But reduce the radius of the sun to zero, and it makes great explosions.

2 Lunar Cell creates fantasy moons and planets of every imaginable kind. With an internet connection, it can even display current cloud data!

3 SuperBladePro offers the best beveling tools around. Turn any selection into glittering jewelry, customized with a huge range of parameters.

4 Glitterato is the solution for making star fields, complete with two nebula generators if you want them. A perfect companion to Lunar Cell.

299

KPT Collection

AI'S POWER TOOLS are not so much the granddaddy of all filters as the slightly peculiar uncle from the tropics who you wouldn't leave alone with the children. The inventor of the wacky interface, Kai Krause, spent much of the 1990s designing filters that range from the useful to the downright absurd. Now the best of the KPT sets have been combined in the KPT Collection, which pull together the weirdest and the most fascinating of the bunch.

Most of these are not everyday filters, and some you'd rarely touch. The ability to replicate the effect of ink dropping into water, for example, may not be one you need regularly; and while Mandelbrot sets may make interesting patterns, you're not going to reach for this tool on a daily basis.

The effects are fascinating and fun to use, and some are capable of generating fascinating background textures. KPT Gel, shown in the main image, allows you to paint with golden treacle and use a variety of tools to distort and roughen the surface. Many of the filters allow you to generate QuickTime movies from a series of states, which then flow smoothly between the different saved operations. Certainly, no overview of Photoshop filters would be complete without at least a cursory nod to the master.

Manufacturer: Corel

URL: www.corel.com

OTHER KPT FILTERS

1 Frax4D builds fascinating, shiny surfaces of gleaming metal. Tricky to control, you're exploring the surface rather than generating exactly the effect you want.

2 FraxFlame makes intricate string-like patterns that are great background images. But be warned – each of these images can take several hours to render.

3 If you're tired of Photoshop's meagre range of lens flares, KPT LensFlare offers a huge variety that's fully customizable.

4 KPT Projector allows any image to be tiled and viewed from any angle: here, a small selection of bricks has been reproduced nearly to infinity.

Index

Where page references in multiple-number entries are shown in **bold type**, this indicates a page or section in which particular attention is paid to this subject.

T HE IMAGES SHOWN ON THE NEXT FOUR PAGES come from the AbleStock collection of royalty-free photography. These high resolution images are provided for you to use for your own work: read the license agreement in the AbleStock folder on the CD for full terms and conditions.

Where most photo libraries are geared towards providing finished, glossy images, AbleStock is one of the few who cater specifically for the needs of the photomontage artist. Often, the same character is photographed from a dozen different angles, so you can be sure to find the image you need. Over 36,000 images are available on their website, and an annual or six month subscription allows you to download up to 30 Photo-Objects (cutouts) and 30 background images every day, to use as you wish.

Included here are 100 images I've selected as being of particular use for photomontage. To find out more, visit the website at www.ablestock.com.

People

All these people come complete with clipping paths. To separate them from their backgrounds, click on Path 1 in the Paths palette and choose Make Selection from the pop-up menu in the same palette.

AbleStock001.jpg

AbleStock002.jpg

AbleStock003.jpg

AbleStock004.jpg

AbleStock005.jpg

AbleStock006.jpg

AbleStock007.jpg

AbleStock008.jpg

AbleStock009.jpg

AbleStock010.jpg

AbleStock011.jpg

AbleStock012.jpg

AbleStock013.jpg

AbleStock014.jpg

AbleStock015.jpg

AbleStock016.jpg

AbleStock017.jpg

AbleStock018.jpg

Ablestock019.jpg

AbleStock020.jpg

AbleStock021.jpg

AbleStock022.jpg

AbleStock023.jpg

Ablestock024.jpg

AbleStock025.jpg

AbleStock026.jpg

AbleStock027.jpg

AbleStock028.jpg

Ablestock029.jpg

AbleStock030.jpg

AbleStock031.jpg

AbleStock032.jpg

AbleStock033.jpg

Ablestock034.jpg

AbleStock035.jpg

AbleStock036.jpg

AbleStock037.jpg

AbleStock038.jpg

Ablestock039.jpg

AbleStock040.jpg

AbleStock041.jpg

AbleStock042.jpg

AbleStock043.jpg

Ablestock044.jpg

AbleStock045.jpg

307

AbleStock046.jpg

AbleStock047.jpg

AbleStock048.jpg

Things

All the things have clipping paths: remove them from their backgrounds in the same way as the people (see previous page).

AbleStock049.jpg

AbleStock050.jpg

AbleStock051.jpg

Ablestock064.jpg

AbleStock065.jpg

AbleStock052.jpg

AbleStock053.jpg

AbleStock054.jpg

Ablestock066.jpg

AbleStock067.jpg

AbleStock055.jpg

AbleStock056.jpg

AbleStock057.jpg

Ablestock068.jpg

AbleStock069.jpg

AbleStock058.jpg

AbleStock059.jpg

AbleStock060.jpg

Ablestock070.jpg

AbleStock071.jpg

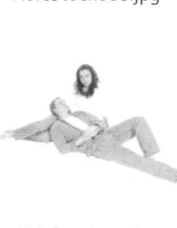

AbleStock061.jpg

AbleStock062.jpg

AbleStock063.jpg

Ablestock072.jpg

AbleStock073.jpg

AbleStock074.jpg

AbleStock075.jpg

Places

No clipping paths here – all the images are squared up, so have no need of them. Use these images as backgrounds for your people, or as views through windows.

AbleStock076.jpg

AbleStock077.jpg

AbleStock086.jpg

Ablestock087.jpg

AbleStock088.jpg

AbleStock078.jpg

AbleStock079.jpg

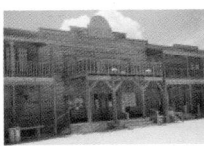

AbleStock089.jpg

Ablestock090.jpg

AbleStock091.jpg

AbleStock080.jpg

AbleStock081.jpg

AbleStock092.jpg

Ablestock093.jpg

AbleStock094.jpg

AbleStock082.jpg

AbleStock083.jpg

AbleStock095.jpg

Ablestock096.jpg

AbleStock097.jpg

AbleStock084.jpg

AbleStock085.jpg

AbleStock098.jpg

Ablestock099.jpg

AbleStock100.jpg

 This symbol, which appears throughout the book, indicates that you'll find a Photoshop file on the CD to accompany the workthrough. The files are in a folder called Chapter Files, and each one includes all the elements of the starting point for each workthrough so that you can try the techniques out for yourself. Each Photoshop file on the CD contains a note outlining the task you're supposed to complete.

 This symbol indicates that, in addition to the Photoshop file, there's also a QuickTime movie on the CD that shows the workthrough played out in real time. I've included movies where there's some benefit to being able to see the artwork being created 'live'; sometimes it's easier to understand a concept when it's played out for you rather than just by reading about it.

The folder named Demo Software includes demonstration versions of several of the third party plug-ins that I've discussed in Chapter 11 (in both Mac and Windows formats), as well as a demo version of Adobe Dimensions (discussed in Chapter 10). The demo versions are all designed to show you the full capabilities of the filters, and most are save-disabled to prevent you from applying the effects to real artwork. The demos are saved in .sit or .zip format; you'll need a third party utility such as Stuffit or WinZip to decompress them so you can install them onto your hard disk. To try out the plug-in filters, you'll need to install them into the Plug-ins folder inside the Photoshop folder on your hard disk. The CD also includes a selection of high resolution royalty-free images from AbleStock, detailed on the previous pages. And there's also a demonstration version of Hemera Photo-Objects which includes many images from their collection.